NOTES FROM Susie

CHOOSING GRATITUDE
IN LIFE'S LOW PLACES

MARK & SUSIE EDWARDS

Notes from Susie
Choosing Gratitude in Life's Low Places

Published by Celebrating Grace, Inc.
© 2016 by Celebrating Grace, Inc.
6501 Peake Road
Building 800
Macon, Georgia 31210
(877) 550-7707
www.celebrating-grace.com
www.NotesFromSusie.com

ISBN 978-1-936151-15-8

First Printing

For information about special discounts available for bulk purchases, sales promotions, fund-raising and educational needs, contact Celebrating Grace at (877) 550-7707 or inquiries@celebrating-grace.com.

Cover painting by David Arms
Cover design by Gordon Brown
Interior layout by Julie Lundy

Publisher's Cataloging-in-Publication data
Names: Edwards, Mark D., author. | Edwards, Barbara Sue (Susie), author.
Title: Notes from Susie : choosing gratitude in life's low places / Mark and Susie Edwards.
Description: Macon, Georgia: Celebrating Grace, Inc., 2016
Identifiers: ISBN 978-1-936151-15-8 | LCCN 2016937096
Subjects: LCSH Edwards, Barbara Sue (Susie) -- Health. | Edwards, Mark D. | Grief--Case studies. | Cancer--Patients--United States--Family relationships. | Gratitude. | Christian life. | BISAC BIOGRAPHY & AUTOBIOGRAPHY / Women | BODY, MIND & SPIRIT / General | SELF-HELP / Death, Grief, Bereavement | SELF-HELP / Personal Growth / General.
Classification: LCC RC265.6 .E39 2016| DDC 362.196/9940092--dc23

CONTENTS

FOREWORD

Initially, the thought of keeping family and friends informed as to the progress Susie was making with her newly begun battle with cancer was a practical matter. We all anxiously read the posts written by Mark and his family hopefully as we followed each new communiqué. We were hopeful because the idea that something so dreadful as cancer could take away someone so delightful as Susie seemed preposterous. Such a thing could not be so hope was ever present.

With no particular pious intent originally, these notes evolved into a blog, a current way to communicate, then to an epistle, an ancient way to communicate. While hardly sounding religious or like letters from St. Paul, they were called, "Notes from Susie." Eventually, as the disease progressed, they seemed to be dreaded medical reports that became more and more ominous. While the news continued, the timbre of the words took on a – I look for the right word – more spiritual, more eternal, more theological turn. To be more precise, on the journey Susie was making, the word I was looking for was hopeful. The message became a testimonial to Susie's trust and dependence on God. She showed us something awesome and awful. It was not her bald head or her wasting body. She revealed her remarkable character. We, who had the eyes to see, saw that she had the "faith to be sure, the heart to be pure, and the strength to endure all her tribulations."

This book is not merely the chronicling of Susie's too short life. Her life continues in the hearts and memories of her children, Weslee and Nathan. She was so profoundly devoted to them, that we all knew it. Her marriage to Mark was a stellar example for all of us as to what, "in sickness and in health" means. She seemed to love others quickly, but to Mark her love was loyal, joyful and faithful "until death us do part."

Notes from Susie continue to us even though she died. Interesting word, died. Did she? Die? Somehow in my stumbling, bumbling, staggering journey towards eternity, I heard that Death had been conquered and Susie, through the love planted in the hearts of her family, is still passing on to us the good news of eternal life in Christ.

She was/is a honey!

RAGAN COURTNEY
Playwright, poet, actor

ACKNOWLEDGMENTS

It has been well said that it takes a village to raise a child. In that same spirit, I'd like to submit that it takes a herd to battle cancer. A few pages from here, you will learn more about that word *herd*, but generally it refers to the host of friends and family who helped my wife, Susie, and me live and die at the hands of this dreaded disease. It is impossible to name the whole herd, but I will attempt to include everyone by identifying some groups and citing a few individuals. My family joins me in the following heartfelt words of gratitude.

By far, the longest-lasting and largest group is the membership at First Baptist Church, Nashville, Tennessee, where Dr. Frank R. Lewis is senior pastor. For nearly four decades these friends have become more like family to the Edwards household. They ministered *with* us all these years, but during our battle with cancer they ministered mightily *unto* us. In addition to praying for us regularly, this crowd sent literally hundreds of cards and brought food to our house at least twice a week for more than two years. House cleaners were sent, musicians showed up to give us evenings of hymns, gift cards arrived, flowers by the dozen followed every treatment, Thanksgiving dinner was delivered, a decorator came to "trim the hearth and set the table" for Christmas—every creative gesture of love, help, and support imaginable came our way. This congregation was the earthly body of Christ during our hard journey.

Special thanks go to Dr. Donna Scudder, Dr. John Wheelock, and Dr. Charles Penley, who quarterbacked Susie's treatment at different phases along the way. The medical teams at St. Thomas Midtown Hospital and Tennessee Oncology are among the best, and we appreciate their professional attention and loving care. Linda Cartee, our longtime pharmacist friend at CVS-Brentwood, could not have been more helpful or of greater service to us. We had only heard others hail the work of Alive Hospice, but we have added our voice of praise for their responsive and caring ministry, especially given the dire winter weather conditions we experienced during their weeks with us.

Not everyone knows their neighbors, but we know and love ours; they, too, prayed and provided for us in appropriate ways—never hovering, but occasionally bringing us something, checking on us regularly, and standing by ready to do anything for us at a moment's notice.

Don Beehler has been my trusted editor and primary shaper of this volume. He came to the table with an experienced and objective eye, but through the process has become encourager, sojourner, and friend. Kim Hester has worked with me in many capacities for thirty years. Her help with this manuscript and other related minutiae has been invaluable. Thank you, Don and Kim.

Finally, I am most indebted to Tom McAfee, who invited me to put our cancer and caregiving journey into book form and provided the means to do so. Tom approached me about the project, saying, "It's a story that needs to be told." Tom and his family know firsthand about premature death as well as the challenges that cancer creates. But through the years the McAfee family and foundation have shared their resources generously so that many stories of Christian faith may be told far and wide, all to the glory of God.

M. D. E.

INTRODUCTION

Life was going along well when we woke up on March 1, 2013. My wife, Susie (a.k.a. Honey), and I both had good jobs. Our kids were now adults and off our payroll. The mortgage payoff was clearly in sight. Many friends were nearby, and we could pretty much call our own shots. But late that Friday afternoon came the call we all dread from the doctor: Susie had ovarian cancer.

The day of Honey's first cancer surgery, Weslee, our adult daughter, told us we needed to set up an open Facebook group to keep our several circles of friends and family, near and far, informed. This would (1) reduce the number of phone calls we would have to make and field, (2) relieve our worry as to who we had told what, and (3) ensure that correct information was being communicated. We agreed, provided Weslee would host the group.

Because of Susie's love and practice of writing notes of encouragement to literally hundreds of people through the years, we decided the natural name of the posts should be "Notes from Susie." Although she and I tag-teamed authorship, those posts were clearly about her. What began as a mere progress report delivered on social media eventually morphed into a virtual blog relating to Honey's illness, outlook, and Christian faith. The further into the process we got, the more philosophical, theological, and hymnological the

installments became. As time wore on, readers began to report using our posts as daily devotionals and recommending that the material be compiled and published as a book.

Notes from Susie is a representative group of posts in chronological sequence sufficient to tell her story of faith, gratitude, and joy even in the midst of battling cancer, which claimed her life two years later. There is more than subtle irony here too good to miss—all our married life, I have been the one on the stage and in the light, which was precisely what Honey preferred; now the book comes out and it's about her—I'm laughing and loving it! She would be honored but probably embarrassed also. We'll try to remember to ask her later.

Recently walking midday in the heart of Washington, D.C., I noticed a group of eight or ten preschool children crossing a busy street. I thought, *Who in the world would be crazy enough to attempt that?* But on closer look, they were tethered together by a series of alternating light-weight plastic rings joined to short sections of rope. As these little ones walked along two abreast with the rope/rings between them, each child was holding one side of a ring and another child the other side. A lead teacher had the front ring and another brought up the rear holding the last ring. They walked along slowly, but orderly—pretty remarkable. It was the safest way for a group that size and that age to navigate from any place to another. Individually out there in that street, they're likely to be unseen and accidentally run over, but a whole string of them is more visible and makes the dangerous trek much safer.

Thinking about that later, it occurred to me that's the way Honey and I traveled our tricky journey. There were a lot of people walking with us holding onto rings attached to one another with a rope of hope. We were safe as long as we held on to our ring attached to others.

Then came to mind Moses and the ancient children of Israel wandering around in the wilderness those forty years going from one place to another. They lived under a protective cloud by day and pillar of fire by night and fed on God's manna. We and our wonderful "herd" traveled somewhat like that for two years. Reflecting on that story, I thought, *Who was the Moses figure in*

our wilderness wandering? The answer came quickly—clearly, it was Honey. She was out ahead of us all pointing the way; she showed us how to travel a hard journey. Her eye and heart were firmly fixed on God, and her faith made us strong and gave us hope.

Later mentioning this image to Weslee, her immediate response was, "Yeah, and who was the Aaron figure?" Gosh, I forgot about Aaron! When God called Moses to "lead My people" some of his objections were "Who am I?" "They won't believe me!" and "I don't speak very well." Aaron then enters the story, dispatched and designated by God to speak for Moses, to "be as a mouth for you."

I can almost hear sweet Honey object, using Moses' same words. That's the way she was. She always preferred that others be out front and speak. I firmly believe, though, that through her illness, she began to realize the fullness of what she had to offer others. Weslee identified me as Honey's Aaron, and if she's right, I'm more than delighted to be.

Posts were written primarily to close friends, most of whom would understand an occasional inside joke or know a specific person or deed mentioned. For example, you'll read from time to time about Honey's "manger," which is the recliner where she took time to rest and frequently dozed off when she lacked energy to make it through the day.

Throughout the book, reference will be made to our children—Weslee and Nathan. Both are thirty-something and both live in West Tennessee, three hours from me. Weslee is a family counselor and hubby, Chris, teaches college English. Their three boys are Jonathan (eleven), Andrew (seven), and Thomas (five). Nathan and wife, Corri, have Daniel (eight) and Ella (two). Our son, Nathan, is a full-time accountant but is also a part-time church musician. Corri presides over their household.

In our original, unedited journal entries, we made almost daily acknowledgments of the delicious meals provided for us primarily by our church family those two years. This very practical ministry, which was coordinated through

the Meal Train website, supported, sustained, and encouraged us in ways that are difficult to fully express in words. For the most part the almost daily mentions of these meals in our journal entries have not been included for the larger audience here, but in no way does that diminish the impact or gratitude we have for the breadth and regularity of acts of kindness delivered by dear friends who walked this hard journey alongside us.

I also should note that some of the shorter entries have been grouped together to cover a several-day period, and there are a number of places where Susie and I go back and forth in the updates, sharing our personal perspectives on what transpired in a particular week. In the editing process we have from time to time moved certain comments from their original placement to improve the flow of the writing, but the words—and the emotions behind them—are faithfully recorded here as they actually transpired.

My sincere prayer is that this book will provide comfort and encouragement to those who are personally dealing with a serious illness, as well as to those who love and care for them.

Mark Edwards
Seabrook Island, South Carolina
July 2015

MEET
SUSIE

BOY MEETS GIRL

I met Susie West in the spring of 1968, both of our junior years—hers high school and mine college. Four of us college students had been dispatched to Kerrville, Texas, to lead a weekend youth revival at her home church. I have been a career music director, the kind who waves his arms in front of congregations when they sing, but before that, I had always been a keyboardist.

My role that weekend was playing the Hammond organ and leading the after-service fellowship times. With the first evening activities completed, Jerry Fleming, the weekend arm-waiver/roommate, and I would be housed and hosted by the Grady West family. Transporting us to their house were daughters Susie and younger sister, Brownie.

They lived a few miles out of town on a picturesque hillside spot overlooking the Guadalupe River. The trip to the house was eventless, only meaning there was not an accident. But just a few months beyond her sixteenth birthday, Susie was not an experienced driver and she was either showing off a little for the college guys or simply was not aware of a few things. The latter was more like her.

Either way, in the backseat of the '64 Ford Falcon, Jerry and I were holding on for dear life to something—I'm not sure to what—since this was pre-seatbelt era. I suspect we also exchanged looks of near terror a few times. (The thought never crossed my mind that in less than two and a half years, that driver and I would be married and we would be paying her car insurance.)

The girls deposited us in their off-at-college brother's basement apartment—a great place, sort of out back and away from the ebb and flow of the rest of the family—which consisted of the girls, parents, and maternal grandmother—Mama—whose quarters were just above the apartment.

Nothing else about that weekend stuck in my mind. Perhaps the frequent trips to and from the church that weekend in the backseat of that '64 Falcon were memorable enough!

THE LORD MOVES IN MYSTERIOUS WAYS

In a few weeks and back at school, I received a phone call from the pastor of that revival church asking if I would consider being the church's summer youth director. I would, I did, and I began work the first week of June.

Moving to Kerrville for the summer, the church provided housing for me at two separate church-member homes—the Atkinsons' and then the Houses'—a month or so at each. Mid- to late summer, the pastor inquired as to my interest in retaining that church position during my senior year at Howard Payne University, commuting on weekends. My job would be expanded to include directing the church's youth choir (which was already larger and better than the adult choir) and leading music for the Sunday evening service. Things worked out for that to happen, and the West adults offered the church their basement as my weekend quarters.

Getting to know the West family during that school year plus most of the next summer was a pivotal time for me and a tremendous blessing. Interestingly, I spent more time with Mrs. West (Mimi) than anyone else. Susie had her high school buds, her steady boyfriend, and everything else that goes with a girl's senior year. I learned a lot about Susie from her mother, who Susie declared picked me out before she (Susie) ever did.

SUSIE'S STORY

According to Mimi, Susie was adopted at ten days of age. Susie's birth mother was from Georgia and, unmarried, went away to Mexico to give birth, was there one night, became frightened, and came back into the United States—to San Antonio—where Susie was born. Mimi said that Susie was always the cuddly sort, whereas Brownie, her also-adopted sis just twenty-six days younger than she, was the more outward, performing type.

From early on, Susie was particularly close to Mama, who lived with them essentially all of Susie's life. Her brother, Abner, the only biological West offspring and twelve years older than Susie, says that, as a preschooler, she

would hang out with Mama's friends when they came over every week to play canasta all day. Abner says Susie knew how to play canasta before she knew how to read.

PAIRING UP

Susie and I ended up washing Sunday lunch dishes nearly every week—a task that took much longer than was necessary. Over a period of many months, I learned who Susie was and experienced firsthand many of her best traits. Even as a teenager, she was genuinely interested and concerned about others. She was not out front but certainly ran deep. Some of her friends were more popular than she, some were high school cuter, and some more recognizably talented. Susie rather lived under those radars and there didn't appear to be any jealousy toward the others. Even at age seventeen by now, Susie seemed like a person who would one day be a wonderful wife and mother.

Susie and I didn't date while I was employed at her home church, but very soon after I resigned to continue my education, we began. She would enter Baylor in the fall and I would begin seminary in Fort Worth while also serving a church in nearby Azle. We spent parts of most weekends together that school year and then married July 31, 1970.

Her parents, especially Mimi, were not all that excited about her getting married at age eighteen—and rightfully so—although they knew me well and even liked me. One big issue was that they were afraid she would not complete her college education which, for us, was never a question. Maybe we compromised—they gave their consent and I paid her college costs.

With a single "I do," Susie stepped from being a teenager into the role of wife and church staff spouse, the latter a position that too many find tricky at best. During those early years, she did have a couple of probable panic attacks, but a slow, relaxed late-night drive seemed to settle her spirit and widen her perspective. But by and large, she navigated it well, especially for someone her age; as she matured into it, she absolutely loved being the wife of the minister of music.

NATCHITOCHES, LOUISIANA

When I finished seminary in 1973, we accepted the invitation of First Baptist Church, Natchitoches, Louisiana, to become their minister of music. (Natchitoches is a historic, classy, little college town where the movie *Steel Magnolias* was filmed.) Susie lacked one year to receive her degree. We moved to Natchitoches in August, immediately enrolled at Northwestern State University, and graduated the next May. During our four years in that wonderful church, Susie sank deep roots into people's lives and became endeared to many of our peers, other families on the church staff, and of course, senior adults.

Our daughter, Weslee, was born and we built our first house when we lived in Natchitoches. It was the ideal church, pastor with whom to work, and town for a couple just beginning their ministry and establishing a family. Still after nearly four decades, that little town and those dear people remain unto us as the biblical Bethany was to Jesus—places of comfort, unconditional acceptance, and deep love.

MUSIC CITY BOUND

We moved to Nashville in November 1977 to join the staff at First Baptist Church. The similarities between the church we were leaving and the one to which we were going were striking. The major differences were size and stage. The church in Nashville was much larger and its stage more visible. But both of us were ready for it, though neither of us sought it nor saw it coming.

We were excited about our new opportunity, though our move ten hours farther east had to be difficult for both pairs of South Texas parents. But we were young and I don't remember looking any direction but forward. Susie was a whopping twenty-six years old and, like it or believe it or not, a lot of people would be looking at her and to her and even taking some cues from her. She never missed a beat doing what she had always done—took on tasks she could do and supported her husband's ministry behind the scenes in ways that may seem small. Whatever it takes to help him succeed and make

our family strong was her dual calling and primary commitment. Our family grew—Nathan was born toward the end of March 1979.

Besides singing in the sanctuary choir, she began directing the preschool choir (ages four to five) on Wednesday nights a few years, and worked with even younger ones during Sunday school much longer. She was a natural with little ones and somehow knew just what to do when. Mimi told me a long time ago that all Susie ever wanted to do was be a mother; she was good at it.

In a few years when the sanctuary choir experienced significant growth and we regularly had visitors attend rehearsals, I had the bright idea of having Susie become the choir greeter to register visitors, give them music, help them into rehearsal comfortably, and introduce them during the break. Boy, was that a good idea, and boy, was she good at that, too! Whereas, as a child and even into early married life, she was a shade shy and deferring to others, now she was meeting people, delivering convincing smiles, and hugging folks; occasionally she would have the "opportunity" to hear a choir member's or visitor's tale of woe. She was a minister in her own right and everyone loved her … because she first loved them.

This proved to be good prep ground for the job at church that she loved most—greeter at the main entrance. The ministry she performed outside the music suite all those years she was now doing for the larger congregation at the main parking lot entrance. We always drove to church on Sunday mornings together—and early—so she sort of opened up the welcome center and was on hand for the arrival of most of her favorite demographic: senior adults. None of them came to play canasta, but the fellowship shared was the same. When Jonathan, our first grandson, was able to stand alongside Susie—and drink a Sprite—he joined her on the greeter team. They were both proud!

SUSIE BECOMES HONEY

Speaking of Jonathan, Susie's choice of her grandmother's name, long before there were any grands, was Honey. We knew a couple of other Honeys; I had called her "Honey" for many years, it fit her, and it just seemed right. When Jonathan arrived nearly eleven years ago, the name Honey was set in stone

and it stuck. A big part of Honey's pride and absolute delight were those four rough and tumble little boys: Weslee's three—Jonathan (eleven), Andrew (seven), and Thomas (five), and Nathan's Daniel (seven), and then finally Ella (two), whom Honey nicknamed Sweet Cheeks. The feeling was mutual and all the family knew it.

FAITH RUNS DEEP

Someone characterized people's Christian faith as either simple or complex. Honey was the former, and I say the lucky one. I'm the latter and have to think through it all, try to modify it, massage it, and work at it. Not Honey. She was a "what He says we will do and where He sends we will go, never fear, only trust and obey" person. She didn't consider herself a good Christian witness, mostly due to a narrow view of "witness" pretty much limited to buttonholing nonbelievers and converting them. Honey wasn't going to buttonhole anyone for any reason, but she certainly was an effective witness.

Honey was a pray-er although she didn't like to pray aloud, much less in public. She used the time writing notes to people as an opportunity to pray for them. I often saw prayer lists around the house tucked away in safe places. I know she prayed for me, our kids, grandkids, and a host of others all the time. It was private but very personal and regular.

Her faith ran deep, borne out of her spirit of profound gratitude that produced joy. She always remembered provisions made for her—a birth mother who chose life over death, a family who adopted her, Jesus who died for her, a husband who loved her, good job, friends, family, our house and home, and the list goes on. Getting sick was a downer for her, but it provided a whole new group of friends and professionals. And the interesting thing was that she didn't have to work at interacting with people or being grateful, that's just the way she was.

The last two years of her life when I would put her to bed, she would always say, "Thank you for everything you did for me today," and she meant it. Often she would continue, "We are so blessed," and then rattle off a list of things that came to mind. All our married life, she would adapt to whatever the

circumstance and be okay about it. She could honestly sing with the hymn writer, "Whatever my lot, Thou hast taught me to say, 'It is well with my soul.'" It really was in life and it certainly is now.

A GOOD RUN

As already mentioned, Honey was eighteen the first two weeks we were married and that's mighty young. I was twenty-two, and as Mimi said about me, "You already knew what your profession was going to be and already doing it." We were married almost forty-five years, and it was fun. We both said "I do," and we did.

We both were raised in strong Christian homes—our families loved us, believed in us, supported us in all the right ways, stayed out of our business, and allowed us to be autonomous. In ministry all our married lives, we were always encircled by caring, loving, nurturing people. We loved and were committed to one another and said so; we both knew it and celebrated it.

Our home was our castle and a safe place of refuge, stability, and comfort largely to Honey's credit. Even when my work was stressful or the kids had issues, the home fires were burning and Honey was calmly stoking the coals. I brought in the paycheck, and Honey spent it—partially true.

We talked about stuff. When something was bothering either of us, we talked through it, sometimes having to work through the heat to get to the light. We never ended the day angry at one another, which sometimes made for lengthy pillow talk. But it was important.

God blessed us with two wonderful children—some years more wonderful than others. Weslee and Nathan were real kids living in the everyday real world, but they were not rebellious as children, they didn't embarrass us as teenagers, or deny us as adults (I don't think!). The saying that it takes a village to raise a child was certainly true of them. Living nearly a thousand miles from their grandparents and cousins, our church people filled in every blank on the page. Contented children yield contented parents.

It was a good run; it just ended too soon.

NOTES FROM SUSIE

Somewhere along the way, Honey began writing notes to people. Perhaps she did that longer than I remember, but for at least the last twenty-five years, she scripted a phenomenal number of personal notes to people—the sick and sad, birthday cards by the dozens, teenagers who impressed her in some way, children who were baptized, those whose leadership in worship blessed her—anyone she knew who needed a word of encouragement or an expression of gratitude received a note from Susie.

In our office at home there was a small three-drawer chest devoted to her stock of neatly organized cards for all occasions. The Hallmark people could have crowned her Customer of the Year. One day in that store, I used Honey's Hallmark Crown Card and the clerk readily recognized it and asked how Honey was doing. She loved Honey and even stood in the long line at her visitation to speak to us. I'm not sure the post office made the connection but should have.

When I retired from First Baptist Church Nashville after thirty years, unbeknownst to me, she asked the planners of one of the events if she (Honey) could say a few words. When she stepped up to speak, no one, NO ONE, was more surprised than I. She never wanted to be in the limelight or the center of any kind of public attention, always preferring the sidelines or back hallway. But true to her sense of appropriateness and consistent with her modus operandi, she identified and read her presentation as a "note from Susie." It was great, and the adoring congregation loved it. It was a note of deep gratitude. Standing up front in public was out of character, but the content was so in character, and everyone knew it.

When we set up our Facebook page to keep our friends and family informed about Susie's health, one of us decided the natural name of the posts should be "Notes from Susie."

While Honey was recovering from extensive surgery, I began scripting the updates. It was a couple of weeks post-op before she began writing. Convinced that our readers were more interested in hearing from the patient than the

caregiver, I always encouraged her to write. Unsurprisingly, she discounted her writing ability and was pretty sure what she had to say would not be interesting at all—absolutely *wrong*! She had written hundreds of personal notes to individuals for many years. These posts were not that much different.

Like most people, the more she wrote, the better she became and the more enjoyable it was. So we tag-teamed this discipline those two years. Typically, after dinner dishes were done and we were settling in for an evening of television reruns, one of us would ask, "Are you going to write tonight or am I?" or she'd say, "I sure hope you have something to say tonight 'cause I've got nothin'!" No one has tallied it up, but it seems like I drew the short straw more nights than she. Of course, there were a lot of nights that she barely had enough energy to sit up, much less peck out a post. I was proud of the pieces she wrote, and I think she surprised herself. But she was always amazed that what she wrote was a blessing to others. That was just her.

LIFE TURNS ON A DIME

Honey hadn't been her usual chipper self for a couple of months, but her routine and periodic doctor visit didn't seem to reveal anything out of the ordinary. Still she was not feeling any better and we both were becoming a little concerned, so her doctor decided she would order a scan of Honey's abdominal area where the discomfort seemed to be centered. The doc's comment was something like, "Let's do this scan, but you don't have cancer or anything like that." A few days later, late Friday afternoon, March 1, 2013, the clearly startled doctor called Honey still at work saying the scan results had been returned and that she had ovarian cancer.

In his editorial following Honey's death, *Baptist and Reflector* editor Lonnie Wilkey—Honey's boss and longtime friend—recounted that afternoon: "Two years ago I was in my office late on a Friday afternoon when I heard Susie and Mary Nimmo, another staff member, sobbing. I thought something had happened to one of their relatives. But I soon discovered Susie had just heard from her doctor that she had been diagnosed with cancer. I kept my

composure that day for their sake, but I am not ashamed to admit that tears have flowed for Susie in the days since, and they continued on March 24" [two years later].

She went home and waited for me to come home from my week's work.

As always I came in the back door and though I hadn't seen anyone or heard anything, the house's usual nerve center was quiet and dark, and the air was heavy. At that point Honey got up from the sofa crying, then reporting the fresh bad news. I held her and we both sobbed speechlessly for several minutes trying to process the shock. Cancer is what other people have. I don't remember much of the next hour, but I'm sure she told me what the doctor said and we both worked on some form of dinner. We sat down to eat and I probably mumbled some sort of thanks for the food and asked for help to face the days ahead. It was all so surreal. That's when one is glad that the Almighty already knows and hears the groanings of the believer's heart. Surely we made a few phone calls, but we mostly just stayed close to one another all evening.

We were both better the next morning. Somehow by the grace of God, there was new resolve in Honey especially. Perhaps fear of the unknown was worse than the known, so she seemed ready to face whatever lay ahead. It was a big weekend at our church that involved a rehearsal at our house that afternoon, which we were able to host and even enjoy. Perhaps this was the first evidence that Honey would be a special patient in the days to come.

I'm reminded of something else Honey's brother, Abner, said about her: "When God said, 'Let there be light,' I believe He had Susie in mind."

This book is an attempt to distill into mere words at least a glimpse of that light that God placed in Susie which she, in turn, showed freely and shared honestly throughout her life even as cancer was claiming her body.

THE
JOURNEY
BEGINS

Most of you know that Susie is a sender of notes and greeting cards, and that "what goes around, comes around." Today's mailbox yielded twenty-one for her, yesterday eighteen, the day before fifteen, and there is a stack at her work and still a stack at St. Thomas Midtown Hospital. I couldn't help but smile at the thought of how many people were delighted to finally have an occasion to select and send a card to her, the Great Sender of Cards.

There is a new hymn in the *Celebrating Grace Hymnal* titled "Children Are a Gift from Heaven." When that author wrote that hymn, he had only young children; but I'm tellin' ya, adult children are also gifts from heaven. Our kids have been and are about like many of yours, but during the past month both of ours have been special gifts from heaven. Each of them spent the first two nights in the hospital with their mom following surgery, and both have been appropriately attentive since. What was that about, "The apple doesn't fall far ..."? We could not be more thankful for our two "gifts from heaven."

The road ahead is uncertain, but we will negotiate it
with the Father's love and hand, and the support and prayers
of all our family and friends. We are abundantly blessed.
—Susie, March 17, 2013

APRIL 4–7, 2013

THURSDAY

Travelling today and intermittently pondering our journey ahead and at hand, these hymn words came to mind:

> *We walk by faith and not by sight.*
> *No gracious words we hear*
> *from Him who spoke as none e'er spoke;*
> *but we believe Him near.*
> *We walk by faith and not by sight,*
> *led by God's pure and holy Light!*
> *Prepare us for the journey, Lord,*
> *and may we know Your power and might,*
> *as we walk by faith and not by sight.*

"WE WALK BY FAITH" – WORDS BY HENRY ALFORD AND LLOYD LARSON; MUSIC AND REFRAIN © 1998 BECKENHORST PRESS INC. ALL RIGHTS RESERVED. USED BY PERMISSION.

I don't know about you, but I prefer sight … I think. However, Christians are called to a faith walk. We're working at it. Thanks for walking with us. Surely, part of our journey ahead—which we didn't choose and don't prefer—will be steep in places, but we are trying to find some fun along the easy stretches. We've noticed that, so far, fun seems to show up most often and best when our kids are here. And tonight they are.

SUNDAY

Our son, Nathan, says about his family-in-law that they travel in a herd. Whether it's just for Sunday lunch or a trip to the beach, one can look for a caravan. Nathan also reports that the whole Cornutt herd has a good time,

whate'er befall. That's the way Susie and I feel about our current trip—we're traveling in a herd. If you are reading this, you're part of our herd and we appreciate your praying and providing for us at every turn. I suspect we're approaching an unknown steep stretch, so we are hoping you can hang with us and hold us up. In case you don't know, Honey's attitude and outlook are remarkable.

This week, lean with us into this old hymn reclaimed in the *Celebrating Grace Hymnal* (#57):

> *Be still, my soul: the Lord is on your side.*
> *Bear patiently the cross of grief or pain;*
> > *leave to your God to order and provide;*
> > *in every change God faithful will remain.*
> *Be still, my soul: your best, your heavenly friend*
> > *through thorny ways leads to a joyful end.*
>
> "BE STILL, MY SOUL"– KATHARINA VON SCHLEGEL, 1752;
> TRANS. JANE BORTHWICK, 1855

This new journey is so much easier with all of you beside us.
Thanks for your love, support, and prayers.
God is so good and He continues to bless us. We are ever
in His hands and live in His peace and mercy. —Susie

NOTES FROM Susie

TUESDAY

The first of six chemo treatments were today, and I was one of three "newbies." Nettie, who I met at our chemo ed class last week, and Louise, who I just met today, were the other two. Please pray for them—not just for their cancer treatments, but for strength and courage and peace. Nettie's pastor husband died in 2011, and she doesn't have the church family support that we have. She isn't telling many people about her condition and has to rely on a few close people to take care of her.

Louise is a single lady and works at her Seventh-Day Adventist church. She also has to rely on someone for transportation and other care. I don't know about her support system. These ladies' situations make me sad and thankful. Sad because they don't have a solid support system and thankful because our support system is so solid and deep. Thanks to each of you for walking this journey with us. We are truly humbled and grateful.

In a card today, I received a grocery list and phone numbers from Sharon, church member and nurse practitioner at Vanderbilt-Ingram Cancer Center. The list was for things to have on hand for "queasy" times. The list will be used tonight at Target. Another blessing added to the Thankful List. You are a wonderful group of friends and family, and God is so good to bless us with you. I don't know how people cope with any of life's situations without love and prayers and support from family and friends. Today, this part of the journey has not been bad, and I anticipate that we will be "more than conquerors through Christ." Amen.

As anticipated, at least some of the downside of chemo has arrived. In the patient's words, "I'm not worth shootin'!" Apparently, the climb has begun; but the sooner we start climbing, the sooner we get over the mountain. Thanks for helping us along.

We know not what the morrow may bring—none of us ever knows—but we end this day with hearts of gratitude to God for His daily dose of grace and to you for being His hands and heart unto us. —Mark

He leadeth me! O blessed thought!
O words with heavenly comfort fraught!
Whate'er I do, where'er I be,
* still 'tis God's hand that leadeth me!*

Lord, I would clasp Thy hand in mine,
* nor ever murmur or repine,*
* content, whatever lot I see,*
* since 'tis Thy hand that leadeth me!*

REFRAIN

He leadeth me, he leadeth me,
* by His own hand He leadeth me;*
* His faithful follower I would be,*
* for by His hand He leadeth me.*

"HE LEADETH ME! O BLESSED THOUGHT!" – JOSEPH H. GILMORE, 1862

SUNDAY

"This is the day the Lord has made; we will rejoice and be glad in it." And we have done both. The sun played hide and seek with the clouds, temps were cool, the birds were singing bright and early, and the flowers were in full bloom with brilliant colors. God is on His throne and He is in control. How comforting is that?

I was able to go to church downtown today. Going is both energizing and "fatiguing." Being with our herd is both of those at the same time, but I don't mind coming home tired because it soothes my soul to be with loved ones. Just like medicine hugs from grandsons, you give me wonderful medicine with your hugs and smiles. I am eternally grateful.

Have you noticed that the U.S. Postal Service has reversed its decision to stop Saturday mail delivery? Well, we can thank all of you for that. The number of cards that we still receive is amazing. Each card—bought, handmade, musical, funny, serious—is carefully read and enjoyed. You each write messages of encouragement, love, and support. When I read your name, I say a prayer of thanksgiving and pray for you, often remembering a special time together. I don't take your messages lightly. You are cherished family to us. God is so good and He blesses us every day.

❧

WEDNESDAY

There's something on TV where a sports team, leaving the locker room on their way to the court or field of play, rubs some statue's head for good luck.

We're trying that around here. Before heading to the office this morning, I rubbed Honey's stubby head a few times. We texted back and forth midday, and I asked her to rub her head a couple of times on my behalf. We are happily discovering that a dreaded disease like cancer doesn't have to be dreadful all the time.

We appreciate all you are doing for us—your concern, prayers, provision of good food, restocking our supply of note cards and stamps, and a dozen other good things.

You are teaching us new means of ministry and we thank you.
When we get to the other side of this mountain,
we're going to be better at it unto others. —Mark

Mary Lou and James,
Thank you for the Grandmother book and beautiful flowers. I had no idea you were so involved in flowers and judging and shows. I know very little about them except they are beautiful and I love them.

James, I hope your back is healing and you have less pain.

Love,
Susie and Mark

SATURDAY

Today has not been a stellar day for Honey. In fact, it was bloomin' lousy. She spent this beautiful day being mostly horizontal. We had hoped to attend a concert tonight—forget that! We are doing okay for the road we're traveling. Honey's attitude is good, she says I'm taking good care of her, we are able to joke around about stuff, I rub her stubby head regularly, many people are praying for us, and you're seeing to it that we have plenty to eat. All we have needed, God's hand—and yours—are providing.

Here are some good words that come to mind at the end of a down day:

> *All the way my Savior leads me;*
> *cheers each winding path I tread,*
> *gives me grace for every trial,*
> *feeds me with the living bread;*
> *though my weary steps may falter,*
> *and my soul athirst may be,*
> *gushing from the Rock before me, lo!*
> *a spring of joy I see.*
>
> "ALL THE WAY MY SAVIOR LEADS ME" – FANNY J. CROSBY, 1875

SUNDAY

I think one of the lessons I have to learn along this journey is that every day will not be the same. I thought that each day away from treatment meant a better day with more energy. I am learning that's not entirely true. I need to take each day as it comes and listen to my body. Just because three months ago I worked full time, ran errands, went to church, and went along with all

my daily activities doesn't mean that I can do all of that now. Remember, new normal, NEW NORMAL!

Last week I felt good and probably did way too much. I paid for it Saturday and today. I have gotten approval from my surgeon to work "as tolerated." I know what that means, and my task is to make sure I practice knowing what "as tolerated" means. I'll let you know how that works for me!! Tough assignment but learning the new normal. My internist asked me this week if I had good support. I told her we had enough support to share with fifteen others. I know that not everyone has you. We love you and so appreciate all you do and are for us.

Every day will not be the same ...
but we are blessed beyond measure. —Susie

Day by day and with each passing moment,
 strength I find to meet my trials here;
 trusting in my Father's wise bestowment,
 I've no cause for worry or for fear.
He whose heart is kind beyond all measure
 gives unto each day what He deems best—
 lovingly, its part of pain and pleasure,
 mingling toil with peace and rest.

Every day the Lord Himself is near me
 with a special mercy for each hour;
 all my cares He gladly bears and cheers me,
 He whose name is Counselor and Power.
The protection of His child and treasure
 is a charge that on Himself He laid;
 "As your days, your strength shall be in measure,"
 this the pledge to me He made.

"DAY BY DAY" – CAROLINE V. SANDELL-BERG, 1866

FRIDAY

This morning I was a purple-pajamaed, fleece-wrapped, stubby-haired blob, but by the time lunch was over I was a showered, dressed, make-uped, wigged woman with earrings on!! Not quite the transformation of caterpillar to butterfly but more like caterpillar to moth! It's hard to get everything together these days.

Today I am thankful for:

- Dr. Wheelock; Meagan, Kricia, and Marquita, my chemo nurses
- Terry and the other techs at PathGroup who don't hurt when they do the weekly blood work
- Medicines that kill the bad stuff and for medicines that ease the side effects of the medicines that kill the bad stuff
- Treasured friends who sign up for the Meal Train and provide wonderful nourishment
- A husband who is ready, willing, and able to do whatever it is I need or want (The only trouble is I don't know what I need or want.)

> *Joys are flowing like a river, since the Comforter has come;*
> *He abides with us forever, makes the trusting heart His home.*
> *Blessed quietness, holy quietness what assurance in my soul!*
> *On the stormy sea He speaks peace to me, how the billows cease to roll!*
> *"Blessed Quietness"* - Manie Payne Ferguson, ca. 1897

FRIDAY

An older lady friend of mine whom I truly love to greet at the church door sent me a beautiful card this week. In it, she told me of a medical condition she is facing and that was not good news. Her words were, "Let's hang in

there." When I wrote her back I assured her we would hang in there and much more. She put a card inside the card with the two Scripture verses I will send to each of you. I have this card taped to my bathroom mirror for inspiration every day:

> *"Let Him have all your worries and cares,*
> *for He is always thinking about*
> *and watching everything that concerns you."*
> 1 PETER 5:7

> *"And now just as you trusted Christ to save you,*
> *trust Him, too, for each day's problems:*
> *live in vital union with Him."*
> COLOSSIANS 2:6

I love *vital union*.

God blesses us all along this new path and provides
all that we could ask or want. —Susie

MONDAY

The cards and calls continue to come in and we love reading each one. Knowing how I love to write notes, many of you have sent extra cards to add to my growing collection! Even the Colonial Williamsburg Foundation got into the act today. How did they know? Hmmm, could they want something? The cards they sent are pretty but have no special meaning to me. However, the ones we receive from you are treasured.

THURSDAY

My next treatment is Tuesday. THAT WILL BE THE HALFWAY POINT. In most aspects, the week will be a challenging one, but knowing we are halfway through this journey is something to celebrate and we will be doing that. God continues to provide everything we could ask and need, including calming our fears. Here's a hymn in *Celebrating Grace Hymnal* (#55) which speaks to that:

> *Give to the winds your fears,*
> *hope, and be undismayed;*
> *God hears your sighs and counts your tears,*
> *God shall lift up your head.*

> *Leave to His sovereign will*
> *to choose and to command:*
> *with wonder filled you then shall know*
> *how wise, how strong His hand.*

> "GIVE TO THE WINDS YOUR FEARS" – PAUL GERHARDT, 1653;
> TRANS. JOHN WESLEY, 1737 (PSALM 37)

We pray you will each have a good night and wonderful weekend. We plan to do just that. Thank you, dear friends, for holding our hands and walking this journey with us. You're treasures sent from God to bless us and we are grateful.

It is interesting the things we take for granted. Take energy, for instance—I never really thought about the energy I had before March, my old normal. I certainly think about it now and I am so thankful for the energy that I do have, my new normal. I am even more aware of God's provisions now and try to be always grateful—also a work in progress.

> *"For I know the plans I have for you," declares the Lord,*
> *"plans to prosper you and not to harm you,*
> *plans to give you hope and a future."*
> JEREMIAH 29:11

In the margin of John 11, I have written,
"God gives His presence even when He doesn't
give His protection." I would modify this to say,
"...when He doesn't protect us from everything." —Susie

Mark

True to form, we showed up at the doc's office a full thirty minutes early—one certainly wouldn't want to miss anything! Before we got completely out of the pickup, Honey was already carrying on with a nurse arriving for work, greeting her by name and picking up where they left off three weeks ago. We weren't in the waiting room long until one of Honey's chemo cohorts arrived, checked in, and sat down beside her—the party bell rang. Pretty soon Honey was called in for her visit with the doc before the treatment. In a few minutes Nettie strolled in and greeted me enthusiastically across the room as though we were the only two in there.

Honey returned in few minutes and, rather than coming over to me, went straight for Nettie and they started it up until I gathered up our extensive gear and headed her off to the chemo palace. Eyeing the room of recliners in rows with a couple of women already under way, our patient said something about anticipating more of a semicircle configuration. In a minute, Honey introduced me to another of her newest best friends: Lana, the chemo nurse. My part adequately played, I was dispatched to my office.

Nearly four hours later and on the way home, accounts of the day reveal that early on Honey—already attached to chemo—commenced rearranging recliners into the circle she had anticipated, that is until Lana told her she needed to sit down, that her fluids were flowing "the other direction." Lana caught the spirit of the circle and completed the reconfig, so "now seven of us can face each other. We just had the best time visiting! The time passed so quickly!" And apparently, everyone broke out their five loaves and two fish; all went away filled, because there was no mention of lunch on the way home. Maybe it was all the steroids. Or just maybe it's a whole herd of people praying Honey through every step of this journey. Likely some of both, but we are bloomin' sure of the latter.

"Thank You, God, for today's surprisingly joyful experience, for a unique opportunity to enjoy some of your people—cancer veterans, one or two chemo newbies, some fellow believers, nurses—all making the best of bad situations. May we remember this bright day when we must endure the darker ones ahead. We thank You for medical science and those who use their creative abilities to the good of Your creation. Thank You for the gift of living in this country where medical care is available and for sufficient resources to receive it. Make us keenly aware and appropriately responsive to those less fortunate."

This is not a fun journey, but, boy,
it could be so much worse:
we credit you and thank you
for making the difference.
—Mark

In Christ we live in common bonds
of friendship, love, and trust.
Together we can fully know
the cause of Christ is just.

In Christ we live and pray
for needs of body, mind, and soul,
and trust our God's unchanging love
to make the broken whole.

REFRAIN

The love and faith we share are strong.
In Christ we live; in Christ we live!

"*In Christ We Live*"– Jane Martin and Donn Wisdom
© 2010 Celebrating Grace, Inc.

MAY 22, 2013

Cancer is wretched, and I wouldn't wish it on anyone. However, blessings come in unusual circumstances, and I have been blessed along this journey. Jan, a circle friend, and her husband celebrate fifty years of marriage this week, and yesterday was her final infusion. Today when I saw her, we hugged, probably for the final time. I wished her well and assured her of my continued prayers, and celebrated her anniversary. She will continue with radiation near her home outside of Bowling Green for several weeks. We are bonded. Nettie was there today, and we continued where we left off yesterday. We are planning a lunch the week we are feeling good, and we both look forward to that.

In our not-so-round circle yesterday there were seven with the full crowd but dwindled because some finished first. I met three new ones. We all bring our bag of tricks with books, snacks, iPads, puzzles, etc. to share and to help pass the time. However, most of the time we talked. Our subjects ranged from families, work, doctors, faith, and there were seldom lulls in the conversations. These ladies are believers and we can freely share our faith, and that is so refreshing and encouraging. I really look forward to my infusion days. God works in mysterious ways, His wonders to perform.

> *Every promise we can make,*
> *every prayer and step of faith,*
> *every difference we will make*
> *is only by God's grace.*
> *Every mountain we will climb,*
> *every ray of hope we shine,*
> *every blessing left behind*
> *is only by God's grace.*
>
> *Every soul we long to reach,*
> *every heart we hope to teach,*
> *everywhere we share His peace*
> *is only by God's grace.*

Every loving word we say,
 every tear we wipe away,
 every sorrow turned to praise
 is only by God's grace.

REFRAIN

Grace alone which God supplies,
 strength unknown He will provide.
Christ in us, our Cornerstone;
 we will go forth in grace alone.

How comforting it is to know He will provide and give us the grace. Thank you, Father. And thank you, dear herd, for lifting us up to the Father. We are given strength and courage through your prayers. We have now reached the halfway point in this journey. We are celebrating this.

THURSDAY

The Meal Train is not the only thing that arrives on schedule around here; so does the aftermath of chemo two days after the treatment. Honey has been horizontal—in the bed or manger—all day. On days like these, she doesn't eat much, has to force water down, and manages nausea and joint aches with meds that work well. She doesn't hurt but is just generally uncomfortable, in part because she's been down all day, and refers to herself as a blob. I offered to take a picture of her to send with this, but somehow that got vetoed pretty quickly. Having taken her nighttime meds, she's in bed now. I've rubbed her stubby head a couple of times, so she's good. Still, her spirit is good under the circumstances, and she promises that tomorrow will be better.

Somehow the attention we receive on a daily basis seems to be just right—a phone call or two, a doorstep visit by a neighbor, Meal Train, and cards—yes, still cards. Whoever is orchestrating all of that seems to know precisely what we need and in what forms and dosages. We are keenly aware that we are not alone on this journey, that we have a heavenly Father, an attentive family, and a herd of friends traveling alongside at our pace, guarding our steps.

Here are stanzas one and three from a hymn that's been around a few hundred years but is still relevant. The tune, written by the same person, is in a wonderful minor key—not at all a dirge, but a majestic statement of steadfast faith in an unchanging God:

> *If you will only let God guide you,*
> *and hope in Him through all your ways,*
> *whatever comes, He'll stand beside you,*
> *to bear you through the evil days;*
> *who trusts in God's unchanging love*
> *builds on a rock that cannot move.*

Sing, pray, and swerve not from His ways,
 but do your part in conscience true;
 trust His rich promises of grace,
 so shall they be fulfilled in you;
 God hears the call of those in need,
 the souls that trust in Him indeed.

"*If You Will Only Let God Guide You*"– Georg Neumark, 1657 (Psalm 55:22); trans. Catherine Winkworth, 1863, alt.

SATURDAY

Yesterday was the pits. I admit I shed a few tears but at the same time was able to thank God for my comfortable bed and soft pillow. I was also asking Him for grace, strength, and comfort. And He provided—again. Soon, I was able to relax and rest and heal.

He is so faithful and true and always present. —Susie

Mark

Honey and I fantasized about both of us going to church today, but this morning she just didn't have what it would take to eat breakfast, get ready, and then actually go. So I went to worship nearby and wouldn't you know it, the preacher talked about money. How dare him! But he was on target and it was a meaningful service.

When I got home, Honey was exactly where I left her—in the manger. But she had called our longtime CVS pharmacy friend, Linda, who coached her through some over-the-counter meds for a nagging side issue. Honey needed to get out of the house for a spell, so we ran by CVS en route to Publix for yet more cantaloupe to complement our plans for lunch. She was pretty fatigued by the time we got home, so I assembled lunch, which we thoroughly enjoyed out on the deck. As you know, today was beautiful.

Sunday afternoons and naps go together, so she kept that part of the Sabbath holy. I opted to mow the yard, which I love to do and which actually constitutes rest for me; so, in that sense, I kept that part holy as well.

A short—and very slow—walk up the street followed dinner and dishes. So, as I said, Honey seems to be crawling out for the third time.... I hope. Judging by the first two cycles, it's about that time. It appears we are fully at the halfway mark—a good place to be.

Today being Trinity Sunday, here's a Trinitarian hymn:

> *Creator God, creating still,*
> *by will and word and deed,*
> *create a new desire in us*
> *to meet the present need.*

Redeemer God, redeeming still,
 with overflowing grace,
 pour out Your love on us,
 through us, make this a holy place.

Sustainer God, sustaining still,
 with strength for every day,
 empower us now to do Your will.
Correct us when we stray.

Great Trinity, for this new day
 we need Your presence still.
Create, redeem, sustain us now,
 to do Your work and will.

Thank you. dear ones. for walking this journey with us and
holding us up. We love you and appreciate you and
thank God for you. —Susie

Many of you have mentioned how much you appreciate our nearly daily posts. I'm glad they are meaningful to you; be assured that your nice words are meaningful to us. We didn't plan to do this; in fact, we didn't plan to have any reason to do this. When we got Honey's diagnosis and plan of action, our daughter, Weslee, offered to set up a site for keeping interested people informed periodically and to avoid having to remember who we told what. Good idea, Wes!

But I suspect these writings are doing as much to help Honey and me deal with and work through our situation as they are a blessing to you. And it is pretty amazing. This nightly discipline seems to heighten our awareness of the positive, to be an occasion for counting blessings (and naming them one by one), to live in the present, and to celebrate grace. And the more one does those things, the more one is sensitized to such things.

Of equal blessing and greater delight is seeing who is checking on us, who's reading our ramblings occasionally—a college roommate; a family friend from way back; youth choir accompanist—a high school gal—from nearly forty years ago; Brad in Little Rock and Kathleen in Dallas—both former Chapel Choir singers waist-deep raising their own families; fellow ministers of music; siblings; Jerry from Howard Payne; fellow church members; our friend Kelly in Atlanta; some of Weslee and Nathan's friends and in-laws; and dozens more who "Like," some who comment, and others who read but don't feel the need to respond—totally okay, I ordinarily live in that last batch. Thanks for helping us; maybe we're helping each other.

Here's an oldie, but a goodie:

> There's within my heart a melody;
> Jesus whispers sweet and low,
> [He says] "Fear not, I am with you,
> peace be still," in all of life's ebb and flow.

Though sometimes He leads through waters deep,
trials fall across the way;
though sometimes the path seems rough and steep,
see His footprints all the way.

REFRAIN

Jesus, Jesus, Jesus,
sweetest name [we] know,
fills [our] every longing,
keeps [us] singing as [we] go.

"He Keeps Me Singing"– Luther B. Bridgers, 1910

You are all holding our hands and it is such
a feeling of physical and emotional reassurance.
There is the peace that passeth all understanding.
Very thankful to each of you, treasured friends. —Susie

Sweet Sweet Anne,

I love you. Sunday when you held my hand, I felt you giving me your strength, comfort, love, and peace. Thank you, dear friend, for walking this journey with us. God knew long ago how much we would need you. He's so smart!!

Have a good Easter week. We definitely thank God for you.

Love,
Susie Edwards

I had a really good phone conversation with [my friend] Julie this afternoon. She is a little behind me in our cancer journey, and we were able to talk about the generosity of so many people. We agree it is so humbling to be on the "receiving" end of such gift-giving people. It will make us be better gift-givers when we are able.

I bought a new book today, *Grace*, by Max Lucado. I like his writings, and this title drew my attention. I am learning so much about grace these days and it is so real. Under the title is written, "more than we deserve, greater than we imagine." On page 49 it says, "Of all the things you must earn in life, God's unending affection is not one of them. You have it."[1] How comforting is that? On another page, it says, "To accept grace is to accept the vow to give it."[1] What a responsibility.

You are part of God's grace gifts to us—
"more than we deserve and
greater than we imagine." —Susie

We are travelers on a journey, fellow pilgrims on the road;
we are here to help each other walk the mile, and bear the load.
I will hold the Christ-light for you in the night-time of your fear;
I will hold my hand out to you, speak the peace you long to hear.

Sister, let me be your servant, let me be as Christ to you;
pray that I may have the grace to let you be my servant, too.
Brother, let me be your servant, let me be as Christ to you;
pray that I may have the grace to let you be my servant, too.

I will weep when you are weeping, when you laugh, I'll laugh with you;
I will share your joy and sorrow, till we've seen this journey through.
When we sing to God in heaven we shall find such harmony,
born of all we've known together of Christ's love and agony.

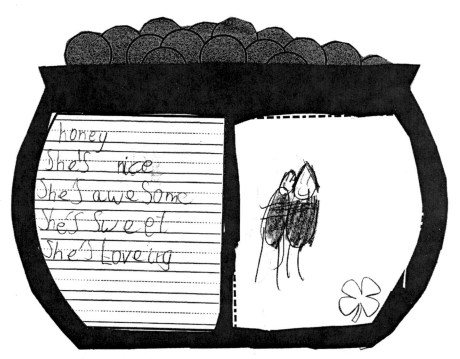

ANDREW HILL (GRANDSON), AGE 7

NOTES FROM Susie

MONDAY

[This post was written after Susie's third day in the hospital for treatment for an appendix issue. Because of her chemo, the medical team opted to drain the abscess around the appendix, treat it with antibiotics, get things "cooled off" in there, and then possibly remove the appendix at a later date.]

Today I had a pity party. I'm in the hospital receiving two units of blood and a pain level of 10, by myself with all the time in the world to think about me … so I did. In walks Amanda, the IV therapist. She asks if I'm okay and I tell her about my "party." "Go ahead," she says, "this is a good place to have one." And just like that, my party comes to a screeching halt. What nerve! I had just asked God for comfort, and He sent Amanda. Amazing! And then Alyssa walks in a short time later, for an extra measure of comfort and love.

I will say I had a good reason for the party. I looked up from the bed and saw one pole, two pumps, seven bags all pointing downward; two IVs both in my arm; and a partridge in a pear tree (if only). That was quite overwhelming at the time. I am much better now and so thankful for the people God sends my way.

The sun is now shining outside and within. It doesn't take long for things to turn around here, and that's a good thing. Blessings abound. Thank you, wonderful friends, for holding our hands during this journey. We can do nearly anything as long as you are beside us supporting us with love and prayer, visits and calls, and cards.

THURSDAY

Honey is tired of the bloomin' bed and being stuck and poked. I'm weary of running to and from the hospital, home and my Cool Springs office; sleeping in the recliner; and a bunch of other stuff. But it is not all bad, the people are helpful, you are praying and checking on us in one way or another. And in it all, God is being faithful.

I'm reminded again of that last stanza of the old hymn:

> *Though vine nor fig tree neither*
> *expected fruit should bear,*
> *though all the fields should whither,*
> *nor flocks nor herds be there;*
> *yet God the same abiding,*
> *His praise shall tune my voice,*
> *for while in Him confiding,*
> *I cannot but rejoice.*

"SOMETIMES A LIGHT SURPRISES"–WILLIAM COWPER, 1779
(HABAKKUK 3:17–18)

SATURDAY

It has been most interesting and eye-opening to be exposed to and visit with medical staff representing a wide range of cultural backgrounds. In the past few days, we've introduced you to KoSAR who is Kurdish, Stella from the Native American reservation in South Dakota, and Candace from small-town Mississippi. Today we had Nathaniel, who is a Jehovah's Witness from nearby Franklin, and our nurse tech overnight is Odi—short for some longer name

that doesn't exactly roll off the American tongue—from Nigeria by way of the University of Texas, the other UT. She's very professional and at complete ease in her job. We live in a different world and I believe we are richer for it. I know we've enjoyed this part of our hospital stay.

Our tech tonight is Ashti, who is a Kurd from Iran. She is absolutely beautiful and has a very engaging personality. She's been in here exactly once but we feel like we've known her a long time. She was telling us how she has dealt with depression as the result of some of her treatment in her early years in Iran. It is hard to imagine how anyone could mistreat that beautiful child. Her entire family escaped to the United States.

Let's do our hymn now.

> *Jesus loves the little children,*
> *all the children of the world;*
> *red and yellow, black and white,*
> *they are precious in His sight;*
> *Jesus loves the little children of the world.*
>
> "Jesus Loves the Little Children"– Anonymous

Susie is a good sport about it all and walks straightway into it with a great attitude and full confidence that you and I and the Lord walk alongside her. —Mark

[On June 11, Susie had returned home after nine days in the hospital.]

I went to work for a little bit and met with our HR person to get things rolling for long-term disability. I am thankful for good insurance and a good job, but boy can insurance stuff make you want to say bad words!!!!! I had hoped to be able to work a few hours when I could to help me think about things other than when my next doc appointment is, what meds to take when, my lack of strength and energy, etc. My doctor won't let me return to work now, so I'll have to find something else to occupy my time. Mark needs a summer quillow and my new granddaughter needs a baby quilt. It seems ridiculous that I can shop for stuff and make things, but I can't go to work. Oh well.

I talked to my friend Nettie this afternoon. She had her infusion yesterday and was feeling the effects of it this afternoon. It takes longer for us to recover from the infusions but she has now had her fourth infusion so she is two-thirds through. I am so glad for her. I assured her of my prayers. If I can continue my chemo next Tuesday, I'll meet a new group of friends and I'll look forward to that. However, I will always remember my first group of new "sisters." A special bond is built when people go through things together. Thank you, Father, for the opportunity to establish new relationships.

A really oldie but really goodie, "God Will Take Care of You":

> *Be not dismayed whate'er betide,*
> *God will take care of you;*
> *beneath His wings of love abide,*
> *God will take care of you.*

> *Thro' days of toil when heart doth fail,*
> *God will take care of you;*
> *when dangers fierce your path assail,*
> *God will take care of you.*

No matter what may be the test,
 God will take care of you;
 lean, weary one, upon His breast,
 God will take care of you.

REFRAIN

 God will take care of you,
 through every day, o'er all the way;
 He will take care of you,
 God will take care of you.

"GOD WILL TAKE CARE OF YOU" – CIVILLA D. MARTIN

Thank you, all who send cards.
They lift my spirits and bring a smile.
I appreciate your love and prayers. —Susie

Mark

I think our patient did pretty well the first half of today, but the fourth quarter had its challenges. She drove herself to have her routine Friday blood work done, which itself wasn't too bad, except it drained all her energy. We had looked forward to Brandon and Marilyn coming over for a movie or game night, but we had to call it off. Honey just wasn't up to having company. She is very weary of feeling bad, of "being a blob," of there being so much she wants to do but can't, etc., etc.

The early evening was pleasant, so I suggested we go for a ride out in the country. It was great, driving along with the windows down in the pickup breathing the cool, fresh evening air. On the way home, we stopped by Sonic and enjoyed an ice cream cone. The excursion turned out to be great therapy and her outlook seems much improved. She's even sitting over there agreeing, smiling like she does, fuzzy head and earrings.

She finally heard from the drain doc's office today. They have the CT scan results and she will go in Monday midday for that report, then to her oncologist who hopefully will give her the go-ahead for infusion four Tuesday. (We really need that to happen … if you know what I mean.) The chemo nurse said that Honey's numbers are good, pointing to the favorable possibility of Tuesday actually happening.

Another little bumpy stretch of the road right now, but Honey is okay and we're okay. Brings to mind an old gospel song Dad and my dear friend Jimmy used to sing:

> *In shady, green pastures, so rich and so sweet,*
> *God leads His dear children along;*
> *where the water's cool flow bathes the weary one's feet,*
> *God leads His dear children along.*

Sometimes on the mount where the sun shines so bright,
 God leads His dear children along.
Sometimes in the valley, in darkest of night,
 God leads His dear children along.

REFRAIN

Some thro' the waters, some thro' the flood,
 some thro' the fire, but all thro' the blood;
 some thro' great sorrow, but God gives a song,
 in the night season, and all the day long.
"GOD LEADS US ALONG" – G. A. YOUNG

Thank Goodness.

We are always aware of your presence
with us along this path.
God is supplying our needs,
many of them through you.
—Mark

SUNDAY

I was able to go to church nearby with Mark and that was good, but very taxing. I do enjoy and need to get out but with little energy, it is very tiring and I'm ready to come home and relax in the manger. I do have quite a bit of anxiety about this week. I go to the drain doctor tomorrow and hope to get that bothersome apparatus removed. I also hope that Dr. Rosen will give me the go-ahead to have my infusion on Tuesday.

Knowing that I don't have much energy to begin with, all the events of the week will be hard. BUT, if all goes as I plan and want, I'll be free of the drain and have my fourth infusion, and be two-thirds of the way through the treatments. Please pray for peace and grace and calm. "I can do all things through Christ who strengthens me." Thank you, Father.

In Max Lucado's book *Grace*, I read this week, "Grace is God walking into your world with a sparkle in his eye and an offer that's hard to resist. Sit still for a bit. I can do wonders with this mess of yours."[1] I love the sparkle-in-His-eye part and claim that He is working wonders. How blessed I am.

The last stanza of "At the Break of Day" reads,

> *At the close of day I seek You once more,*
> * magnify Your name, worship and adore.*
> *Even in the darkness shines Your light so blest.*
> *Jesus, now I lay my spirit in Your arms to rest.*
>
> *"At the Break of Day"* – Words and music by Aristeu Pires, Jr. © 1990 JUERP. International copyright secured. All rights reserved. Trans. © 1992 Ralph Manuel.

1. Drain removed: √

2. Chemo treatment: on hold until Dr. Wheelock's associate reviews the report from Dr. Rosen, the drain doctor.

3. Appendectomy in August: probably. The hospital stay for the abscess amounted to "Band-aid," knowing that surgery would be needed post chemo. Hopefully it can be done using laparoscope.

God is so good and He continues to answer prayers—some yes, and some wait. But still He answers. Thank you, pray-ers, for your faithfulness to the task. I was quite anxious about today, maybe even worried. Nathan says that he knows worrying works—most things he worries about never come to pass! I did pray for peace, but human weakness also was evident in the events of the day. Next time I'll ask for more faith and trust in God's ultimate wisdom and goodness.

After the doctor's appointment we celebrated with a shared Sonic ice cream cone. We really know how to commemorate the big moments!!! Just right for each of us. I can't think of anyone I'd like to share things with more than my ever faithful husband and caregiver. We went for a walk tonight and walked a little faster and farther. It feels good but I can tell I haven't used those muscles in a long time. I'll work on that.

Tonight I'll sleep better without that extra appendage at my side. Before I close my eyes, that will be another thing I'll thank God for.

We are so humbled and encouraged by your love and prayers.
Thank you, dear ones, for holding our hands
along this journey. —Susie

TUESDAY

RATS RATS RATS!!! I did not kill the messenger and she was thankful. They have postponed my next chemo until July 2. My doctor wants to be sure that I am completely healed from the abscess before they start giving me the "poison" again. My head knows that is a good decision, but my heart is not there yet. MY plan was to be finished with this much sooner. Perhaps there is a better plan.

There are some good things about the postponement—I will probably get to go to [Nathan's wife] Corri's baby shower this weekend in Birmingham for our granddaughter. I hope to be at church Sunday morning. I might be able to go with Mark to Maryville for the Celebrating Grace Conference in July.

THURSDAY

I am trying to rebuild my strength and energy, so I'm walking on the treadmill. This morning I went one mile in twenty-five minutes—moving like a herd of turtles! Slowly but surely, I'll build back up. The lack of energy and stamina continues to be the main frustration. Having to wait on the next infusion was not what I had wanted, but I would really have had a very difficult time this week if I had the treatment. I guess the doctors really do know what they are talking about by having me wait for my body to heal. Sometimes I hate it when others are right.

> *I lift up my eyes to the mountains—*
> *where does my help come from?*
> *My help comes from the Lord,*
> *the Maker of heaven and earth.*
> *He will not let your foot slip—*
> *he who watches over you will not slumber;*

indeed, he who watches over Israel
will neither slumber nor sleep.
The Lord watches over you—
the Lord is your shade at your right hand;
the sun will not harm you by day,
nor the moon by night.
The Lord will keep you from all harm—
he will watch over your life;
the Lord will watch over your coming and going
both now and forevermore.

PSALM 121

I have decided to declare 2013 as my year of medical challenges and then start 2014 on a new healthy journey. We'll see how all that works out for me. —Susie

The Lord's my Shepherd, I'll not want;
He makes me down to lie
in pastures green; He leadeth me
the quiet waters by.

My soul He doth restore again,
and me to walk doth make
within the paths of righteousness,
e'en for His own name's sake.

My table Thou hast furnished
in presence of my foes;
my head Thou dost with oil anoint,
and my cup overflows.

"THE LORD'S MY SHEPHERD, I'LL NOT WANT" – SCOTTISH PSALTER, 1650

MARK & SUSIE EDWARDS

53

FRIDAY

The day was beautiful and I had breakfast on the deck. Somehow cereal tastes better when the morning is cool, the birds are chirping, and God's creation is in full view. His creation is definitely a work of art, and it is nice to just take the time to truly see what's in front of us. I guess this is another one of the lessons I am learning along this journey.

From Max Lucado's *Grace*: "Sustaining grace meets us at our point of need and equips us with courage, wisdom, and strength. Sustaining grace promises not the absence of struggle but the presence of God."[1]

SUNDAY

This morning we went to our steeple at First Baptist. Oh my word!!! Heaven came down and filled my soul. Hugging those people and smiling at them and visiting was a breath of fresh air and so encouraging. I got lots of free medicinal hugs. Can't beat that kind of healing. And then I even got to my Sunday school class! Again, a joy to be with those friends. And then, the worship service. And then, lunch with our friends Pastor Frank and Lori. And then, home at 2 p.m. and the recliner for several hours! Bone tired but feeling so blessed and happy. There is no substituting the corporate community at church. God is so good, and we continue to be humbled and amazed by His goodness.

I have said it before and I feel it to my bones, cancer is wretched and I wouldn't want anyone to have it. BUT, I am so thankful for the lessons I am learning through this journey. It would have been easier to learn these lessons without the cancer, but I probably would not have learned them without it. Positive things can and do come out of hardships. God Almighty has a plan

for us and even though we can't always see it or like it, He knows best and blesses us. Our trust is in Him.

Something else from Lucado's *Grace*: "When grace happens, generosity happens. Unsquashable, eye-popping bigheartedness happens."[1] I am here to testify that grace is happening at our church.

We continue to receive wonderful cards and words of encouragement and love. Thank you, dear herd, for your generosity. You bless us and we are thankful for each of you.
—Susie

Dear sweet Susie,

Oh, how I love to get mail from you! You have such a gift of encouragement. I'm so humbled that you continue to encourage *me* in your hard season. Thank you for my sweet note & the beautiful book. I've peeked in it a little bit, but I'm waiting until next week, when Aaron & I are at the beach on Annie's due date, to really soak it in & let the words wash over me. I can already tell it's going to be a book I treasure forever. I was sorry to read Mark's latest update & hear that you've been feeling

MONDAY

I think Honey's wonderful weekend has about caught up with her, but she did great and I'm so glad she felt good the whole time. Going to church yesterday was a real plus for her, too. She is so energized by people, and folks at our church are at the top of her list. Many there said some very nice things to me about her and, of course, that was gratifying too.

I led the music during worship at our church yesterday and took the opportunity to mention something about how the congregation has ministered to us all these years—closing in on thirty-six to be exact—and in recent days. Some of you may know that in the mid-'90s we thought we were moving to Dallas. For several months we had been in serious conversations with a larger church out there, and their pastor and I were good friends—he and I had led a lot of events and worship conferences together around the country.

Well, it turned out that I didn't get the opportunity after all. We were okay with it, although coming in second never feels quite right. But we had a peace about the whole thing, and I knew that we'd "understand it better by and by"—to quote an old gospel song. Sure enough, in eight months that pastor was gone, leaving the church in a total tail-spin. As it turns out, that church has had a parade of short-term ministers of music ever since then and there's no reason to believe that I wouldn't have been a short-termer there also.

As near a miss as that was, in the larger scheme of things, it is only of minor consequence. The greater "understand[ing] it better by and by" connects to the journey Honey and I are traveling now. There is no little doubt in our minds that had we moved to north Dallas back then, we would not have had the level of care, nor depth of support, that we receive today from this part of our "herd." We couldn't see seventeen years down the road, but I choose

to believe the Lord could. God certainly didn't cause Honey's illness, but He saw it coming and knew His church in Nashville. Thanks for being the body of Christ unto us.

It reminds me of another old song we sang as kids in South Texas:

> *My Lord knows the way through the wilderness,*
> > *all I have to do is follow.*
> *Strength for today is mine all the way,*
> > *and all that I need for tomorrow.*
> *My Lord knows the way through the wilderness;*
> > *all I have to do is follow.*

A simple song worth remembering and living into.

God provides words from people when we need them most and helps lift spirits and brings smiles. —Susie

We had the best two weekends in a row and are so thankful for them. Tomorrow I have another infusion. I am both glad and anxious about that— glad because with each one I am closer to the finish line, anxious because it slams me and that is not a walk in the park. But I know the meds are working and so I can manage it all. And my loving Mark is here. I am thankful for the meds and the doctors and nurses who administer it all and for Mark.

Today we received the new CD recorded by our friend Gena. She and Lyn (husband) were in our church years ago and now live in Keller, Texas. I have not listened to the entire CD yet, but "Be Not Afraid" has been a favorite ever since our choir sang it.

Lyn wrote some devotional thoughts about each of the songs Gena recorded. I have read the thought for this song and, as always, Lyn is right on.

> *What, then, do songs like "Be Not Afraid" have to say to us?*
>
> *They say that those things which we humans naturally fear are in fact not too big for God. We know that in the mystery of God there is a plan for us, just as He had a plan for His people when He first said "Fear not, for I have redeemed thee. I have called thee by thy name; thou art mine."*
>
> *When we pass through the waters, God is with us, and suddenly, as long as our eyes are on Him, we find ourselves walking on the waters.*
>
> *The floods come, often caused by life's storms, and we fear when we realize that He has not calmed the storm or held back the flood. But then, with eyes on Him, we realize the flood is not sweeping over us.*

This helps my anxiety and reminds me "Fear not, for I have redeemed thee. I have called thee by name; thou art mine."

Be not afraid,
 for I have redeemed you;
 be not afraid,
 I have called you by name.
When you pass through the waters,
 I will be with you;
 when you pass through the floods,
 they will not sweep o'er you.
When you walk through the fire,
 you will not be consumed;
 you are mine,
 you are precious in my sight.

I will get to see Nettie tomorrow and I am glad for our reunion. I will pass along the prayers that so many of you offer for her. She will be thankful. Thankful has been the theme for tonight's update and brought to you by a very thankful heart.

Yes, I am still anxious (afraid) but knowing "I am His" calms my fears. I am thankful. —Susie

TUESDAY

YEA YEA RATS RATS

YEA YEA: my doctor's appointment went well. Fourth infusion went as scheduled and I was able to visit with Nettie. The Benadryl had a sleepy effect on both of us, so in spite of the steroids, we both napped. This day of treatment is feeling a little different than the others. I am feeling tired earlier so maybe the effects will be moved up some. There is more pain in my feet and toes, and I'll be taking something stronger tonight for the pain. I can already tell I'm going to sleep better, too!

RATS RATS: when chemo is being administered, a doctor must be in the office. Apparently all the doctors are taking the week of July 22 off, so my usual chemo on July 23 will be postponed until July 30. This will push my last chemo down to Aug. 20 instead of the 13th. I was going to celebrate my birthday, on the 14th, with the last treatment (again this was MY plan). Instead, I will celebrate the last treatment being on [daughter-in-law] Corri's birthday. That's good, too. Since the chemo will last longer, I had to reschedule my appointment with the surgeon who will do my appendectomy. That will probably be the first part of September—at least I hope so.

It is such a bother trying to coordinate all of these appointments. I'll be glad to resume a more friendly schedule when I can eliminate some of the reasons for the appointments and also some of the doctors (although they are good and nice people, I won't miss them).

"God is so good, He's so good to me." Oh, yes He is. —Susie

We know we are back in the chemo routine full-strength. Right on schedule, two days following her infusion, Honey is in a pattern she describes as a "blob"—horizontal roughly 90% of the day sans any energy. She has difficulty being comfortable very long in her manger or in the bed, but she doesn't complain … much.

We've been at this now for a little more than four months. It is difficult to remember how things were prediagnosis, but this experience is helping us be more aware of and thankful for the small and simple things in life—a good way to live. We are more keenly cognizant of whatever strength we have, of our herd of supportive friends, of the place of prayer, and the daily provision and presence of God.

All this calls to mind an anthem the choirs at our church have sung through the years. Its music is upbeat and its text is based on Psalm 46:

> *God is our refuge and strength,*
>> *a present help in times of trouble;*
>> *though the mountains shake in the heart of sea,*
>> *though the waters roar and foam,*
>> *we will not fear.*
>
> *Come and behold the work of the Lord,*
>> *the awesome acts of God.*
>> *He is in the midst of His people,*
>> *in all the earth.*
>
> *We are His hands, He is the stone, He will cleanse us,*
>> *He is the air, we are His song;*
>> *we will celebrate His presence,*
>> *all the day long.*

God is our refuge and strength,

> *a present help in times of trouble;*
>
> *though the mountains shake in the heart of sea,*
>
> *though the waters roar and foam,*
>
> *we will not fear.*

Dear Jordan,

I thank you for reminding me that I need to be an encourager. Your skit last night in the choir program was so good. I am glad you do so many good things at church.

Have a good week at school and thanks for all you do.

Love,
Susie Edwards

Mark

Today has been another "blob" day for the patient. She's getting pretty good at this part. She doesn't seem as beset by blob days as in previous cycles, which is a good thing. Her joint pain and muscle aches seem to be more pronounced this time, but her appetite is better and nausea is not as prevalent. She just has more fun things to do and more good people to see than blob days allow. But all in all, she's a good sport about it all.

We're doing fine under the circumstances, just taking it one day at a time, thankful for meds, beds, mangers, friends, and the good Lord—all we have needed... .

Here's a hymn well over two hundred years old and probably never made any top-ten list, but it is one worth pondering:

> *God moves in a mysterious way*
> > *His wonders to perform;*
> > *He plants His footsteps in the sea*
> > *and rides upon the storm.*
>
> *You fearful saints, fresh courage take;*
> > *the clouds you so much dread*
> > *are big with mercy and shall break*
> > *in blessings on your head.*
>
> *Judge not the Lord by feeble sense,*
> > *but trust Him for His grace;*
> > *beneath a frowning providence*
> > *He hides a smiling face.*

Blind unbelief is sure to err
and scan His work in vain;
God is His own interpreter,
and He will make it plain.

"GOD MOVES IN A MYSTERIOUS WAY"– WILLIAM COWPER, 1773

This now four-month road trip Honey and I are traveling is definitely a "cloud [we] so much dread." But we can bear witness that the cloud is "big with mercy" and that there are "blessings on our head." We do "trust Him for His grace" and sense His "smiling face," confident that one day "He will make it plain." Thanks be to God!

Truly, God does move in a mysterious way, His wonders to perform. He doesn't cause the storms, He rides them and helps us ride them out. —Mark

MONDAY

I woke up yesterday, Sunday, singing "This is the day that the Lord has made and I will be exceeding glad. This is the day the Lord has made and I will be exceeding glad." I know there are more words but I forgot them, and I think I got the gist of it anyway.

Sunday was a day of YEA YEA YEA YEA YUCK.

Let's start with the YEAs. Nathan called last night about 5 p.m. and the family was headed to the hospital. About 9:30 p.m. we got a text with statistics and a picture of the Edwards family of four. Ella Anne was born at 8:10, weighs six lbs. thirteen oz., and is nineteen inches long. Is there anything more precious than God's babies? Words fail when trying to describe miracles. We will have to make room in the toy chest for dolls and tea sets to go with action figures and superheroes. I think there's plenty of room.

Now for the YUCK (I'd rather camp on the YEA). This round of side effects has been very different and more challenging. Very little has been predictable. Yesterday I had to rely more on pain and nausea meds. I am so thankful for the meds to get me over the hump and make things manageable. The meds take me to La La Land, and I use the energy I have just to breathe in and out. Today is an improvement and again I am thankful for the provisions of our loving Father. "All I have needed...."

We have a plaque that says "When there are no words, there's music." Well, I have no words for all the wonderful things that are happening in our lives but I have lots of music. Glorious, wonderful music of praise and thanksgiving. —Susie

From *The Red Sea Rules* by Robert Morgan: There was a gospel song many years ago that said, "In some way or other the Lord will provide. It might not be my way. It might not be thy way. And yet in His own way, the Lord will provide."[2] This is another lesson I am learning along this journey.

I'm reminded again of this verse on my vanity mirror:

> *At the close of day I seek You once more,*
> > *magnify Your name, worship and adore.*
> *Even in the darkness shines Your light so blest.*
> *Jesus, now I lay my spirit in Your arms to rest.*
>
> *"AT THE BREAK OF DAY"* – WORDS AND MUSIC BY ARISTEU PIRES, JR. © 1990 JUERP. INTERNATIONAL COPYRIGHT SECURED. ALL RIGHTS RESERVED. TRANS. © 1992 RALPH MANUEL.

At the close of this day, I am thanking our Father for:

- Our herd
- More meds to make me okay
- A warm and dry house while I listen to the rain storming outside
- His provisions of rain for the earth
- Paula and her supply of a good meal enjoyed last night
- Family and family-friends across several states

My new doctor today gave me some reassuring news, and that puts me at ease about what seems to be my ever-increasing medical issues. Knowing that each new "twitch" in this body is probably caused by the cancer stuff and medications is reassuring and frustrating! I am even more thankful that I only have two more infusions and then we will address the appendectomy, and then recovering with everything being over hopefully by October. At least that is MY PLAN!!! Lately, my plans haven't turned out so good, so maybe that is a prayer request—that my plan can be His plan. And if not, then the prayer is that I am grateful for His plan.

Red Sea Rule 4: Pray. "They cry out to the Lord in their trouble, and He brings them out of their distresses. He calms the storm, so that its waves are still" (Psalm 107:28–29). This is much more reassuring than what the doctor says.

The writer also talks about group prayer. "God doesn't always say yes to all our requests, but He listens with unusual attentiveness when two or three gather in united prayer—and He responds in His own way and time with power and wisdom."[2] "Unusual attentiveness." I like that and I believe that is what is happening when you, our herd, pray for us. We know it. We feel it.

> *My Shepherd will supply my need;*
> *Jehovah is His name;*
> *in pastures fresh He makes me feed*
> *beside the living stream.*
> *He brings my wandering spirit back*
> *when I forsake His ways;*
> *and leads me, for His mercy's sake,*
> *in paths of truth and grace.*

The sure provisions of my God
 attend me all my days;
 O may Thy house be my abode,
 and all my work be praise.
There would I find a settled rest,
 while others go and come;
 no more a stranger, nor a guest,
 but like a child at home.

"MY SHEPHERD WILL SUPPLY MY NEED"- ISAAC WATTS, 1719 (PSALM 23)

We are ever thankful for each of you and thank God each time we remember you. individually and as a group. God continues to bless us and protect us and give us grace and mercy beyond measure. —Susie

Noel,

What a wonderful sight to see you baptized this morning. And your letter to God was great. I never thought about being in the backseat of a car driven by God. You are very smart and I am sure God is so proud of you.

Love,
Mrs. Susie

The sweetest granddaughter in the world is helping Honey write this update. Joy floods my soul and thanksgiving overflows. God's blessings never cease and we praise Him.

I have loved everything I've done the last twelve days, but it was energy draining and I can really feel it now. Family energizes and drains at the same time. I think that's the way it is supposed to be and I wouldn't have it any other way.

The time with sweet Ella and Daniel was wonderful. Oh yes, and with their parents too! Funny how sometimes we grandparents tend to forget the parents of the grands!! They are a super family and we are very proud of all of them. The villages of Twelfth Street Baptist Church in Gadsden, Alabama, and First Baptist in Nashville did a wonderful job helping raise Corri and Nathan to be fine Christian people. God provided wonderful people to love and be role models for these two. Thank you, Father.

Weslee is so much fun. She always brightens my day and knows what to do and how to do it to make sure I'm well cared for while she is with me. Sometimes she gets a little bossy, but she has to when I would rather not pace myself. At times there is a fine line between who the parent is and who the child is. She is a super mom and wife and daughter and loves those roles. Thank you, dear ones of First Baptist, for helping her grow into a wonderful Christian woman. She and Chris have three super boys and they are great parents to them. Thank you, Father.

A new hymn from the *Celebrating Grace Hymnal* (#685):

> *Children are a gift from heaven,*
> *each soul trusting and unique--*
> *God's example of faith's journey*
> *for all people who will seek.*

Children help us to discover
how our lives should be each day;
joy unbounded, grace, forgiveness
are the lights that mark the way.

They surprise us as we listen
to each question, thought, and plea;
unexpected pleasures find us
through their innocence and glee.

Children need our care and guidance,
teaching with each word and deed;
for they watch our actions closely,
learning how to serve and lead.

REFRAIN

Children are a priceless treasure,
sent from heaven like a dove;
poetry yet to be written,
they bring laughter, joy, and love!

Tonight's theme is family.
Children are priceless treasures,
and God has blessed us. —Susie

NOTES FROM Susie

This has been a very full two weeks for me and I can really tell it. My energy level is below zero, but I am able to do the things that I need to the most. Today I went to the visitation for our friend Allison. What a lovely young lady she was and we will miss her.

Thank you, dear herd, for continuing to love and support and pray for us. We feel it so much and know God hears your prayers. Tuesday will be my fifth infusion—only one left after that!!!! You will hear us shouting from the rooftops and praising God for His goodness. I'm not out of the woods yet but have come a long way. The journey hasn't seemed so bad with you by our sides. Thanks for fighting this battle with us. Just a few more months.

We have a big week coming up: Mark's retirement dinner from Celebrating Grace Monday; infusion Tuesday; injection and our forty-third wedding anniversary Wednesday. And that is only the first half of the week. I have so much to be thankful for in those three days. Thankful for Tom McAfee and the six years at Celebrating Grace where Mark has loved being part of the new hymnal, and meeting so many new friends. That this will be my fifth infusion, with only one more to go. For powerful meds that help the chemo poison to work and do its job. For forty-three wonderful years with the best husband I could ask for.

All glory be to God on high
* and thanks to Him forever!*
Whatever Satan's host may try,
* God foils their dark endeavor.*
He bends His ear to every call
* and offers peace, goodwill to all,*
* and calms the troubled spirit.*

O Father, for Your lordship true
we give You praise and honor;
we worship You, we trust in You,
we give You thanks forever.
Your will is perfect and Your might
relentlessly, confirms the right;
Your lordship is our blessing.

Lord Jesus Christ, the only Son
of God, Creation's Author,
Redeemer of Your wandering ones,
and source of all true pleasure:
O Lamb of God, O Lord divine,
conform our lives to Your design,
and on us all have mercy.

O Holy Spirit, perfect gift,
who brings us consolation:
to men and women saved by Christ
assure Your inspiration.
Through sickness, need, and bitter death,
grant us Your warm, life-giving breath;
our lives are in Your keeping.

God continues to bless me in more ways than I know.
He is certainly more powerful than the meds! —Susie

NOTES FROM *Susie*

I wish you could have been at our house tonight. For lots of years, on Sunday nights Mark would come home after church and play the piano. Weslee and Nathan remember those times. Well, tonight he did it again. There is something calming and smoothing when listening to him from another room. Tonight he played a hymn that I didn't know (there are lots of those!). You'll like this one; it is #540 in the *Celebrating Grace Hymnal:*

> *We cannot measure how You heal*
> > *or answer every sufferer's prayer;*
> > *yet we believe Your grace responds*
> > *where faith and doubt unite to care.*
> *Your hands, though bloodied on the cross,*
> > *survive to hold and heal and warn,*
> > *to carry all through death to life*
> > *and cradle children yet unborn.*
>
> *The pain that will not go away,*
> > *the guilt that clings from things long past,*
> > *the fear of what the future holds,*
> > *are present as if meant to last.*
> *But present too is love which tends*
> > *the hurt we never hoped to find,*
> > *the private agonies inside,*
> > *the memories that haunt the mind.*

So some have come who need Your help
* and some have come to make amends,*
* as hands which shaped and saved the world*
* are present in the touch of friends.*
Lord, let Your Spirit meet us here
* to mend the body, mind, and soul,*
* to disentangle peace from pain,*
* and make your broken people whole.*

Tonight, the third stanza is especially meaningful. The physical touch of you this morning at church, and the long-distance touch of others of you, is so important and appreciated by us.

When there are no words. there is music and my head is so full of music I can't settle on one song. God continues to bless us in every way. His love and provisions are overwhelming. and we are grateful. —Susie

Mark

Today Honey had round five (of six) infusions. We arrived at the appointed spot early and, of course, the first person we saw was Nettie. Plenty of hugs and howdies for both of us from her and her helper, Carmelita. It's almost like we've known these two forever. Honey and Nettie immediately cranked up their animated conversation, comparing aches, successes, Nettie's teal toenail polish, and stuff like that. Today was Nettie's final treatment, and Honey was almost as excited about that as was Nettie; in fact, Honey had assembled a graduation bag for her to help celebrate the joyous occasion. Before long, the pair of patients was summoned to their respective doc offices for pregame activities, leaving Carmelita and me in the waiting room to discuss things that caregivers talk about. It was great fun.

In due time, Nettie reappeared, gathered her gear, and Carmelita accompanied her down the hall to the chemo palace. Some ten minutes later, Honey returned from the visit with her doc and we followed suit down that same hall. Entering the palace and knowing where Honey preferred to set up shop, I parked my patient's paraphernalia in the appropriate recliner ... right next to Nettie, of course. Confident that all was well, Honey and I said our good-byes. Starting to leave but realizing that I might not see Nettie when I returned to retrieve Honey, I went over to give Nettie a quick hug and wish her well. Turning to leave again, I noticed that Honey had commenced "working the room," obviously checking on other infusion friends occupying chairs at a distance—one must see to the important things first, you know.

She beats all I ever saw. She just loves people—all people—and is genuinely interested in their well-being and goings-on. She is energized in such situations ... which may have something to do with the healthy doses of steroids the night before and the morning of the treatments. But whatever, it is fun to sit and see the interaction and brightness she brings to that otherwise

rather "cloudy" room. I rescued Honey (or the rest of the room) about 2:45 p.m. and got her settled back at home. She was tired, ate a snack, and made haste unto the manger.

Here's a good hymn from the Catholic tradition. I'm sure you've at least heard it. It is #51 in the *Celebrating Grace Hymnal*.

You who dwell in the shelter of the Lord,
who abide in His shadow for life,
say to the Lord, "My refuge,
my Rock in whom I trust."

REFRAIN

And He will raise you up on eagle's wings,
bear you on the breath of dawn,
make you to shine like the sun
and hold you in the palm of His hand.

The snare of the fowler will never capture you,
and famine will bring you no fear:
under His wings your refuge,
His faithfulness your shield.

And He will raise you up.... .

"ON EAGLE'S WINGS" – WORDS AND MUSIC MICHAEL JONCAS © 1979 OREGON CATHOLIC PRESS, 5536 NE HASSALO, PORTLAND, OR 97213. ALL RIGHTS RESERVED. USED WITH PERMISSION.

Thank you, God, for eagle's wings that raise us up pretty often these days. And thank you, herd, for flying with us these five months now. The flight is not nearly so scary "under His wings" and by your side. —Mark

Honey was able to run some errands this morning. I came home for lunch then to take her to get the usual Neulasta injection the day following infusion. By the time we got home, she was pretty well spent, has been in the manger since, and appears to be down for the count. She got an early start on her "no count" days after this round. But, of course, she brightens up when people come to visit, sometimes too much.

We had planned to go out for dinner tonight since this very day forty-three years ago, Honey and I said vows that included the words "better and worse, richer and poorer, sickness and health." Like most couples, surely we gave some thought to each of those possibilities and fully meant our "I dos"; but gosh, at ages eighteen and twenty-two, things are good and getting better, we're going to have enough to live comfortably, and we absolutely feel great!

But if couples are blessed to live long enough, at least one of those brighter sides will likely dim. Certainly, such is the case at our house this year. But by now and by the goodness of God, our vows are deeper and our joys are greater because both have been seasoned and proven. So, the current, unseen detour isn't so bad—yet another grace to celebrate. "We do!"

> *Praise God, from whom all blessings flow;*
> *praise Him, all creatures here below;*
> *praise Him, above ye heavenly host;*
> *praise Father, Son, and Holy Ghost.*
>
> *"Praise God, from Whom All Blessings Flow"* – Thomas Ken, 1674

Marriage to the right person over the long haul is one of God's rich blessings—especially when navigating a steep climb.
—Mark

AUGUST 5-6, 2013

MONDAY

[*Written after several days in the hospital*]: It seems I do have an infection and a new antibiotic, so I am staying one more night to make sure the meds don't mess up my stomach. There sure are lots of things that have to interact just right or lots of things could interact just wrong!

As I write this, Mark's dad is having a heart procedure in San Antonio. His attitude is wonderful, and he has wonderful care at St. Luke's. In fact, he reported a sing-fest in his room earlier and a marvelous prayer from one of his nurses. Ministers abound in patient care facilities! We regret not being there but are so thankful that he is in good hands—and not from the insurance people! Thank you for your prayers for him.

Now back to this patient. I am feeling better than I have in about two weeks. I have some energy (that happens when all you do is lie around doing nothing)! I am thankful.

Last week Mark was doing an arrangement of "In This Very Room." On Thursday, as I listened, I was comforted by the music and words. This chemo brain doesn't allow for total word recall, but I know love, hope, and power are all part of that song. In the bed at home and the bed at the hospital I have felt all of those: love, hope, and power. Amazing love, amazing hope, and amazing power. All of these from our Almighty God. What more could I ask for? How overwhelmingly blessed I am/we are.

It's all good news tonight, I'm tellin' ya! Both Honey and my dad came home from their respective hospitals. Our herd must be a prayin' machine!

Tonight's hymn is another jewel from the African-American tradition. It's in a minor key and let's not sing it too fast.

> *I want Jesus to walk with me.*
> *I want Jesus to walk with me.*
> *All along my pilgrim journey,*
> > *Lord, I want Jesus to walk with me.*
>
> *In my trials, Lord, walk with me.*
> *In my trials, Lord, walk with me.*
> *When my heart is almost breaking,*
> > *Lord, I want Jesus to walk with me.*
>
> *When I'm troubled, Lord, walk with me.*
> *When I'm troubled, Lord, walk with me.*
> *When my head is bowed in sorrow,*
> > *Lord, I want Jesus to walk with me.*
>
> *"I WANT JESUS TO WALK WITH ME"* – AFRICAN-AMERICAN SPIRITUAL

It is a blessed assurance knowing that Jesus and you, indeed, walk with us along our pilgrim journey. Our love and thanks unto all. —Mark

MONDAY

I have a specific prayer request. I was in the hospital for an infection, and I learned over the weekend that I have yet another one. That makes two infections going on at the same time. For the hospital infection, I need to eat yogurt and cottage cheese. For the second infection, I shouldn't eat yogurt and cottage cheese! What's a girl to do? The request is to pray that both infections are gone this week or at least that they do not postpone the infusion. Thank you.

You know how sometimes you forget something you knew a long time ago and then all of a sudden it reappears? Well, here is a hymn from decades past:

> *Are we weak and heavy laden,*
> > *cumbered with a load of care?*
> *Precious Savior, still our refuge;*
> > *take it to the Lord in prayer.*
> *Do thy friends despise, forsake thee?*
> *Take it to the Lord in prayer;*
> > *in His arms He'll take and shield thee;*
> > *thou wilt find a solace there.*
>
> *"WHAT A FRIEND WE HAVE IN JESUS"* – JOSEPH SCRIVEN, 1855

> *I know the plans I have for you, says the Lord, plans for your welfare and not for harm, to give you a future with hope. Then when you call upon me and come and pray to me, I will hear you. When you search for me, you will find me; if you seek me with all your heart, I will let you find me, says the Lord.*
>
> JEREMIAH 29:11–14

Both hymn and Scripture are so comforting and calming.

Chemo brain is definitely working overtime—or maybe there's nothing to work at all! I saw a card one time that said something like "of all the things I miss, I miss my mind most of all." That applies to this puppy. Another day of just OK energy level. I am finding that about two hours of "up and going" is about all I have in me.

My friend Peggy, who has a wonderful ministry of encouragement, sent me a wonderful book, *My Beautiful Broken Shell*. I have seen it before and loved it then. I especially love it now. If you haven't read it, a real short read, please do so. It's a very encouraging story. "A wave crashes, sending tiny sand crabs scurrying for safety ... and I am reminded that even the smallest creatures depend on each other. Especially in our brokenness, we need the Lord ... and we need one another. Thank you, Lord, for filling my life with people who care. Thank you for my family, for my friends, for those who are always there for me."[3]

> *Who will separate us from the love of Christ?*
> *Will hardship, or distress, or persecution, or famine,*
> *or nakedness, or peril, or sword? ...*
> *No, in all things we are more than conquerors*
> *through him who loved us.*
> *For I am convinced that neither death, nor life, nor angels,*
> *Nor rulers, nor things present nor things to come,*
> *Nor powers, nor height, nor depth,*
> *Nor anything else in all creation,*
> *Will be able to separate us from the love of God*
> *in Christ Jesus our Lord.*

ROMANS 8:35, 37–39

(NEW REVISED STANDARD VERSION BIBLE, COPYRIGHT © 1989 THE DIVISION OF CHRISTIAN EDUCATION OF THE NATIONAL COUNCIL OF THE CHURCHES OF CHRIST IN THE UNITED STATES OF AMERICA. USED BY PERMISSION. ALL RIGHTS RESERVED.)

Today I am thankful for another day; for two hours of energy; for the ability to feel pain in my leg, because not everyone has a leg; for eyesight to see precious children; for people who love us and show that love; for my brokenness so that I must rely on our Father for His strength; for a husband who loves hymns, plays them from his heart and, in so doing, blesses me; always for strong meds to destroy disease; and for researchers who fight to find cures. —Susie

Gracious God, we give You thanks for Your countless gifts to us...
 for the earth and the bounty of creation,
 for life and health,
 for home and harvest,
 for work and rest.

May we live now and always as thankful people.

NOTES FROM Susie

"This is the day the Lord hath made and we will rejoice and be glad in it." It has really been a wonderful day. I love worshiping with our family of faith at First Baptist Church Nashville. I didn't get to see and hug as many friends as I wanted, but it will happen. Coming into church late and leaving early tends to limit my time, but for now, that is what is called for. And I am thankful for any time I have.

Our friend Rusty sang and Mark played "In This Very Room," and it was a wonderful time of worship. I wake up in the night singing that song, and Mark says it is because he played it so much last week. He's not wrong about some things but he is about this. That is just a wonderful song with so much power that it stays with me. Thanks to both for making my worship time.

> In this very room, there's quite enough love for all of us.
> And in this very room, there's quite enough joy for all of us;
>> and there's quite enough hope, and quite enough power
>> to chase away any gloom,
>> for Jesus, Lord Jesus, is in this very room.

"IN THIS VERY ROOM" – WORDS AND MUSIC BY RON AND CAROL HARRIS © 1979 RON HARRIS MUSIC. ALL RIGHTS RESERVED. USED BY PERMISSION.

Today I am thankful for the energy to go to church: for our community of faith: for a comfortable home to rest my weary bones: for activity. noise. and love when the family comes and for quiet and calm when they leave: for lots of laundry to do because that means we have had family: for music. —Susie

DID YOU HEAR IT? At 1:30 this afternoon I walked out of the Surgical Center and did a yell and jig—well maybe a shuffle! You should have been able to hear me from South Carolina, Louisiana, and Texas. I AM NOW AN OFFICAL GRADUATE. Thank you to all who prayed us through this part of the journey. We all succeeded. Now on to the next thing on the list for this journey.

I missed Nettie today. The waiting room wasn't as noisy with our greetings, and I had to wait until I got into the treatment room before I knew that Gloria was there. We had a good time visiting. Kricia, our chemo nurse, called me Nettie Jr. once. Then Nettie called me tonight. We talked about some of the things we would have talked about this morning. She invited me to come to her house for fried catfish, hush puppies, and all the other trimmings. That was during the last treatment and we continued on that theme tonight. We will all win when the dinner is served (all except our cholesterol levels). But who cares? We have a good reason to celebrate, and celebrate we will.

Things I am thankful for today:

- I was able to have the last infusion
- At least one of my infections is cured
- Wonderful doctors who are specialists in their fields
- Chemo nurses who are so kind and friendly and take such good care of us
- Powerful drugs to heal my body and powerful drugs to counteract my not-so-fun side effects
- Prayers warriors who continually pray in our behalf
- A lifetime of friends who are more like family
- A husband who thinks I'm beautiful even without hair and lots of scars and loves me and takes such good care of me
- A God who gives me grace and mercy and always, always provides for me

All glory be to God on high
 and thanks to Him forever!
Whatever Satan's host may try,
 God foils their dark endeavor.
He bends His ear to every call
 and offers peace, goodwill to all,
 and calms the troubled spirit.

O Father, for Your lordship true
 we give You praise and honor;
 we worship You, we trust in You,
 we give You thanks forever.
Your will is perfect and Your might
 relentlessly, confirms the right;
 Your lordship is our blessing.

Lord Jesus Christ, the only Son
 of God, Creation's Author,
 Redeemer of Your wandering ones,
 and source of all true pleasure:
 O Lamb of God, O Lord divine,
 conform our lives to Your design,
 and on us all have mercy.

O Holy Spirit, perfect gift,
 who brings us consolation:
 to men and women saved by Christ
 assure Your inspiration.
Through sickness, need, and bitter death,
 grant us Your warm, life-giving breath;
 our lives are in Your keeping.

Praise God from whom all blessings flow. —Susie

MARK & SUSIE EDWARDS

Mark

Jane, our keen-eyed decorator, dropped by late morning with a container of the best homemade orange sherbet I've ever eaten. Seeing Honey for the first time in several months literally stopped Jane in her tracks; she just hollered, blown away at how good Honey looks—more than twenty pounds lesser and the cute wig. "She looks like a young woman," she whispered to me; and to her blurted out, "And you don't even need a face-lift!" They both hooted.

Jane's a live wire, so funny and we just love to be with her. They made each other's day. Later Margi came by for a short visit and to give Honey something she had gotten her on a recent trip to Oregon. Our friends are wonderful.

In church Sunday, we sang a hymn that rang true again and anew:

> *In the lightning flash across the sky*
> *His mighty power I see,*
> *and I know if He can reign on high,*
> *His light can shine on me.*
>
> *When the thunder shakes the mighty hills*
> *and trembles every tree,*
> *then I know a God so great and strong*
> *can surely harbor me.*
>
> *When refreshing showers cool the earth*
> *and sweep across the sea,*
> *then His rainbow shines within my heart,*
> *His nearness comforts me.*

REFRAIN

I've seen it in the lightning,

 heard it in the thunder, and felt it in the rain;

 my Lord is near me all the time,

 my Lord is near me all the time.

The past few months, "lightning and thunder" have happened around our house, but there have also been some refreshing "showers." But, by God's grace, we sense the rainbow and know that our Lord is near us all the time. —Mark

In heavenly love abiding,

 no change my heart shall fear;

 and safe is such confiding,

 for nothing changes here:

 the storm may roar about me;

 my heart may low be laid;

 but God is all around me,

 and can I be dismayed?

Green pastures are before me,

 which yet I have not seen;

 bright skies will soon be o'er me,

 where the dark clouds have been:

 my life I cannot measure,

 the path of life is free;

 my Savior has my treasure,

 and He will walk with me.

"In Heavenly Love Abiding" – Anna L. Waring, 1850

MARK & SUSIE EDWARDS

FRIDAY

Honey was down most of the afternoon as Wednesday's Neulasta injection kicked in its own aftereffects of joint and muscle pain. But meds trumped most of that discomfort, and she was able to eat a good dinner at the table. Now for her favorite pastime— writing notes of thanks and encouragement. These days, the thanks part of that has been a big job because so many have done so much for us. Words are inadequate to express our deep gratitude, but still she tries.

Tonight's hymn is actually half of a hymn—the second half—that most of us know. The first half extols the glory, power, love, and might of God. The latter half is not the flip side, but another side of God.

> *Thy bountiful care what tongue can recite?*
> *It breathes in the air, it shines in the light,*
> > *it streams from the hills, it descends to the plain,*
> > *and sweetly distills in the dew and the rain.* [I say Amen!]

> *Frail children of dust, and feeble as frail,*
> > *in Thee do we trust, nor find Thee to fail:*
> > *Thy mercies how tender, how firm to the end,*
> > *our Maker, Defender, Redeemer, and Friend.*

"O WORSHIP THE KING" – ROBERT GRANT 1833 (PSALM 104)

This weekend has been a "no count" one but things are going to start looking up any minute now! Side effects are lingering longer this time, but it is the last time, so we're good. We had an appointment with the surgeon this morning and have scheduled a CT scan for next Tuesday. Everything Dr. Rosen [surgeon for my appendectomy] said was encouraging, and we feel good about that. He's another doctor we like, are pleased with, and thankful for. We are checking things off one at a time and we rejoice in that.

> *Joys are flowing like a river,*
> *since the Comforter has come;*
> *He abides with us forever,*
> *makes the trusting heart His home.*

REFRAIN
> *Blessed quietness, holy quietness,*
> *what assurance in my soul!*
> *On the stormy sea He speaks peace to me,*
> *how the billows cease to roll!*

> *Bringing life and health and gladness,*
> *all around this heavenly Guest,*
> *banished unbelief and sadness,*
> *changed our weariness to rest.*

> *Like the rain that falls from heaven,*
> *like the sunlight from the sky,*
> *so the Comforter is given,*
> *coming on us from on high.*

Blessed quietness, holy quietness,
 what assurance in my soul!
On the stormy sea He speaks peace to me,
 how the billows cease to roll!

"BLESSED QUIETNESS" - MANIE PAYNE FERGUSON, CA. 1897

These words were so important last week during my weepy time. Pain was harder for some reason, and the Comforter did come to me and He did change my weariness to rest and the billows did cease. Again, all I have needed He has provided.

We have an amazing Father who is always present.
Blessings abound. —Susie

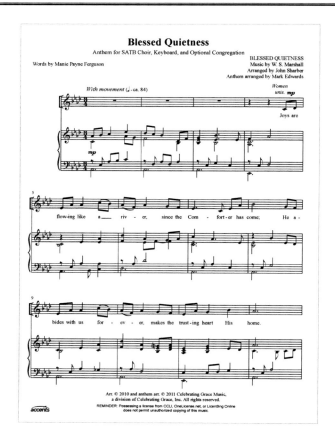

We seem to be in a holding pattern at the moment. The CT scan will be next Tuesday and then we are off to Martin, where our daughter and family live, for the Soybean Festival on Tuesday night, and Grandparents Day in kindergarten with Andrew and lunch with Jonathan on Wednesday. We have missed so much in our grandchildren's lives this year. That has been one of the hardest things to adjust to during this journey. My spirit is willing, but this body is very weak. I'm not used to that and I know it will take time to regain my strength and stamina. Let's pray for patience in that regard.

> *When peace like a river, attendeth my way,*
>> *when sorrows like sea billows roll;*
>> *whatever my lot, Thou hast taught me to say,*
>> *"It is well, it is well with my soul."*

REFRAIN

> *It is well, with my soul,*
>> *it is well, it is well with my soul.*

> *Though Satan should buffet, though trials should come,*
>> *let this blest assurance control,*
>> *that Christ has regarded my helpless estate,*
>> *and has shed His own blood for my soul.*

> *My sin—oh, the bliss of this glorious thought:*
>> *my sin, not in part but the whole—*
>> *is nailed to the cross and I bear it no more,*
>> *praise the Lord, praise the Lord, O my soul!*

> *And, Lord, haste the day when the faith shall be sight,*
>> *the clouds, be rolled back as a scroll,*
>> *the trump shall resound and the Lord shall descend,*
>> *"Even so"—it is well with my soul.*

REFRAIN

It is well, with my soul,

it is well, it is well with my soul.

"IT IS WELL WITH MY SOUL"– HORATIO G. SPAFFORD, 1876

Today. I am thankful for the assurance that "it is well."- Susie

God, You alone will satisfy our longing.
We wait, O God, for you alone.

We survive by our faith that fears and tombs and tribulations
are preludes to eternal life.
We wait, O God, for You alone.

We wait, hoping to meet You in our gardens of sorrow
as You met Mary.
We wait for You to come to us behind locked doors of fear
as You came to the disciples.
We wait, O God, for You alone.

Soon enough we will walk to the tombs again
and discover resurrection;
learning that if weeping endures for a night,
joy comes in the morning.
We wait, O God, for You alone.

And when the morning finally comes,
its light is ever more brilliant
as we remember how You carried us in the night.
We wait, O God, for You alone. Amen.

"PERSEVERANCE"– GARY FURR © 2010 CELEBRATING GRACE, INC.
ALL RIGHTS RESERVED.

NOTES FROM Susie

Our "hymn of the day" is more a Prelude than Postlude and only the chorus of a hymn. I will be surprised if many of you know it. For some reason, it has come to mind several times this week during my morning walk.

> *Singing I go along life's road,*
> *praising the Lord, praising the Lord.*
> *Singing I go along life's road,*
> *for Jesus has lifted my load.*
> "SINGING I GO"– ELIZA E. HEWITT

We grew up with a recording of George Beverly Shea singing that song; we even had a copy of it in some paperback songbook, and our dad sang it some. It probably had a stanza or two, but none of it comes to mind.

Over the past six months, many of you have commented on Honey and my inclusion of hymns in these updates. And some have commented about seeing and sensing our faith along this journey. Not surprising that both comments often come in the same sentence, for hymns and faith are seamlessly connected.

The psalmist said, "Let the words of my mouth and the meditation of my heart be acceptable in Thy sight, O Lord, my strength and my redeemer." (Psalm 19:14) It is generally accepted that what comes out of one's mouth springs from that which resides in one's heart. True enough. Anger in one's heart tends to spew forth all manner of poisonous speech, song, and more. Likewise, from a heart of Christian faith, "with deeds of love and mercy, the heavenly kingdom comes."

But I propose that this accepted directional flow also travels in the opposite direction—that words in the mouth don't so much begin as meditations of the heart as they become meditations of the heart. (That's one reason that

what we sing in worship is so important; words in our mouths are formative of our hearts and our faith.)

Honey and I grew up in "hymn homes." My dad was the volunteer music director in our small-town church in which Mom played the small organ. Honey's Mimi was a soloist in their larger-town church choir. All the kids in both homes took piano lessons, one important goal of which was to be able to play hymns. Several hymnals could be found on the living room piano or in its bench and they were frequently sung from. Attendance at Sunday morning, Sunday night, and Wednesday night church was assumed, and hymns were always on the program. It's no wonder Honey and I experience and express our faith through hymns.

Words in our mouths for a lifetime have literally become the meditation of our hearts. Thanks for singing along life's road with us. —Mark

Make a joyful noise unto the Lord, all ye lands.
Serve the Lord with gladness;
 come before His presence with singing.
Know ye that the Lord He is God:
 it is He that hath made us, and not we ourselves;
 we are His people, and the sheep of His pasture.
Enter into His gates with Thanksgiving,
 and into His courts with praise:
 be thankful unto Him, and bless His name.
For the Lord is good; His mercy is everlasting;
 and His truth endureth to all generations.
PSALM 100 (KJV)

Honey has had a persistent pain in her left leg from her hip to the tip of her little toe. She has fought it—mostly losing—for too many days by now, and it's taking its toll on her. It is hard to get comfortable, and constant pain wears down even a strong person, among whom Honey is chief. (It has not gone unnoticed that these issues for her happen on holidays and weekends.) Meds take the edge off the discomfort, but something else must be done. We had planned to go downtown to church yesterday, but that didn't happen. The plan is a trio of epidural steroid injections two weeks apart. Please pray for some relief.

Tomorrow morning Honey has a CT scan to see how well the chemo has done its work. She anticipates a report within twenty-four hours of the scan. A good report would be yet another matter of specific prayer. Thank you.

We are also waiting on the oncologist and surgeon to coordinate their schedules so that we can get her long-awaited appendectomy done, hopefully next week. They will try to do the procedure using laparoscope, but they are not overly optimistic that will be possible given the extent of her first surgery. If they have to be more invasive, she will spend at least one night in the hospital.

Other than her leg pain, I think Honey is much improved. She's eating well and doing a few tasks around the house, and more than ready to get up and go. But her nonstop off-the-chart pain greatly limits all manner of activity, no matter how ready she is to do otherwise.

There's not a lot of uplifting, fun news tonight, but such is part of the journey. We're hanging in there and have some lighter time, too. We even took a field trip to Wendy's for a Frosty® a little while ago.

I must tell Jesus all of my trials;
 I cannot bear these burdens alone;
 in my distress He kindly will help me;
 He ever loves and cares for His own.

I must tell Jesus all of my troubles;
 He is a kind, compassionate friend;
 if I but ask Him, He will deliver,
 make of my troubles quickly an end.

REFRAIN
I must tell Jesus! I must tell Jesus!
I cannot bear my burdens alone;
 I must tell Jesus! I must tell Jesus!
Jesus can help me, Jesus alone.

"I Must Tell Jesus" – ELISHA A. HOFFMAN

Thanks for helping us carry our
burdens in so many ways. —Mark

As most grandparents know, there's nothing like hugs and smiles from the grands that help us feel better. It may not do anything for the physical condition, but it works wonders for the emotional side of illnesses. Last weekend and Monday were very challenging days. My leg pain was not letting up, but a call to Dr. Donna and a new prescription is helping the situation. The pain is much better, is manageable, and getting better. We had the CT scan without a hitch.

> *O the deep, deep love of Jesus, vast, unmeasured, boundless, free,*
> > *rolling as a mighty ocean in its fullness over me!*
> *Underneath me, all around me is the current of His love,*
> > *leading onward, leading homeward, to that glorious rest above.*
>
> *O the deep, deep love of Jesus, spread His praise from shore to shore!*
> *He who loves us, ever loves us, changes never, nevermore;*
> > *He, who died to save His loved ones, intercedes for them above;*
> > *He, who called them His own people, watches over them in love.*
>
> *O the deep, deep love of Jesus, love of every love the best!*
> *Vast the ocean of His blessing, sweet the haven of His rest!*
> *O the deep, deep love of Jesus—for my heaven of heavens is He;*
> > *This my everlasting glory—Jesus' mighty love for me!*
>
> "O THE DEEP, DEEP LOVE OF JESUS" – SAMUEL TREVOR FRANCIS, 1898, ALT.

We are slowly but surely marking things off the list of "things left to do." Your prayers and love are seeing us through, and we appreciate it. You bless us every day.

Thank you for walking this journey with us
and for being God's healing touch. —Susie

YEA YEA YEA RATS

#1 YEA: The CT scan shows something is "decreased in the right lower quadrant." I don't have any idea what that means, but I think "decreased" means good. I'll call the doctor and see if he can shed some light on the report and let us in on the secret!

#2 YEA: The steroid injection this morning didn't hurt at all. I can't decide if I have been poked, prodded, pulled, and probed so much this year that I just don't feel stuff anymore or what. The main thing I felt was the cold when they washed the injection site. It may be a day or two before I feel any real relief, and I am totally excited about that.

#3 YEA: Surgery is scheduled for Sept. 13. I'm not superstitious about Friday the 13th. Mark's only concern is that it is on a Friday with the weekend staring us in the face. Again—all my stuff happens on weekends and holidays. I'm lucky that way.

#1 RATS: Daniel's birthday party is the 14th, and we will have to miss that. This is just one more thing we have missed with our grands this year. It just means that next year we will have do lots of super things with them.

We are checking things off our "things left to do to beat this bothersome disease" list. Feels good. Things I am thankful for: a little more energy today; trained professionals who know what they are doing to help people get well and feel better; a herd of people who support, love, and pray for us; a loving God who takes care of our every need and gives us grace and mercy.

> *There's the wonder of sunset at evening,*
> *the wonder as sunrise I see;*
> *but the wonder of wonders that thrills my soul*
> *is the wonder that God loves me.*

There's the wonder of springtime and harvest,
 the sky, the stars, the sun;
 but the wonder of wonders that thrills my soul
 is the wonder that's only begun.

REFRAIN

O, the wonder of it all! The wonder of it all!
Just to think that God loves me.
O, the wonder of it all! The wonder of it all!
Just to think that God loves me.

We thank God for each of you. dearest ones. Thanks for traveling this journey with us and lifting us up to God the Physician. He grants the requests of His children. —Susie

FRIDAY

My energy level is improving, and the leg pain is much better. Yesterday's steroid injection is already helping, and I am so very thankful. I took only one pain pill this afternoon but that is a far cry from other days. Thanks for the prayers concerning the leg pain. Nothing like prayers and meds. Today was my last weekly blood work! Hurray, one more thing checked off my list of last things. It seems things are moving faster than they have in the past few months.

SUNDAY

I do it a lot. It hasn't just happened this year. I have always jumped the gun on lots of things and then I have to backtrack. I'm talking about the steroid injection. The actual injection didn't hurt and never has. Friday was a really good day and I didn't have to take pain meds. And because my leg didn't hurt, I did some errands. I didn't think I overdid, but I must have because Saturday was not as pain free as I would have liked!!!! RATS. Does this go back to not having enough patience? I guess I'll be working on that for the rest of my life.

But today, Sunday, we were able to worship with our community and that was wonderful. Lots of hugs and well-wishes.

> *O Love that will not let me go,*
> *I rest my weary soul in Thee;*
> *I give Thee back the life I owe,*
> *that in Thine oceans depths its flow may richer, fuller be.*

O Light that followest all my way,
I yield my flickering torch to Thee;
my heart restores its borrowed ray,
that in Thy sunshine's blaze its day may brighter, fairer be.

O Joy that seekest me through pain,
I cannot close my heart to Thee;
I trace the rainbow through the rain,
and feel the promise is not vain that morn shall tearless be.

"O LOVE THAT WILL NOT LET ME GO" – GEORGE MATHESON, 1882

There is something about being in a place
of corporate worship with family and friends
that is so encouraging and uplifting. —Susie

Since I am coming to that holy room,
Where, with Thy choir of saints forevermore,
I shall be made Thy music; as I come
I tune the instrument here at the door,
And what must I do then, think here before.

JOHN DONNE, FROM *HYMN TO GOD IN MY SICKNESS*, CA. 1630

MARK & SUSIE EDWARDS

I have been a part of a Bible Study group on Tuesday mornings at Belmont University for more than twenty years. Seven or so of us take turns bringing the breakfast and leading the discussion. It is a good gathering. While most of our two decades we've walked through a book of the Bible, of late we've taken to books of sermons. One of our favorite preachers and writers is Barbara Brown Taylor, whose collection of sermons, *The Bread of Angels*, we have just begun.

Today's installment was the title chapter in which she bases her sermon on God's provision of manna to His ancient chosen children wandering around in the wilderness those forty years. Consistent with her giftedness, she did all manner of good things with that text. Being a southern gal, she likened manna unto grits and explained that the word *manna* comes from the Hebrew *man-hu*, meaning, "What is it?" God reminded Moses, and she us today, that manna wouldn't keep so there's no need to hoard it, that if it is to serve its purpose of sustaining life, it has to be gathered and consumed on a daily basis.

Since March 1, Honey and I have experienced a bit of wilderness wandering ourselves. There have been some scary times, some times that we have neither known the road nor could even see the path. With the Apostle Paul, we still "see through the glass darkly." Oftentimes, deciding which turn to take or what call to make was a shot in the dark. By the grace of God, we hadn't been here before. I have put Honey to bed too many nights with her hurting to tears and there's not one thing to do to help. Sweet dreams! Yeah, right!

BUT

Since day two, there has remained a sense of peace, okay-ness, and even joy along our jagged journey that we certainly didn't expect and have had difficulty explaining. We knew it was there, but just didn't know what to call it ... until today. It's *manna*! Back to Barbara Brown—

"If you are willing to look at everything that comes to you as coming from God, then there will be no end to the manna in your life … because it is not *what it is* that counts but *who sent it.* The miracle is that God is always sending us something to eat. Day by day, God is made known to us in the simple things that sustain our lives." Whoa!

The prayers of friends, the constant support of family, a Meal Train, and a peace that passeth all understanding, etc., etc. *Man-hu*—"What is it?"—we ask. It's all manna. "'It is the bread that the Lord has given you to eat,' you will believe it. You will say, 'Thanks be to God,' and start trying to figure out how to eat the stuff."[4]

In no way are we proclaiming that our wandering is done, for we know not what all lies ahead for either or any of us; there may well be some serious bumps yet to come, but we know to look for and to celebrate God's daily manna. Thanks be to God.

> *Through it all, through it all,*
> > *I've learned to trust in Jesus, I've learned to trust in God;*
> > *Through it all, through it all,*
> > *I've learned to depend upon His Word.* [A-manna!]

> *"THROUGH IT ALL"* – ANDREA CROUCH © 1971, RENEWED 1999 MANNA MUSIC INC. /ASCAP (ADMIN. BY CLEARBOX RIGHTS). ALL RIGHTS RESERVED. USED BY PERMISSION.

Did you notice which music publisher holds the copyright to that little song? Wouldn't you know it: Manna Music Inc.
—Mark

WEDNESDAY

More manna: Last night Sam and the men's quartet came to rehearse at our house. They have done that before, and I can't tell you how wonderful it is to hear them practice—less than perfect (after all, it is a rehearsal) but so good. They are singing at our steeple Sunday and I'll miss that. I wish you could all go hear them. After they rehearsed the song for Sunday, we sang several other favorites from the hymnal. Having music in our home is so soothing, calming, encouraging, and worshipful.

> *He calms my hurts and dries my tears,*
>> *He gives me strength to face my fears,*
>> *He sends His grace through all my years,*
>> *He gives His song to me.*
>
> *My Savior, Jesus, I'll adore,*
>> *my weary soul He will restore,*
>> *I'll praise His name forevermore,*
>> *He'll give His song to me.*

REFRAIN
Jesus is the song of life,
> *Jesus is the song of joy,*
> *Jesus is the song of love;*
> *Jesus gives His song to me.*

"Jesus Is the Song" – Words and Music David Danner © 1979 Broadman Press (SESAC) (Admin. LifeWay Worship c/o Music Services). All rights reserved. Used by permission.

We have a beautiful song to sing. Don't miss the music all around you.

Yay, yay, booyay?

Yay #1: The doctors were able to do Mom's surgery laparoscopically. She is out, did well, is doing well, and will probably go home tomorrow.

Yay #2: Her oncologist was able to be there and get a good view of all the spots that needed checking up on.

Booyay?: There are a couple spots (smaller than a pinhead) that they biopsied and will know the results of mid-week next week, but the doctor is leaning towards a positive reading. Her oncologist said that they were so small that the CT scan wouldn't have even picked them up, so it was good he was in there to see what he needed to (hence the yay part of that). Not 100 percent sure what all that mean in terms of future treatments. Stay tuned for updates on that next week.

Guess it's my turn for a song. Can't remember if Honey and Papa (Mark) have done this one or not, but I've been whistling, singing, and humming it for the last week or two:

> *In the lightning flash across the sky*
> *His mighty power I see,*
> *and I know if He can reign on high,*
> *His light can shine on me.*

> *When the thunder shakes the mighty hills*
> *and trembles every tree,*
> *then I know a God so great and strong*
> *can surely harbor me.*

When refreshing showers cool the earth
 and sweep across the sea,
 then His rainbow shines within my heart,
 His nearness comforts me.

REFRAIN

I've seen it in the lightning,
 heard it in the thunder, and felt it in the rain;
 my Lord is near me all the time,
 my Lord is near me all the time.

We have had lots of lightning and thunder and rolling seas,
but we have also had more grace, goodness, mercy,
and God's faithfulness. We continue to rejoice in
His goodness to us and thank Him for it. —Susie

Sunday when we sang an expression of Gratitude you were in my thoughts. I truly thank God for you. He did a super job when He made you and He was especially generous to me when He gave me you. I couldn't ask for more.

Susie

"This is the day the Lord has made, and I will rejoice and be glad in it." How can I not rejoice in this day? The temps are cool, the sun is shining, and I am out of the hospital. God continues to bless in so many ways.

Have I mentioned that MY PLANS don't always turn out? MY PLANS were that this appendectomy was my last biggie and that all this cancer stuff would be behind us when 2014 rolled around. Well, it doesn't look like that will be the case. RATS! It seems that my oncologist found a few pinhead-size tumors still hanging on. So, that means another round (six infusions) of chemo is staring us in the face. But the second round won't be as harsh as the first, according to the oncologist. The first round was very manageable, and I am trusting that the second round will be more so. We can do this.

I know it is not Christmas yet, but here is a new hymn to me that can be a year-round hymn:

> *His name is called Emmanuel,*
> > *more wonderful than words can tell.*
> *God is with us! Alleluia!*
> *Born in our darkness, He is Light;*
> > *born in our weakness, He is Might.*
> *God is with us! Alleluia!*
>
> *Rejoice, and lay aside your fear.*
> *Rejoice, the Holy One is here.*
> *God is with us! Alleluia!*
> *Lift up your voices, come and sing.*
> *Come worship Christ, the newborn King.*
> *God is with us! Alleluia!*

And here's an older hymn text that also brings me comfort:

Guide Me, O Thou great Jehovah,
pilgrim through this barren land;
I am weak, but Thou art mighty;
hold me with Thy powerful hand;
Bread of heaven, Bread of heaven,
feed me till I want no more.

Open now the crystal fountain,
whence the healing stream doth flow;
let the fire and cloudy pillar
lead me all my journey through;
strong Deliverer, strong Deliverer,
be thou still my strength and shield.

When I tread the verge of Jordan,
bid my anxious fears subside:
bear me through the swelling current,
land me safe on Canaan's side;
songs of praises, songs of praises,
I will ever give to Thee.

GUIDE ME, O THOU GREAT JEHOVAH – WILLIAM WILLIAMS, 1745

Laying aside one's fear is easier said and sung than done,
but realizing "the Holy One is here"
and very near makes it possible. —Mark

TUESDAY

I liked it better when our family calendar had lots of days with nothing written on them. Not so these days. Growing old and having medical issues is not for sissies. Today has been better than yesterday, and tomorrow will be better than today. I say that almost every day because it is true and we are headed in the right direction. I am thankful to be able to report that. I am thankful to a mighty God who loves me and provides for me. I am thankful for our mighty herd of prayer warriors who encourage us and keep praying for my healing.

Someone mentioned this hymn the other day, and I love it. Thanks for reminding me of it.

> *And He will raise you up on eagle's wings,*
> *bear you on the breath of dawn,*
> *make you to shine like the sun*
> *and hold you in the palm of His hand.*

> *You who dwell in the shelter of the Lord,*
> *who abide in His shadow for life,*
> *say to the Lord, "My refuge,*
> *my Rock in whom I trust."*

> *The snare of the fowler will never capture you,*
> *and famine will bring you no fear:*
> *under His wings your refuge,*
> *His faithfulness your shield.*

> *You need not fear the terror of the night*
> *nor the arrow that flies by day;*
> *though thousands fall about you,*
> *near you it shall not come.*

And He will raise you up on eagle's wings,
 bear you on the breath of dawn,
 make you to shine like the sun
 and hold you in the palm of His hand.

PATIENCE PATIENCE PATIENCE PATIENCE PATIENCE

Maybe if I write it one hundred times, I'll have more of it! I really am thankful that the appendectomy was separate from the first surgery in March and that Dr. Wheelock (oncologist) was in the OR last Friday. He was able to find the very small tumors remaining, and in a few weeks we will meet with him and determine the next plan of action to get rid of those pesky things! Continuing with more chemo at this time is MUCH better than going six–eight months or more and then finding out I needed more chemo.

Dr. Wheelock mentioned that the next chemo medicine would not be as harsh and the side effects would be milder. I'm all for that. Hopefully that means I'll be out and about more, have more energy and strength, able to work a few hours per week and go to church more. How I have missed being with everyone. That's another prayer request, please.

We still receive cards daily, and I am thankful for the words of encouragement and prayers. —Susie

SATURDAY

I received this card today from a friend at Tennessee Baptist Convention. She sent it to me, but the words are for everyone:

> *Sometimes life just doesn't make any sense.*
> *Bad things happen to good people and we all wonder why.*
> *But even in those moments, some things remain true—*
> *God loves you …*
> *He has a plan for your life …*
> *You are loved …*
> *You are never alone …*
> *And even the darkest night must lead to dawn.*

I send this card to those of you who are hurting now.
God is mighty and He is good. His grace is sufficient.
I can testify to all of that. —Susie

SUNDAY

Church is where we find community, and today Kay and Roger sang a song about what the church should be. It was beautiful and expresses what I feel about the church. Every time I am able to attend, I find all the love, support, and encouragement that carry me through each day but especially my difficult ones. The hugs, smiles, and conversations are wonderful, and thanks to each of you who give me those things.

Here's a relatively new hymn included in the *Celebrating Grace Hymnal* (#569):

In Christ alone my hope is found;
 He is my light, my strength, my song.
This cornerstone, this solid ground,
 firm through the fiercest drought and storm.
What heights of love, what depths of peace
 when fears are stilled, when strivings cease.
My Comforter, my all in all,
 here in the love of Christ I stand.

In Christ alone who took on flesh,
 fullness of God in helpless babe.
This gift of love and righteousness,
 scorned by the ones He came to save,
 till on that cross, as Jesus died,
 the wrath of God was satisfied,
 for every sin on Him was laid;
 here in the death of Christ I live.

There in the ground His body lay,
 light of the world by darkness slain.
Then bursting forth in glorious day,
 up from the grave He rose again.
And as He stands in victory,
 sin's curse has lost its grip on me,
 for I am His and He is mine,
 bought with the precious blood of Christ.

No guilt in life, no fear in death,
 this is the power of Christ in me.
From life's first cry to final breath
 Jesus commands my destiny.

No power of hell, no scheme of man
can ever pluck me from His hand,
till He returns or calls me home,
here in the power of Christ I stand.

Mike,

I thank you for your wonderful CD. I have listened to it several times today and it has soothed my hurting body and restored my soul. It is so musical and worshipful and so you. Thanks for sharing your talent. I am thankful for your friendship through these years.

We pray 2014 will be a very good year for you.

Love, Susie

MONDAY

At home by 10 a.m. and I was ready for my pity party! I didn't invite anyone except God to this party, and that was good. He doesn't mind those events but other people don't have a good time. I just began telling Him all the things I'm tired of: feeling bad, leg hurting, no energy, feeling helpless, so much medication, blah, blah, blah, etc. After about two minutes, I was tired of listing all the stuff and just stopped. God didn't say anything, He just listened. And that was what I needed. I felt Him and He gave me grace and love. And I was OK and able to relax and calm down. I still have all that stuff and am still tired of it but I can manage it now. Can we call this manna?

On my mirror, the Scriptures I have are: "Let Him have all your worries and cares, for He is always thinking about you and watching everything that concerns you" (1 Peter 5:7), and "And now just as you trusted Christ to save you, trust Him, too, for each day's problems; live in vital union with Him" (Colossians 2:6). I guess that's what I did and He did. Thank you, Father.

I am thankful today for a God who allows me
to suffer but is there with me when I do. —Susie

꙰

𝓜𝓪𝓻𝓴

TUESDAY

Although officially retired, I still do a little work with Celebrating Grace; I just like it—and them—too much to lay it aside completely. Yesterday I was writing them a blurb about the nearly four-hundred-year-old hymn, "Now

Thank We All Our God." A bit of research revealed that Martin Rinkart, a German pastor, wrote those stanzas as a prayer for his children to learn and say. It wasn't even set to music until a dozen years later.

All of that is pretty cool, but even more amazing is that he penned those words about midpoint of the deadly, desperate Thirty Years War. Among other hardship, the killing, famine, and epidemic meant that many days he was presiding over literally dozens of funerals. How does one remain thankful with all that going on?

He wasn't the first at that. More than once, the Apostle Paul was imprisoned and beaten half to death; from his jail cell, through busted lip, eye swollen nearly shut, and clanking shackles and chains, he encouraged the early church to "rejoice in all things" and "again I say rejoice." Really?

Neither Honey nor I has been imprisoned or beaten, and our "war" is not but seven months old. Even so, we sense and celebrate the absolute mystery of "rejoicing in all things" and the inexplicable blessing of being able to give thanks during our hard times. And I'm telling you, so far there is healing therein. We can't speak for tomorrow, but the manna seems to be good and enough for today.

Stanza two of that old hymn says it well:

> *O may this bounteous God through all our life be near us,*
> *with ever joyful hearts and blessed peace to cheer us;*
> *and keep us in His grace, and guide us when perplexed,*
> *and free us from all ills in this world and the next.*
>
> *"Now Thank We All Our God"* – Martin Rinkart, 1636; trans. Catherine Winkworth, 1858

Honey has had a better day of less pain and a little more energy which she used up (and exceeded) this afternoon at her office for a couple of hours. At least she's in a better mood about it all. Good for her … and me. Thanks for looking in and lifting up.

WEDNESDAY

Thank you, dear herd, for adding Carole to your prayer list. She is the aunt of Weslee's husband, Chris. They have faith and know God is in control. She is another one we have added to our growing list of those we know and love with cancer. We know prayer is so powerful and helps us get through the days. That is part of God's manna that He provides.

"For I know the plans I have for you," declares the Lord, "plans to prosper you and not to harm you, plans to give you hope and a future. Then You will call upon me and come and pray to me, and I will listen to you. You will seek me and find me when you seek me with all your heart." (Jeremiah 29:11-13)

Those are such comforting words.
Thank you, Father, for listening to us. —Susie

SATURDAY

Monday is my follow-up visit with the surgeon. I anticipate he will release me. Tuesday and Wednesday I'll go to physical therapy, and also on Wednesday I have to go to Dr. Wheelock's office for a "port flush." Every six–eight weeks, I have to do that to keep the port open for the chemo infusions. Then we fly to Texas on Thursday and return the next Tuesday. Busy times, and I'll really have to be careful and patient and pace myself. I'm not real good at any of those things, but going to Texas is very important to me. I need and want to see Mark's dad and my cousins. And a change of scenery will be so good for me.

At the break of day, Lord, I seek Your face,
* there to hear Your voice, feel Your love's embrace.*
As You speak to me in this time apart,
* Lord, I praise Your holy name, I give You my heart.*

At the close of day I seek You once more,
* magnify Your name, worship and adore.*
Even in the darkness shines Your light so blest.
* Jesus, now I lay my spirit in Your arms to rest.*

I was able to go to church downtown and it was good/bad to be with everyone. Good because it is good therapy for me, being the social person I am, to be with people I love and get hugs and well-wishes. Bad because, being the social person I am, I don't know when to say my good-byes. I am so thankful for Mark who is so attentive and watchful and grabs my hand when he needs to take me home.

At some point I plan to be pain-free but it has not happened yet, and may not for several months. I am trying to manage the pain with Aleve or something like that and as I type this, it is working OK. I remember watching my mother take her handful of pills, and I have become her when I look at my handful of pills! I'd rather be my mother in other ways but for now, I'll be thankful for the meds.

I am so thankful for friends who have gone through cancer treatments and have words of wisdom and advise to give. Janet has been so helpful, and tonight we talked about the upcoming plane trip Mark and I will take this week and some things I need to be extra careful about. I never would have thought about wearing a mask or not rubbing my eyes. I hope I can be a been-there-done-that friend to help others who go through what I am now going through. Thanks, Janet.

> *Blest be the tie that binds our hearts in Christian love;*
> *the fellowship of kindred minds is like to that above.*
>
> *Before our Father's throne we pour our ardent prayers;*
> *Our fears, our hopes, our aims are one, our comforts and our cares.*
>
> *We share our mutual woes, our mutual burdens bear;*
> *and often for each other flows the sympathizing tear.*

When we asunder part, it gives us inward pain;
but we shall still be joined in heart, and hope to meet again.

"BLEST BE THE TIE" – JOHN FAWCETT, 1782

We send our love to each of you. dear ones.
God has indeed filled our cups to overflowing
with each of you. We are very thankful. —Susie

Dear Garret and Rick,

I think I saw you in Church this morning. Since Mark has played front basket turnover in choir, I have a hard time focusing far away! I hope before long I'll see you up close.

I hope you are doing well.

Love,

Susan

FRIDAY

Honey is in St. Luke's Baptist Hospital in San Antonio tonight for observation as a result of some GI bleeding. She will have a colonoscopy in the morning. We are okay, are receiving good care in the ICU (no room in the main "inn"), are weary of this, but confident that the Lord knows where we are and what's going on, and that a whole herd is doing what this whole herd does. Honey is in good spirits and doing what she does, connecting with the medical folks around here. In fact, today's nurse—Digna—just came by to say good-bye and turn us over to Neil (Filipino) for the night, who we like very much already.

SUNDAY

Rather than doing a colonoscopy in a hospital far away from home, and because she made significant improvement overnight, Honey was released from the hospital about 1:30 this afternoon and slept the rest of the afternoon. We are thankful for prayers lifted and concerns expressed during this little two-day curve in the road. We received wonderful care and our friend, Tina, gave us excellent counsel recommending St. Luke's Baptist Hospital.

MONDAY

We are home and glad to be. We loved being in Texas with our family. I needed to get away, and except for the hospital glitch, it was a very good time.

Talk about a melting pot of cultures! At St. Luke's Baptist Healthcare in San Antonio, my doctors were Nallipanini and Vaddumpudi from India; Dr. R (I never saw his name written, so I don't know how to spell it); my GI doctor from Pakistan; nurse Neil from the Philippines; nurse Sheryan from Jamaica; and nurses Rosa Lee, Drew, Johanna, Ryan, Jonathan, Digna, and Emy (Emilita) from different cultures in the States. They were all medical professionals and also ministers of the first order. All were very interesting people with wonderful stories to tell. We enjoyed getting to know these people and are so thankful for their care. I don't intend to make a habit of visiting every hospital I see, but it is interesting to meet so many different people.

In Christ there is no East or West,
 in Him no South or North;
 but one great fellowship of love
 throughout the whole wide earth.

In Him shall true hearts everywhere
 their high communion find;
 His service is the golden cord,
 close binding humankind.

Join hands, disciples of the faith,
 whate'er your race may be;
 who serves my Father as His child
 is surely kin to me.

In Christ now meet both East and West,
 in Him meet South and North:
 all Christ-like souls are one in Him,
 throughout the whole wide earth.

"In Christ There Is No East or West"– John Oxenham, 1908

Our worldview is expanding—
another positive aspect of
this journey called cancer. —Susie

Dr. Donna checked me out yesterday, and I still have some GI issues. She recommended some iron for the anemia. Dr. Wheelock raised his eyebrows when I told him about the Texas hospital visit. He agrees with Donna about a possible ulcer, and I'll need to get that looked at before anything else is done. We talked about the chemo drug we will use in the next round and possibly an additional one. Depending on what the upper GI test shows, we may or may not be able to incorporate the second drug. If I do have an ulcer, Dr. McMillan will treat it and will determine when I can start chemo again. Also, if I do have an ulcer, I can't take the second drug because it causes ulcers!!!!!!! I wish I could concentrate on getting rid of the cancer instead of finding all these other things that get in the way. RATS.

As I met with Donna and Dr. Wheelock and described what I have been feeling lately, I was encouraged that these things were normal. My total lack of energy and lethargy and oversensitive skin are all results of the chemo and surgery. The possible ulcer may also contribute to my other symptoms so they were not overly concerned. We will just have to wait on the results from the GI test.

Today Weslee's mother-in-law, Emily, sent a wonderful e-mail. Her sister, Carole, has cancer, and many of you have been praying for her. Emily had visited with Carole over the extended weekend, and Carole had been in the hospital several times over that period of time. While driving back to Georgia, Emily saw a beautiful portrayal of God's presence in the light and dark colors of the sky. The way she described it was so moving, and I could see the colors and image she was writing about. Thanks, Emily, for the beautiful encouragement you sent.

Here are some of the Scripture references Emily sent in her e-mail today:

"You are my lamp, O Lord;
the Lord turns my darkness into Light."

2 SAMUEL 22:29

"This is the message we have heard from him and declare to you:
God is light; in him there is no darkness at all."

1 JOHN 1:5

"For God who said, 'Let light shine out of darkness,'
made his light shine in our heart—
to give us the light of the knowledge
of the glory of God
in the face of Christ."

2 CORINTHIANS 4:16–18

Thank you all for the continued prayers, encouragement, and cards you send. It seems this journey will continue a while longer, but we continue to trust in God's wisdom and provisions.

Some days the dark clouds and gray skies seem
to overshadow everything. But we know God's light
overcomes everything else. Thank you, Father. —Susie

What's up with me and weekends and hospitals!!!!!! Instead of going to Birmingham today, I will go to St. Thomas Midtown this afternoon for a blood transfusion and overnight for observation. My red blood count was 25, and 35 to 45 is normal. They don't want to do the GI test with my blood that low. SOOOOOOOO, here I go again. In some ways I don't mind because I'll have more energy, will get the test done, will get on with the chemo. Maybe we will be able to go to Birmingham tomorrow when I get out. I'll try not to make plans!

Thanks for your continued prayers. I know they are working—not because I'm staying out of the hospital, but because I'm OK with where we are and what's going on! Manna for today.

Mark

When I left the hospital a bit ago, Honey had had one unit of blood and will have at least one more tonight. They said if, after the second installment, her numbers had come up sufficiently, she could come home in the middle of the night or wait until morning. She (and I) opted for the latter.

The sixth-floor staff is very accommodating, and Honey already calls each by name. Sharon, the day nurse, even helped me solve part of a crossword puzzle. The nurse station "traffic director" called Sharon while she was ministering to Honey, and before they hung up Sharon asked the person on the other end to "name a brand of laundry detergent with only three letters." "Era" was the immediate response. That sixth floor is full-service, I'm tellin' ya!

And then we had a very pleasant surprise visit from our longtime friend Susan. She happens to be in town for a conference at Belmont University, happened

to read today's earlier update, and came to see us. What a treat! We swapped stories and showed pictures of kids and grands. It was so good to catch up with her. We are disappointed that our Birmingham plans had to be put on hold, but grateful for the energy that the transfusion will deliver; she's been without it for too long. Thanks for continued prayer and provisions for us.

All we are needing, your and God's hands are providing.
Great is everyone's faithfulness, and we appreciate it. —Mark

The King of love my Shepherd is,
whose goodness faileth never;
I nothing lack if I am His
and He is mine forever.

And so through all the length of days,
Thy goodness faileth never:
good Shepherd, may I sing Thy praise
within Thy house forever.

"THE KING OF LOVE MY SHEPHERD IS" – HENRY W. BAKER, 1868

SUNDAY

I was under the impression that our trip to Birmingham was still on, so when Mark started unpacking his suitcase I said something to him about it. In his wisdom, he gently mentioned that he didn't think it would be a good idea, but if I wanted to go, we would. I pouted a little while but came to the same conclusion. RATS!

But another option was to meet Nathan's family at mile marker 351 (our must-stop place) and have dinner at Logan's. Good compromise. We left early and decided to take the back roads and see some beautiful country and slowly made our way to dinner. The day was just what I needed, and our visit, while not as comfortable as visiting at home, was a good one. Yes, those chubby cheeks on Ella are extremely kissable and I did lots of that. And, yes, Daniel is so sweet, and he even let me kiss on him, too. What more could a Honey want?

TUESDAY

Our friend Lyn said his choir in Fort Worth, Texas, sang an anthem several weeks ago and he sent us the words. They are wonderful and very much where we are in our journey. I hope you will appreciate the words as much as I did. They aren't only for our journey but for others living day by day:

> *God hath not promised skies always blue,*
> *flower-strewn pathways all our lives through;*
> *God hath not promised sun without rain,*
> *joy without sorrow, peace without pain.*

But God hath promised strength for the day,
rest for the labor, light for the way,
grace for the trials, help from above,
unfailing sympathy, undying love.

God hath not promised we shall not know
toil and temptation, trouble and woe;
He hath not told us we shall not bear
many a burden, many a care.

God hath not promised smooth roads and wide,
swift, easy travel, needing no guide;
never a mountain, rocky and steep,
never a river, turbid and deep.

But God hath promised strength for the day,
rest for the labor, light for the way,
grace for the trial, help from above,
unfailing sympathy, undying love.

"GOD HATH NOT PROMISED" – ANNIE JOHNSON FLINT

Thanks, Lyn, for these encouraging words.

We are thankful for both things promised and not promised.
How comforting it is to know He provides all our needs.
—Susie

THURSDAY

Well, yesterday was a very disappointing and frustrating day. I had the endo-scope procedure done, and the results showed no cause for the issues I have been experiencing. No ulcer, which is good and not so good. If I had an ulcer, that would give us a cause for the pain. No ulcer means something else must be going on. Not good news. Dr. McMillen, my gastroenterologist, called Dr. Wheelock, my oncologist, to discuss the next step. Dr. W. is out of the office until Monday (the way my luck has been going lately)! So we are back to waiting again. Stay tuned.

Needless to say I had a doozy of a pity party last night! It seems I just can't get a break and get a clear indication of what all is going on. Mark was invited to this party and he's so much help. He gets frustrated because he doesn't think he can do anything to help me. I disagree—he listens and hugs and hands me Kleenex. That's huge. We are getting pretty weary of this roller-coaster ride—I never have liked roller coasters anyway! Before we turned the lights out, we were both feeling better—no clearer answers but emotions cleansed from a good cry. Today has been better with more energy from the transfusion, and that is a welcome feeling.

We are going to Martin tomorrow to see Weslee and her family. That always helps me when I can get good hugs and smiles from the kids and grandkids. Last Saturday we met Nathan and his family for dinner. Family always pro-vides good medicine and renewed encouragement.

Things I am thankful for:

- A husband who loves me and stays by my side no matter what
- Doctors who try to find answers to my ever growing list of issues
- Family

- More meds
- A God who loves me even when I whine to Him about my frustrations
- A God who gives me grace and manna in abundance
- More energy
- Fall weather

"It Is Well with My Soul" is my song and prayer tonight.
Even through it all. I have no reason to complain.
I am so blessed and even in my weak moments (hours. days).
I know it and acknowledge it. —Susie

SUNDAY

I made it through the weekend fine. I'm tired but not too bad. I'll be in touch with my doctors this week to find out what's next and hopefully we can start something. I will also ask them about going back to work a few hours. I'd like to do that if I can. Today has been two months since my last chemo infusion. A lot has happened since then, but I'm ready to start the second round. Prayer request would be that the GI doctor and oncologist will put their heads together tomorrow and come up with a good plan to address my issues so the chemo can start again. Thank you, dear herd, for all you mean to us. You sustain us when we are down and discouraged. Your smiles, calls, cards, love are incredible, and we are thankful.

Where to begin? Some things have changed and other things have stayed the same. I had the liver biopsy last week, and as expected, there are spots on my liver. We didn't expect Dr. Wheelock to connect liver spots to my colon. What I don't know is what it all means. As far as I recall (and my recall is very iffy at best), no one has ever said, "You have liver cancer stemming from colon cancer." All of that might be true, but my brain does not think in medical terms. Next time I talk to a doctor, I'll ask them to explain this to me. I know I have spots or lesions on my liver and lots of pain in that area. Doc Donna has increased my pain patch dosage, and it will be sooooo good when that kicks in.

Next Thursday I'll see Dr. McMillan, gastroenterologist, and see what he finds. Then I'll get a call from another oncologist with Sarah Cannon Cancer Center to set up an appointment to see what happens next. Have I said I love Doc Donna? Well, we do and are so thankful for her and her expertise, and getting the ball rolling on my issues. God really knew that I/we need her in this whole process. We are more than ready to get this show on the road, and she is helping it get going as quickly as possible.

Besides Doc Donna, we also love Linda, our CVS pharmacist. We have known her for so many years, and she is so personable and helpful. She is also traveling this journey with us. She comes from a large Catholic family, and I was telling her our latest news yesterday. Her family has had lots of cancer, and she is helpful in praying and listening and helping me with dosage questions and other things. I was able to tell her how quickly God gives His grace, comfort, and presence when I tell Him my needs and that I need Him. After all this time, I think I'm beginning to be less surprised at that—that He relieves my pain and anxiety so readily. I am thankful.

Thank you, each one, for being Christ to us.
We are overwhelmingly blessed. —Susie

MONDAY

Dr. Donna called today with some results of the MRI and X-ray. My spine is the same as it was two months ago, and that is good news. There seem to be some dark areas on my right hip that the radiologist isn't sure of. I have a disc of the MRI that I will take to Dr. Wheelock tomorrow and let him look at it. Dr. Donna was going to talk to him today and they would try to come up with something. Maybe the chemo is causing some nerve damage or something. I have an appointment with Dr. Curt Hageneau next week. He is a neurologist, and he and his family used to be members of First Baptist Church. It will be good to see him again to renew acquaintances and also so he can find out the cause of my issues with my right leg. I don't like starting out the day taking two oxycodone!!! I'm taking so much medicine, I feel like I'm walking around in a fog all the time—I'm sure I act like it, too. One day I'll be my new normal self. It might be fun trying to figure out who/what that is.

Tomorrow is the first infusion of my second round. I'm anxious to get started again. This is a new medicine and I don't know the side effects. The schedule will be different, so maybe I'll complete the six infusions earlier than last time. I'm for that. My prayer request for tonight is that the infusion will go well and I'll not have any trouble tolerating the meds.

I'll have more to report tomorrow.

Thank you for holding our hands and walking with us on this journey. It is so much easier with you alongside with us.
We love you dearly. —Susie

Round two chemo has begun, and stanza one is in the books. Walking down the sidewalk toward the chemo clinic this morning, I asked Honey if she thought she would find a new friend this go-round. Her response was something of a positive nature. We arrived in the office early and there was a fiftyish woman ahead of Honey checking in at the desk. I found what appeared to be a comfortable seat in the waiting room until further instructions.

Talking to the person behind the desk, this woman seemed a little nervous about it all, but finished up and then joined her husband already seated behind me. Pretty soon Honey came and sat down. It was easy to overhear the couple's conversation, and it became more than obvious that Angie was a rookie to this routine. Well, that's all Honey needed. She turned around to them smiling broadly and reassuring calmly that things would be okay. The two of them talked a little more, and soon Angie, then shortly we, were ushered into the chemo room.

Entering the room, I took a phone call and Honey went to the port-accessing station. Finishing the phone conversation and getting ready to leave, I noticed that Honey and Angie had set up shop next to one another in a room full of recliners, mostly empty. Angie seemed more at ease and Honey seemed more at home. They spent the morning connecting, and I predict you'll hear more about that later. She beats all I've ever seen! The Bible speaks of bearing witness "as you go." Honey gets that!

Tonight I'm reminded of a stanza my dear friend and former colleague Jimmy Dunn used to quote on occasion:

> *For the love of God is broader than the measure of the mind;*
> *and the heart of the Eternal is most wonderfully kind.*
>
> *"THERE'S A WIDENESS IN GOD'S MERCY"* – FREDERICK W. FABER, 1854

Today is the first day in many that I didn't have to start off with oxycodone to get out of bed. I don't know if it had to do with the infusion or the steroids yesterday, but I don't really care. The fact remains that I was basically pain free all day. For that I thanked God several times.

Mark mentioned Angie, my new friend from yesterday. I also met Teresa, and today I met Anita. I didn't get to visit with Teresa yesterday except to introduce myself. Anita was there today for the Neulasta injection we get the day after an infusion. Anita is a veteran at the chemo stuff, and I enjoyed meeting her. Angie works part-time in a lab, and she also likes to research things on the Internet. Both of those are good and bad. She knows a lot from her work and also browsing the Internet. Sometimes too much information increases our anxiety level—and I think Angie might have info overload (her husband agreed with me today).

We all have some of that when we HAVE to experience new things, and she is right to have some apprehension. But once she has been through one infusion and knows what to expect next time, she'll be fine. I won't be with her next time since our schedules are different. I enjoyed her. As I was waiting at the elevator, there was another lady who had just been in the same room getting her Neulasta. I saw her yesterday but don't know her name. I told her it didn't take long to spend nine thousand dollars in that office (the cost of the injection), and she agreed but added she had to drive from Waverly to get it! Another thing I have learned to be thankful for—that I live close to the medical professionals I need!

About an hour into my infusion, Nathan sent me a picture of granddaughter Ella (age four months). She had the happiest smile on her face, and it brightened my whole day. Our children and grandchildren are so important to us on this journey. They are so supportive and encouraging at every turn.

Things I am thankful for: Mark and all he is and does, our children and grands, new friends, longtime friends, good food, good insurance, a painless day, wonderful medical facilities, beautiful flowers delivered today, cards received, a fantastic herd who is in our corner pulling for and with us, beautiful fall colors.

Here is a nice Advent hymn from the *Celebrating Grace Hymnal* (#80) and written by my brother-in-law, Randy Edwards. Advent is still a month away, but these are good words any time of year.

> *Hope, peace, joy, and love! These are the gifts You bring from above.*
> *Jesus, Emmanuel, come to be light of Your hope, reflected in me.*

> *Hope, peace, joy, and love! These are the gifts You bring from above.*
> *Jesus, Emmanuel, come to be light of Your peace, reflected in me.*

> *Hope, peace, joy, and love! These are the gifts You bring from above.*
> *Jesus, Emmanuel, come to be light of Your joy, reflected in me.*

> *Hope, peace, joy, and love! These are the gifts You bring from above.*
> *Jesus, Emmanuel, come to be light of Your love, reflected in me.*

"HOPE, PEACE, JOY AND LOVE" – WORDS AND MUSIC BY RANDY EDWARDS AND SHERRY UPSHAW FROM WITHIN THE SEASONS OF OUR LIVES © 1999 BIRNAMWOOD PUBLICATIONS (ASCAP), A DIVISION OF MORNINGSTAR MUSIC PUBLISHERS INC. ST. LOUIS, MO. ALL RIGHTS RESERVED. USED BY PERMISSION.

I pray I am a reflection of these.

Thank you, wonderful friends, for what you are to us.
This journey would be so much harder without you.
We are thankful we don't have to do this alone.
You are treasures God has given us. —Susie

FRIDAY

I have an appointment for a bone scan on Monday. The MRI showed some shadowy places on my right hip, so we'll get that checked out. The only day I don't have a doctor's appointment next week is Thursday. Does anyone know a doctor I'm NOT seeing that I can look in on!!!!!!

Things I am thankful for:

- A beautiful day
- Great medical facilities and professionals
- A safe neighborhood where children can come and trick or treat, and I can safely go to the door and give out candy
- The Meal Train starting again and for our wonderful helpers
- The ability to see the wonderful way God shows Himself in creation

> *My Savior is the Lord and King,*
> *He has control of everything,*
> *He loves me and He bids me sing,*
> *He gives His song to me.*

REFRAIN

> *Jesus is the song of life,*
> *Jesus is the song of joy,*
> *Jesus is the song of love;*
> *Jesus gives His song to me.*

> *He calms my hurts and dries my tears,*
> *He gives me strength to face my fears,*
> *He sends His grace through all my years,*
> *He gives His song to me.*

My Savior, Jesus, I'll adore,
my weary soul He will restore,
I'll praise His name forevermore,
He'll give His song to me.

Jesus is the song of life,
Jesus is the song of joy,
Jesus is the song of love;
Jesus gives His song to me.

SATURDAY

Not much energy today and just a general feeling of everything being uncomfortable. I was able to forgo oxycodone until about 4 this afternoon when all of a sudden things turned from uncomfortable to hurt. I am thankful the pain waited late in the day to begin. We again thank God for good meds to ease the hurts.

We plan to keep the Lord's Day tomorrow and worship at our steeple downtown. I have to choose where I spend my energy, and I always choose to spend it at our church. Few things help me more than being with "our people." You are near and dear and you lift my spirits. Thank you. I hope to see some of you close up for hugs and smiles.

"God is so good. God is so good. God is so good. He's so good to me." He is and I'm so very thankful. —Susie

The music today was absolutely tailor-made for my ears and my life this year. A wonderful friend, Valerie, sang "Blessings" by Laura Story. Not only is her voice a true gift from God, this song spoke to me like no song has in a long time. It talks about "trials are mercies in disguise" and "blessings come through raindrops." I can certainly testify to that. Valerie will send me all the words. I was totally awed. I'll never forget her beautiful voice singing this wonderfully appropriate song, and I felt like she was just singing it to and for me. Mark told her it was not fair for her to blow us both out of the water like she did. All three of us hugged and cried after church.

And then—the choir sang "An Expression of Gratitude," based on Philippians 1:3–6, 9–11, which has been a favorite of mine for years. Sometimes I lip-synch some of the anthems I know but not today. All I could do was just sit, listen, cry, and be so thankful. Today I truly worshiped.

Things I am thankful for:

- A wonderful friend with a gorgeous voice
- Music that speaks to and restores my soul; "when there are no words, there's music"
- Friends who are the embodiment of Christ
- A day of little pain and energy to go to church
- "Blessings thru the raindrops" and "trials that are mercies in disguise"

Thank you, Father, for my raindrops and trials.

Tomorrow begins a week of lots of doctors and tests. We pray for good results and solutions and for little anxiety for what is ahead.

YEA RATS

YEA: Dr. Donna called and said nothing shows up on my bone scan. NO BONE CANCER. Maybe that deserves more than one YEA! I don't really mind having all these tests done because they help us check off the absolute horrible things that could be happening. Tomorrow I see Dr. Curt and see what he says about some nerve issues.

RATS: My second infusion kicked me harder and sooner than last week. I have a week off, so maybe since it all came quickly, it will go away quickly.

Things I am thankful for:

- Good test results
- Wonderful medical professionals who are ministers in what they do
- A beautiful granddaughter to go with our four handsome grandsons
- Weslee and Nathan and their families
- Mark, who continues to sit in waiting rooms when I have procedures, and he doesn't complain—much!

And thankful for a God to never leaves our side and blesses us in all things. My vocabulary is so limited when I try to find words.

> *I love You, Lord, and I lift my voice*
> *to worship You, O my soul, rejoice!*

> *Take joy, my King, in what You hear:*
> *may it be a sweet, sweet sound in Your ear.*

We love you, dearest friends in the whole wide world.
Words fail me but feelings and emotions do not.
You are God-sent treasures. —Susie

We have eliminated several things that could have been major challenges, and for that we are thankful. The bone scan was clear and the visit with Dr. Curt (neurologist) was encouraging. He thinks that my pain is due to neuropathy caused by chemo and diabetes. If that is the case, maybe when the chemo is over, I might get back to the little bit of numbness from diabetes. That will be a real blessing.

Today I was able to go to work for a few hours. It really took its toll on me, and I was in the recliner most of the afternoon. Things kind of sneak up on me, and my energy is completely zapped before I know it. Mark is threatening to take me to work and pick me up to "help" me take better care of myself. It seems I'm a slow learner and I need someone with better control. I am so glad I have him to take care of me. I really want to be able to spend more time at the office. I have received some cards and notes of encouragement from readers of the *Baptist and Reflector*, and I have appreciated them so much. I think God intends us to have community with those that we have never met.

> *When upon life's billows you are tempest tossed,*
> *when you are discouraged thinking all is lost,*
> *count your many blessings, name them one by one,*
> *and it will surprise you what the Lord hath done.*
>
> *Are you ever burdened with a load of care?*
> *Does the cross seem heavy you are called to bear?*
> *Count your many blessings, every doubt will fly,*
> *and you will be singing as the days go by.*
>
> *When you look at others with their lands and gold,*
> *think that Christ has promised you His wealth untold;*
> *count your many blessings, money cannot buy*
> *your reward in heaven, nor your home on high.*

So, amid the conflict, whether great or small,
 do not be discouraged, God is over all;
 count your many blessings, angels will attend,
 help and comfort give you to your journey's end.

REFRAIN

Count your blessings, name them one by one;
 count your blessings, see what God hath done.

"COUNT YOUR BLESSINGS" – JOHNSON OATMAN JR.

There is no way I can count ALL my blessings but I do start naming them all the time:

- *Baptist and Reflector* Family - coworkers and subscribers
- Five healthy grandchildren
- The opportunity to visit with all of you through these posts
- Thoughtful surprises in the mailbox and at the door
- Connecting with neighbors more deeply

God has been/is overly generous with us in the blessing department. Thank you. Father. —Susie

MONDAY

This week is an off week for my chemo, but I have two doctor appointments in the morning. That will just about do me in for the day. Everyone is going to be here for Thanksgiving! If only I could, I would be jumping and doing a jig. Everyone is being so considerate of me and how I feel. I will cook some but we will bring in lots of things.

THURSDAY

Today has been a wonderful day. Mark's brother Randy is here, and we drove around Franklin, to Leiper's Fork and ate at Puckett's Grocery. And NO pain all day! Did I say it has been a wonderful day? I wasn't kidding.

In Leiper's Fork there is an art gallery in an old barn just as you go into town. We aren't usually art people, but someone said we just HAD to go in the barn. Well, we did, and it was amazing. The artist is David Arms. I had never heard of him but his stuff is fabulous. I intend to go on the Internet and find out more about him. His explanations about his art are as fascinating as his work. He is definitely a Christian.

The most captivating piece was *Be Still, My Soul*. I don't know if that was the name of it or not, but that was the hymn. Absolutely gorgeous. That is my song for tonight:

> *Be still, my soul: the Lord is on your side.*
> *Bear patiently the cross of grief or pain;*
> > *leave to your God to order and provide;*
> > *in every change God faithful will remain.*
> *Be still, my soul: your best, your heavenly friend*
> > *through thorny ways leads to a joyful end.*

Be still, my soul: your God will undertake
 to guide the future as in ages past.
Your hope, your confidence let nothing shake;
 all now mysterious shall be bright at last.
Be still, my soul: the waves and winds still know
 the Christ who ruled them while He dwelt below.

Be still, my soul: the hour is hastening on
 when we shall be forever with the Lord,
 when disappointment, grief, and fear are gone,
 sorrow forgot, love's purest joys restored.
Be still, my soul: when change and tears are past,
 all safe and blessed we shall meet at last.

"BE STILL, MY SOUL" – KATHARINA VON SCHLEGEL, 1752;
TRANS. JANE BORTHWICK, 1855

Beautiful painting, wonderful words, gracious Lord. —Susie

"[Be Still, My Soul] is one of my favorite hymns. I love and believe the
line 'thro thorny ways leads to a joyful end'. That is the hope in this life
that keeps us putting one foot in front of the other. It is because of this hope
that I can rest in His hands – though fragile and vulnerable – and be still,
looking to the day when we shall meet at last."

DAVID ARMS, ARTIST
Leiper's Fork, Tennessee
www.davidarms.com

WEDNESDAY

Yesterday was infusion day and today is Neulasta day. We are halfway through this second round and we rejoice in that. I saw my new friend, Angie, yesterday, and it was her second infusion. It was good to catch up with her.

I will say I'm more than a little weepy these days. There are lots of reasons for that, but the one that readily comes to mind is all the love and support given us. You are incredible people/family, and we are so overwhelmed and humbled. We love you all and thank God for you several times a day.

Last night I was really feeling like I had been poisoned for four hours and so I went to bed early without telling Mark. He was playing the piano and I didn't want him to stop. Last night for the first time I felt depressed. While my tears were flowing and I was praying for God to heal my body, soul, and spirit, Mark was randomly playing hymns. But then he played "Morning Has Broken." And it had. Just when I needed it, God gave me reassurance that all is going to be OK and He loves me and is close. And He and Mark healed my broken soul and spirit.

> *Morning has broken like the first morning,*
> *blackbird has spoken like the first bird.*
> *Praise for the singing! Praise for the morning!*
> *Praise for them springing fresh from the Word!*
>
> *Sweet the rain's new fall sunlit from heaven,*
> *like the first dewfall on the first grass.*
> *Praise for the sweetness of the wet garden,*
> *sprung in completeness where His feet pass.*

Mine is the sunlight! Mine is the morning
born of the one light Eden saw play!
Praise with elation, praise every morning,
God's recreation of the new day!

Thank you, Father, for answering my prayers, for soothing my body, for using my husband to send me Your message. You are the Almighty God and Healer. —Susie

SUNDAY

Energy is at a bare minimum these days, and this next week will be very busy. Everyone is coming to our house for a very special Thanksgiving. They are all special, but this one has much more meaning. Lots of tears will be flowing—most of them happy tears.

Lots of people have given me strict instructions about the activities this week. Our family will help, of course, but we also have the official Meal Train and the unofficial Meal Train. This is where lots of my tenderness comes from. Overwhelming, loved ones, generous to a fault. Tears are already flowing. Our cup overflows. Fourth infusion of six is Tuesday—a heck of a thing to do Thanksgiving week!!! BUT, that means I'll be two-thirds through with round two. How can I not add the infusion as something to be thankful for?

Good pre–Thanksgiving Day to each of you. We hope you all have special time with good food and good family. Some friends brought us a Thanksgiving Tree tonight—a simple branch from the yard and paper circles cut out for us to write on. All of us who can write will add circles to the tree this weekend. This will be a new annual tradition.

Infusion four went well yesterday. I think I have noticed that the beginning of a round of infusions is easier mentally than the end of the round. I am now two-thirds through with this round and they are harder. Not sure what makes it that way but, for me, it is what it is. Last week God used Mark and music to help me over the bump. Last night, He used Mark and humor to help me. Why am I still surprised at all the ways God shows Himself and blesses me? I am so thankful for each new insight.

The scheduled Meal Train arrived yesterday with wonderful soup, bread, and pumpkin roll. Thanks, Janis, for the great soup on a very cold night. The unofficial Meal Train arrived on Monday night with another excellent offering. Thanks, Rick and Janet. And today, Marianne and David brought most of our dinner for Thanksgiving. Our cup—and pantry and fridge—overflows. What generous people you are and how very thankful we are for your meals and for you.

Besides the Meal Train, we have a flower family. Without fail, the day after an infusion, gorgeous flowers arrive. They have been coming since my first infusion of my first round. They bring sunshine and love into our home, and the card always reads, "Encouraging Day Flowers!" And they are. Thanks, Sam and Barbara.

And there are the card senders. You are still keeping the U.S. Postal Service operational! I can't name every one of you, and I receive cards from people I have never met. The words and thoughts and Scriptures always seem to come at just the right time when I need them the most. Thank you.

Weslee and her family are here tonight. Chris has the turkey soaking in brine, Corri is bringing the dressing, and with things brought today, we lack for nothing. We know several families who have lost loved ones recently. For them this will be a hard time. Remember in prayer those who are sad and thank God for them.

A new song for me from *Celebrating Grace Hymnal* (#374):

> *I thank You, Lord, for each new day, for meadows white with dew,*
>> *for the sun's warm hand upon the earth, for skies of endless blue,*
>> *for fruit and flower, for lamb and leaf, for every bird that sings,*
>>> *with grateful heart I thank You, Lord, for all these simple things.*
>
> *I thank You, Lord, for wind and rain and for the silver moon,*
>> *for every daisy's lifted face, for every lovely tune,*
>> *for winter's white, for autumn's gold, for harvest and for home,*
>>> *with grateful heart I thank You, Lord, for each good gift I own.*
>
> *I thank You, Lord, for hand and heart to offer up Your praise.*
> *I thank You, Lord, for tongue to speak of all Your loving ways.*
> *For health and strength, for work and play, for loved ones far and near,*
>> *with grateful heart I thank You, Lord, for all that I hold dear.*

This is a very special Thanksgiving for us.
We have been on a rough journey this year,
but through it all God has been faithful providing
everything we need. We are thankful that He
has provided you, our herd, to minister to us
and be His hands on earth. —Susie

NOTES FROM Susie

SATURDAY

How can I keep from singing? Impossible. How can I keep from crying tears of great joy and thanksgiving? Also impossible. Our hearts overflow with all the blessings we receive from God and our herd. All of our family was here the last few days. We are bone tired but we had such a good time. The boy cousins had a great time getting reacquainted, and Sweet Cheeks Ella let her Honey kiss her lots. My family is so great. Each one had a job to do getting the Thanksgiving meal together, and they did a super job. I may not have much energy every holiday!!!!!

Things I am thankful for: my health—even though it is not the best, it could be worse; family; God's provisions for all our needs; God's grace to sustain us; a family who loves each other and God; all the lessons God is teaching me through this journey; that I can express my beliefs and convictions freely; a warm house; friends who are more like family.

> *For the joy of human love, brother, sister, parent, child,*
> > *friends on earth, and friends above, for all gentle thoughts and mild:*
> > *Lord of all, to Thee we raise this our hymn of grateful praise.*
>
> *For Thyself, best Gift Divine! To our world so freely given;*
> > *for that great, great love of Thine, peace on earth, and joy in heaven:*
> > *Lord of all, to Thee we raise this our hymn of grateful praise.*
>
> *"FOR THE BEAUTY OF THE EARTH"* – FOLLIOTT S. PIERPOINT, 1864, ALT.

TUESDAY

You are each precious gifts. Thank you for being God's hands and ministers to us. Every time I look into your face, I see the face of God. We are blessed beyond measure by your generous love and encouragements.

Now thank we all our God with heart and hands and voices,
 Who wondrous things hath done, in whom His world rejoices;
 Who, from our mother's arms, hath blest us on our way
 with countless gifts of love, and still is ours today.

O may this bounteous God through all our life be near us,
 with ever joyful hearts and blessed peace to cheer us;
 and keep us in His grace, and guide us when perplexed,
 and free us from all ills in this world and the next.

All praise and thanks to God the Father now be given,
 the Son, and Him who reigns with them in highest heaven,
 the one eternal God, Whom earth and heaven adore,
 for thus it was, is now, and shall be evermore.

"Now Thank We All Our God" – Martin Rinkart, 1636; trans. Catherine Winkworth, 1858

I am so glad we are not limited to only one day to give thanks to God. It just takes so long to list all the things He has done and continues to do for us. "I stand amazed in His presence." —Susie

Christmas at our church will be wonderful this year. The Hanging of the Green returns and is always a beautiful sight. Laurie does a fantastic job putting it all together. Then on the 15th is Keyboards at Christmas. We are so blessed to have so many talented musicians in our church, and we are thankful they are willing to share their gift with us. Carol-Candlelight on the 22nd is beautiful music and worship and another visual rendering of Christ coming to be light to this dark world. Come to First Baptist Church Nashville any or all of these Sunday nights and you'll receive a great blessing.

Things I am thankful for:

- A wonderful doctor
- Enough energy to do what is needed when it is needed
- A warm house
- Advent season when I can get beyond the busyness and see the real beauty of Christmas take shape at church
- Sharing time and meals with friends

> I want to walk as a child of the light;
> I want to follow Jesus.
> God set the stars to give light to the world;
> the star of my life is Jesus.

REFRAIN

> In Him there is no darkness at all;
> the night and the day are both alike.
> The Lamb is the light of the city of God:
> shine in my heart, Lord Jesus.

I want to see the brightness of God;
 I want to look at Jesus.
Clear Sun of righteousness, shine on my path,
 and show me the way to the Father.

I'm looking for the coming of Christ;
 I want to be with Jesus.
When we have run with patience the race,
 we shall know the joy of Jesus.

"I WANT TO WALK AS A CHILD OF THE LIGHT" – KATHLEEN THOMERSON
© 1970 CELEBRATION

Each of you is a child of the light. —Susie

Carri,

Daniel arrived safely yesterday. He is beautiful. We are so proud of you. We know you will be a great mother and love and take good care of Daniel. He is a miracle to be cherished. I know you will do that. We pray for you – wisdom in bringing up this gift from God.

We love you.

Nonny and Papa

NOTES FROM Susie

DECEMBER 8, 2013

Over the past months, Honey and I have been overwhelmed by everyone's generosity and attentiveness during her illness and treatment. The Meal Train has made endless stops at our house. Wow! What a blessing that has been … and remains! But besides the Train, we have been amazed at the range and creativity of our herd's gift-giving. Yesterday, our friend Gayle gave us most of her day to decorate our house for Christmas. I'm tellin' ya, that's a serious gift to Honey. Susie always loves our house to be "seasonally correct" and does a good job at it, but this year she hasn't had the energy and stamina to do it.

A month or so ago Gayle offered, and in the spirit of learning to be gracious receivers, we let her. That gal, Gayle, is good—she has a keen eye for beauty and the creative hands of an artist. With only one quick trip to the 100 Oaks' Michael's, she took what we had, "molded and made it after her will," and gave it exceptional new life. The tree and dining room table (two biggies for Honey) never looked better, and she made the neatest wreath for the front door complete with stockings for each of our four grandsons and this year's Baby Ella.

For our entire married life (forty-three+ years), Christmas has always been special to us. It may have had something to do with the programs and music that go along with being a music minister family. But this year, it seems even more special—we probably don't take as much for granted; it means even more for our kids and grands to gather here; and all year, we've been more aware of friends circled around us. Christ's coming into the lives of His people happens in many ways and right in the midst of life experiences. We're experiencing firsthand that, truly, His name is Emmanuel—God with us.

The First Baptist Church Nashville choir used to sing a piece at Christmas time that, though a simple song, was often hard to sing—and to conduct— because of the lump in our throats:

I shall know Him when He comes,
* not with sound of pipe or drum,*
* but by the holy harmony*
* which now His coming makes in me.*

He shall wear no royal robe,
* or a crown of precious gold;*
* but He, my Lord, my King shall be,*
* always, ever be there for me.*

He shall not in cattle warm
* live in splendor, safe from harm,*
* but in a manger cruel He'll sleep*
* warmed by the breath of cows and sheep.*

Come, Lord Jesus, tarry not;
* find in me a resting spot.*
My heart is open, come, dwell within;
* let love be born in me again.*

By the holy harmony which His coming makes in me
* I shall know Him;*
* I shall know Him;*
* I shall know Him when He comes.*

I'm not sure, but it seems like there's an extra measure of holy harmony at our house this season. And most assuredly, you are a big part of His advent unto us. So, welcome to our house ... and thanks so much for coming! —Mark

NOTES FROM Susie

Worship yesterday was special to us. Mark and I were invited to light the Advent Wreath Peace Candle during the morning service. It was an emotional, meaningful time for us. The Peace Candle was perfect for us, although any of the candles would have been meaningful to us this year. Except for the day of my cancer diagnosis, I have felt God's peace. I don't understand it and I don't question it. I just know it's there. I have felt lousy and hurt and been anxious sometimes, but the peace has been there and God has been so evident to me. I know Who's in control and it isn't me. I am thankful for that.

Last night was the Hanging of the Green at church. We haven't had that for several years, and I have missed it. I rested most of the afternoon so that I could attend that special event. I knew some of the music the Sanctuary Choir sang from my many years in the choir. Those pieces were special then and again last night. I think the one song that really spoke to me was "All Is Well." Two girls in the Young Musicians Choir sang a verse, and then the Sanctuary Choir joined them. Their voices were so sweet, and I wept. Again, God used their music to soothe my soul and spirit. And there is nothing like the emotion I feel when the garland bearers raise the greenery above their heads and place it over the rail of the balcony and secure it. The beauty and pageantry of decorating "our house" for the coming Christ is beyond words. Next Sunday night is Keyboards at Christmas. That is another fantastic time and I'll be in the balcony for that, too.

I mentioned having my soul soothed last night. Tomorrow is another infusion day, and I always get anxious beforehand. This is the next to the last one. December 17 is my last infusion and we are so thankful. This second round has gone faster than round one, but in some ways it has been harder. It doesn't matter. We have wonderful doctors and meds and chemo nurses, and we couldn't ask for any better care.

I don't know the words to "All Is Well" so I'll share another hymn I love. Originally a choir piece, its hymn version is in our new *Celebrating Grace Hymnal* (#136):

Where shepherds lately knelt, and kept the angel's word,
I come in half belief, a pilgrim strangely stirred;
but there is room and welcome there for me.

In that unlikely place I find Him as they said:
sweet newborn Babe, how frail! And in a manger bed:
a still small Voice to cry one day for me.

How should I not have known Isaiah would be there,
his prophecies fulfilled? With pounding heart I stare:
a Child, a Son, the Prince of Peace for me.

Can I, will I forget how Love was born and burned
its way into my heart unasked, unforced, unearned,
to die, to live, and not alone for me?

"WHERE SHEPHERDS LATELY KNELT" – TEXT BY JAROSLAV J. VAJDA © 1986
CONCORDIA PUBLISHING HOUSE, WWW.CPH.ORG. USED WITH PERMISSION.

Thank you, herd, for all the ways you are Christ's hands and feet to us. We wish for you Hope, Peace, Joy, and Love. —Susie

NOTES FROM Susie

DECEMBER 12, 2013

The last several days have not been my best, but we are hanging in there with the hope of better days ahead. When Mark reminded me that there is only one more infusion to go, I had to say that I can't celebrate yet because I'm trying to get over the one this last Tuesday. It's just a feeling of blah. Some of that is because of the infusion and some is because Christmas is my very favorite time of the year and I feel like I'm missing out on so much—baking, Christmas parties, shopping in malls, going to ALL the Advent events, and more. I know this is just how it is for now and most of the time that works, but right now.... .

Things I am thankful for: God who provides all my needs and understands when I'm down, ears so I can listen to wonderful Christmas music, eyes to see the beauty all around me, friends who bring dinners to us.

> *Love came down at Christmas,*
> > *Love all lovely, Love divine;*
> > *Love was born at Christmas;*
> > *star and angel gave the sign.*
>
> *Worship we the God-head,*
> > *Love incarnate, Love divine;*
> > *worship we our Jesus,*
> > *but wherewith for sacred sign?*
>
> *Love shall be our token;*
> > *love be yours and love be mine;*
> > *love to God and others,*
> > *love for plea and gift and sign.*
>
> "LOVE CAME DOWN AT CHRISTMAS" – CHRISTINA ROSSETTI, 1885

Experience the wonder and awe of Christmas —Susie

Mark gave me the biggest surprise of my life today! Yes, the cancer diagnosis was a big surprise on the negative end of the spectrum, but Mark's surprise was huge on the positive end of the spectrum. It's a good story.

We love Leiper's Fork. I think it brings out the "country" in Mark. On a day trip several weeks ago when Mark's brother was here, we headed to Leiper's Fork just to drive and walk around. It doesn't take much time to do either one. We went in the shops, ate at Puckett's, and ended up in David Arms' art gallery. Inside the door was a magnificent painting of *Be Still, My Soul*. I'm not really an art appreciator but this one piece took my breath away. Mark and I said a few words and looked around the gallery. But my eyes kept going back to the painting. I bought a box of notecards and we left. Several weeks later, my Texas brother came to visit and a friend drove us around, going to Leiper's Fork again.

We went in the shops, ate at Puckett's, and ended up at David's gallery. I took the chance that the man behind the counter might be the artist, introduced myself, and yes, he was David Arms. We talked a few minutes and got around to the *Be Still* painting. I told him it had been a rough year medically for me and that his painting had really stirred my soul. I bought two more boxes of notecards and two bookmarks with my eyes still wandering to the painting.

This week Mark said he wanted to go to Leiper's Fork to take a picture of something to send to his dad, and hoped I would feel good enough to go with him. After my weekly blood work this morning, we headed to the Fork. We ate at Puckett's (there's a pattern here) and we ended up in David's gallery. When I opened the door, I was so glad David was there and I could introduce Mark to him. They shook hands, and we talked a few minutes, and Mark wandered off. I joined him at the *Be Still* painting. And then I saw the sign: SOLD—to Mark for Honey. I looked at Mark, at the sign, back at Mark. I said a few words, we hugged, and I cried. Mark told me some of his

and David's conversations over the past weeks—we hugged and I cried more. Then he said, "David, I don't think she likes it!" I walked behind the counter and gave David a huge hug.

Those two men have been in cahoots for several weeks figuring out how to pull off this surprise. And pull it off, they did. I never thought it would hang in our home. Mark had told David more about our cancer journey this year and our ministry for a lot of years. David said he always likes knowing who buys his art and a story behind the purchase. He took a picture of us with the painting and we have one of David and me. Those are treasures, too—Creative Memories™ album, here it comes!

Not only do David's designs inspire and are beautiful, the words he writes for each piece are also meaningful. On the *Be Still, My Soul* painting he writes, "This is one of my favorite hymns. I love and believe the line 'thro' thorny ways leads to a joyful end.' That is our hope in this life that keeps us putting one foot in front of the other. It is because of this hope that I can rest in His hands—though fragile and vulnerable—and be still, looking to the day when 'we shall meet at last.'"

This painting is the story of us. It's not just a hymn of comfort during the last nine months but the essence of Mark's entire life and our life together in the music ministry. When Mark and Jean (his twin) were three and Judy (older sis) was five, they were singing harmony on hymns and making home recordings. Music has always been the basis of their home life and even continues now.

Things I am thankful for:
- Artists who use their trade to speak to individuals in a deeply spiritual manner
- Musicians who put words and music together to inspire, encourage, reassure, and comfort individuals going through difficult times
- A God who created all things and gifted individuals to be His voice on earth

Be still, my soul: the Lord is on your side.
Bear patiently the cross of grief or pain;
 leave to your God to order and provide;
 in every change God faithful will remain.
Be still, my soul: your best, your heavenly friend
 through thorny ways leads to a joyful end.

Be still, my soul: your God will undertake
 to guide the future as in ages past.
Your hope, your confidence let nothing shake;
 all now mysterious shall be bright at last.
Be still, my soul: the waves and winds still know
 the Christ who ruled them while He dwelt below.

Be still, my soul: the hour is hastening on
 when we shall be forever with the Lord,
 when disappointment, grief, and fear are gone,
 sorrow forgot, love's purest joys restored.
Be still, my soul: when change and tears are past,
 all safe and blessed we shall meet at last.

"BE STILL, MY SOUL" – KATHARINA VON SCHLEGEL, 1752;
TRANS. JANE BORTHWICK, 1855

Thank you, dear herd, for being God's voice and love
on earth to us. We love and appreciate you. —Susie

DECEMBER 16, 2013

During the worship service yesterday morning, the choir sang, "The Hands That First Held Mary's Child"—an anthem about Joseph—and our minister to children, Shannon, preached on "the ponderings of a mother." When I take the time to really think about Joseph and Mary, I am speechless. These were incredible people to trust God so much and not question Him or the angels that appeared to them. "Do not be afraid." Really????? Ordinary people, yet extraordinary. Thank you, Father, for their faith and obedience.

Today has been good with enough energy to go to the mall for the final touches of Christmas shopping. Monday shopping is so much easier than weekend stuff. Tomorrow is my final infusion. If you hear a huge shout about 11 a.m. or so, it will be me and Mark rejoicing over the fact that we did make it to the end. There were a few times we faltered but knew God was sufficient to give us the grace and strength to see it through. Yesterday at church there were so many of you giving me hugs and encouraging words for this week. Not only has God given us grace and strength, He has given us you to be His earthly voice and touch during this journey. How very thankful we are for our devoted herd to see us through to this end. We are blessed by you.

Scheduled and unscheduled Meal Trains have come and been so welcomed. And who knew how much hand cream a person goes through while taking chemo? Gifts of food and hand cream and visits are all appreciated.

Things I am thankful for:
- Eyes and ears to see and hear beautiful sights and sounds of the Christmas season
- More energy today
- Only one more treatment
- Loving, caring doctors and chemo nurses
- Family and friends who are by our sides all along this path

- A husband and marriage so strong and founded on undying love and commitment
- A God who sent hope, peace, joy, and love to all of us
- The wonder of Christmas in the faces of children

Here is a hymn based on the "Song of Mary" in response to the Angel Gabriel:

My soul proclaims with wonder the greatness of the Lord,
rejoicing in God's goodness my spirit is restored.
To me has God shown favor, to one the world thought frail,
and every age shall echo the angel's first "All hail!"

God's mercy shields the faithful and saves them from defeat,
with strength that turns to scatter the proud in their conceit.
The mighty have been vanquished, the lowly lifted up,
the hungry find abundance, the rich, an empty cup.

To Abraham's descendants, the Lord will steadfast prove,
for God has made with Israel a covenant of love.
Rejoicing in God's goodness my spirit is restored,
my soul proclaims with wonder the greatness of the Lord.

In the busyness of the season, let's take time to really think about the birth of the Christ child and others surrounding the event.

In Sunday school, my teacher asked us what character we would like to play in the Christmas pageant. I didn't answer out loud but I thought I'd like to be one of the animals. They were out of the way and could just sit back and take in the whole scene and ponder the happenings in their own way.

—Susie

We made it. We are finally finished with the infusions, so praising God is really the only appropriate response. I do feel like I've been poisoned again and the effects are showing up, but that is minor in the whole scheme of things. I have had a wide variety of feelings and emotions today. I have always had some anxiety the night before an infusion, and that was the same. Mark has been encouraging saying only one more and then you're through. All correct. However, I told him I had to get through this last one before I could start to even think about celebrating.

My way of dealing with this was just one thing at a time. Beginning with the diagnosis, I wouldn't/couldn't think any further down the road than the next treatment or procedure—diagnosis … oncologist appointment … surgery … port surgery … first chemo … etc. I could handle one thing at a time, but it would be harder if I concentrated on the big picture. There's that saying that goes, "How do you eat an elephant? One bite at a time." That's how I had to approach this. I can do anything one bite at a time. And we have.

Today I allowed myself to think about this journey over the last nine months and what some other results could have been. That did several things: it amazed me, scared me, and made me even more thankful, to name only a very few. Amazed me that we did more than just survive the treatments, we overcame them and came out better on the other side. Scared me because we really did go through some tough things. Going back to amazed, it is amazing what our God-created bodies can withstand. Taking each thing individually was easier to handle. While I was always thankful during each issue and thinking about each issue individually, when I bundled them all together and thought about what they all could have been and done, multiplied the whole thankful part many times.

Each of you has been so instrumental in helping us handle this journey. You were there to send cards, pray, call, visit, hug, pray, say words, pray, send flowers, pray, bring meals, pray, decorate. And each time you did this to the least of His children (us), you were doing it unto Him and being His presence on earth. And it did not go unnoticed. You helped us learn and grow and be better people. Thank you for each and every part you played in our healing and overcoming. We couldn't ask for a better herd.

This journey is not completely over. I'll have blood work done the next three weeks and oncologist appointments every three months with periodic CT scans. That's as far ahead as I know. We will get on with our lives and find the new normal for the future. Things will start looking up with more energy, strength, transitioning back to a work and church schedule. Sounds like a very good way to celebrate Christmas and to start 2014.

We will not dwell on the cancer of this year, but we will dwell on all the things we learned and how abundantly we were/are blessed. It will not rule our lives; only make us more aware of all that is around us and how we can make a difference in other people's lives. And count it all joy. —Susie

WHEW!!!!! We hope all of you have had a holiday full of family, food, friends, chaos, mess, photos, gifts, noise, love, joy, warmth, and good health. Our house was very quiet until about 1:30 Christmas Day when the EF-5 Hill tornado pulled into our driveway! Weslee brought the Meal Train and it was yummy. Then she disappeared into the basement to wrap presents. She says she likes to do that, so we let her. Then the EF-4 Edwards tornado pulled into our driveway about 5:30. It didn't take long for the four boy cousins to create a total mess of the downstairs area while they were having a great time. They don't get together very often, but when they do, the noise level rises and a million Lego pieces are spread out everywhere. Baby Ella stayed upstairs with the grownups, but next year she will be down with them.

2013 was a year we would like to forget. But we can't and in spite of so many challenging things, we were blessed overwhelmingly. We are planning on 2014 being a much better year and getting my health back. People have said it will take at least a year or more to get energy back, so I'll just have to practice patience a bit longer. Today was a bit of a struggle, but Mark makes sure I don't overdo and that I rest a lot. I plan to transition back into working a few hours a week at some point. And I plan to get back to being a greeter and to Sunday school at church. I miss that community. And I plan. . . . And I plan. . . . We'll see how that works out for me! I am learning that many of "my plans" have to be put on hold.

> *Speak, O Lord, as we come to You*
> * to receive the food of Your Holy Word.*
> *Take Your Truth, plant it deep in us;*
> * shape and fashion us in Your likeness;*
> * that the light of Christ might be seen today*
> * in our acts of love and our deeds of faith.*
> *Speak, O Lord, and fulfill in us*
> * all Your purposes for Your glory.*

Teach us, Lord, full obedience,
 holy reverence, true humility.
Test our thoughts and our attitudes
 in the radiance of Your purity.
Cause our faith to rise, cause our eyes to see
 Your majestic love and authority.
Words of power that can never fail;
 let their truth prevail over unbelief.

Speak, O Lord, and renew our minds;
 help us grasp the heights of Your plans for us.
Truths unchanged from the dawn of time
 that will echo down through eternity.
And by grace we'll stand on Your promises;
 and by faith we'll walk as You walk with us.
Speak, O Lord, till Your church is built,
 and the earth is filled with Your glory.

We hope you and yours have a wonderful 2014. As I said, we plan to do better next year. Thanks for traveling the bumpy road alongside us in 2013.

Even though 2013 was a challenging year, I am thankful for all the things I learned and continue to learn. I learned to be thankful for the little things: to make the most of every minute: to not take things for granted: don't put off the important things, like telling people you love them and pray for them: to be thankful for God's grace and mercy: to recognize the "blessings that come through raindrops." And so much more. —Susie

SATURDAY

Here is a sampling of things I have learned and/or been reminded of since March … in no particular order.

- None of us knows what lies ahead—even if we assume we do because we've done our best to plan well.
- Honey is one strong woman who handles all of life with unusual grace, poise, and maturity.
- Our adult children, their spouses, and their kiddos are the best. (I hope all grandparents feel the same way about theirs.)
- All that we need, God's hand does provide.
- It is much easier to give than to receive.
- Prayer works.
- My Lord knows the way through the wilderness, all I have to do is follow.
- Living and ministering in the same place over a long haul is a huge blessing.
- It is good to travel in a herd.
- Blest be the tie that binds our hearts in Christian love.
- Kindness and joy are both contagious.
- Every day is a gift and we should celebrate it.

Once again I want to say thanks for taking special interest in us and being the body of Christ unto us in so many good ways these thirty-six-plus years, but particularly the past nine months. I don't know that we could make it without you.

A very belated Happy New Year to each of you. My prayer for you is that 2014 will be filled with good health, quality time with family and friends, hope, peace, joy, and love. Today was church day, and we were glad to attend. There is no other community like church. It restores my soul, and I love being with our people.

Nine months ago the update started out as mainly a tool to keep anyone who was interested in my medical happenings up to date. This would keep us from having to repeat our news many times and ensure that accurate information was circulating. At one point early on, someone asked me about my kidney cancer! That was a new one. We were glad to set that person straight and also glad for the technology that was available.

These frequent updates are more than just an information tool—they are a way for me/us to thank everyone for their prayers, and a way to voice our struggles, triumphs, and to let people know that God is sufficient in all things.

Going through a journey like cancer has a way of solidifying one's beliefs and convictions. We never know what we are capable of withstanding until we have to withstand something. 2013 was a year of growth, learning, and discovery. I wish I could have learned these things without the cancer, but I am thankful that I learned them. In our family, naturally the hymnal would be the obvious book to turn to for comfort and support, and I have enjoyed learning new hymns as well as revisiting the oldies. What a great source of God's love, comfort, and abiding presence with us in every circumstance!

I am glad to report that my treatments are done and now we just have the maintenance phase. Periodic blood work, scans, and oncologist appointments every three months are on the horizon. So for now, we will suspend the regular updates. We will check in occasionally if there is anything new to report. I will miss these regular visits with you and reading your comments. Most of

you were "family" to us before 2013 hit, and we have enjoyed the reconnection with many of you; some of you are new "family" to us and we have enjoyed that, too.

Thank you for your prayers, which have been so encouraging and appreciated. We couldn't have gotten through this without them. Thank you for your comments about how the updates have encouraged you. We are glad to have done that for you. Please know that God has been with us all the way, and He has sustained us and held us in His arms. He is our provider, healer, sustainer, creator.

I can't sing this like the Westminster Boys' Choir, but sing this in your mind, as this is my prayer for you:

> *The Lord bless you and keep you;*
> *the Lord make His face to shine upon you,*
> *the Lord lift up the light of His countenance upon you,*
> *and give you peace, and give you peace. Amen.*
> NUMBERS 6:24-26

We are thankful, not necessarily for the journey, but for the herd He has provided to travel this journey with us. —Susie

Hello, friends. Goodness it seems like so long since we have connected. I have missed you. I don't miss reporting on my ups and downs and goods and bads during my infusion days. Thank the Lord, those days are behind us—the infusion days, not necessarily the ups and downs! My days are still roller coaster rides but not as bad as before. It is important that I get things done in the morning. My energy is much better but when it tanks, it's gone and so am I. It feels good not to have the scheduled weekly blood work and infusions.

Last night I was reading Max Lucado's *Grace Happens Here*. I think it is a combination of snippets from some of his other books on grace. I remember reading some of this in his other book *Grace*. Something I hadn't read before is, "God has enough grace to solve every dilemma you face, wipe every tear you cry, and answer every question you ask."[5] I've found that to be true.

Things I am thankful for today:

- A wonderful helpful medical doctor and pharmacist
- A loving husband who will do anything I need, but is thankful he doesn't have to do as much
- The best herd in the world loving us and still praying for us
- Hugs and smiles from friends
- Reconnection with Candace, one of my first techs in the hospital during my first surgery
- A loving Father who gives me abundant grace
- Long relationships that are more like family than friends

I have learned so much about grace and it never ceases
to amaze me how much grace God has to give and
how freely He gives it. I am thankful. —Susie

Hello, friends. We had a very good trip to Texas, and I was able to do all that I needed to, see most of the friends I wanted to see, and have the energy to go to the Houston Hymn Festival on Friday night that Mark led. I said I made the trip okay but about 8:00 p.m. after we got home, I hit the wall big-time! I went to bed after taking all my great meds and stayed there for twelve hours. I have told some friends not to be too frustrated when their energy doesn't pick up as soon as they want it to. Perhaps I ought to practice what I preach.

Things I am thankful for:

- A warm, dry house during these cold days
- Meds that help me through the painful times I still have
- The energy I do have
- A good trip to Texas with no surprise medical issues
- Great insurance
- Family and friends who continue to love us and pray for us
- A God that loves me and continues to provide all my needs and blesses me along the way

A song that was sung at the Hymn Festival was "In Deepest Night":

> *In deepest night, in darkest days,*
> *when harps are hung, no songs we raise,*
> *when silence must suffice as praise,*
> *yet sounding in us quietly*
> *there is the song of God.*

When friend was lost, when love deceived,
dear Jesus wept, God was bereaved:
so with us in our grief God grieves,
and round about us mournfully
there are the tears of God.

When through the waters winds our path,
around us pain, around us death:
deep calls to deep, a saving breath,
and found beside us faithfully
there is the love of God.

A beautiful song. and so calming and reassuring
to those of us who have dark days—
and I think that includes most of us at times. —Susie

What a difference a year makes. And what a year we have had!! My cancer diagnosis came a year ago today. We are marking that day as the day we had to figure out our "new normal." We celebrate today not just survival but a life abundant. We have had a roller-coaster ride with plenty of ups and downs, painful days and pain-free days, blessings galore, love and support from family and friends, delicious meals from very generous people, God's mercy and grace at every turn, lessons learned and celebrated, new friends in the medical profession and other patients, and so much more.

Mark and I were asked to speak at the 3M (senior adult) lunch at church two weeks ago. Some of you were not there and so I'll give you a quick recap! There were many things I learned, so many blessings, and things I am thankful for:

- Over a nine-month period I had lots of procedures and hospital stays, and during that time I learned that our bodies can endure a lot. I remembered the Scripture, "I will give thanks to Thee, for I am fearfully and wonderfully made." I learned that prayer works—I mean REALLY works. My head knew it but now my heart also. You really can feel God's presence.

- On lots of bad days, I would pray for God to ease the pain and restore my soul. And He did. It was almost a tangible feeling of God wrapping His blanket of love around me. That was new to me. I learned that it is harder to receive than to give. First Baptist Church Nashville is full of very generous people who lovingly provided meals, visits, prayers, cards, and so much more.

- I have a brother who has been estranged from the family for over fifteen years. He called me after my surgery in March—a huge blessing. Songs and hymns have been so comforting. In church my friend Valerie sang a song that said, "What if your blessings come through raindrops?" and "What if trials of this life are Your mercies in disguise?" We have certainly found this to be true.

- I always knew Mark was wonderful, but he has surprised me in so many ways. He says he hasn't minded sitting in waiting rooms with me, and I sort of believe him! Waiting around hasn't always been one of his strong suits! We have watched family members and church members be caregivers to their spouses, and we have learned some things from them. Thanks to all of you for being wonderful role models. There is nothing like a "herd" traveling the journey with us to get us through the days. You are God's hands and feet on this earth, and your ministry is invaluable. The medical profession is full of people who are not just doctors, nurses, and techs—they consider their work a ministry and they do it well. I am thankful for them and the powerful medicines available to ease the body pains.

These are just a few of my thoughts. I still have recovering to do, and it is still taking much longer than I want. One thing I haven't learned is to be patient! That continues to be a prayer request.

There are so many hymns running through my feeble mind tonight, but I'll choose this one. Thank you, Johnson Oatman Jr., whoever you were:

> *When upon life's billows you are tempest tossed,*
> *when you are discouraged thinking all is lost,*
> *count your many blessings, name them one by one,*
> *and it will surprise you what the Lord hath done.*
>
> *Are you ever burdened with a load of care?*
> *Does the cross seem heavy you are called to bear?*
> *Count your many blessings, every doubt will fly,*
> *and you will be singing as the days go by.*
>
> *When you look at others with their lands and gold,*
> *think that Christ has promised you His wealth untold;*
> *count your many blessings, money cannot buy*
> *your reward in heaven, nor your home on high.*

So, amid the conflict, whether great or small,
 do not be discouraged, God is over all;
 count your many blessings, angels will attend,
 help and comfort give you to your journey's end.

REFRAIN

Count your blessings, name them one by one;
 count your blessings, see what God hath done.

"Count Your Blessings" – Johnson Oatman Jr.

We will be better givers because we have received. —Susie

Sweet Daniel,
 I miss seeing you
but we are coming
in a few weeks. I am
excited about that.
Pretend you are getting
a hug from me now and
every day until we get
there.
 I love you,
 Honey

> *Praise God, from whom all blessings flow;.*
> *praise Him, all creatures here below;*
> *praise Him, above ye heavenly host;*
> *praise Father, Son, and Holy Ghost.*

"PRAISE GOD, FROM WHOM ALL BLESSINGS FLOW" – THOMAS KEN, 1674

And blessings have been flowing all week. We started out last Sunday in Birmingham with the dedication of our Sweet Ella. It was a special time for their family, all the grandparents, and two nieces. Nathan and Corri are doing family the right way and teaching Daniel and Ella the importance of God and church and family. We are very proud of them and love those grands.

Tuesday I had my three-month checkup with the oncologist. I had lots of questions, but the most pressing was, "Do I have cancer?" "Did I have cancer?" or "Am I in remission?" The explanation is that I have recurring ovarian cancer because I had to have two rounds of chemo. We did blood work to check blood counts and CA125 and a CT scan will be scheduled. But at this point, I am in remission!!!! YEA YEA and Double YEA. We didn't kick up our heels, but you could hear our sighs of relief all down the block. Did I mention blessings this week?

Wednesday, I saw Dr. Donna, had a thyroid scan and bone density scan. We are trying to get rid of some of my meds, and that's good news. No news on the bone density, but Donna left a message about something on the thyroid. There's nothing we need to do now, but when she returns from spring break we'll talk next week. More blessings. I was able to work a few hours Thursday and Friday at the office and that was good. Not ready for full-time but it was good to be with my coworkers. More blessings.

On Thursday, our friend Keith Christopher brought us lunch and a surprise. Keith is a songwriter, composer, and church musician, and he wrote a choir

anthem with a dedication line to Mark and me. What a wonderful gift. The title is "Refuge" based on Psalm 46:1–2 and Isaiah 43:2–3, and the name of the publishing company is Hope—how appropriate!

I am your refuge, I am your strength.
I am your helper in time of trouble;
> *so do not fear, no, do not fear for I am your God.*

And when you pass through the waters, I will be with you.
And when you cross o'er the river, I will be your guide.
And when you walk through the fire, you'll not be burned,
> *for I am your God.*

You are my refuge, You are my strength.
You are my helper in time of trouble;
> *I will not fear, I will not fear, for You are my God.*
You are my God.

"Refuge" – Words based on Psalm 46 and Isaiah 43; music Keith Christopher © 2014 Hope Publishing Company, Carol Stream, IL 60188. All rights reserved. Used by permission.

Sounds to me like Refuge AND Hope!

He played a recording of it, and we were speechless. The Scriptures are familiar, and his music was so soothing, calming, restoring, and strengthening. Keith knows something about waters and fires, and his music conveys so much about our gracious and loving God. This spoke to us like the *Be Still, My Soul* painting. Thank you, dear friend.

We will always remember how super-blessed we are to have friends and family like you. Our journey was made so much easier with each of you holding our hands and traveling this path with us. We've not reached the end of the journey, but it is getting closer.

There are so many things we are thankful for. I can't begin to mention all of them. I am thankful for a God who loves me and provides my every need, for His grace to me in all things. And I am thankful for our "family" and that

means each of you. You have ministered to us so generously this past year. Thank you for being God on earth. We are humbled and appreciative.

I don't want to repeat last year, but I never want to forget all our blessings and lessons and growth in faith that our journey brought. —Susie

NOTES FROM *Susie*

In my last update, I mentioned several blessings of that week. After I went to bed I started reviewing the things I had done that day—things I did and wished I hadn't, and things I didn't do and wished I had. Does anyone else do that? Anyway, as I thought about the update I remembered two other blessings that happened that week that I failed to mention. So this is an addendum to that update, and I'll add some other thoughts.

Corri is our daughter-in-law. When we prayed for Nathan to find a wife to love him, take care of him, and work alongside him to establish a loving Christian family, we did not know her name. Well, Corri is her name. She is as beautiful inside as she is outside. Corri's father is a minister of music, and she is well acquainted with staff positions in church and the ups and downs of that ministry. She is a part-time preschool minister, and Nathan directs the youth choir at the church.

Their Sundays are extremely hectic with those positions and two children to look after. She is as considerate of me and my health as Nathan is, and hesitates to ask me to look after Daniel and Ella while she runs an errand. I appreciate their concern and love. Corri is a true blessing. Nathan wouldn't be the easiest person to live with—he might have some of his father's quirks!!! We are so proud of him and all that he stands for. God blessed us the day both he and Weslee were born, and He continues to bless us with our children and their families.

And there is Chris, our son-in-law. When we came home from Birmingham, he walked in our door not long after. He teaches English at college. He is not teaching classes this semester so he can do research and write. He came to use the library at Vanderbilt. He is so easy to have. When he gets hungry, he knows where all the snacks are. When he gets thirsty, he knows where to find his Coke Zero. He has "his" chair in our den. His body may be in the room with us, but he usually has his iPad, computer, cell phone, books, journals,

pens, and crossword puzzles close at hand. He may be looking at something or reading something, but he is aware of what's going on around him and will join in the conversation when he needs/wants to. He doesn't need to be entertained and is content to be left alone or included.

Weslee and Chris are polar opposites in most every way—Weslee is energized by people, they make Chris tired! Weslee hates to read, Chris reads all the time and books that are hundreds of pages long. Weslee doesn't enjoy cooking, Chris really enjoys it. They are opposites but they bring out the hidden qualities in each other. Another perfect match.

We are blessed by Corri and Chris not only because of whom each of them is as a person but also by how they relate to us. The role of in-law is sometimes a difficult one for all involved. However, Corri and Chris blend in well with everyone, and both are comfortable coming to spend time with us without their spouse and children. We enjoy spending time with Weslee and Nathan alone and even enjoy spending time with Chris and Corri alone. It is a treat whenever any of our children come, and with the busy schedules they all keep, we make the most of our time together.

Today I had my first CT scan since my last chemo in December. I'll hear from Dr. Wheelock soon about the blood work from last week and scan this week. Then I'll hear from Dr. Donna next week when she returns from spring break about my thyroid scan and bone density scan. I keep reminding myself of two things: I'm not thirty anymore, and growing old is not for sissies!

Spring is coming but first we'll have a few more cool days. But when it does get here, we will be so thankful that we won't be able to stop thanking God for His goodness and beauty. —Susie

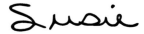

I can't remember what I said in my last update. I think I mentioned the spots on my thyroid. I have an appointment with a new endocrinologist in May. Dr. Donna says we don't have to worry about that now. That is good news. Not so good news is that my CT scan done last Thursday shows spots on my liver that were not there in September. Bummer. Dr. Wheelock is puzzled by that since my CA-125 [a blood test to detect ovarian cancer] is very good. Anyway, tomorrow morning I'm having a needle biopsy done. Dr. Donna says it's not a big deal, and I have certainly had worse done over last year! Amen to that. We are trusting that all will be okay, and if it isn't, God will continue to provide and take care and see us through.

Last Sunday in church we sang and spoke a lot about grace. Oh, what a wonderful word and gift. We have experienced so much of that gift in the last thirteen months. We sang two songs that are fabulous and so promising. I'll only share parts of one and all of the other.

> *Grace alone which God supplies,*
> *strength unknown He will provide.*
> *Christ in us, our Cornerstone;*
> *we will go forth in grace alone.*

"GRACE ALONE" – WORDS BY JEFF NELSON AND SCOTT WESLEY BROWN © 1998 UNIVERSAL MUSIC – BRENTWOOD BENSON PUBL. (ASCAP) (ADM. AT CapitolCMGPublishing.com). ALL RIGHTS RESERVED. USED BY PERMISSION.

And then "Wonderful Grace of Jesus." I bet you can't help but sing parts on this one!!

> *Wonderful grace of Jesus, greater than all my sin;*
> *how shall my tongue describe it, where shall its praise begin?*
> *Taking away my burden, setting my spirit free,*
> *for the wonderful grace of Jesus reaches me.*

Wonderful grace of Jesus, reaching to all the lost,
by it I have been pardoned, saved to the utter most;
chains have been torn asunder, giving me liberty,
for the wonderful grace of Jesus reaches me.

Wonderful grace of Jesus, reaching the most defiled;
by its transforming power ransoming God's dear child,
purchasing peace and heaven for all eternity—
and the wonderful grace of Jesus reaches me.

REFRAIN
Wonderful the matchless grace of Jesus,
deeper than the mighty rolling sea;
higher than the mountain, sparkling like a fountain,
all sufficient grace for even me;
broader than the scope of my transgressions,
greater far than all my sin and shame.
O magnify the precious name of Jesus, praise His name!
"WONDERFUL GRACE OF JESUS" – HALDOR LILLENAS, 1918

Thank you, pray-ers, for keeping us in your prayers these long months. Please continue along this part of the journey. I'll keep you up to date on my latest issues as they arise. It's kind of frustrating because it seems just when things are looking up, something else pops up. I don't understand it, but I don't have to. I know we are trusting God for this part of our journey just like we trusted Him with the last part.

<div align="center">

All I have needed, my Lord hath provided.
Can't help but be thankful. —Susie

</div>

NOTES FROM Susie

FRIDAY

Here we go again. Honey's oncologist called after dinner tonight with results of Monday's liver biopsy. They did find cancer but it is not from the ovaries. The most likely source is the colon. He was unable to reach the doctor who did Honey's colonoscopy (2005) and her endoscopy last October. They will connect Monday so we can get on with treatment. This is not the best news, but there is at least some relief in having a better idea what we are dealing with.

As you would expect, Honey is not thrilled about this; but, as you would also suspect, her spirit is good and she has a peaceful resolve to beat it. So once again, you are cordially invited to journey with us, for you are the absolute best traveling companions we know.

Tonight, we are leaning into this nearly two-century-old stanza by Henry Alford and this recent refrain scripted by my friend Lloyd Larson:

> *We walk by faith and not by sight.*
> *No gracious words we hear*
> > *from Him who spoke as none e'er spoke;*
> > *but we believe Him near.*
> *We walk by faith and not by sight,*
> > *led by God's pure and holy Light!*
> *Prepare us for the journey, Lord,*
> > *and may we know Your power and might,*
> > *as we walk by faith and not by sight.*

"*We Walk by Faith*" – words by Henry Alford and Lloyd Larson; music and refrain © 1998 Beckenhorst Press Inc. All rights reserved. Used by permission.

Onward!

MONDAY

Bright and early Saturday morning after we got the oncologist's not-so-good news Friday night, Doc Donna called with calm, caring words of love and encouragement, assuring Honey that she would get right on her new situation and get things moving. And sure enough, shortly after 8 this morning, the gastroenterologist's office called to set up a procedure Thursday morning next week. We were hoping the procedure would be sooner, but Honey needs to be off some of her other medications at least seven days. In the meantime, Donna prescribed a pain patch to more effectively ease the almost constant pain Honey has. Hopefully, that will kick into high gear in a day or two.

The herd, near and far, is gathering and encircling us with love, concern, and prayer. Last week at a "union meeting" in Dallas, two people I didn't even know looked me up saying that they have been praying for us and wanted an update. What a blessing! Thank you.

Tonight in the deacons' meeting, our friend Tom Hellams shared a devotional thought from Philippians 4:

> *Rejoice in the Lord always; again I will say, rejoice!*
> *Let your forbearing spirit be known unto all. The Lord is near.*
> *Proceed no further in worry, but in all things by prayer and petition*
> *with thanksgiving, let your requests be made known to God.*
> *And the peace of God, which passes all understanding,*
> *will guard your hearts and your minds in Christ Jesus.*

It sounds like music in my ear.

When we choose joy. we realize. more keenly. that the Lord is near. And when we make our requests known to God with genuinely thankful hearts. He gives us peace which we cannot fully understand. but only experienced and celebrated. —Mark

Where to begin? Some things have changed and other things have stayed the same. I had the liver biopsy last week, and as expected, there are spots on my liver. We didn't expect Dr. Wheelock to connect liver spots to my colon. I know I have the spots. What I don't know is what it all means. As far as I recall (and my recall is very iffy at best), no one has ever said, "You have liver cancer stemming from colon cancer." All of that might be true, but my brain does not think in medical terms. Next time I talk to a doctor, I'll ask them to explain this to me. I know I have spots or lesions on my liver and lots of pain in that area. Doc Donna has increased my pain patch dosage, and it will be sooooo good when that kicks in. Until then, I still take the oxycodone to try to take the edge off.

Next Thursday I'll see Dr. McMillan, gastroenterologist, and see what he finds. Then I'll get a call from another oncologist with Sarah Cannon Cancer Center to set up an appointment to see what happens next. Have I said I love Doc Donna? Well, we do and are so thankful for her and her expertise, and getting the ball rolling on my issues. God really knew that I/we need her in this whole process. We are more than ready to get this show on the road, and she is helping it get going as quickly as possible.

Besides Doc Donna, we also love Linda, our CVS pharmacist. We have known her for so many years, and she is so personable and helpful. She is also traveling this journey with us. She comes from a large Catholic family, and I was telling her our latest news yesterday. Her family has had lots of cancer, and she is helpful in praying and listening and helping me with dosage questions and other things. I was able to tell her how quickly God gives His grace, comfort, and presence when I tell Him my needs and that I need Him. After all this time, I think I'm beginning to be less surprised at that—that He relieves my pain and anxiety so readily. I am thankful.

And thank you, each one, for being Christ to us.
We are overwhelmingly blessed. —Susie

Well, today finally got here. I wasn't sure it would, and I had quite a meltdown on Tuesday. But that didn't last long and we are good.

We met with new oncologist Dr. Penley today, and he said I was a mess. We could have told him that a long time ago!! He confirmed what we suspected and was upfront and honest with us. I do have colon and liver cancer. Some hard news to hear, but we will take things as they come. He had not gotten all my records from the other oncologist, so he didn't have a definite plan of action yet. I will have a PET scan Monday and another appointment with Dr. Penley on Tuesday. Because the liver cancer is not contained in one area, surgery is not an option. I will have more chemo and when he gets the other report, he'll determine what my chemo "cocktail" will be.

Things I am thankful for:

- Living in a country that has excellent healthcare facilities
- Christian doctors
- Good insurance
- Powerful drugs for powerful and ugly health issues
- Family and friends who pray
- A God who continues to bless us and provides all our needs

As you may recall, last year a friend of ours named Keith wrote an anthem and dedicated it to us. It is a wonderful piece in every way and says exactly how I feel, not only after today's news, but every day. The title is "Refuge." I wish you could hear a choir sing it. It always leaves me speechless:

> *I am your refuge, I am your strength.*
> *I am your helper in time of trouble;*
> *so do not fear, no, do not fear for I am your God.*

And when you pass through the waters, I will be with you.

And when you cross o'er the river, I will be your guide.

And when you walk through the fire, you'll not be burned,
 for I am your God.

You are my refuge, You are my strength.

You are my helper in time of trouble;
 I will not fear, I will not fear, for You are my God.

You are my God.

Thank you, dear herd, for your prayers, love, and support. We thought and hoped my cancer journey was over but it doesn't seem so. We covet your continued prayers. We send our love to each of you. —Susie

MARK & SUSIE EDWARDS

APRIL 29, 2014

Mark

Honey had a PET scan yesterday and a follow-up visit with Dr. Penley this afternoon. We are dealing with fairly advanced colon cancer that is not curable and surgery is not an option. She will begin yet another round of chemo first thing tomorrow (Wednesday) morning. They will infuse her a couple of hours, then send her home with a chemo pump she will wear forty-six hours, then return to the office Friday for removal.

This will be the routine every other week and will likely continue for four months or so, depending on how she tolerates the drugs. The goal is to extend life and improve quality of life—the very same reason any of us ever go to any doctor for any reason. We don't look forward to more chemo, but under the circumstances, this is as good as it can be and she is beyond ready to get on with it.

All the waiting around we've done for the past couple of months has been difficult, especially when Honey has had so much constant pain. But it seems as though we've finally figured out the level and quantity of meds she can manage to get some relief—a grace we can certainly celebrate.

Honey was understandably very quiet all morning. (I dealt with my anxiety by mowing a couple of yards.) We had lunch on the deck and talked about our situation some. It was finally time for our appointment, and we had a good, lengthy, informative visit with the doc. He's great and speaks honestly about hard subjects, but with gentleness and great care. We were instructed to stop by the lab on our way out for Honey to contribute a vial or two of her blood.

I took a seat in the lab waiting area and immediately heard Honey beginning to do "her thing"—getting to know and visit with the other med staff in the office. I'm tellin' ya, that woman's countenance had lifted, and she was all smiles and enjoying making new friends while they stuck her and made arrangements for the days ahead and at hand. Amazing, indeed ... and good!

Shortly after we got home Cheryl, our next-door neighbor, rang the doorbell with dinner in hand—wow! And there were notes and cards in the mailbox and messages on our phones.

Here's a stanza we can all sing; it is true of all:

> Through many dangers, toils, and snares,
> [we] have already come;
> 'tis grace hath brought [us] safe thus far,
> and grace will lead [us] home.

"AMAZING GRACE" – JOHN NEWTON, 1779

Thanks for caring for us, for going the distance with us, and for signing up for another lap or two. —Mark

Dear Ones,

* I thank God for hope and promise and I hope you do too. I don't have answers but I have lots of love coming your way. I have my arms wrapped around you tight.*

* I love you back,*
* Mom*

WEDNESDAY

Last night Honey slept well. This morning she got right up pre-6 a.m., showered, and ate a healthy dose of my famed scrambled eggs. She was pretty anxious in the chemo waiting room, although she wasn't exactly sure why. The chemo nurse came and got us about 8. Our patient picked out a recliner in full view of all the action at the busy nurses' station.

Debbie, the nurse we had yesterday and again this morning, is very nice, and soon the three of us carried on a lighthearted conversation, so Honey seemed to settle in comfortably. The infusion lasted a little more than three hours, and we got home a little after noon. Apparently, the side effects of these drugs are quick-acting; she was feeling bad before we got home and has been in the manger or on the bed since.

A few weeks ago, I agreed to lead choir rehearsal tonight at our church, so her longtime family friend Myrte came and sat with her for a couple hours while I was at choir. They enjoyed catching up some and tending to their separate business some. It is SO nice to have friends with whom one feels comfortable being quiet in the presence of.

Our friend Janis, who managed the Meal Train for us last year, cranked it up again last night and a dozen people have already climbed aboard. Wow, what a blessing! (Incidentally, Janis, herself, is having radiation treatments twice every day this week for recently discovered breast cancer. Fortunately, this series of treatments is all that required. Good for her, indeed!) That's where we are, taking it one day at a time.

> *A wonderful Savior is Jesus, my Lord,*
> *a wonderful Savior to me;*
> *He hideth my soul in the cleft of the rock,*
> *where rivers of pleasure I see.*

He hideth my soul in the cleft of the rock
that shadows a dry, thirsty land;
He hideth my life in the depths of His love,
and covers me there with His hand.

"He Hideth My Soul" – Fanny J. Crosby, 1890

Mark

THURSDAY

For everyone who was worried about Honey last night—including me—we seem to be okay this morning. It's not unusual for me to "travel" during the night. Lately, I've started out in the bed but usually end up in the den on the sofa or in my manger. But Honey crashes in the bed and, lately, stays there sometimes until 8 or 9 o'clock in the morning. She was sick, sick at bedtime last night I'm tellin' ya! I awoke—still in the bed—about 4:30 for my typical bathroom visit and noticed that Honey had escaped. Found her in her manger, and so as not to awaken her, quietly slipped into my quillow on the sofa. About an hour later as the sun was threatening to come up she began retracting her electric chair to get up. I led off our brief conversation:

> Hi, buddy; how'd ya do last night?
>
> *Okay.*
>
> How are you feeling?
>
> *Much better.*
>
> Oh, praise God!
>
> *I thought I wanted to go see Him last night*
> *… and kick Him in the shin!*

I hooted! Sounded just like Granny (my mother who endured several of her last years of near bed-ridden existence) to me.

With that, she got up and headed off back to the bedroom at her near normal non-chemo tempo. She's still there and I suspect will be a good bit of the morning.

My hope is built on nothing less
than Jesus' blood and righteousness;
I dare not trust the sweetest frame,
but wholly lean on Jesus' name.

When darkness seems to hide His face,
I rest on His unchanging grace;
in every high and stormy gale,
my anchor holds within the veil.

REFRAIN
On Christ, the solid Rock, I stand;
all other ground is sinking sand,
all other ground is sinking sand.

"THE SOLID ROCK" – EDWARD MOTE, 1834

Don't know what the day will hold, but it already looks brighter and wanted you to know and celebrate with us. Thanks for helping us. —Mark

This is Day Six of what our friend Julie just today termed "Big Girl Chemo." Honey's two rounds last year were hard, but mild compared to what she's barely endured since last Wednesday. It has been severe and almost constant. On a scale of 0 to 10 her intake of food and liquids is a little north of 1, but that's quite an improvement. Most of the time she's on the bed, although she was able to get a shower and is now watching some television in the den. She's very weary of this. We'll have a talk with the oncologist before she agrees to another treatment like this first one.

Still, there is so much to be thankful for, and God's manna still shows up when we least expect it. Case in point—we love where we live. Our "hood" and house are less than twenty years old, it is quiet, and we have wonderful neighbors. We are less than a mile from nearly any kind of food, pharmacy, or service that we need on a daily basis. Today, Honey decided a Sonic cherry-limeade would taste good and gave me strict instructions what she had in mind. Got it! So I pulled up to the red Sonic button, and I began telling the order-taker how we want it:

"I want a small cherry-limeade with a lot of ice and a little of the cherry-limeade. This is for a cancer patient who loves Sonic ice but needs a little flavor in it."

"That's one small cherry-limeade with a little flavoring in the bottom."

"That's it."

"That's a dollar thirty. I'll have it right out."

Not more than a minute later a gal comes bouncing out their door and smiling to my window. "Here's your small cherry-limeade with a little flavoring, and I brought you an extra cup of ice."

"Aren't you the nicest person!" as I collected the cups and extended my two one-dollar bills toward her.

"Ah, don't worry about that!" and bounced away, still smiling.

One wouldn't think a dollar and thirty-cent fountain drink could wipe out "such a worm as I," but it certainly did. I wept all the way home, and a little bitty tear lets me down just telling you about it. Sonic Brentwood and corporate are going to hear from me.

Then Julie, who has undergone her own chemo recently, shows up at our door unexpectedly with a big bag of goodies for Honey. She and I visited a few minutes inside our door, and in conversation about Honey's lack of appetite I report that Honey thinks some pretzels would taste good; so Julie goes to the store and brings back another bag—pretzels and other salty stuff that Honey might like. Later Betty called saying that husband Randy is delivering Meal Train en route to his meeting in Franklin.

I walked into the bedroom this afternoon where Honey was resting and listening to a CD of my brother Randy singing:

> *The Great Physician now is near,*
> > *the sympathizing Jesus;*
> > *He speaks the drooping heart to cheer,*
> > *oh! hear the voice of Jesus.*
>
> *Sweetest note in seraph song,*
> > *sweetest name on mortal tongue;*
> > *sweetest carol ever sung,*
> > *Jesus, blessed Jesus.*
>
> "THE GREAT PHYSICIAN" – WILLIAM HUNTER, 1859

That IS a sweet carol … and more good manna for today.

This stretch of road is pretty steep so far, but you, our herd, are helping. You are dear to us, and we appreciate your every thought and prayer on our behalf. —Mark

Susie Mast

With the exception of a few intermittent happy moments, today has been yucky—thank you very much! How's that for a positive attitude and grateful heart? But if we don't report and "fess up" about the downside, you may be tempted to dismiss our upside tales. Besides, there's no need to sugarcoat the awfulness of the disease Honey is enduring and I am tending. As our friend Janet says, "It's definitely not for sissies!" Honey is far from being a sissy, but it is still wiping her out most of every day of late. And at this point, we don't really know if the culprit is the cancer or the chemo to control it.

Yes, we are angry, though not at God—although Honey did say early in the week that she wanted to kick the Almighty in the shin. I wouldn't be at all surprised if God joins us in our anger. Cancer, suffering, and a host of other bad things in the world were not at all what He had in mind for His creation. I, for one, plan to talk that over with Him one of these days. But more than anger, God is One of love Who goes with us....we believe.

Yesterday, Honey insisted that I go to Birmingham to attend Nathan's youth choir home concert. Of course she wanted to go, but just wasn't up to it. However, she did get to attend via FaceTime, which was just wonderful. The choir did great, and we are proud of the work Nathan has done for the past three semesters holding that group together and conducting them like a bloomin' pro. The choir even sang "Be Still, My Soul" for Honey. How special was that! Even though I drove back last night, our friend Myrte came and spent the afternoon with Honey and then spent the night. We certainly appreciate and enjoy her.

This being Mother's Day weekend, all our gang planned to be here. This morning we called that off because Honey felt so bad and she didn't want the grandkids to be here when she couldn't smile convincingly, fun around with them, and most importantly not be able to "make the Target run." But Weslee

and Nathan are coming by themselves, and, as Weslee says, "leave the noise at home." Nathan's Corri and Wes' Chris are great kids-in-law, and we love them dearly and appreciate their keeping the home fires burning.

I'd like to share one of my favorite new hymns in the *Celebrating Grace Hymnal* (#54). It seems to speak meaningfully to our family this Mother's Day weekend:

> *Like a mother with her children You will comfort us each day,*
> > *giving guidance on our journey as we seek to find our way.*
> *When we walk through fiery trials, You will help us take a stand;*
> > *when we pass through troubled waters, You hold out Your tender hand.*
>
> *In Your image You have made us, calling each of us by name,*
> > *giving strength for every challenge as our gifts we fully claim.*
> *We can hear you gently saying, "Do not worry, do not fear;*
> > *for I'll always go beside you; every moment I am near."*

Thanks be to God: His comfort and guidance unto all! —Susie

MAY 11, 2014

Susie Mark

I have crawled up out of the depths to at least start this update. As Mark has related, this has not been a fun almost two weeks. Four to five minutes into the first infusion on April 30, I knew we were not in Kansas anymore! I did walk into the room fine but had trouble walking out. Then home and to bed where I stayed until Friday morning for the trek to have the pump disconnected. Barely walked in with assistance and to a bed. Pump gone, hooked to fluids, two hours later to the hospital for transfusion, more fluids, sedative, anti-nausea drugs, and what we thought would be an overnight stay. WRONG—more fluids, more sedative and anti-nausea stuff. Home on Sunday to bed to stay. Call to doc on Wednesday with stomach and gut issues to no avail. A trip to doc's office on Friday afternoon for more fluids and nausea drugs. I felt better mostly because I knew Weslee and Nathan were headed our way.

(Tag—I'm it. Honey sat in this desk chair as long as she could, so now I'm up to bat.)

We had a great Mom's Day weekend. Weslee and Nathan are good at being adult children. They are very different from one another—they do family, work, church, and many other things in different ways. They couldn't live under the same roof—theirs nor ours—and each would drive the other crazy; but they love one another and when they get together, a LARGE time is had by everyone in their hearing. I hope many of you feel the same way about your offspring.

Honey is scheduled for a second infusion Tuesday and doctor visit immediately before. The doc will have to either change the drugs or reduce the dosage employed last time. Honey will not knowingly agree to a second stanza of the song we sang two weeks ago. There are supposedly many drug options for this type of cancer, and we're going to give them a full opportunity to use some of them.

The phone rang mid-afternoon today and it was Honey's very first chemo friend, Nettie, calling just to check on her. They haven't talked in several weeks and Nettie was concerned; she assured me of her prayer support for Honey. Sweet, sweet lady, that Nettie! Then Sarah Lou called about the time Cheryl from next door showed up with fresh-baked cupcakes. Wow, they are good! Then Amy checked signals for Meal Train tomorrow night. So, yeah, we're being seen after by a herd of the best people in the world. We so appreciate everyone's help and continuous offers to do anything for us they can. This is a hard road and a steep climb, but you make it easier even if you feel otherwise.

Mowing the yard Friday—not one of Honey's better days—this old gospel song from childhood came to mind:

> Trials dark on every hand, and we cannot understand
>> all the ways that God would lead us to that bless-ed promised land;
>> but He'll guide us with His eye, and we'll follow till we die,
>> we will understand it better by and by. [GOOD!]

[Everybody sing the chorus now!]

> By and by, when the morning comes,
>> when the saints of God are gathered home,
>> we will tell the story how we've overcome;
>> we will understand it better by and by.
>
> *"WHEN THE MORNING COMES"* – CHARLES A. TINDLEY

I didn't know or even think much about any of that as a child; boy, I do now!

"This is the day the Lord has made:
we will rejoice and be glad in it."
It is and we have. —Mark

In the Nashville area there is a television commercial where a blind man is singing, "It's a good day today, it's a good day today, it's a good day I say." He goes on to sing about the sun shining and birds singing and ends with a big smile and laugh. Well, yesterday and today I have been singing with him.

We went to our scheduled appointment yesterday not knowing what would happen. We knew that we couldn't have a repeat of the first treatment two weeks ago. My body would not be able to tolerate another poisoning like that one. Because of the dehydration, anemia, weight loss, and other things, Dr. Penley decided to postpone the treatment a week and next Tuesday try again with a half dosage. If I tolerate that better, he'll work up to 75 percent. We will take this one step at a time and continue to pray for positive results. He did report that some numbers pertaining to my liver were better, so that is good news. I am using this week to rest and regain some strength so that next week will go well.

My appetite is picking up, and that's good news. Have we mentioned what good cooks we have at our church? Over the last few months I have been watching the Food Network channel. I will put our ladies and gentlemen up against any of those on TV. Monday Amy was the Meal Train and brought halibut stew. We had never heard of it but it is delicious. Today, Mary brought dinner that was not only tasty but colorful as well. Susan came by yesterday with fresh-from-the-field strawberries. Oh my!! I'll not have any trouble gaining the weight back with food like this. Thank you, treasured cooks.

> *In deepest night, in darkest days,*
> *when harps are hung, no songs we raise,*
> *when silence must suffice as praise,*
> *yet sounding in us quietly*
> *there is the song of God.*

When friend was lost, when love deceived,
dear Jesus wept, God was bereaved:
so with us in our grief God grieves,
and round about us mournfully
there are the tears of God.

When through the waters winds our path,
around us pain, around us death:
deep calls to deep, a saving breath,
and found beside us faithfully
there is the love of God.

Things I am thankful for: a reprieve from a treatment this
week; Dr. Penley; Harlan, Stephanie, Dale, Lauren, Bobbie,
Becky, and others at the hospital and Tennessee Oncology who
help me; "heart" friends; good cooks; my excellent caregiver,
Mark, who is always ready, willing, and able to help me with
anything; the ability to laugh and have a good time even in
the midst of hard days; a loving Father who is always with me
providing everything that I need; love, prayers, and support
from so many people, some of whom we have never met.

—Susie

Susie

SUNDAY

This morning at church, the First Baptist Church 2014 graduating seniors sang "Wings of the Dawn," a perennial youth choir favorite at our church for more than twenty years. They did a fabulous job! It is so encouraging to all of us because no matter where we are, God is there. How comforting is that? That choir piece is based on Psalm 139:

> *You have searched me, Lord,*
>> *and you know me.*
> *You know when I sit and when I rise;*
>> *You perceive my thoughts from afar.*
> *You discern my going out and my lying down;*
>> *You are familiar with all my ways.*
> *Before a word is on my tongue*
>> *You, Lord, know it completely.*
> *You hem me in behind and before,*
>> *and you lay your hand upon me.*
> *Such knowledge is too wonderful for me,*
>> *too lofty for me to attain.*
> *Where can I go from your Spirit?*
>> *Where can I flee from your presence?*
> *If I go up to the heavens, you are there;*
>> *if I make my bed in the depths, you are there.*
> *If I rise on the wings of the dawn,*
>> *if I settle on the far side of the sea,*
> *Even there your hand will guide me,*
>> *Your right hand will hold me fast.*
> *If I say, "Surely the darkness will hide me*
>> *and the light become night around me,"*
>> *even the darkness will not be dark to you;*
>> *the night will shine like the day,*

for darkness is as light to you.
For you created my inmost being;
 You knit me together in my mother's womb.
I praise you because I am fearfully and wonderfully made;
 Your works are wonderful,
 I know that full well.

MONDAY

Our Heavenly Father heard every prayer on my behalf from each of you for today's treatment, and He granted your requests. I am beginning to feel the poison given me, but things are so much better today than three weeks ago. Thank you each one for your petitions for both me and Mark. We appreciate them.

The treatments take about four hours and then I go home with a pump that delivers continual doses of chemo for forty-six hours. I return on Thursday morning to have the pump disconnected, and I'm free until June 3 at 9:15 a.m. when the next infusion is scheduled. I think this will be routine for three to four months. Dr. Penley will increase the dosage back up when he sees how well I tolerate the chemo.

All of our prayers for Janis were answered with her cancer battle. I learned that Dr. Penley was going to be her new oncologist, and when we met with Dr. Penley, I mentioned Janis had an appointment with him today. He had not met her yet, but she came in at 1:30. I was able to visit with Janis before I left and she went in. She likes him, and he'll be a good doctor for her. Everyone wins.

A new *Celebrating Grace* hymn (#293) from Sunday:

O for a faith, a living faith, the faith that Christ imparts;
belief not locked in ancient creed, but flamed within the heart.

O for a vision of a world where truth and justice reign;
where each is seen as Christ Himself, respect, with love remain.

O for a hope, hope for today, that peace on earth will come,
and all earth's children share, as one, this planet as our home.

O for a fellowship of love, the love that welcomes all;
that helps the burdened with their load,
and lifts them when they fall.

In gratitude for this, our church, a growing faith we claim.
We here resolve, for years to come, to serve in Jesus' name.

O for a faith, a living faith, the faith that Christ imparts;
belief not locked in ancient creed, but flamed within the heart.

Things I am thankful for: a better infusion day, Dr. Penley, answered prayers from our herd, chemo drugs that heal, wonderful cooks in our church who provide for us, a loving God Who loves us and blesses us in so many ways, songs that restore my soul and bring me peace. —Susie

THURSDAY

Experiences like Honey and I are presently navigating bring into sharp, close focus many things that ordinarily we would be too busy to remember. Here are three remembered and celebrated anew today:

1. Every moment of life is an absolute gift that deserves to be relished.

2. Honey and I served three churches in forty-three years of marriage, and all three have been fabulous congregations who loved, nurtured, cut us slack, and took good care of us … and still are.

3. We are being prayed for far and wide.

Okay, a golden oldie tonight:

When upon life's billows you are tempest tossed,
when you are discouraged thinking all is lost,
count your many blessings, name them one by one,
and it will surprise you what the Lord hath done.

Are you ever burdened with a load of care?
Does the cross seem heavy you are called to bear?
Count your many blessings, every doubt will fly,
and you will be singing as the days go by.

When you look at others with their lands and gold,
think that Christ has promised you His wealth untold;
count your many blessings, money cannot buy
your reward in heaven, nor your home on high.

So, amid the conflict, whether great or small,
do not be discouraged, God is over all;
count your many blessings, angels will attend,
help and comfort give you to your journey's end.

REFRAIN

[Sing it and mean it!]

Count your blessings, name them one by one;
count your blessings, see what God hath done.

"COUNT YOUR BLESSINGS" – JOHNSON OATMAN JR.

MONDAY

Sunday was a Holy day for several reasons. First is that God made the day. Second, we were able to go downtown to witness the baptism of our friend Steve. It was a holy moment when he pronounced loudly and confidently, "Jesus is my Lord and Savior." What a great day for him and his family. His in-laws were able to come from Georgia to witness this wonderful day in Steve's life. Wife Sally and her parents and others have been marvelous role models and prayer warriors to bring this day to pass. Holy, indeed.

In the words of my father-in-law, I have been "no count" most of these days. It doesn't take long before I completely give out and can't do much except spend time on the bed or in the manger.

The other day on Facebook someone shared this quote from Renee Swope, "Sometimes life takes us places we never expected to go. And in those places God writes a story we never thought would be ours." You may have seen it. I think this applies to us. We certainly never expected to be traveling down the cancer path and never expected to be writing updates.

"For I know the plans I have for you,
plans to prosper you, to give you hope and a future."

JEREMIAH 29:11

Some of you have said how the updates help you. If so, we are glad. They have helped us, too, put down some thoughts, some of which are new to us, and to help me process the experience.
—Susie

Steve,

Sunday was a wonderful day – for you, for your family, for God. I know He did a dance over you. I'm sorry I wasn't there to hug your neck but I was watching on TV. We love you and your family.

Love,
Susie Edwards

THURSDAY

It has been a busy two days. Yesterday was an appointment with Dr. Fassler, endocrinologist, to check a possible thyroid issue. As it turns out, it is not something we need to address at this point, and I won't see her again until December when they will do another ultrasound. Sounds good to me. *Thank you, Father, for more answered prayer.*

Today, since I had some energy, Mark took me to Cool Springs for retail therapy (therapy for me, misery for him). We have two weddings coming up and I needed something appropriate to wear for them, and we had church directory pictures taken this afternoon and if my energy held out I would look for something for that. Energy didn't hold out and I already had something to wear for the photo, and the Meal Train was coming at noon, so we needed to hurry home. Successful shopping for the weddings, so mission accomplished. Church pictures turned out pretty well so all is well.

I am feeling the activity of yesterday and today so this is a short update. We plan to take it easy tomorrow so we will be able to worship on Sunday. We love being with community and having the fellowship with "heart friends." I don't know who said that but I really like the term. It really describes all the people we love.

The second stanza of "At the Break of Day" goes like this:

> *At the close of day I seek You once more,*
> *magnify Your name, worship and adore.*
> *Even in the darkness shines Your light so blest.*
> *Jesus, now I lay my spirit in Your arms to rest.*

"AT THE BREAK OF DAY"– WORDS AND MUSIC BY ARISTEU PIRES, JR. © 1990 JUERP. INTERNATIONAL COPYRIGHT SECURED. ALL RIGHTS RESERVED. TRANS. © 1992 RALPH MANUEL.

Tomorrow is my third infusion. We will still have the half dosage and trust that my side effects will be tolerable and minimal. Thank you for all the prayers you say on my behalf. I feel them and appreciate them. They help get me through the rough times.

We have another commercial that we really like and we have used it at our house. A national auto insurance company has a camel (whose name is Caleb) that appears inside an office, of course on Wednesdays, walking around saying, "Oh, no. Does anyone know what day it is? Come on, Mike, Mike, Mike, Mike, Mike, I know you know. It's hump day!" Well, Mark has become Caleb. More than likely, he will wake me up tomorrow saying, "Oh, no. Does anyone know what day it is? It's PUMP day!" (For this round of chemo, they send me home with a pump that I get to wear and enjoy for the next forty-six hours.) We laugh about it and it helps lighten my day.

I have started calling him Caleb, and he even signed the card he got me for Mother's Day with "C." Somehow our names have evolved over the years. We started out Mark and Susie, then Fred and Thelma, M & S, Honey and Papa, Honey and Mark, and now Honey and Caleb. Fun names and times to help with the harder times and ease tensions. *Thank you, Father, for a husband/ caregiver who is sensitive to my needs and feelings and helps lighten the load.*

> *Joyful, joyful, we adore Thee, God of glory, Lord of love;*
> *hearts unfold like flowers before Thee, opening to the sun above.*
> *Melt the clouds of sin and sadness; drive the dark of doubt away;*
> *Giver of immortal gladness, fill us with the light of day!*
>
> *"Joyful, Joyful, We Adore Thee"* – Henry van Dyke, 1907

Thank you, Father, for heart friends
that You send our way. —Susie

MONDAY

This morning when we walked in to Tennessee Oncology, I registered at one window and Mark went to the other window where, to our surprise and delight, Tammy was being trained for a new job in the Centennial location. Tammy is the wife of our friend Keith, who wrote "Refuge" for us. I continue to rely on that song to help me through the hard times and to reassure me that God is my refuge and strength. *Thank you, Father, for new and old friends.*

> *Wonderful grace of Jesus, greater than all my sin;*
> *how shall my tongue describe it, where shall its praise begin?*
> *Taking away my burden, setting my spirit free,*
> *for the wonderful grace of Jesus reaches me.*

REFRAIN
> *Wonderful the matchless grace of Jesus,*
> *deeper than the mighty rolling sea;*
> *higher than the mountain, sparkling like a fountain,*
> *all sufficient grace for even me;*
> *broader than the scope of my transgressions,*
> *greater far than all my sin and shame.*
> *O magnify the precious name of Jesus, praise His name!*
> *"WONDERFUL GRACE OF JESUS" – HALDOR LILLENAS, 1918*

WEDNESDAY

"Caleb" proclaimed this was "Dump the Pump" day, and so it was. We reported to Tennessee Oncology at 1 p.m. where I met Janell to disconnect the pack around my middle. It really isn't so bad when you get used to it. I just have to

remember to bathe instead of shower, stand farther away from the counters, and make sure I don't get a kink in the tubing where the chemo drugs flow into the port. This is just part of my new normal for the time being, and we can live with that.

For some reason, I woke up this morning humming "O Sacred Head, Now Wounded." I know it's not exactly a June song, but here it is anyway:

O sacred Head, now wounded, with grief and shame weighed down,
now scornfully surrounded with thorns, Thine only crown;
how pale Thou art with anguish, with sore abuse and scorn!
How does that visage languish which once was bright as morn!

What Thou, my Lord, hast suffered was all for sinners' gain:
mine, mine was the transgression, but Thine the deadly pain.
Lo, here I fall, my Savior! 'Tis I deserve Thy place;
look on me with Thy favor, and grant to me Thy grace.

What language shall I borrow to thank Thee, dearest Friend,
for this, Thy dying sorrow, Thy pity without end?
O make me Thine forever, and should I fainting be,
Lord, let me never, never outlive my love to Thee.

"O SACRED HEAD, NOW WOUNDED" – PAUL GERHARDT, 1656

Things I am thankful for: chemo drugs, nurses and doctors who really care about patients, marvelous rain, good music, children who keep in touch and are considerate of us, days of feeling good. —Susie

JUNE 10–14, 2014

TUESDAY

This has already been a busy week and it's only Tuesday!! We saw Dr. Donna on Monday, and she gave us an encouraging report. All my lab work is good and feeling around on my liver, she reports that it is smaller. I take that as a good sign. I have wondered how they will know if the chemo is working, and I suppose that is one sign. We'll take that. Dr. Wheelock was today, and he also gave encouraging reports. We don't know the lab results yet but he says all looks good. The CA-125 is the gauge for the ovarian cancer, and if it is below 35, I'm in remission. We'll take that, too. This week my main side effect has been the lack of energy.

Tonight I am thankful for

- Dr. Donna, Dr. Wheelock, Dr. Penley, Michelle, Leigh Ann, Krisia, Lana
- Research people who search for cures for all kinds of diseases
- Family, both biological and heart family
- Answered prayers and good days
- The chance to get away for a few days
- Rain
- God's magnificent Creation
- Living in Brentwood for thirty-six plus years
- Blessings beyond measure
- God Who continues to provide all our needs

> *Praise God from Whom all blessings flow;*
> *praise Him, all creatures here below;*
> *praise Him, above ye heavenly host;*
> *praise Father, Son, and Holy Ghost.*

"Praise God, from Whom All Blessings Flow" – Thomas Ken, 1674

NOTES FROM *Susie*

We are home from a wonderful short trip to South Carolina. Besides the lack of much energy, I did well and we had a good time with Mark's twin sister, Jean, and her husband, Mickey. We really are thankful the trip was good with no incidents. It was slow-paced and just what we needed. I have felt pretty good these two weeks, and my body will probably tolerate more poison. Oh joy!!! It's what we need to do to wipe this cancer out so that we can get on with our lives. We are all for that.

A new song to me:

> *All things are Yours: we make that true*
> *when we return our gifts to You;*
> *and so we give, and so we share,*
> *in Christ's strong name expressing care.*
>
> *"Give out of love," Your Word commands;*
> *we are Your head, Your heart, Your hands.*
> *Your Word you underscore with deeds*
> *by using us to answer needs.*
>
> *O what a joy to give, and then*
> *out of compassion give again.*
> *You have no needs—though that be true,*
> *the gifts we share are given to You.*
>
> *All things are Yours: we make that true*
> *when we return our gifts to You;*
> *and so we give, and so we share,*
> *in Christ's strong name expressing care.*

Things I am thankful for as we approach Father's Day: Jean and Mickey and good family times: a safe trip and traveling mercies: good food: a great home: heart friends: a dad who taught me so many things and loved me without question: a father-in-law who I love dearly and blesses me: Mark, who is a super dad to Weslee and Nathan. —Susie

Sweet Nathan,

I love you. Thanks for being my son. I am so proud of you - who you are and what you are and what you do. You are a blessing to me and have been always. I am proud of the way you handled being a staff kid and how you managed and related to all things presented to you. I love to see you relate to people - babies and "home bound" people and all

in between. I am proud of your solidness and firm foundations and beliefs. You are a strong committed Christian and very ethical in all your dealings. I do thank God for you and letting me hold you as a baby and hugging you as a man. You are great.

I love you.
Mom

No I am not dying! Just want you to know.

TUESDAY

Four down, – ? to go. Today's treatment went as planned with Dr. Penley increasing my chemo dosage to 70 percent. I can tell I got more chemo, but so far it isn't bad. It's hard to describe how it makes me feel. I don't hurt anywhere; my stomach is questionable even though my pre-meds include two anti-nausea meds; I am most comfortable lying on the bed or reclining in the manger with my eyes closed.

Today I'm thankful for:

- Dr. Penley, Jessica, Denise, and Rene, who took good care of me
- Powerful meds to wipe out my cancer
- Mark, who is so sensitive to my needs and will do anything for me
- New friends going through chemo
- Our herd that prays for us before, during, and after treatments
- A loving God Who blesses us and provides our every need

> *Every promise we can make,*
> *every prayer and step of faith,*
> *every difference we will make*
> *is only by God's grace.*
> *Every mountain we will climb,*
> *every ray of hope we shine,*
> *every blessing left behind*
> *is only by God's grace.*
>
> *Every soul we long to reach,*
> *every heart we hope to teach,*
> *everywhere we share His peace*
> *is only by God's grace.*

Every loving word we say,
 every tear we wipe away,
 every sorrow turned to praise
 is only by God's grace.

REFRAIN

Grace alone which God supplies,
 strength unknown He will provide.
Christ in us, our Cornerstone;
 we will go forth in grace alone.

I'm officially out of steam for tonight. We return to the chemo house to have the pump disconnected Thursday morning, and that will be good. I'm beginning to get used to it, but I have to be aware of it. The treatments, appointments, and pumps are really mainly just a bother, but worth it if it will kill these cancer cells and let me get on with my life and the things I want to do. Let's all pray for my patience and calm during this time. (I think I just heard an "Amen!" from the other room.) Thanks.

FRIDAY

Several people along this journey have asked me if I have moved past my anger stage. The answer is no, because I haven't had an anger stage. I know that in grief, and I suppose a diagnosis such as cancer, there are stages that the person and family go through: denial, anger, bargaining, etc. I really have not been angry at anyone and especially not God. I don't ask a lot of "why" questions and certainly not, Why me? I have been so blessed all my life—from a birth mother choosing adoption rather than abortion, to very loving parents, to a wonderful husband and children. What do I have to be angry about? I can't think of anything.

Next Tuesday is my fifth infusion. We will probably keep the dosage at 70 percent, which is okay with me. I want to get used to the side effects of this before we add harsher ones. My anxiety level goes up in the days leading up to the infusions. Please pray for calm and grace to endure. Also pray that these drugs are kicking these cancer cells in the teeth, never to come back again—in the present locations or any other places!!!

Now thank we all our God with heart and hands and voices,
　　Who wondrous things hath done, in whom His world rejoices;
　　Who, from our mother's arms, hath blest us on our way
　　with countless gifts of love, and still is ours today.

O may this bounteous God through all our life be near us,
　　with ever joyful hearts and blessed peace to cheer us;
　　and keep us in His grace, and guide us when perplexed,
　　and free us from all ills in this world and the next.

All praise and thanks to God the Father now be given,
　　the Son, and Him who reigns with them in highest heaven,
　　the one eternal God, Whom earth and heaven adore,
　　for thus it was, is now, and shall be evermore.

"Now Thank We All Our God" – Martin Rinkart, 1636; trans. Catherine Winkworth, 1858

We are so thankful for each of you, our herd.
You provide love, prayers, support, encouragement. —Susie

Mark

7:10 a.m.—"Oh no! Anybody know what day it is?" Caleb asked, to which our patient already making up the bed responded with a broad smile, "It's POISON day!" Well, Caleb had PUMP day in mind, but POISON day is more accurate.

Our appointment at the Poison Palace was at 10:30, and true to form we arrived in plenty of time. (Our disrespectful kids kid us—mainly Honey—about early arrivals for everything.) We went through the regular routine of blood work, followed by brief time in the waiting room, then to Dr. Penley whom we have liked since day one. With each visit—more than a half dozen by now—the connection with him has grown closer, and today he seemed as much like family as physician. Well, Honey's all over that! She had several questions related to recent blood test results sent to her; he took every one of them seriously, explained the nuances of some of the numbers, and generally eased her inquiring mind. Basically, the numbers that were slightly outside the normal ranges are not things that are problematic to her condition. Good to know.

It is nice to be able to trust one's doc unconditionally and know that he/she is doing their very best to help their patients. In our twenty-minute consult, there was quite a bit of belly laughter and lightness; Honey's convincing smile brightened the room and the conversation. Visit completed and headed out the door, he approached Honey to pat on her (or something), but Honey grabbed him for a hug. He may have been surprised, but certainly didn't seem to mind nor was he uncomfortable.

In the infusion room, there are typically a dozen or so others in our same boat. Some are reading, some are sleeping, caregivers are watching and waiting, while Honey is bright-faced and visiting with the staff. I love that gal and I'm very proud of her. She continues to rise to the challenging occasion and

is clearly showing all of us how to do hard things like have cancer. We know full well we are dealing with some serious stuff, but apparently there is more than one way to approach even such.

Here's a good spot for tonight's hymn, stanzas two and three:

> *I lift my eyes; the cloud grows thin; I see the blue above it;*
> > *and day by day this pathway smooths, since first I learned to love it.*
> *The peace of Christ makes fresh my heart, a fountain ever springing;*
> > *all things are mine since I am His—how can I keep from singing?*
>
> *What though my joys and comforts die? My Savior still is living.*
> *What though the shadows gather 'round? A new song Christ is giving.*
> *No storm can shake my inmost calm, while to that Rock I'm clinging;*
> > *since Christ is Lord of heaven and earth, how can I keep from singing?*
>
> *"HOW CAN I KEEP FROM SINGING"* – ROBERT LOWRY, 1869

There's a book or a saying or something that proclaims
that joy is a choice and, by the wonderful grace of Jesus,
so far we have been able to make that choice,
as difficult as it is at times. —Mark

JULY 3, 2014

Susie

Happy July 4th Eve! I hope you all have a safe holiday whether traveling, grilling, shooting fireworks. Celebrate family and our country.

I am now de-pumped and can move more easily without bumping the fanny pack into things. It's more of a nuisance than anything since I have to make sure the tube doesn't get twisted and it start beeping at me. I would have to really work hard to mess up the medicine flow, but we are prepared if anything does happen.

Today I was able to go to the store, fix some lunch, have the pump disconnected, and have a nice long visit with Myrte, our longtime family friend, eat some dinner, and do this update. I'm about done in for the evening and it's only 6:30—waaay too early for bed!

When Myrte was here we talked about our health issues and struggles, family, Scriptures, and songs that get us through the dark nights and hard times of life. When Myrte's mother's health was failing, she moved her mother to Franklin to live with her and then into a nursing facility close at hand. During that time, Myrte used Cynthia Clawson's song "The Journey" as her daily devotion. Thanks, Myrte, for the song and the love and friendship. I love you.

Here are the words to the refrain:

> *Give me the heart to be pure,*
> *give me the faith to be sure,*
> *give me the strength to endure,*
> *all my tribulations.*

Sounds like a good prayer to me. I'll add this to my collection of meaningful songs. —Susie

This is the day the Lord hath made, we will rejoice and be glad in it. Amen. I had to rejoice and be glad at home. Not the way I like to spend Sundays but for this week, we had to make do. I was able to worship via the live streaming from our church, and I'm glad about that. Thursday night I began a downhill spiral and am still in that mode. I have felt like I did last year when we started this journey when all I could do was sit in the manger and breathe in and out. I don't sleep most of that time but just try to relax with eyes closed and no moving. I'm not in much pain, and for that I continue to be thankful. Caleb, my alarm camel, has let me sleep a little later each morning, and that helps.

Mark says that I am the one who goes into a room and strikes up conversations. Well, the same can be said about him except in different venues. Example: Most mornings he wakes up and is out the door about 5:30 for his walk. He picks a blade of grass, puts it in his mouth to chew on, and sets out at a pretty good clip—until he crosses Old Hickory Blvd. For the past year or so, they have been doing construction on retail space in front of the LifePoint Building close to our house. In the beginning stages, he would come to a complete standstill and, depending on how close he could get, strike up a conversation with the men pouring concrete, paving the parking area, or putting up steel. I'm not sure names were mentioned, but lots of questions, answers, observations, and general stuff were exchanged.

Mark has always been interested in how things are put together, how they work, techniques, etc. He learned this from his dad, and the two of them can always come up with ways to solve issues and find better ways to build little projects. They both have gotten lots of pleasure out of this. It isn't really a way to build a relationship because he might or might not ever see the same people working on the project at different times. However, it is a way of expanding his horizons, affirming the workmen for the good job they do, and them as people. Isn't that what we need to do along our journey called life? We are better people because of the ones we have met, in all arenas.

Last update I mentioned Cynthia Clawson's "The Journey." After I played the song, of course I remembered it. It was one of those things that I listened to at the time but it didn't sink in, and sadly I didn't pay much attention to. Well, like so many other things, I am paying much more attention to things these days—songs, Scripture, books. Man, I missed out on so much and have to spur my stick horse to play catch-up!

Another new song for me from *Celebrating Grace Hymnal* (#54):

> *Like a mother with her children You will comfort us each day,*
> > *giving guidance on our journey as we seek to find our way.*
> *When we walk through fiery trials, You will help us take a stand;*
> > *when we pass through troubled waters, You hold out Your tender hand.*
>
> *In Your image You have made us, calling each of us by name,*
> > *giving strength for every challenge as our gifts we fully claim.*
> *We can hear you gently saying, "Do not worry, do not fear;*
> > *for I'll always go beside you; every moment I am near."*
>
> *With Your vision You inspire us, giving each a holy call;*
> > *we will open doors of freedom by Your power in us all.*
> *Life abundant spreads before us as with eagle's wings we soar;*
> > *joining in Your new creation, we rejoice forevermore.*

Thank you, each one, for the blessing you have been to us and continue to be. Some of you have been with us all our lives, others only while we have been in Nashville. You each touch our lives in a wonderful way and we are thankful. —Susie

"Oh no, does anyone know what day tomorrow is?" No, Caleb, it is not hump day but infusion day! This is my sixth infusion and I anticipate another increase in dosage—yea and oh no. Yea, because we need to get the dosage back to 100 percent so we can wipe this stuff out. Oh no, because there will be harder side effects. But I guess they go hand in hand, and since we have our herd behind us with lots of prayers and love, we can manage anything. God is always gracious to us and provides our needs, and we are so thankful for His presence and touch on and in our lives.

We will have a CT scan done probably next week to see what progress has been made. A prayer request might be that progress HAS been made and the news encouraging. Thank you. As tomorrow approaches, please pray for my peace of mind and strength of body. Pray for Dr. Penley as he directs my treatment and for the nurses who are so kind and compassionate. Chemo patients couldn't do without the love and support given by these caring providers.

This new song of gratitude from *Celebrating Grace Hymnal* (#374) keeps echoing in my mind:

> *I thank You, Lord, for each new day, for meadows white with dew,*
> *for the sun's warm hand upon the earth, for skies of endless blue,*
> *for fruit and flower, for lamb and leaf, for every bird that sings,*
> *with grateful heart I thank You, Lord, for all these simple things.*

> *I thank You, Lord, for wind and rain and for the silver moon,*
> *for every daisy's lifted face, for every lovely tune,*
> *for winter's white, for autumn's gold, for harvest and for home,*
> *with grateful heart I thank You, Lord, for each good gift I own.*

I thank You, Lord, for hand and heart to offer up Your praise.

I thank You, Lord, for tongue to speak of all Your loving ways.

For health and strength, for work and play, for loved ones far and near,

with grateful heart I thank You, Lord, for all that I hold dear.

Many of you are an important part of our lives and have been for so many years. And many of you have been a part of our lives since we started this cancer journey. Thank you, each one, for walking this path with us and going to our Father on our behalf. Each prayer is heard and will be answered. You overwhelm us. —Susie

Give thanks to God, He is Creator,
sing to the Lord, O sing a new song!
He is our Lord and our Redeemer,
Sing to the Lord, O sing a new song!

Give thanks to God, tell of His greatness,
sing to the Lord, O sing a new song!
Glory is His, there is none other,
sing to the Lord, O sing a new song!

Give thanks to God, come with rejoicing,
sing to the Lord, O sing a new song!
Come celebrate, lift up your voices,
sing to the Lord, O sing a new song!

REFRAIN

Worship the Lord and stand amazed;
worship the Lord with endless praise.

NOTES FROM Susie

WEDNESDAY

This is the day the Lord has made, and I will rejoice and be glad in it. This should be my first thought every morning. Yesterday was my sixth infusion, and Dr. Penley decided to stay at the 70 percent dosage. I have a CT scan scheduled for next Thursday morning and hopefully there will be some good news in it concerning the liver. After that, he'll determine the next course of action. Then I will have my regular scheduled chemo treatment on July 29. We are so fortunate to have such wonderful specialists in town.

Sing this oldie with me again:

> *In the lightning flash across the sky*
> *His mighty power I see,*
> *and I know if He can reign on high,*
> *His light can shine on me.*

> *When the thunder shakes the mighty hills*
> *and trembles every tree,*
> *then I know a God so great and strong*
> *can surely harbor me.*

> *When refreshing showers cool the earth*
> *and sweep across the sea,*
> *then His rainbow shines within my heart,*
> *His nearness comforts me.*

REFRAIN

[Now, everyone on the refrain …]

I've seen it in the lightning,

heard it in the thunder, and felt it in the rain;

my Lord is near me all the time,

my Lord is near me all the time.

I could add my own verse to this song:

"When the chemo goes into my veins and kills the cancer cells, then I know my God who heals the sick can surely heal me, too." Okay, so I won't quit my day job. Oh wait … I don't have an active day job. Hmmmm.

Every day is a gift and I am thankful. When I open that gift. I find lots of different things waiting for me. and I take each one as it comes. finding at least one good thing in it. God grants so many good things to me. —Susie

SUNDAY

Thursday I had a CT scan, and Tuesday we will see Dr. Penley to get the report and see what the next step is. I have had eighteen chemo infusions and my body is beat up. I am having more liver pain and am taking more pain medicine than I want to. When asked how I'm doing, I answer okay. And if I'm doing okay, then it's a good day. I don't feel overly optimistic about the

report from the scan. Mind you, I don't have an M.D. after my name, nor do I have one-hundred thousand-plus dollars in school debt to get those initials. I am just going by how I feel. Please pray that I am wrong. I really don't mind being wrong.

Tuesday I have an appointment at 1:15 p.m. I don't think I'll have a treatment since that is too late to start. Please pray that the report won't be as negative as I think it will be and that I'll have peace and calm while we wait and afterwards. Have you ever noticed that most of the time anticipating outcomes can be worse than the outcome? Let's pray that will be the case this week. And if not, then let's pray that we will still have peace and calm to continue to rely on our Father's provisions and grace to us.

This week I received a book of quotes and Scripture verses compiled by Kelly Lewis Vonfeldt in 2003. She found an extra copy and sent it to me. I'm so glad she did. Here are a few from the first pages:

- "The past is history; the future is mystery. Today is a gift. That's why it is called the Present."
- "If you know that God's hand is in everything, you can leave everything in God's hand."
- "Rejoice in your hope, be patient in tribulation, be constant in prayer" (Romans 12:12).

I'm really going to enjoy the rest of the pages.

No one has a better herd than we do. Thank you for the specific prayers all day today. Your prayers for peace and calm were answered in a mighty way. Dr. Penley is a very caring man/doctor and told us the not-so-good news in a very gentle manner. The scan showed the tumors are bigger and the current chemo regimen is not working. He did say there are other options to try if I/we wanted to. Mark and he get one vote each, and I get three votes.

Right now we will try a new treatment that includes the infusion in the office, and then instead of the pump, I will take an oral mediation twice a day for a week. We know it is not a cure and probably won't be very effective. The goals are to extend life and have a good quality of life at the same time. These two don't always go together, and we will just try it and see what happens. In the words of Dr. Penley, "Cancer sucks out loud." Amen to that.

I'm not ready to give up. And besides, I have too many projects that I need to finish! My quality of life is pretty good, and I still do lots of things I want to do and be with people I love. Our plan would be very different, but we know God is in control and we are thankful. Please continue to pray for us as we navigate this development. Weslee and Nathan could use your prayers, too. We need strength, assurance, peace, grace, and wisdom to know what to do. Thank you.

More from Kelly's notebook:

- "Never let an impossible situation intimidate you. Let it motivate you" (Rick Warren).

- "God never wastes a hurt. There is a purpose behind your pain" (Rick Warren).

- "We walk by faith, not by sight" (2 Corinthians 5:7).

We will continue to take one step at a time and process this as we can. We are very tender at this time and probably will be for a time, but we still know that God has a plan and it is a perfect plan. —Susie

I waited patiently for the Lord;
 he inclined to me and heard my cry.

He drew me up from the desolate pit,
 out of the miry bog,
and set my feet upon the rock,
 making my steps secure.

He put a new song in my mouth,
 a song of praise to our God.
Many will see and fear,
 and put their trust in the Lord.

Happy are those who make
 the Lord their trust,
who do not turn to the proud,
 to those who go astray after false gods.

You have multiplied, O Lord my God,
 your wondrous deeds and your thoughts toward us;
 none can compare with you.
Were I to proclaim and tell of them,
 they would be more than can be counted.

PSALM 40:1-5

MARK & SUSIE EDWARDS

As I write this, I am tender for a different reason from last night. Last night I was tender because of the difficult news we got about my cancer. Today I am tender because I have read all the comments on Facebook and texts and e-mails. We are blown away. How can we be discouraged or frightened or sad when we are so blessed? No way. Our God is a mighty God and greatly to be praised, and I do praise Him. This journey continues to be a roller coaster, with ups and downs coming very close together. Thank you all for your words, your love, your prayers.

After lunch I came home and starting working on my albums. I have more of an urgency to finish all the things I have started. It's good for me to have that. Next week I will begin a new treatment schedule. Tuesday I will have my regular chemo infusion but instead of leaving with the pump, I will take an oral chemo drug twice a day for seven days, then off seven days. Then have infusion again and the cycle starts.

I talked with a pharmacist this morning about the drug and side effects. Some may be unpleasant, and some may be a lot more than unpleasant. We'll just have to wait and see how I tolerate the drugs. Maybe a specific prayer request is that my body will tolerate the drugs and the dosage won't have to be reduced. Thank you.

I found another new hymn in the *Celebrating Grace Hymnal* (#398), "Jesus, Walk Beside Me." Our friend Anna Laura (one of our herd, in good standing), wrote the hymn tune—"BEULAH"—naming it for her mother. Here's the hymn:

> *Jesus, walk beside me.*
> *When the storm clouds hide me,*
> *raise my thoughts above.*

Jesus, end my sadness.
Lift my soul to gladness,
> *buoyant with Your love.*
Morning comes and joy returns.
Lonely times and tears are ended
> *when one's soul is tended.*

When dark rains are falling,
> *may I know my calling,*
> *hearing well Your voice.*
When cold winds are blowing,
> *warm my heart to glowing,*
> *teach me to rejoice.*
Help me serve with eager hands,
> *knowing gifts of grace unbounded,*
> *by Your love surrounded.*

In my times of sorrow,
> *when I dread tomorrow,*
> *I will turn to You.*
In each time of grieving,
> *strengthen my believing;*
> *lift my spirit, too.*
As I live from day to day,
> *praying that Your care will guide me,*
> *Jesus, walk beside me.*

"Jesus, Walk Beside Me" – Words Mary R. Bittner © 2004 Wayne Leupold Editions, Inc. Used by permission.

We are so thankful for small things and don't take those for granted. I get up every morning thankful for the rest and a new day. God provides. —Susie

Last week I got a call from Park Pharmacy where my new chemo pill comes from. I take three tablets twice a day for seven days, off seven days, and then chemo again. The pharmacist is obliged to inform me of all the possible side effects of the drugs, and I guess I appreciate that??!! I do think it is important to know SOME things I MIGHT experience, but I don't need to know ALL possible ways this drug could abuse my body. By the time she finished, I seriously wondered why I thought I wanted to do this.

Sunday night I had quite a meltdown, but it didn't take too long to get on track again. I love my husband/caregiver/friend/advisor/policeman. He lets me talk and puts in his two cents worth when I want it and need it. Two cents is what he would value his input, but I think it is worth far more than that—of course I'm the optimistic one of our twosome! We cried, talked, hugged, sat quietly, and just were. Soon, some friends came over and things were so much better. They brought Don's soup and Rubynelle's banana pudding. YUMMY. Onward and upward.

Sunday we were downtown for worship and so glad to be there. Gwenn sang, "His Eye Is on the Sparrow." Amazing! Last week I woke up several mornings singing that song. I couldn't come up with all the words, not unusual these days, but the first words are, "Why should I be discouraged?" Then bits and pieces came to mind. A wonderful song with lots of encouragement. That is a "why" question that I ask. Thanks, Gwenn.

Yesterday I called Dr. Penley's office to talk about side effects and if he thought I could tolerate the drugs. Instead, I talked to nurse Lindsey, and she helped me so much. She calmed my fears. Yes, there are lots of unpleasant side effects, but after talking with Lindsey, I figured I could handle the new treatment. Have I said what wonderful nurses I have at Tennessee Oncology? Well, they are the best in my book. *Thank you, Father, for Lindsey.*

Today was my first infusion of new drugs. They called us into the testing area, and we ran right into Don, our longtime friend, there with his wife, Kaye, who is going through chemo herself. We enjoyed a brief foursome visit, the guys went their separate ways while Kaye and I received our infusions sitting together—an unexpected delight. We will keep you posted on this new path along this journey.

> *I'm making a journey, Lord, the greatest journey of all.*
> *My step may fail, Lord, so please don't let me fall.*
> *The way is narrow, Lord, and sometimes I feel alone.*
> *When my heart fears, Lord, I softly pray this song.*
>
> *Give me the heart to be pure,*
> *give me the faith to be sure,*
> *give me the strength to endure,*
> *all my tribulations.*
>
> *I need some courage, Lord, to make it just one more mile.*
> *I want to hold your hand, I want to see you smile.*
>
> *Give me the heart to be pure,*
> *give me the faith to be sure,*
> *give me the strength to endure,*
> *all my tribulations.*

Thank you, faithful herd, for your prayers for us. It is truly amazing how calm and peaceful we feel about this new treatment. We don't go into it thinking all will be well. We know there will be hard times ahead, but we are confident that even when God doesn't give His protection, He gives His presence. These are notes in my Bible in John 11. I don't remember who said it, possibly Pastor Frank, but it made an impression a long time ago. It still does. *Thank you, Father, for Your constant presence.*

I can say lots of things about this journey,
but one thing I will say is that it is not boring. —Susie

MARK & SUSIE EDWARDS

231

WEDNESDAY

Honey's infusion eight days ago was the first of the new regimen—round four. The side effects have been manageable and much akin to those accompanying round one, which we were enjoying this time last year. You may remember that round three involved the infusion itself, followed by her wearing a pump for forty-six hours. Instead of the pump she now leaves the infusion room with a load of pills that she takes twice a day for a week. She has now completed the first cycle of all that and has had some pretty good days since Sunday. The cycle starts over again Tuesday. This is one tough gal we're talking about, you understand.

As you would expect, she maintains her positive attitude, gentle spirit, grateful heart, and million-dollar smile, even when she doesn't feel wonderful. She's decided that it doesn't really make her feel better to lie around all day, so she gets up at a decent hour, showers and dresses (including the earrings, of course), and goes about her business even though at a slower pace than she prefers. By nightfall, she's pretty worn out and sleeps well.

I am standing in for Joe at our church the month of October while he is on sabbatical. He's nice enough to let me choose the anthems the choir will sing those Sundays, so I have spent some time recently on the hunt. It's my chance to do some of my favorites, and I appreciate him giving me that opportunity. It can't be all easy to have one's predecessor "on hand."

One of the favorites we'll sing that month is "At the Break of Day"—a South American hymn translated by Ralph Manuel, friend and former missionary to Brazil, and beautifully arranged for choir, keyboard, and violin by another friend, Michael Cox. The hymn version also appears in the *Celebrating Grace Hymnal* (#304):

At the break of day, Lord, I seek Your face,
 there to hear Your voice, feel Your love's embrace.
As You speak to me in this time apart,
 Lord, I praise Your holy name, I give You my heart.

At the close of day I seek You once more,
 magnify Your name, worship and adore.
Even in the darkness shines Your light so blest.
 Jesus, now I lay my spirit in Your arms to rest.

SUNDAY

My second treatment on these new drugs is this Tuesday. To this point none of the bad side effects have visited me. I do have some cold sensitivity and a few mouth sores. I need to dust off my wigs again since my hair is very thin—not coming out a lot but thinning. Glad I kept them. Still have the pain and fatigue, but everything is very manageable. *Thank you, Father.*

Here is yet another new hymn of gratitude from *Celebrating Grace Hymnal* (#24):

> *Creator God, we give You thanks for all the glories You have made.*
> *Help us to see You in Your work, the Artist in the art displayed.*
>
> *As we survey Your handiwork, restrain our minds from petty greed.*
> *Respect before Your great design is reverence paid to You indeed.*
>
> *What You have given us in trust is only ours to rightly use.*
> *Deliver us from thoughtless deeds that plunder, pillage, and abuse.*

Help us to see Your draftsman's hand in every blade of grass, each flower,
that we may stand in awe before the work of Your creative power.

Many of you have posted photos of beautiful sunrises and
sunsets, so I know you see God's handiwork and stand in awe.
How can we see that and not be thankful people? —Susie

I love you and know
you are going through a
new journey right now. You'll
make it and you have lots
of support. You are more
Capable than you know and
don't let any body bring
you down.
 We're here for you.
 I love you "Joy",
 Mom

WEDNESDAY

This is the day the Lord has made; I will rejoice and be glad in it. It has been a very good day. The sun has been out, there has been some rain so we have had the best of both. There is the heat and humidity but with cool homes and workplaces, we can handle that.

Yesterday was infusion day, and it went well. When I told Dr. Penley how good the last two weeks had been, he was surprised. No major side effects, only minimal ones and very manageable. I'll take this any day. Now if these drugs will shrink the tumors, our prayers will be answered. Jessie is my nurse, and yesterday we talked about Max Lucado and Sarah Young and her books, and the frustrations of trying to have a quiet time daily. We both struggle, and she says she's going to try harder. *Thank you, Father, for Jessie and her faith and skills as a nurse and her compassion for patients.*

I am reading Max Lucado's book *God Will Carry You Through*. These are short stories from people who have experienced many different hardships and how God has been with them all along. On page 24 in Cindy's story, she writes, "I had once heard faith defined as 'confident obedience to God's Word despite the situation or consequences.'"[6] I like this. I'll add it to my list of faith definitions.

Today's new hymn is the first verse only of "All Glory Be to God on High":

> *All glory be to God on high*
> * and thanks to Him forever!*
> *Whatever Satan's host may try,*
> *God foils their dark endeavor.*
> *He bends His ear to every call*
> *and offers peace, goodwill to all,*
> *and calms the troubled spirit.*

"ALL GLORY BE TO GOD ON HIGH" – NICOLAUS DECIUS; TRANS. GILBERT E. DOAN
© 1978 AUGSBURG FORTRESS PRESS. ALL RIGHTS RESERVED. USED BY PERMISSION.

You know we have mentioned all along this cancer journey how bad it is, but also how blessed we are. Well, another blessing came last week. I have a brother, Randy, who lives in California, and like some families experience, there has been some estrangement for many years. I don't know how he found out about my surgery last year in March, but he called me the day after the surgery. I was surprised but I am so thankful. Over the last eighteen months, we have talked and texted, and he's coming to see us in October. I am so excited. I hate this cancer but I love this blessing. Randy had lots of health issues himself several years ago. He is much better now, but we can compare notes on our aches and pains. Isn't that what "old folks" do when we get together?! *Thank you, Father, for a second chance with my brother.*

I'm reminded tonight of this hymn from *Celebrating Grace Hymnal* (#39):

> *God moves in a mysterious way*
> > *His wonders to perform;*
> > *He plants His footsteps in the sea*
> > *and rides upon the storm.*
>
> *You fearful saints, fresh courage take;*
> > *the clouds you so much dread*
> > *are big with mercy and shall break*
> > *in blessings on your head.*
>
> *Judge not the Lord by feeble sense,*
> > *but trust Him for His grace;*
> > *beneath a frowning providence*
> > *He hides a smiling face.*
>
> *Blind unbelief is sure to err*
> > *and scan His work in vain;*
> > *God is His own interpreter,*
> > *and He will make it plain.*

"GOD MOVES IN A MYSTERIOUS WAY"– WILLIAM COWPER, 1773

Mysterious ways, indeed. Why am I so surprised and amazed at all He can do and does? I don't ever want to take His love and grace for granted. —Susie

It Is Well with My Soul

Anthem for SATB Choir, Piano, Organ, and Optional Congregation

Words by Horatio G. Spafford

VILLE DU HAVRE
Music by Philip P. Bliss
Arranged by Mark Edwards

*Organ may either double piano or rest until measure 43.

accents

> *Now thank we all our God with heart and hands and voices,*
> *Who wondrous things hath done, in whom His world rejoices;*
> *Who, from our mother's arms, hath blest us on our way*
> *with countless gifts of love, and still is ours today.*

"Now Thank We All Our God" – Martin Rinkart, 1636;
trans. Catherine Winkworth, 1858

This has been a great day. It was infusion day, and that went well. I asked Dr. Penley if he could tell by pushing on the liver area if it was larger. He said using his "hand scan" he couldn't really tell much, and the CT scan was the best indicator of size. However, I have blood work done every time, and he said there are tumor markers they use. My CEA [blood test for certain cancers] on July 29 was 3540.0; that's high. On August 19, it was 2340.0.

He was really pleased and said the new drugs are working, and he's pleased that my side effects are so minimal. So, we will continue with the next three infusions and oral meds and then schedule another CT scan. We were very pleased with this visit. *Thank you, Father, for answering so many prayers on our behalf. You continue to provide for us and take care of us.*

The side effects showed up immediately after the infusion. Before I left the room, I had to throw away my Diet Coke with ice because my mouth was so sensitive to the cold. My fingers and knuckles and joints were tingling and freezing up. The anti-nausea meds they give me make me very sleepy. All of this is manageable and will subside next week.

My heart has been hurting so much lately. Not primarily because of our situation, but because we know so many people who are in crisis situations. There is cancer, depression, Alzheimer's, ALS, addictions, family matters.

Tonight's hymn is another new one (*Celebrating Grace Hymnal* #75) and I hope is encouragement:

If I fly as birds at dawning, travel to the farthest sea,
 You are there, my God, my Refuge, there to hold me lovingly.
In my time of desolation help me feel Your presence near.
Send a light amid the darkness, bringing hope to calm my fear.

In my mother's womb You formed me, piece by piece with tender care.
Secretly You placed within me words of life for me to share.
God, Your thoughts for me are boundless, more than I can ever know.
They will comfort me forever. What a debt to You I owe!

Keep me faithful, full of wonder, as my days on earth unroll.
Walk beside me, and protect me from those who would wound my soul.
Search me, test my inmost being. Root out all my selfish ways.
Lead me on to life eternal. I will praise You all my days.

"*IF I FLY AS BIRDS AT DAWNING*"– WORDS EDITH SINCLAIR DOWNING © 2009
WAYNE LEUPOLD EDITIONS, INC. USED BY PERMISSION.

Thank you, wonderful herd, for taking care of us through meals, prayers, hugs, love, cards, calls, friendship, and all the other ways this chemo brain can't think of at this time. God continues to bless us overwhelmingly. —Susie

I was able to go to church today and be with our heart friends, and I loved every minute. Mark had to take my hand and lead me to our seat in the balcony because I was doing too much visiting for my own good. He has to do that a lot. I can never get too many hugs and smiles from the best people in the world. Thank you for giving me the best medicine—the side effects of hugs don't leave me feeling bad.

On infusion day, I get two anti-nausea meds and steroids. On Wednesday I was riding high on the steroids, and so I was able to get lots done. I changed out my closet and finished getting all of my quilting materials gathered to send another load to Barbara. She is an avid quilter and makes beautiful quilts. I was glad to find a good home for my things. Over the years I have collected lots of scraps, kits, and even had some squares pieced. If I lived to be a hundred and twenty, I would not get all my projects done. Our granddaughter Ella's quilt was my last baby quilt to do for our grands. Now I can continue with my photo albums and making Christmas trees. Too many projects, not enough energy.

Things I am thankful for:

- A community of faith
- A faithful God who provides ALL our needs
- Powerful chemo drugs
- A husband who looks after my well-being and lovingly takes good care of me
- Heart friends who are so generous in providing for us
- Blessings beyond belief

> *Like a river glorious is God's perfect peace,*
> *over all victorious in its bright increase;*
> *perfect, yet it floweth fuller every day;*
> *perfect, yet it groweth deeper all the way.*

REFRAIN

Stayed upon Jehovah, hearts are fully blessed;
finding as He promised, perfect peace and rest.

Hidden in the hollow of His blessed hand,
never foe can follow, never traitor stand;
not a surge of worry, not a shade of care,
not a blast of hurry touch the spirit there.

When a joy or trial falleth from above,
traced upon our dial by the Sun of Love,
we may trust Him fully all for us to do;
they who trust Him wholly find Him wholly true.

"LIKE A RIVER GLORIOUS" – FRANCES R. HAVERGAL, 1874

This hymn has been a favorite of mine for many years. It is so hard for me to just say the words to hymns; they just flow easier when I sing them.

Thank you, heart friends, for your love, prayers, hugs, encouragement for us. God continues to provide grace, peace, calm when we need it.

Never underestimate your gift of a smile or hug. —Susie

SEPTEMBER 15, 2014

I'm always a little anxious the day before an infusion. When I talked to Weslee today about my infusion I said, "It is what it is." She asked what is it? Well, poisoning is exactly what it is. I don't know if there is any other way to put it. That is a very negative image. But it is also positive knowing that it is targeting the cancer cells and killing them. As long as that happens, I'm glad and thankful. I am learning that our bodies are "fearfully and wonderfully made," and we are a lot stronger than we think. We are part of God's incredible creation.

Several of you have commented on our updates and mentioned how inspiring they are. Last year in March after my first surgery, Weslee said that an update on Facebook would be a good way to let people who were interested know how we were doing and what was going on. This started out as mainly a way to pass along information. Somewhere along the way it turned into something much more. It never occurred to me that I would/could write anything that would inspire people.

This is another thing that God is doing in my life. He is teaching me things every day, and He is enabling me to pass some things along to others. He has blessed me overwhelmingly all my life, and I am so thankful for all He has done, is doing, and will do. How can I keep from singing? Anything that is inspiring in an update is not from me but our loving Father who is taking very good care of me.

We continue to be well taken care of in every way—prayers, love, cards, calls, meals, unique gifts. Thanks to all of you for having such an important part in encouraging us through this journey. One reason we are not struggling any more than we are is because of each of you. You make this rough road smoother. Sandra, David, and Marianne brought wonderful dinners last week, and Diane and Aubrey came tonight. Where did we get such marvelous cooks? Thank you.

One of my long-term projects is my Creative Memories™ albums. I found out this week that CM is no longer (I really have been in a cave or recliner). Problem is they have the best albums, and I haven't found any like them yet. However, Kim was a former consultant with CM and she has some supplies that she offered me. She was going to put those goodies in a casserole dish but didn't have one big enough. This is another of the unique gifts we have been given. First Baptist Church Nashville has the most giving generous people I know.

My life flows on in endless song; above earth's lamentation,
* I hear the sweet, though far-off hymn that hails the new creation.*
Through all the tumult and the strife, I hear the music ringing;
* it finds an echo in my soul—how can I keep from singing?*

What though my joys and comforts die? My Savior still is living,
What though the shadows gather 'round? A new song Christ is giving.
No storm can shake my inmost calm, while to that Rock I'm clinging;
* since Christ is Lord of heaven and earth, how can I keep from singing?*

I lift my eyes; the cloud grows thin; I see the blue above it;
* and day by day this pathway smooths, since first I learned to love it.*
The peace of Christ makes fresh my heart, a fountain ever springing;
* all things are mine since I am His—how can I keep from singing?*

"HOW CAN I KEEP FROM SINGING" – ROBERT LOWRY, 1869

I hope you each have a wonderful week. I'll report later on this week and let you know how this fourth infusion has gone. I anticipate the side effects, and I also anticipate I will be able to manage them all. When I don't see you, please know that you are not far from my thoughts. I know many of you are struggling with so many things. I am praying for God's comfort and grace to wrap around you.

God is present in each of you,
and you are His hands and feet. —Susie

Infusion four of round two of 2014 is in the books. Today went well, and the side effects have arrived on schedule. The cold sensitivity is a bother, mainly in my hands. Washing my hands with tap water feels like electric shocks running up my arms. I have never liked being shocked, and so this is really an interesting sensation. I don't like it but it does keep me away from one of my vices—ice cream! Oh well.

I'm stating the obvious when I say that music plays an important part in our lives. Over the last eighteen months, several people have written and/or arranged musical pieces in our honor. What wonderful, unique gifts to us. Last year Keith wrote an anthem called "Refuge." Beautiful, and I listen to it often. Then Ken wrote one of his unusual songs about our journey. What a gift he has. Also, last year Philip, our sanctuary handbell director, wrote an arrangement of "Day by Day" and recorded it. It, too, is a beautiful arrangement of a favorite hymn.

Also, my brother-in-law Randy wrote a very moving piece for orchestra and oboe, and titled it "Susie's Gratitude." He debuted it at the concert in Washington, D.C., that our choir was part of over Labor Day Weekend. All of this gorgeous music is on my phone to be played as often as I want or need it. What an honor to have these friends take the time using their gifts and talents in this way. We appreciate them and their gift to us. We are humbled.

Tonight's hymn is an oldie but goodie, "Now Thank We All Our God":

> *Now thank we all our God with heart and hands and voices,*
> *Who wondrous things hath done, in whom His world rejoices;*
> *Who, from our mother's arms, hath blest us on our way*
> *with countless gifts of love, and still is ours today.*

O may this bounteous God through all our life be near us,

with ever joyful hearts and blessed peace to cheer us;

and keep us in His grace, and guide us when perplexed,

and free us from all ills in this world and the next.

All praise and thanks to God the Father now be given,

the Son, and Him who reigns with them in highest heaven,

the one eternal God, Whom earth and heaven adore,

for thus it was, is now, and shall be evermore.

"Now Thank We All Our God" – Martin Rinkart, 1636;
trans. Catherine Winkworth, 1858

Thank you each for your comforting prayers and love. You are Christ's hands and feet on this earth and you are doing a very good job. You are true blessings. —Susie

Amy,

Thanks for making the stew "just for the halibut!" It was really good. I'll confess, we wondered but we've had it for dinner and lunches. Thanks for the meal and for your friendship, love, support, prayers, and lots of other stuff. Your family is a treasure.

Love,
Susie and Mark

MARK & SUSIE EDWARDS 245

Several months ago, Gordon and Gayle told Mark they wanted to do something for us. This is another unique gift. Gordon, Gayle, and Vicki came over Thursday night and "heaven came down." They did not give a concert; it was much better than that. They are all fabulous musicians, and they came just to sing and relax and give us their best. And they did exactly that. Nothing was rehearsed or planned. It was just an evening of heavenly music, friends, and love. It doesn't get any better. Gayle brought some music she had, and we had hymnals. Gordon and Gayle have fantastic voices, and Vicki can play anything put in front of her and even improve on what's written. They started with "It Is Well with My Soul," and I was a messy puddle!

Another unique gift to me today was beautiful jewelry made by Joyce. She tells me that jewelry making is her therapy, and her pieces are wonderful. I get to benefit from her therapy. I have several of her creations, and I wear them proudly.

Last week had moments of pure joy and utter sadness. We found out our niece Karyn and her husband, Marty, will be parents in March 2015. Pure joy. Sadness came when we found out that Headly had passed away. Headly and Mary Alice are pillars at First Baptist. There is a hole left there. But we celebrate a life well lived.

This Tuesday is my fifth infusion. This round is almost over and then a CT scan to see how effective the chemo is. Please continue to pray that the drugs are doing the job, for manageable side effects, and for Dr. Penley and all my excellent nurses. We are so fortunate to have great medical care.

My hymn tonight is "Give to the Winds Your Fears" (*Celebrating Grace Hymnal* #55):

Give to the winds your fears,
 hope, and be undismayed;
 God hears your sighs and counts your tears,
 God shall lift up your head.

Through waves and clouds and storms
 He gently clears the way;
 wait for His time, so shall the night
 soon end in joyous day.

Far, far above your thought
 His counsel shall appear,
 when fully He the work has wrought
 that caused your needless fear.

Leave to His sovereign will
 to choose and to command:
 with wonder filled you then shall know
 how wise, how strong His hand.

"GIVE TO THE WINDS YOUR FEARS" – PAUL GERHARDT, 1653;
TRANS. JOHN WESLEY, 1737 (PSALM 37)

We are so humbled and blessed by each of you.
Your love, hugs, cards, meals, prayers, flowers, songs,
encouragements mean so much to us. This journey is easier
because of you, and we thank God for you. —Susie

MARK & SUSIE EDWARDS

WEDNESDAY

Lovely autumn flowers arrived today, on schedule, from Sam and Barbara. Flowers have been their unique gift to us during our journey.

Looking through the index of the *Celebrating Grace Hymnal*, I found this hymn (#670). I've never heard it before (nothing new) and it says it is a stewardship hymn; in my mind, stewardship comes in many forms. It's good.

> *Take my gifts and let me love You, God who first of all loved me,*
> *gave me light and food and shelter, gave me life and set me free.*
> *Now because Your love has touched me, I have love to give away,*
> *now the bread of love is rising, loaves of love to multiply.*
>
> *Take the fruit that I have gathered from the tree your Spirit sowed,*
> *harvest of Your own compassion, juice that makes the wine of God.*
> *Spiced with humor, laced with laughter—flavor of the Jesus life,*
> *tang of risk and new adventure, taste and zest beyond belief.*
>
> *Take whatever I can offer—gifts that I have yet to find,*
> *skills that I am slow to sharpen, talents of the hand and mind,*
> *things made beautiful for others in the place where I must be:*
> *take my gifts and let me love You, God who first of all loved me.*

"Take My Gifts" – Words Shirley Erena Murray © 1992 Hope Publishing Company, Carol Stream, IL 60188. All rights reserved. Used by permission.

MONDAY

I am beginning to collect some sayings, songs, quotes, etc., that speak to me at certain times along this journey. Some I get out of books, some are songs of

popular singers, some I even get off Facebook that are passed along. I'll share some of these and will give credit when I know who says it.

"Sometimes life takes us places we never expected to go. And in those places God writes a story we never thought would be ours" (Renee Swope). That is certainly true in our case.

I hate cancer and all the ways it has robbed me of things I want to do, but I am interested in this new story God is writing for my life. I am finding more and more blessings along the way. —Susie

Lord, I lay my life before You,
here I give to You my all.
I will follow where You lead me;
I have heard Your Spirit call.
I will live my life in service
as a mirror of Your grace –
living always in Your presence,
looking always toward Your face.

Savior, keep me ever near You
as I travel down this road.
Let me always lean on You, Lord,
for the strength to bear the load.
Lord, remind me, on this journey
I will never be alone.
You will guide me and protect me,
for You claim me as Your own.

"Lord, I Lay My Life Before You" – Jan McGuire © 2010 Celebrating Grace Music, a division of Celebrating Grace, Inc. All rights reserved.

MONDAY

> *When upon life's billows you are tempest tossed,*
> *when you are discouraged thinking all is lost,*
> *count your many blessings, name them one by one,*
> *and it will surprise you what the Lord hath done.*
>
> *Count your blessings, name them one by one;*
> *count your blessings, see what God hath done.*
> "COUNT YOUR BLESSINGS" – JOHNSON OATMAN JR.

This has been the song I have sung since Wednesday. My brother Randy came that day, all of our kids and families came on Friday, and Mark came back home on Sunday. I was not only able to name some of my blessings, I was able to see and hug them. Families are so important, and I am thankful for all of mine. These are blood families, but I am also thankful for my "heart" families. God has given us wonderful people to love.

Tomorrow is the last infusion of this round, and then later a CT scan to find out if these new drugs are working. I don't know if we will do the scan before or after our trip. Please continue to pray that the drugs are working, for minimal side effects (I still have the cold sensation in my hands), that my toe will heal quickly. Goodness, that sounds like so much to ask. Thank you for your prayers and support.

WEDNESDAY

Hymn 78 in *Celebrating Grace Hymnal* appears in the Lenten section of the book. That may be so, but I think it is very appropriate for any time of year.

And I think it is just right for tonight.

How deep the Father's love for us, how vast beyond all measure;
that He should give His only Son to make a wretch His treasure.
How great the pain of searing loss; the Father turns His face away
as wounds which mar the Chosen One bring many unto glory.

Behold the Man upon a cross, my sin upon His shoulders;
ashamed, I hear my mocking voice call out among the scoffers.
It was my sin that held Him there until it was accomplished.
His dying breath has brought me life; I know that it is finished.

I will not boast in anything: no gifts, no power, no wisdom;
but I will boast in Jesus Christ; His death and resurrection.
Why should I gain from His reward? I cannot give an answer.
But this I know with all my heart: His wounds have paid my ransom.

We love each of you and appreciate you more than words
tell. God continues to bless us overwhelmingly and we are so
thankful. "How can I keep from singing?" —Susie

WEDNESDAY

This is the day the Lord has made, and I am exceeding glad. Beautiful colors are beginning to really come alive and I still marvel. I don't think I will ever get used to seeing the amazing colors every fall. Last week I had my last infusion of round four. All the side effects of the chemo happened right on schedule, and those are subsiding. I am blown away by the cards I receive from people I have never met and probably won't. Today the following was on a card. I have heard it before but it was a good reminder of how limited cancer is:

> *Cancer is so limited...*
>> *It cannot cripple love.*
>> *It cannot shatter hope.*
>> *It cannot corrode faith.*
>> *It cannot destroy peace.*
>> *It cannot kill friendship.*
>> *It cannot suppress memories.*
>> *It cannot silence courage.*
>> *It cannot invade the soul.*
>> *It cannot steal eternal life.*
>> *It cannot conquer the spirit.*

The author is unknown, but I think he/she sums it up pretty well.

MONDAY

God's promise:

> *I am your refuge, I am your strength.*

I am your helper in time of trouble;
 so do not fear, no, do not fear for I am your God.

And when you pass through the waters, I will be with you.
And when you cross o'er the river, I will be your guide.
And when you walk through the fire, you'll not be burned,
 for I am your God.

And my response:

You are my refuge, You are my strength.
You are my helper in time of trouble;
 I will not fear, I will not fear, for You are my God.
You are my God.

This is our friend Keith's anthem – so beautiful the words and music. This is my go-to song whenever… I have God's promise, and He has my response. What more could I want? Not a thing. And I am so thankful and comforted. This doesn't mean I've got it all together—not even close. It does mean we have His grace and love to guide us and give us peace.

Tomorrow we get the results of the CT scan done on Friday. We are so very thankful for each of you. So whatever Dr. Penley tells us about the scan, we will not fear because we know without a doubt Who is in control, and He will provide all we need.

I am anxious because not knowing some things does that to me. But when I sing these words and claim His promise, I am calmed. And knowing of our herd's prayers always helps and encourages us. —Susie

Thanks so much for your prayers. We are thankful and we feel God's assurance and presence. We had a less than good report from Dr. Penley. It was not a surprise to any of us that the scan shows no new tumors but larger ones, meaning the meds I have been taking are not doing the job. The first meds I took were the big guns for colon cancer, and they are the ones that almost put me under. So we cut back on the dosage. The CT scan after those six infusions showed no signs of shrinking, so we changed to something else less toxic to my system. Apparently my tumors are resistant to drugs. Dr. Penley is contacting labs to find out what other drugs are out there that we might try. He will use these next three weeks to put together another plan. We will talk about it and then decide what we want to do.

The day has been a trying one. I admit that I had a meltdown about 10 this morning, but Mark was so good. He didn't try to offer any explanations or make light of the situation. He was just there with just the right "whatever" I needed. What a blessing he is. After we left Dr. Penley's office, I asked Mark if this was the time to wonder if prayer works. As soon as I got those words out of my mouth, I said no. Here I am relatively healthy, able to get out and go to church, do retail therapy, take a trip, be with people I love, have a pretty normal life.

In the waiting room we saw a woman who may have been younger than I, in a wheelchair being helped by someone who might be her husband. She looked like she was having a really bad day and probably has experienced many bad days recently. I said a short prayer for her. After I asked and answered my "does prayer work" question, I remembered this lady and lots of others who are suffering so much more than I am.

Yes, we have been praying for the tumors to shrink and the meds to work. We have also prayed that I will have good days. We have prayed for other friends who have serious illnesses to be healed and they have been. So, yes,

prayers do work. I don't remember who said it, but "God gives His presence even when He doesn't give His protection." We have experienced this time and time again on this journey.

We are human and we still have our meltdowns and pity parties, but they don't last long and we soon recognize and feel His overwhelming presence. Such is today. We are very disappointed about the scan results and the ineffectiveness of the drugs, but we know Who holds the future—and all we have needed, His hand has provided.

For years we have sung this benediction written by our dear friend David for one of our anniversaries at First Baptist Church. The text is from the *Book of Common Prayer* and our choir—along with some of us in the balcony—sang it last Sunday at church. I think many can sing it with me now:

> *Direct us, O Lord, in all our doings, with thy most gracious favor.*
> *Direct us, O Lord, and further us with Thy continual help;*
>> *that in all our works begun, continued and ended in Thee,*
>> *we may glorify Thy name and receive everlasting life,*
>> *through Jesus Christ our Lord. Amen.*

"PRAYER FOR BLESSING" – WORDS ADAPTED FROM THE BOOK OF COMMON PRAYER. TEXT ADAPTION BY DAVID SCHWOEBEL. MUSIC BY DAVID SCHWOEBEL © 1986 BY HINSHAW MUSIC, INC. USED BY PERMISSION.

It sings better than it writes!

Thank you, dearest herd in the whole world.
You continue to be God's hands and feet in your
ministry to us. Thank you for your prayers and always
know that we may not understand things,
but God is constantly blessing us. —Susie

There is sunshine in my soul today,
more glorious and bright
than glows in any earthly sky,
for Jesus is my light.

There is music in my soul today,
a carol to my King;
and Jesus, listening can hear
the songs I cannot sing.

There is music in my soul today,
for when my Lord is near,
the dove of peace sings in my heart,
the flow'rs of grace appear.

There is gladness in my soul today,
and hope and praise and love
for blessings which He gives me now,
for joys "laid up" above.

REFRAIN

O there's sunshine, blessed sunshine,
when the peaceful, happy moments roll;
when Jesus shows His smiling face,
there is sunshine in my soul.

"SUNSHINE IN MY SOUL" – ELIZA E. HEWITT

A friend reminded me today of this song and especially the second verse. Jesus hears the songs we can't sing, the words we can't say, whether they are words of sadness, grief, or extreme joy. He hears, He loves, He is present, He is Alpha and Omega.

Thank you, everyone, for your comments. They are so encouraging and a reminder that we aren't traveling this path alone. There are so many friends in Tennessee, Alabama, Texas, South Carolina, and other states I can't remember who are praying for us. Some of you are friends we have known for many years, others we have never met. You are God's blessings to us, and we thank Him for you.

MONDAY

Right now I have so many songs swirling around in my head that I can't settle on one. They all have to do with God's provisions, His love, His peace, His constancy, His joy. I am so very thankful for His care of me, and Mark. Mark continues to be healthy, and that is reassuring to me (and to him, too). I pray for his health on a daily basis! He is one of God's major provisions for me, and I never take that for granted. We love you. Thanks for your love of us and constant prayers. You are another major provision to us during this journey.

God blesses us every day in so many ways. —Susie

I HATE CANCER. It is evil, destroys health, leaves people with little energy to enjoy life and all that goes with it, and so much more. I don't say this because I have cancer. Just this week we have learned of three good friends who have recently been diagnosed with some form of the wretched disease. One is a former pastor of ours in Natchitoches, Louisiana; another is Mark's cousin's wife; and the third is a friend I know through my editor boss at work.

Cancer doesn't care if it ruins a family financially or emotionally. It doesn't matter if you are rich or don't have two pennies to rub together. It doesn't care if you are a Christian or an unbeliever. It just doesn't care about anything. I am mad. I've been stewing about this since Tuesday when I found out about Stacy, the third friend. I don't understand what's happening to so many people we know and love. It seems cancer is everywhere.

We have prayed for people who have battled this, and they have been given the good news of remission or "no sign of the tumors." We praise God for that and thank Him. Unfortunately, we have also mourned the deaths of some others. We have grieved but have also thanked God for sustaining the families and giving them comfort and grace. It is so frustrating at times that cancer (and other evil things in this world) seems to be winning.

BUT:

> *A mighty fortress is our God, a bulwark never failing;*
> *our helper He, amid the flood of mortal ills prevailing.*
> *For still our ancient foe doth seek to work us woe;*
> *his craft and power are great, and, armed with cruel hate,*
> *on earth is not his equal.*

Did we in our own strength confide, our striving would be losing,
 were not the right Man on our side, the Man of God's own choosing.
Dost ask who that may be? Christ Jesus, it is He;
 Lord Sabbaoth, His name, from age to age the same,
 and He must win the battle.

And though this world, with devils filled, should threaten to undo us,
 we will not fear, for God has willed His truth to triumph though us.
The Prince of Darkness grim, we tremble not for him;
 his rage we can endure, for lo, his doom is sure;
 one little word shall fell him.

That word above all earthly powers, no thanks to them, abideth;
 the Spirit and the gifts are ours through Him who with us sideth.
Let goods and kindred go, this mortal life also;
 the body they may kill: God's truth abideth still,
 His kingdom is forever.

"A MIGHTY FORTRESS IS OUR GOD" – MARTIN LUTHER, CA. 1529, TRANS. FREDERICK
H. HEDGE, 1853 (PSALM 46)

Thank you for letting me vent and get this out of my system. Now maybe I can get on with the good things that I have to be thankful for—and there are so many. I am thankful for each of you, our herd. What a blessing you are to us. I am thankful for Dr. Penley and his staff. They are compassionate professionals who minister to us on good days and trying days. I am thankful for Mark, who always puts my needs before his own and takes such good care of me. I am thankful that we had a wonderful trip to Texas and New Mexico, and that I have been feeling good lately. I am thankful for family and "heart family." I am thankful for a church community who ministers to us in prayers and thoughts. There are so many more things I could name, but I'll save them for another time.

You truly represent God on earth and sustain us
on days that aren't so good. —Susie

TUESDAY

We had a consult with Dr. Penley hoping he would have a new plan of action. No such luck. He had contacted several labs before we went on our Texas/ New Mexico trip, but he has not heard from them yet. That was disappointing, but he did say there were some options available that we could explore. I am not a candidate for any clinical trial plans because of my previous cancer.

That was, again, disappointing, but understandable since they want to collect the most accurate medical results for the chemo drugs. I go back in two weeks, and by that time he ought to have some news and we'll start on something else. He's giving me Thanksgiving off, and we are planning on my feeling good when all our family is here to celebrate a time of thanks and family. I'm for that.

It was so good to be at church Sunday and worship with so many heart families. I am thankful for each hug and smile and handshake. That is good medicine, and the side effects are all positive. Thank you for each prayer, thought, and love support that you offer for us. We feel them, and they go a long way to encourage us.

> *My Shepherd will supply my need; Jehovah is His name;*
> *in pastures fresh He makes me feed beside the living stream.*
> *He brings my wandering spirit back when I forsake His ways;*
> *and leads me, for His mercy's sake, in paths of truth and grace.*
>
> *When I walk through the shades of death, Thy presence is my stay;*
> *one word of Thy supporting breath drives all my fears away.*
> *Thy hand, in sight of all my foes, doth still my table spread;*
> *my cup with blessings overflows, Thine oil anoints my head.*
>
> *The sure provisions of my God attend me all my days;*
> *O may Thy house be my abode, and all my work be praise.*
> *There would I find a settled rest, while others go and come;*
> *no more a stranger, nor a guest, but like a child at home.*
>
> *"MY SHEPHERD WILL SUPPLY MY NEED"* – ISAAC WATTS, 1719 (PSALM 23)

Our whole family is coming in for Thanksgiving, and we are excited about that. Marianne has offered to help with the Thanksgiving table, and we appreciate that. She is a wonderful cook and has provided many meals for us during the last twenty-plus months. She is very generous. I'll do some of the cooking, and the kids and spouses will pitch in, as always. We'll try to keep it simple—we'll see how that works for me!

I thank You, Lord, for each new day, for meadows white with dew,
for the sun's warm hand upon the earth, for skies of endless blue,
for fruit and flower, for lamb and leaf, for every bird that sings,
with grateful heart I thank You, Lord, for all these simple things.

I thank You, Lord, for wind and rain and for the silver moon,
for every daisy's lifted face, for every lovely tune,
for winter's white, for autumn's gold, for harvest and for home,
with grateful heart I thank You, Lord, for each good gift I own.

I thank You, Lord, for hand and heart to offer up Your praise.
I thank You, Lord, for tongue to speak of all Your loving ways.
For health and strength, for work and play, for loved ones far and near,
with grateful heart I thank You, Lord, for all that I hold dear.

"WITH GRATEFUL HEART I THANK YOU, LORD" – WORDS AND MUSIC BY MARY KAY BEALL © 1991 HOPE PUBLISHING COMPANY, CAROL STREAM, IL 60188. ALL RIGHTS RESERVED. USED BY PERMISSION.

We hope you all have a wonderful Thanksgiving week with family and friends.

Always know that we thank God for each of you
and count you as treasured blessings. —Susie

DECEMBER 16, 2014

Advent is full of exciting things—class parties, church music programs, shopping, cooking, decorating, wrapping, time with family and heart families—and much, much more. Make the most of the time you have and make lots of memories.

The list is long of all the things I want to be involved in, but alas, the spirit is willing but the body is very weak. I'm still trying to learn how to pace myself, but in that area, I'm a very slow learner. I think I'm doing pretty well until the day after, and I'm paying for my transgressions. Some things are worth the recliner days: like the day after I've been to church and had lots of wonderful hugs and warm smiles and being with our heart family. It doesn't get any better than that. We have cherished friendships, and those blessings can't be counted or denied.

This is a week of doctor visits on a daily basis, church staff party, MRI, PT for Mark, *Baptist and Reflector* Christmas lunch, and a new doctor. I'm happy to explain the last.

Some of you may know our son, Nathan, works for Surgical Care Affiliates, a company that does business with free-standing outpatient surgery facilities. His territory includes Tennessee, Kentucky, and Ohio. That's the reason he gets to stop by here on his way to meetings, and we get quick but wonderful visits. Until recently Vanderbilt Medical Center was one of his facilities. He has offered on several occasions to contact doctors connected with Vanderbilt on our behalf. Even though SCA is no longer connected with Vanderbilt, he met a lot of wonderful doctors. After our last meeting with Dr. Penley, he told us there really were no other viable options for my medical treatments. Nathan again offered to help any way he could.

Mid-Sunday morning he contacted a Dr. Sternburg at Vanderbilt via e-mail asking if Dr. Sternburg could look at my medical records and maybe suggest an oncologist we could see. As Mark and I sat down in the balcony Sunday

morning, we received a Nathan-forwarded e-mail from a Dr. Neuss, chief medical officer at Vanderbilt-Ingram Cancer Center, saying he would be glad to talk to us about my case and to call him on Monday morning.

I also talked to Sharon, a church member and oncology nurse at the cancer center, about doctors there. At 8:05 Monday morning I called the number Dr. Neuss had given Nathan, and the doctor himself answered on the first ring. I was very surprised. It was evident he had been looking at my information before I called, and we talked about fifteen minutes. He said he would talk to some people and get back with me.

Shortly after lunch, Pam called from Dr. Neuss' office, took some more information, and set up an appointment for me with Dr. Berlin for 2:00 p.m. Friday, as in this coming Friday. Again, everyone I talked to was so nice and helpful. We feel very good about this and so appreciate Nathan having wonderful contacts and doctors who are so helpful and compassionate. Dr. Neuss was very open and let us know that there may not be another treatment option and we certainly know that, but he was willing to look at all my records and scans (and there are many) and see what can be done.

We do not believe in coincidences but providence. From the beginning of the cancer journey, doctors have been in the right places at the right times, and we have felt good about our treatment and our doctors and nurses. We are going to the appointment with feelings of excitement, optimism, and thankfulness. If Dr. Berlin finds a new plan, we will be thankful. If he doesn't, we will be thankful. God has been working in and through all of this for twenty-plus months, and we don't expect He'll quit now. Our faith is still strong and sure, and we know Who holds the future.

That was a very long explanation of things that have happened in that area just since Sunday morning. Please pray for Dr. Berlin and that if there is some treatment out there, that he will find it and I might be a candidate. Thank you, wonderful herd, for your continued faithfulness on our behalf. We love you and are so overwhelmed by your love, prayers, support, and generosity during these long months. We could not ask for anyone more giving than you have been. You are wonderful and we are thankful.

"When upon life's billows we are tempest tossed, when we are discouraged thinking all is lost. Count your many blessings, name them one by one, and it will surprise you what the Lord has done." That is so true but why are we surprised? I'm embarrassed to say I am and shouldn't be. —Susie

O the deep, deep love of Jesus, vast, unmeasured, boundless, free,
 rolling as a mighty ocean in its fullness over me!
Underneath me, all around me is the current of His love,
 leading onward, leading homeward, to that glorious rest above.

O the deep, deep love of Jesus, spread His praise from shore to shore!
He who loves us, ever loves us, changes never, nevermore;
 He, who died to save His loved ones, intercedes for them above;
 He, who called them His own people, watches over them in love.

O the deep, deep love of Jesus, love of every love the best!
Vast the ocean of His blessing, sweet the haven of His rest!
O the deep, deep love of Jesus—for my heaven of heavens is He;
 This my everlasting glory—Jesus' mighty love for me!

"O THE DEEP, DEEP LOVE OF JESUS" – SAMUEL TREVOR FRANCIS, 1898, ALT.

This is the day the Lord has made, we will rejoice and be glad in it. We are rejoicing and are glad, but maybe even a little more so today.

We had our appointment with Dr. Berlin this afternoon an hour after the scheduled time. That didn't matter. We were just glad to have gotten an appointment this week. I had never been in the Vanderbilt-Ingram Cancer Center, and we were very impressed. Once again we can say that all along this cancer journey the doctors, nurses, and facilities have been extremely impressive. We have thoroughly enjoyed our association with these medical professionals. They are all well-educated and knowledgeable in their field. But more than that, they are compassionate, caring people and truly have the patient's well-being and best interests in mind.

Sharon, friend and church member, came to see us when we arrived. She has worked at Vanderbilt for many years, and as she says, "I feel like this is my home, and I want to welcome my guests." And she did exactly that. It wasn't long before we saw Sherry, also a friend and church member. She has worked there two years, and when I asked her what she did, those around us said, "What doesn't she do?" She helped us get checked in quickly and even when she spotted Dr. Berlin, she brought him over to us and introduced us. With Nathan's help putting us in contact with the right people at Vanderbilt, Sharon also helping with her connections with the Vanderbilt doctors, and Sherry putting in her two cents worth, we are again convinced that it is not what you know but who you know!!!

Dr. Berlin makes a very good first impression, being warm, caring, inviting your trust, friendly. He pulled up my scans, called Dr. Penley (at 4 p.m. on the Friday afternoon before Christmas week), conferred with two radiologists there on site, and talked with us between all of those doctor consults. Part of me thinks he left the room because he could tell by the look in my eyes that we were getting WTMI (waaaaaay too much information)!

He and the radiologists concluded the scans needed to be redone and reread. So the first step is to have a CT scan done Monday night at 9 at Vanderbilt and within twenty-four hours, he will contact us with their findings. The best news is that we do have options, several, and it is a matter of choosing which one is best for me. I may even be eligible for some trials. Dr. Berlin knows Dr. Penley professionally and personally, and they work together often with great respect for each other.

I think this is all I'll share right now. You may be experiencing WTMI, too, and I think that is probably all I know myself at this time. Needless to say we are very optimistic and hopeful—of course we have always had hope.

Since we started doing the updates and many of you have written comments, Mark and I have discussed how much the messages from each of you have meant to us. You say things like how we are an inspiration, and how our words and the hymns encourage you and mean so much to you. Well, your words and messages inspire us, bless us, and encourage us. When I read the comments, I thank God for the one commenting, and think how you make me stronger and encourage me to hang in there; your prayers are always with us. You send just the right words to help at just the right time. Thank you for being God's people. God has done, and continues to do, amazing things in my life, our lives. I am thankful He is using me in whatever way He can. That is a scary, humbling thought.

Reports from my other doctors this week: Dr. Donna says my brain is still intact and sinuses are better; Dr. Wheelock says things are good from the ovarian angle. I'm glad this week is over because I'm not sure I could stand too much good news overload.

> *My life flows on in endless song; above earth's lamentation,*
> *I hear the sweet, though far-off hymn that hails the new creation.*
> *Through all the tumult and the strife, I hear the music ringing;*
> *it finds an echo in my soul—how can I keep from singing?*

What though my joys and comforts die? My Savior still is living,
What though the shadows gather 'round? A new song Christ is giving.
No storm can shake my inmost calm, while to that Rock I'm clinging;
* since Christ is Lord of heaven and earth, how can I keep from singing?*

I lift my eyes; the cloud grows thin; I see the blue above it;
* and day by day this pathway smooths, since first I learned to love it.*
The peace of Christ makes fresh my heart, a fountain ever springing;
* all things are mine since I am His—how can I keep from singing?*

"HOW CAN I KEEP FROM SINGING" – ROBERT LOWRY, 1869

Thank you, wonderful herd, for being you to us and helping us in so many ways. We cannot thank you enough. Affirmation that prayers do work.

It is 8 p.m. while I am writing this. We didn't leave Vanderbilt until after 5 p.m. Dr. Berlin just called offering more explanations about the CT scans that had been taken. More good news is that my tumors are not where they were in March, but they haven't grown like we had thought they had. Amazing.

We wish hope, peace, joy, and love to each of you this Advent season. Worship the Christ child, born the King of kings.

We have so many things to be thankful for. God continues to bless us overwhelmingly. and we are overwhelmingly thankful. We serve an amazing God who doesn't promise to protect us from bad things but does promise us to give us His presence. What more could we ask for? Nothing. —Susie

DECEMBER 22, 2014

Wow! What a day! Today was scheduled to be fairly quiet, knowing that Honey would have a 9 p.m. CT scan and I would have a mid-afternoon PT session. WRONG! The phone rang about 9 a.m.—VUMC—saying Honey's scan was now scheduled for noon and then another call thirty minutes later—Dr. Berlin's office—reporting that they had made arrangements for Honey to see the doc at 2:15 TODAY to discuss scan results. We are impressed with the speed with which things are getting done.

My work in the shop on three Christmas projects was truncated, I grabbed a quick shower, and we left about 10:45 to allow us time to have a bite to eat close to the hospital and check-in at the appointed time. The scan finally happened about 1 p.m., and then we walked down the "never-ending hall" (so labeled by Ainsley, last week's Cancer Center checker-inner) to the cancer center, arriving shortly before 2. The doc wasn't able to arrive until 3, but he brought with him better news than we've had of late. The new scan revealed that the most recent round of chemo Honey endured, indeed, has had some positive effect on her tumors. (Apparently some kind of computer glitch had skewed earlier sequence of scans that neither Dr. Penley nor Dr. Berlin had discovered until the latter took a closer look last week and verified with his in-house radiologists.)

Bottom line is that Honey will resume chemo using the same meds as her latest round, and it all begins Friday of this week at 8:15 a.m. She will return to Tennessee Oncology for those treatments, but will have scans at Vanderbilt. We don't really understand that kind of arrangement, but we love and trust both docs, and they work together frequently on patients; so Honey will be one of those. It seems to us that this will be the best of both worlds—we'll let you know.

We left the Medical Center and went by Bucky and Joann's house to pick up the takeout for dinner. What a blessing that Meal Train continues to be.

We were able to go to church yesterday and collect hugs from many of our faithful herd … and more hugs at the restaurant afterwards. We had planned to attend the annual Carol-Candlelight service last night, but I had not fully lost my persistent cough, and Honey was not up to it and needed to rest up for the busy week. Little did we know just how busy it would be … already!

Tomorrow I'm helping with the funeral of one of Honey's special senior adult friends, Vern. Many of you know Vern and of his extended ministry until his death at ninety-four-plus years. Who's gonna fill his shoes?

Weslee and crew show up here Wednesday and Nathan's gang Thursday night. They'll all be here a few days, so business will pick up in a most wonderful way.

In the waiting room someplace today, I was emailing a professor friend in West Texas telling him of our almost two-year journey. A stanza of a good hymn came to mind; I shared it with him and here with you:

All the way my Savior leads me;
cheers each winding path I tread,
gives me grace for every trial,
feeds me with the living bread;
though my weary steps may falter,
and my soul athirst may be,
gushing from the Rock before me, lo!
a spring of joy I see.
"ALL THE WAY MY SAVIOR LEADS ME" – FANNY J. CROSBY, 1875

Merry Christmas from our house to yours!

There are so many of those phrases that neither Honey nor I fully understand—tender mercies. a guided life. heavenly peace. and divinest comfort—but I'm tellin' ya. we're experiencing all of it around here. and our hearts are glad and grateful. —Mark

Wesley

Nathan and I had decided that for Christmas this year, our present to Mom and Dad wouldn't be found in a box but instead would be found in the gift of time spent together. The adults were going to have dinner together without the children and with help from Lori, Sherry, and David.

Mom wasn't up to taking us up on the gift Friday night, so we punted and had pizza at home with the children. That night, though not what we had planned, had its own fond memories. One such memory that I have of Friday night was that while talking to Mom in her room she began mentioning other friends who were battling health issues. In the middle of listing those she was sure to thank God for the blessing He continues to bestow upon her. She amazes me.

Sunday we were going to bring Mom to church where Dad was leading music and we had plans to all be there. But true to fashion, our plans don't always matter. Mom woke up early with a backache that kept her horizontal for most of the morning. By the time we got home from church it wasn't any better and seemed to be getting worse, so a quick call to Dr. Donna and meds were en route.

Around 5 p.m. I went in to check on Mom and to see how the meds were working. As she tried to roll over and pain had not subsided, the next statement out of her mouth was, "I am so blessed." It blew me away. Always thankful, no matter what! About 8 p.m. Dad convinced Mom that a trip to the ER might be a good idea just to be on the safe side. We got in and were seen pretty quickly.

We had wonderful nurses, and of course Mom made lots of friends even while she was in pain, which is exactly like we know Mom to be. She said her Pleases and Thank-yous, learned everyone's names, and made sure to thank them by name before they left. Have I mentioned that Mom is amazing?

So here we sit. Waiting. Making friends. Waiting some more. Trying to make Mom laugh. Mom trying to make sure everyone else is taken care of. Waiting. Talking. Sharing. Waiting. Making more friends. Now it's 5:27 … a.m.

My faith has found a resting place,
not in device nor creed;
I trust the Ever-living One,
His wounds for me shall plead.

Enough for me that Jesus saves,
this ends my fear and doubt;
a sinful soul I come to Him,
He'll never cast me out.

My great Physician heals the sick,
the lost He came to save;
for me His precious blood He shed,
for me His life He gave.

REFRAIN

I need no other argument, I need no other plea,
it is enough that Jesus died, and that He died for me.

"MY FAITH HAS FOUND A RESTING PLACE"– LIDIE EDMUNDS, CA. 1890

DECEMBER 29, 2014

Greetings from our home away from home—the sixth floor of St. Thomas Midtown Hospital. We've spent at least two dozen nights in this very wing/floor during the past two years. We landed here at midnight last night after four hours in the ER. Honey had an MRI this morning that showed a compression fracture at T5, which completely explains the severe pain that brought us here. Since she has not fallen, lifted anything heavy, or had an episode of any kind, docs are suspecting that her cancer has metastasized to those bones. This is not good news.

Tomorrow morning they plan to do a procedure that injects cement to the affected area to relieve the compression and thus the pain. While there they will do a biopsy to prove or disprove their theory. If they are right, they can use radiation to control the pain. She is currently on heavy doses of IV pain meds. (Over there sacked out most of the time, she's not very helpful or talkative to Wes and me, but somehow she seems be able to call her "meddies" by name. You get the idea that's important to her.) Everything is about pain management rather than anything curative. This is both good and not so good.

Weslee sent her family back home to West Tennessee—hubby Chris is a real keeper—while she and I play tag team the next couple of days. At her "encouragement" Nathan is staying put in Alabama for the time being, but the two of them are in near constant contact. Responsible and attentive adult children are only one blessing for which we are grateful these days.

Other blessings are the wonderful medical people close at hand; long-tenured careers that provided the means for adequate health insurance; and a herd of gracious, generous, and supportive people traveling this hard journey alongside.

Here is a stanza we sang from the *Celebrating Grace Hymnal* (#419) at First Baptist yesterday:

Jesus is Lord, the tomb is gloriously empty;
* not even death could crush this King of Love.*
The price is paid, the chains are loosed, and we're forgiven;
* and we can run into the arms of God.*

Get out of the way. or better yet.
lock arms with us ... and RUN! —Mark

Sweet Tom and Julie:

The orchid arrived the other day. When it arrived, it reminded me of our time in Hawaii! Thank you for bringing wonderful memories into our home. Thank you not only for the beautiful flower, but for the special relationship we enjoy. It's hard to believe that this relationship started over seven years ago! It was a God-given thing, and we are thankful.

We love you,
Mark and Susie
(scribe: Martha)

DECEMBER 30, 2014

Mark

I discovered that the best way to sleep well on a hospital room recliner is to get zero sleep the night before. The contours of that chair fit my back and bottom just fine. Grace comes in all forms and shapes.

Honey had her kyphoplasty [the surgical filling of an injured or collapsed vertebra] mid-morning, which reportedly provides instant pain relief in most cases. Apparently, Honey is an exception to those high odds because four-plus hours later, she's still waiting … and hurting. Dealing with her illness is so much easier for me than handling her suffering—that's the hard part. But the docs are zapping her with other relief agents, which relax her and make her sleepy.

Ahead of her procedure I accompanied her to the procedure room. Sitting there observing the flurry of activity in preparation for her, six personnel, all the equipment, etc., one begins to realize some of the whole arena of health-care costs. Wow! The second thing that came to mind was the awareness that there are many people in the world with health issues just like Honey's—some even worse—for whom this kind of medical care is not even an option. Oh my soul! Didn't they know better than to be born in that part of the world or into those circumstances?

This doesn't seem to be one of our brighter days along this stretch, but in the midst of Honey's most painful episode after arriving back in her room, our friend Linda brought her a candle to provide some symbolic light of hope when things seem a little dark. (LIGHT THAT THING!) Hovered over Honey's bed, I was able to get only a glimpse of Angel Linda, and she was gone.

Now at 4 p.m., a single sign that Honey is making at least some improvement emerges. Nurse Ellen reports that Honey can now think about what she'd like for dinner later. Honey has had nearly no food at all since noon

Sunday, so, consulting the in-house room-service menu, Weslee offers aloud, "chicken noodle soup, vegetable soup, tomato soup." No response. Minutes later … .still no response. A couple minutes later, eyes still shut and in a raspy voice, "Hamburger!"

We're waiting on the docs involved to huddle and decide on the best plan ahead, which most likely will include pain-controlling radiation; when that will start; requirements for our going home; … oh, and one hamburger. Under the circumstances, we certainly don't mind being here and we are enjoying finding new friends. Wes just overheard nurse Ellen say to a doc out in the hall that the patient in room 28 is just wonderful. Anyone surprised that she was referring to Honey?

Today, we're leaning especially hard into these wonderful words of life:

> *Pardon for sin and a peace that endureth,*
> *Thine own dear presence to cheer and to guide;*
> *strength for today and bright hope for tomorrow,*
> *blessings all mine, with ten thousand beside!*

"GREAT IS THY FAITHFULNESS" – WORDS THOMAS O. CHISHOLM © 1923, REN. 1951 HOPE PUBLISHING COMPANY, CAROL STREAM, IL 60188. ALL RIGHTS RESERVED. USED BY PERMISSION.

Thanks for looking in on us today … yet again. It is helpful to be able to share this steep journey with you. —Mark

Mark

The hospitalist—a new term to me that translates into an M.D. who only works sections of the hospital, quarterbacking care—is making noises like we might go home sometime later in the week and possibly begin daily radiation treatments beginning Monday. All of that is still preliminary chatter pending biopsy results, and Honey making some progress in the mobility and eating departments.

Weslee is on her way back home. We so enjoy what she brings to any room, and this week, a hospital room. She and Nathan are in very close communication about our situation and, as someone observed just today, are maintaining a healthy balance of presence and distance. We couldn't ask for more or better. It is also gratifying to see how their respective wide circles in Martin, Tennessee, and Birmingham, Alabama, continue to encircle us.

The staff (nursing and otherwise) around here is wonderful—personable, professional, and seem to appreciate being appreciated. Honey excels at that. While mopping our floor this morning, the housekeeper and I had a delightful conversation that centered mostly on matters of faith. She is bringing in the New Year at her East Nashville church and seems to live in the part of the Advent season some of us often neglect: the glorious return of Jesus. She's not obnoxious about it at all, but probably thinks about and looks toward it more than some of the rest of us. Good folks, this bunch!

Honey is over there asleep (again), not wanting anything to eat, gently fighting to get better, and appreciating everything everyone is doing to help her get there.

> *For the joy of human love, brother, sister, parent, child,*
> *friends on earth, and friends above, for all gentle thoughts and mild:*
> *Lord of all, to Thee we raise this our hymn of grateful praise.*
> "FOR THE BEAUTY OF THE EARTH" – FOLLIOTT S. PIERPOINT, 1864, ALT.

Honey and I are so grateful for your many and continuous expressions of love and support, for your "gentle thoughts and mild." Oh yeah, and Happy New Year! —Mark

Great God, we sing Your guiding hand
by which supported still we stand;
the opening year Your mercy shows;
that mercy crowns it till its close.

By day, by night, at home, abroad,
still are we guarded by our God;
by His incessant bounty fed,
by His unerring council led.

With grateful hearts the past we own;
the future, all to us unknown,
we to Your guardian care commit,
and peaceful leave before Your feet.

In scenes exalted or depressed,
You are our joy, You are our rest;
Your goodness all our hopes shall raise,
adored through all our changing days.

"GREAT GOD, WE SING YOUR GUIDING HAND" – PHILIP DODDRIDGE

THURSDAY

Our patient is more alert today, but between pushes of the magic med button, she reports a pain level of 8. Once the button is pushed, she drifts off to sleep pretty quickly. Morning victories today include a semi-shower, a "full" hair-washing, standing on her own at the sink to brush teeth, and a very short walk out in the hall with coaching of the physical therapist, April, assistance of a walker, and me managing her fluid tower. We looked like a bloomin' train inching along down the hall, but at least we're moving forward in the mobility department.

We're still waiting on results from the bone biopsy, which will determine the next plan treatment-wise. We will be here until Honey can get around better and her pain is under control to a manageable level of 3 or 4 on a scale of 1 to 10. We're not there yet. Everyone around here has "lost" their holiday today, so there seems to be a little extra camaraderie up and down these halls. We're all in that same boat, so why not make the best of it? Honey's helpers are always nice, but today seem a bit more relaxed as they go about their many tasks. Good job, everybody!

> *Blest be the tie that binds our hearts in Christian love, (Amen!)*
> *the fellowship of kindred minds is like to that above. (Good!)*

Yep, that describes y'all and us.

> *Thy bountiful care, what tongue can recite?*
> *It breathes in the air, it shines in the light,*
> *it streams from the hills, it descends to the plain,*
> *and sweetly distills in the dew and the rain.*
>
> *"O Worship the King"* – Words Robert Grant, 1833

The image of God's care streaming and descending
to this hospital room and into our home is a good one.
Me think it bountiful. —Mark

Kent and Kathy brought Honey a canvas wall hanging about the size of a floor tile that reads,

> *Peace.*
>> *It does not mean to be in a place*
>> *where there is no noise, trouble*
>> *or hard work. It means to be in*
>> *the midst of those things and still*
>> *be calm in your heart.*

Those lines could easily be included in the 121st Psalm and make perfect sense and even harmony. Thanks, Kathy and Kent. We found a spot in our hospital room where Honey and her helpers can see it.

MONDAY

We're home! Honey was evicted, freed, released, and blessed at noon today, much to our surprise and delight. Preparing to leave, sweet nurse Jamie (who had "gone the distance" with Honey the past two days) explained med instructions, hugged her, gave us parting instructions, hugged her, rolled her out to the car, hugged her, and sent us on our way.

Tomorrow morning she has an appointment with Dr. Penley, and hopefully he will have biopsy results and a definitive plan moving forward. Words are woefully weak to express our gratitude for your gestures of support and words of encouragement. You are so ably and faithfully embodying the human side of "all I have needed, God's hand hath provided."

This is the day the Lord has made, and it was a gorgeous day. I am back among the living, and I'm thankful for that. Once again God has provided with good medical professionals and facilities, and a praying herd that is so faithful and generous with the prayers.

We went to the ER Sunday night (12/28) and through my muddled brain I heard stuff like, "surgery," "radiation," "cement," "bone cancer," and such. All I could think was, "Oh great, one more thing to get a handle on." Fortunately, I didn't have too long to think about that since I had some really good pain meds and was in and out of sleep much of the night. Once again, my nurses were the very best, and we knew that St. Thomas Midtown is more than just a job. They are caring, compassionate ladies who really want the well-being of the patient to be the priority.

We had so many people come by to see us, pray with us, and just visit. Thank you, each one, for just being there for us—again. God, the Father, came to visit us in the hospital, just like it says in the Bible.

My heart is so full of emotions at this time. So much happened the last weeks of 2014 that makes my heart sad. Our precious friend Vern died before Christmas, and then beautiful lovely lady Gayle passed away shortly there-after. Sometimes it is hard to take it all in, but God gives us grace and mercy to help us through. Thank you, Father, for providing.

This is all my muddled brain (yes, I still have it) has tonight. There are so many hymns of joy, thanksgiving, love, hope, peace, provisions that I can't settle on one. I'll write another update tomorrow and "talk" a little more. Until then, always know that we love you, are thankful for you, pray for you, and are blessed by you.

We keep needing the grace, and He keeps giving it to us. —Susie

THURSDAY

Yet another doctor day, first to try to solve some lower GI issues and then to Dr. Penley to chart the way ahead on the heels of a one-week hospital stay. The biopsy taken during the kyphoplasty ten days ago revealed that the cancer had, indeed, moved to those bones. This was disappointing, of course, but not a surprise at all. Next week Honey will have a full-body bone scan to see if there are other parts of her skeleton that need to be addressed. Monday we will meet with the doctor in the Tennessee Oncology group that deals with radiation. Chemo is scheduled to resume Monday, the nineteenth. Sounds like a fun month, huh?

Honey is tired of all this, absorbing what seems to be one punch in the gut after another, but she still maintains her sweet spirit, so thankful for all our medical helpers and our praying/encouraging herd. One specific prayer request could be for endurance, perseverance, and patience. Even though some days are harder than others, we are at peace in the heat of this battle, and we certainly thank God for that.

> *Like a river glorious is God's perfect peace,*
> *over all victorious in its bright increase;*
> *perfect, yet it floweth fuller every day;*
> *perfect, yet it groweth deeper all the way.*
> *Stayed upon Jehovah, hearts are fully blessed;*
> *finding as He promised, perfect peace and rest.*
> "LIKE A RIVER GLORIOUS" – FRANCES R. HAVERGAL, 1874

We are finding those 150-year-old words are still true.

I am not going to any more doctors ever again!!! It appears that every time I do, they find a new type of cancer, and so I figure if I don't go, I'll be better off. Does that sound right? Probably not. It was worth a try.

The GI stuff is getting better, and we are thankful. We have the very best medical people available. Donna is exceptional, and we are thankful to her on a medical professional basis and a heart family basis.

Thank you, Father:

- For Donna and her expertise
- For pharmacists who are the finest and try to help us with all the new language we have been learning over the last two years
- For two of the greatest kids I know. They are talking to each other, not unlike they always have. Now they are talking behind our backs, but in our behalf … we think. We loved watching them grow up, and they have become wonderful adults; we are so proud of them for being the strong Christian people they are
- For the best prayer warriors possible. I met another one today while doing my retail therapy. I think I have met Mary Lou before, but I got to re-meet her again
- That my taste buds were a little better tonight. I was able to enjoy more of my meal
- For my friends at Dillard's Clinique, who help me try to look healthy
- For a husband who is so caring, compassionate, loving, and patient when he's waiting for me for all my appointments, and who helps me try to keep all my meds straight—a huge job
- For a warm house, clothes, and adequate insurance to provide these necessities
- For all the blessings you give us

There are so many more things we are thankful for, but I'll save some for a later update.

Next week promises to be another very busy week. Monday, we see a new doctor, Dr. Lloyd, a radiologist at Tennessee Oncology, to let us know about the radiation treatments, and Thursday a full-body bone scan to see if there are any more of those nasty cancer cells anywhere. Please pray there are not.

"For I know the plans I have for you, plans to prosper you, to give you hope and a future." (Jeremiah 29:11)

We are really getting tired of this journey called cancer and even though our faith continues to be strong and we have so much to be thankful for, there are days of weariness. Your love and prayers keep us going. —Susie

Sweet Darling Daniel,

Thank you for praying for me. I do have some places that hurt and some days I am very tired. But your prayers help me and God hears you and helps me too.

Please keep praying.

I love you,
Honey

I wish I could write this wonderful, uplifting newsy update telling everyone how wonderful things are and how good I've felt lately and how great I feel about everything. I'm sorry, but if I'm to be real along this journey, the really ugly stuff goes with the good stuff, and this unfortunately is in the former category.

It really started Saturday when I was having a party with me as the only invitee. It had been a very painful day, and my attitude was less than positive. I came to the end of my rope about 7 p.m. Poor Mark was part of the party because he happened to be in the kitchen when I was looking for my meds. I don't know what triggered it, but the floodgates opened and we both lost it together. I didn't recognize it at the time, but this was a sweet time of healing and goodness from our healing Father. Sometimes the most precious moments are the ones we don't see at the time but dawn on us later. Sleeping on the couch for several hours before going to bed helped. Sunday was better.

Then came today—Monday, another new doctor, more treatment, more nurses, more uncertainty, more pain. As we waited in the doctor's reception room I thought about how long it has been since I have felt halfway good. I couldn't remember that feeling. I was very tired of feeling bad, and that feeling begins to work on you after a while. That's not a very good feeling. However, the doctor and nurses were very good and friendly (like I knew they would be), the radiation treatment didn't take long and wasn't painful at all, and the pain meds were working so the pain was easing off. All afternoon I spent in the manger sleeping and being "no count." So I guess I can say that this has been a better day!! In fact, I know I can say this has been a better day.

I will repeat the treatment routine every day for at least two weeks. I return to Dr. Lloyd's office downtown every day for about a twenty- to thirty-minute treatment, having Saturday and Sundays off. I understand, except for fatigue,

there will be few, if any, side effects, which is good news. This radiation targets the specific place where the bone has the tumors. I have a full-body bone scan on Thursday, and that will tell us if the tumors are anywhere else. A specific prayer request is that there are none. Thank you, praying herd.

As I type this, I am doing much better and I am aware of God's presence and grace to us all along the way. I am sorry it isn't a bird whistling, sunny day, all's-right-with-the-world update. I really have very few days like last Saturday and today.

We have some wonderful neighbors, among them Terrell and Cheris and their two sons. Terrell is a state trooper, Cheris is a schoolteacher, and their sons go to school at David Lipscomb. They are members of Brentwood Baptist and we love spending time with them—which is limited. Terrell has texted Mark several times lately just checking on us, offering dinner one night this week, and generally seeing what they can do for us. I hope everyone has neighbors like them, and I hope we can all be neighbors like them. We are blessed by them.

I do have some songs about counting blessings and being thankful; we do and we are. We send our love and hugs to each of you. My next update will be better as will tomorrow.

The bad days really help me appreciate the good ones
and all the people we have who are praying, loving,
and supporting us along the way. —Susie

Three radiation treatments down and at least seven to go. According to Dr. Lloyd, the goal of radiation is relieving pain, and so far it has not. But he also said relief is not immediate, that it takes some time for it to work. We were glad to know that, though sorry to hear it, and today we are more than ready for it to kick in. Daylong pain at her current level is no fun, and by the end of the day, Honey is worn out. Today began with a predawn low blood sugar episode, so this hump day has been especially challenging. But on the way home from radiation, Honey's dear friend Rosie cut her hair—a bright spot indeed. Even through all the pain, Honey maintains her sweet spirit and expresses appreciation for everything people do for her.

After lunch, Honey headed to the manger and stayed there all afternoon—exactly where she needed to be. According to Bro. Lloyd, the main side effect of radiation is fatigue, and that part IS immediate. Great! Just what she needs—more fatigue!

We continue to realize and celebrate the cloud of witnesses around us near and far making this climb with us. While Honey was resting, I was able to take a walk "in the bright sunlight ever rejoicing" as it were. Returning, Tom, our neighbor up the street ten or twelve houses, was out walking his dog; he hailed me down inquiring about Honey and assuring us of his and wife, Connie's, continued lifting us up during these days. We stood out there and talked of spiritual things for a good while. What a blessing and gift of God! I just don't know how people live without a faith family.

Let's see, tomorrow we hit it early. At 8 a.m., Honey gets an injection in preparation for the bone scan, followed by radiation; then three or four hours later we return for the full-body bone scan. We are still praying that the scan doesn't reveal other diseased areas in her bones that need addressing. A good report would be a huge victory, praise, and relief.

Okay, let's use that hymn reference above. It's a good 'un for today!

Walking in sunlight, all of my journey,
over the mountains, through the deep vale;
Jesus has said, "I'll never forsake thee," [whew]
promise divine that never can fail.

Shadows around me, shadows above me,
never conceal my Savior and Guide;
He is the light, in Him is no darkness;
ever I'm walking close to His side.

In the bright sunlight, ever rejoicing,
pressing my way to mansions above;
singing His praises gladly I'm walking,
walking in sunlight, sunlight of love.

[Everyone on the refrain!]

Heavenly sunlight, heavenly sunlight,
flooding my soul with glory divine:
hallelujah, I am rejoicing,
singing His praises, Jesus is mine.

"HEAVENLY SUNLIGHT" - H. J. ZELLEY, 1899

Trying to sing His praises in a strange land. —Mark

As promised last night, we hit it early this morning. Honey moved slowly and was unsteady on her feet. When we left the house I wasn't sure she would be able to make the trip. An insurance company issue necessitated changing her pain medication, and we think some of her weakness was caused by that shift. We were at St. Thomas Midtown well before 8 a.m. for an injection leading up to her body scan three hours later. From there we headed to the radiation room a couple blocks away—navigating the massive medical maze bypassing an adjoining clinic and crossing busy Church Street without ever having to go outside. All those years visiting church members in that hospital certainly paid off this morning, because I knew my way around. Fully aware she was feeling bad, I was proud of her for agreeing to use a wheelchair. Radiation doesn't take long, and we were on our way home within an hour after first arriving at the hospital.

Then back to the hospital for a 10:30 scan. En route, Honey remarked that she had less pain today than in recent days—YEA! She had perked up a little by then, and the scan didn't take long either—in and out of there in just over an hour. Nearing lunchtime, she suggested we go for some Mexican food, and she ate a good lunch. I was delighted she felt like doing that.

Back at home Judy, longtime friend and a cancer survivor herself, dropped by for a quick visit and to bring Honey a bag of goodies. So good to see her again, and we could have visited a long time. Honey headed to bed—no manger—on the bed for three hours, during which Linda conducted the Meal Train into our station, so dinner was just right. And then on her way home from work, Marilyn stopped in bearing a gift for the patient. I hope you can see some of why we remain grateful and consider ourselves blessed even along this hard journey. This is, in part, what the body of Christ looks like.

Tomorrow Honey has her last radiation treatment, then the weekend off before it and chemo resume Monday. We expect today's scan results then.

Weslee called this afternoon saying she is coming tomorrow but will leave "the noise" (her three boys) at home. We love those little guys and hubby Chris, but she brightens up the place solo. Nathan reports he's coming through toward the end of next week on a business trip. That works out just right.

We hope to see many of you at church Sunday for a least a few herd hugs. Here is a rather new hymn in the *Celebrating Grace Hymnal* (#50), a versification of Psalm 84 in which the Psalmist contemplates worshipping in the house of God.

> *How lovely, Lord, how lovely is Your abiding place;*
> *my soul is longing, fainting, to feast upon Your grace.*
> *The sparrow finds a shelter, a place to build her nest;*
> *and so Your temple calls us within its walls to rest.*
>
> *In Your blest courts to worship, O God, a single day*
> *is better than a thousand if I from You should stray.*
> *I'd rather keep the entrance and claim You as my Lord,*
> *than revel in the riches the ways of sin afford.*
>
> *A sun and shield forever are You, O God Most High;*
> *You shower us with blessings; no good will You deny.*
> *The saints, Your grace receiving, from strength to strength shall go,*
> *and from their life shall rivers of blessing overflow.*

Sit a spell and feast on those riches.
Gratitude and blessings unto each of you. —Mark

Weslee came to stay with us on Friday, and we were so glad to have her. She brings so much joy, and it is hard to feel bad or be down when she's around. She helped with shopping, running errands, and cooking. She had Mark's truck the past two weeks, and a friend was coming this way, so she had a return way home yesterday. She's always conflicted about whether or not to stay longer, but this was a good weekend. Chris and her boys had a three-day weekend, and she doesn't have clients on Mondays. Nathan is coming on Friday and will stay until sometime Saturday so that he can help Mark with his projects. Have I said we have some super kids? We do, and we are so pleased with all they do. They are appropriately attentive and always want to do whatever they can and need to do to help us.

Saturday was a day of absolute fatigue for me. Anytime I sat down and was still for thirty seconds, I either went to sleep or was on the verge of it. Sunday was the same, so Mark and Weslee had time to visit and spend time together. Today I was scheduled for another round of chemo and radiation. Dr. Penley was a little concerned about my appearance and lack of energy, so he post-poned the chemo. He also wanted me to finish the radiation this week, and then we would begin chemo alone next Monday. My bone scan showed a few random cells but no concentrated "hot spots" other than the area they are treating now with radiation; that was very good news. I'll finish the radiation, only four left and everyone seems pleased with how well that has gone. The pain level is still there, but we are working on that.

My taste is still altered, and that causes issues. Mark is so good about being willing to get me anything I would like to eat—the only problem is that I can't think of anything that sounds good, and even if it sounds good at one minute, it doesn't taste good or sound good when he gets it. I don't mind being at my weight, but I don't like how I have gotten here!!!! Gripe, gripe, gripe—I'm never happy! I also have to be careful with dehydration. I stay very thirsty all day and I drink all day, but apparently it's not enough. I'll try harder.

Thank you, herd, for your love, prayers, and for being the blessing you have been for many years and especially for the nearly two years this cancer journey has lasted. We can feel your love, and we thank God for each of you. God has added you as part of our heart family. You are His hands and feet during this time. You are His generous blessing to us.

Holy words long preserved
for our walk in this world,
they resound with God's own heart;
O let the ancient words impart.
Words of life, words of hope
give us strength, help us cope;
in this world where'er we roam
God's ancient words will guide us home.

REFRAIN
Ancient words ever true,
changing me and changing you;
we have come with open hearts,
O let the ancient words impart.

Holy words of our faith
handed down to this age,
came to us through sacrifice;
O heed the faithful words of Christ.
Holy words long preserved
for our walk in this world,
they resound with God's own heart;
O let the ancient words impart.

That's my song for tonight. The ancient words are always with me, if only I will find them, listen to them, and heed them. —Susie

Our apologies for failing to report for several days. Suffice it to say that last week was not stellar. Honey had radiation every day, and last Monday's scheduled chemo was delayed until tomorrow. And it's a good thing—fatigue has been the main issue, and I could see less energy in our patient every morning. Now that radiation is completed, hopefully she will begin to see some energy-level improvement in a few days. Pain has eased some as long as she strictly adheres to the regimen of meds. One bright spot was Nathan spending Thursday night with us. He was here for a Friday morning meeting at Vanderbilt, so we had a few meals together and sat up late Thursday night visiting. Well, he and I did; Honey went to bed.

We planned to go to church this morning and got up accordingly. I showered and did the usual prep work for my infamous Sunday morning scrambled eggs. We had decided that I would go to the early service at nearby Brentwood United Methodist Church where the youth choir was singing a piece I wrote for them last year. Then I would pick up Honey and head downtown. Well, she got up, but not for long; she had a major sinking spell and back to bed she went. So, we were unable to go downtown to hear our choir sing the anthem that our friend Keith wrote for Honey and me last year. But we were able to watch the service online and enjoyed hearing the piece live for the first time.

That anthem text is strong and straight out of the Bible. It has been a favorite passage for some time, but of late, we have been leaning into it a little harder than some other times. Here it is—again—the Word of the Lord through the Psalmist and prophet Isaiah:

> *I am your refuge, I am your strength.*
> *I am your helper in time of trouble;*
> *so do not fear, no, do not fear for I am your God.*

And when you pass through the waters, I will be with you.
And when you cross o'er the river, I will be your guide.
And when you walk through the fire, you'll not be burned,
 for I am your God.

[The Christian's response is—]

You are my refuge, You are my strength.
You are my helper in time of trouble;
 I will not fear, I will not fear, for You are my God.
You are my God.

Honey has been down all day, but hopefully is banking enough strength to resume chemo tomorrow. She definitely wants to and was disappointed last week when Dr. Penley pulled the plug. In between long naps, she sends her love and thanks to the whole herd praying, pulling, and providing for us in so many ways.

We leave you with some other texts we heard and sang at churches this Sabbath day:

- "A mighty fortress is our God, a bulwark never failing ..."
- "Thy bountiful care, what tongue can recite ..."
- "Be strong in the Lord and be of good courage... ."
- "On Christ, the solid Rock I stand, all other ground is sinking sand... ."
- "Be still, my soul, the Lord is on your side... ."
- "Love divine, all loves excelling, joy of heaven to earth come down ..."
- "Praise God, from whom all blessings flow... ."

Wow, those more than qualify as wonderful words of life!
We're certainly claiming them this week and plan to live in
their bright light. —Mark

MARK & SUSIE EDWARDS

I am so glad to reconnect with you. It seems like forever, but I know it hasn't really. As of last Friday, I am officially a graduate of St. Thomas Midtown Hospital Department of Radiation Oncology, complete with a certificate and cookbook. As my family would say and have said in all the mockery we could muster, "Wooooo!" I'm glad to be able to check that off my list. Again, Dr. Lloyd, Bonnie, Sherry, Louise, and April were very good and encouraging and helpful in all ways. We are so thankful for the medical professionals in this area. We can't, and don't, have anything to complain about.

They say the radiation will continue working for two weeks, so I guess I can expect the side effects to linger. Those effects are mainly the fatigue. It is interesting not to have control over when you'll fall asleep. Mark and I will be having a conversation, and he'll have to poke me to wake me up to finish a sentence. It is quite comical at times.

I had made plans to attend worship yesterday, getting out my clothes on Saturday. But, alas when it came time to get up Sunday morning the world was spinning all around and I couldn't sit up. I planned to attend Brentwood United Methodist Church for the early service. The youth choir was singing a hymn arrangement Mark had written for them, and I wanted to hear them. Then we were headed downtown to hear an anthem Keith wrote in honor of Mark and me last year entitled "Refuge." I certainly didn't want to miss that. But again I couldn't make it. We were forced to tune in the live streaming service. The choir did an excellent job singing a wonderful anthem. We are certainly humbled and honored to have a simple, elegant classic written in our honor. The thing is, even though it has our names on it, anyone who is going through hard, trying journeys can claim this as "their" song.

Today I was able to begin chemo again. It seems I have been waiting around a long time to get things going again, but that's not so. It has only been a month since my last chemo treatment. Routine is infusion, chemo pills for

seven days, a week off, and then begin again. Somewhere in there, I will have another scan and maybe a clinical trial. I'm not sure about so many things, but I don't think we'll stack too many things on top of each other. Right now I am feeling better than I have the last two weeks, so for that I am thankful.

I am beginning to fade, so I'll close for now. We are so thankful for each of you. You make it easier for us to continue on this journey. Your comments strengthen us. You say, "You are such an inspiration." Well, thank you, but I am not the inspiration. God is the one Who puts the words and thoughts in my mind, and He arranges them to make sense. If it weren't for Him, this would have no meaning and be a waste of time for all of us.

Here is a stanza and chorus of a sweet, old hymn that Mark is playing just now:

Joys are flowing like a river,
 since the Comforter has come;
 He abides with us forever,
 makes the trusting heart His home.
Blessed quietness, holy quietness,
 what assurance in my soul!
On the stormy sea He speaks peace to me,
 how the billows cease to roll!

"BLESSED QUIETNESS" - MANIE PAYNE FERGUSON, CA. 1897

Thank you, Father, for being THE inspiration. —Susie

First thing this morning, daughter Weslee sent Honey a cartoon of this gal comfortably reclining in perhaps her backyard, pet dog doing the same beside her, obviously both enjoying a king-size nap. The caption reads, "Today, I will be as useless as the 'g' in lasagna." So several times today—between naps, that is—Honey has referred to herself as a "g."

The routine is an IV chemo infusion on day one (Monday this time), and when it's all said and done, you've easily spent half the day. She comes home with forty-two chemo pills to enjoy the next seven days while contemplating the $880 price tag. Day two is typically a good day and yesterday was indeed. Sometime during day three, side effects of fatigue, loss of appetite, and loop-leggedness kick in. This will not change much until the pills go away next Monday. Then she'll have a week off before starting the cycle again. After the next infusion (Feb. 10), she will have another scan at Vanderbilt-Ingram Cancer Center to see how effective the treatments are being.

Today was beautiful where we live, and I was able to get out and take a walk. We don't get as much done these days as we once did—but really, so what? We are trying to see and celebrate the bright spots and lighter moments that do show up along our rather steep climb. I'm telling you, it could be a lot worse … and it clearly is for some. See, I told you there wasn't much to report, but thanks for looking in on us just the same. We're not kidding when we say that these days you are our earthly life and salvation; nor when we say we love you.

A single stanza from Sunday that I've sung and led all my life has particularly stuck this week:

> *When darkness seems to hide His face,*
> *I rest on His unchanging grace;*
> *in every high and stormy gale,*
> *my anchor holds within the vale.*

[We might as well sing the chorus while we're here]

On Christ the solid Rock I stand,
all other ground is sinking sand.
"THE SOLID ROCK" – EDWARD MOTE, 1834

Thank God that our faith and peace within don't depend
on what we can see but on Christ's unchanging grace.
We're counting on it. —Mark

Thanks for calling me
and liking to talk. It
means a lot to me. You
are my joy.
Have a good weekend/week.
I love you,
Mom

Honey has been mostly down—in the manger or in the bed since Wednesday. Perhaps it's the double-whammy of residual side effects from radiation, which ended ten days ago, plus those from chemo six days ago. You may remember that she takes chemo pills for seven days after the actual infusion, so that ends tomorrow morning. Whatever the cause, it has knocked her for a larger loop than ever! She doesn't eat much, although today better than the previous four, thanks to our new friends Steve and Kay. Honey does manage to get a shower most days, but it is a huge ordeal and it takes a lot of her little strength to do it.

This is regain strength/appetite/stamina week at our house, and we only have one doctor's appointment—a follow-up with the radiation oncologist on Friday. Not sure what the punch line of that appointment is, but we will go dutifully. Honey is a very good patient, but all of this is, of course, sometimes depressing to her. We both try to keep an upbeat attitude and to find joy and even a bit of humor along the way, but it is not easy. We are at peace and know that God is in the driver's seat, but it is just a hard road, the same road many of you have traveled.

One thing I like about the *Celebrating Grace Hymnal* is that it includes hymns that give voice to the many moods of worship—praise, confession, prayer, lament, etc. Tonight's hymn is more lament than any other and comes out of the African-American tradition. Certainly these sisters and brothers knew— and many still know—something about traveling a hard road. It is in a minor key and plods along with labored step—sort of matches our current mood around here.

> *I want Jesus to walk with me.*
> *I want Jesus to walk with me.*
> *All along my pilgrim journey,*
> *Lord, I want Jesus to walk with me.*

In my trials, Lord, walk with me.
In my trials, Lord, walk with me.
When my heart is almost breaking,
 Lord, I want Jesus to walk with me.

When I'm troubled, Lord, walk with me.
When I'm troubled, Lord, walk with me.
When my head is bowed in sorrow,
 Lord, I want Jesus to walk with me.

"I Want Jesus to Walk with Me" – African-American Spiritual

The hymn tune name is "SOJOURNER."
Honey and I thank you for being sojourners with us.
The road is hard, but not lonely. —Mark

Honey has been up more today than she has been in almost a week. She finally crawled out of bed this morning about 11:30 wanting a shower and declaring something like, "I want to do better today!" Well, she did get a shower, but it required every ounce of energy she had. She did make it to her manger in the den where she remained until I returned mid-afternoon from physical therapy and a short walk in the neighborhood. Then back to the bedroom for a couple of hours until dinner was ready.

Honey is now back in bed for the night and perhaps a good bit of hump-day morning. She is weary—weary of feeling bad, of taking handfuls of pills at a time, being stuck, infused, scanned, and who knows what else. She is weary of not being able to write notes to so many people she loves and is praying for. You can pray for her spirit, which remains good, but even a patient patient can endure only so much. She thanks me several times every day for helping her, which, of course, I don't mind doing at all. We signed on for "in sickness as in health" and "for better or for worse"; we were abundantly blessed with forty-two-and-a-half years of excellent health and a whole lot of "better." We've had a long time to prepare for this season of "sickness" and "worse." But we still don't like this part at all.

The other day when our choir sang "Refuge," the anthem our friend Keith wrote for us, Joe chose these perfect words to follow it:

> *Be strong in the Lord, and be of good courage;*
> *your mighty Defender is always the same.*
> *Mount up with wings, as the eagle ascending;*
> *victory is sure when you call on His name.*

> *Be strong in the Lord, and be of good courage;*
> *your mighty Commander will vanquish the foe.*
> *Fear not the battle, for the victory is always His:*
> *He will protect you wherever you go.*

REFRAIN

Be strong, be strong, be strong in the Lord;
 and be of good courage, for He is your guide.
Be strong, be strong, be strong in the Lord;
 and rejoice, for the victory is yours.

These days we're hanging on to those words for sure. Thanks for hanging with us.

We cannot tell you how much you encourage us
and brighten our path. —Mark

I sure do think you are great! You are one of a kind and I am so glad to be your Honey. Mommy sends me lots of pictures of you so I get to see your big eyes at home and at work. You make me smile.

I love you,
Honey

MARK & SUSIE EDWARDS

FRIDAY

Our appointment with the radiation oncologist was actually encouraging. Apparently, the radiation did as intended, which accounts for Honey's reduced back pain. And he said that her most recent bone scan didn't reveal other areas that needed attention. Benefits of the radiation continue for several weeks after the treatments, as does the main side effect: fatigue. All in all, we were encouraged, and she is not experiencing anything unexpected or abnormal.

This hymn has been one of Honey's favorites for a long time:

> *Day by day and with each passing moment,*
> *strength I find to meet my trials here;*
> *trusting in my Father's wise bestowment,*
> *I've no cause for worry or for fear.*
> *He whose heart is kind beyond all measure*
> *gives unto each day what He deems best—*
> *lovingly, its part of pain and pleasure,*
> *mingling toil with peace and rest.*
>
> *Every day the Lord Himself is near me*
> *with a special mercy for each hour;*
> *all my cares He gladly bears and cheers me,*
> *He whose name is Counselor and Power.*
> *The protection of His child and treasure*
> *is a charge that on Himself He laid;*
> *"As your days, your strength shall be in measure,"*
> *this the pledge to me He made.*
>
> *Help me then in every tribulation*
> *so to trust Your promises, O Lord,*
> *that I lose not faith's sweet consolation*
> *offered me within Your holy Word.*

Help me, Lord, when toil and trouble meeting,
e'er to take, as from a father's hand,
one by one, the days, the moments fleeting,
till I reach the promised land.

"Day by Day" – Caroline V. Sandell-Berg, 1866

TUESDAY

Today was chemo day again, although Honey didn't feel great; in fact, she felt lousy. We discussed with Dr. Penley a good while about what amounted to the pros and cons of continuing chemo treatments. She has felt bad literally all year—remember, she began 2015 in the hospital with a cancer-related compression fracture in her vertebra that led to two weeks of daily radiation that ended January 23. So it is difficult to tell if the lingering and profound fatigue is left over from radiation, the effects of chemo, or tumor-triggered.

The big, heavy question is whether chemo is doing more harm than good. Dr. Penley assured Honey that, more than anything, he wants to help her and that he would not deprive her of any reasonable treatment she believes will help her. He was not overly enthusiastic about subjecting her to another treatment today, but given the choice, she chose to go forward with it. As usual, she will continue receiving chemo via pills morning and evening for seven days—and feel lousy.

It's "gospel night" tonight at our house. Most of us can sing this one without the book … or the screen.

What a fellowship, what a joy divine,
leaning on the everlasting arms;
what a blessedness, what a peace is mine,
leaning on the everlasting arms.

Oh, how sweet to walk in this pilgrim way, [hmmm!]
 leaning on the everlasting arms;
 oh, how bright the path grows from day to day,
 [are you sure, Elisha?] *leaning on the everlasting arms.*

What have I to dread, what have I to fear,
 leaning on the everlasting arms?
I have blessed peace with my Lord so near,
 leaning on the everlasting arms.

REFRAIN

Lean–ing, lean–ing,
 safe and secure from all alarms;
 lean–ing, lean–ing,
 leaning on the everlasting arms.

"Leaning on the Everlasting Arms" – Elisha A. Hoffman, 1887
(Deuteronomy 33:27)

We're leaning on the everlasting arms and you with us. While this is not totally a "sweet walk" down a growing "bright path," we do remember and celebrate fellowship, joy divine, blessedness, and peace because you and the Lord are near.

If we're honest, I think we'd have to say that a bit of dread and fear of some unknown is still a work in progress for us; pray that our faith and trust will trump those. Onward! And leaning on the everlasting arms. —Mark

A TURN
IN THE
ROAD

We've begun a new chapter. A couple of days after Tuesday's infusion, Honey decided that's enough; no more chemo. "I can't do this anymore."

She wanted all six of us—the two of us, two kids, and their spouses—to make a decision about this together. Actually we did; we all pitched in, but not all in the same room at the same time. We all want the same thing—to live a long time, to grow old and older together, to see the younger ones graduate and marry, to all be together at least a few times a year, preferably at Honey and Papa's at least a few more years. But that option is off the table, so the plot thickens. These are situations that "other people" have to face and decisions "they" have to make. Now "they" is "us." Honey has become weaker by the day. Doc Donna looked in on us this afternoon and is referring us to hospice, which will begin Monday.

My mother passed away in 2007 and lived with almost constant pain her last several years. But even in the midst of all of that, she could still come out with a funny one-liner. After many months of going back and forth on the question of whether to continue treatments that did less and less good, she was asked to sign a statement of her intent, which was to NOT continue. She signed the thing, set the pen down, looked around the room, and said, "Okay, where's my chariot?"

In the style and spirit of my mom, Honey delivered her one-liner a couple nights ago. I had helped her to the bathroom, and as she washed up, she looked in the mirror and said, "Well, don't bury me in this gown!" I assured her that we would not, because I was planning to be buried in it. She's been in bed most of the past three days, keeps hydrated, and eats very little. But she's not in pain and is able to sleep more than anything else.

The hymn idea that's been rolling around in my mind the past couple of days is "I Know Whom I Have Believed":

I know not why God's wondrous grace to me He hath made known,
nor why, unworthy, Christ in love redeemed me for His own.

I know not how this saving faith to me He did impart,
nor how believing in His Word wrought peace within my heart.

I know not how the Spirit moves, convincing us of sin,
revealing Jesus through the Word, creating faith in Him.

I know not when my Lord may come, at night or noonday fair,
nor if I'll walk the vale with Him or meet Him in the air.

REFRAIN

But "I know whom I have believed, and am persuaded that He is able
to keep that which I've committed unto Him against that day."

"I Know Whom I Have Believed" – Daniel W. Whittle, 1883 (2 Timothy 1:12)

The stanzas consist of "I know not why … ," "I know not how … , " "I know not when … , nor if… ." Then the refrain shifts gears and declares, "But I know whom… ." Too many of us too often get hung up on the whys, hows, whens, and ifs of faith, when we ought to give our attention to Whom. That hymn is talking about Christian conversion, not cancer. On the road we're navigating, it is fairly easy to get hung up on the whys, hows, whens, and ifs of cancer, but it is a lot better to focus on that same Whom. Maybe if I say it enough times, it'll be easier to do it.

Tonight I'm sad anew … and dang, it's Valentine's Day! Thanks for your continued concern, prayer support, cards, food, Valentine "happies," and so many other expressions of love. Your kindness reminds us of Whom. —Mark

MARK & SUSIE EDWARDS

Your response to Saturday's update has been overwhelming. There are just too many people and acts of kindness to name; Honey is concerned that she's getting behind in writing her thank-you notes. Of special blessing to me were weekend connections with former youth choir singers, some dating back forty years. Sue Beth—in high school herself—was one of our Natchitoches (Louisiana) youth choir accompanists at least two years in the mid-70s, but I didn't realize "I Know Whom I Have Believed"—Saturday's hymn of the day—was her favorite. And her later college roommate, Karen, wrote us the sweetest epistle that made Honey and me laugh, cry, and celebrate all at the same time. And wow, Kathleen's Facebook comment connecting that hymn to yesterday's corporate Prayer of Confession at her church wiped me out. There's a gal that "gets it" and connects the dots.

Perhaps the most amazing thing happened at Sunday lunch with Todd, a First Baptist Church Nashville Chapel Choir singer in the 80s. (Weslee showed up by surprise early yesterday morning, so I was able to get away for a couple of hours.) When I arrived at the appointed lunch spot, Todd was in the waiting area visiting with a couple about his age and their college-age son. It turns out they go to church together in Birmingham. Todd introduced us, and she began talking to me like we knew one another, handing me a sealed envelope. She and her family had spent a fun weekend in Nashville and were heading south back to Birmingham while Todd was heading north toward Nashville.

She had called Todd, asking where the Edwards live in Brentwood, that she had a note to leave on our doorstep. "It's interesting you should ask. I'm about fifteen minutes from meeting Mark for lunch at Longhorn at the Brentwood exit." Apparently this couple was approaching the Brentwood exit from the opposite direction and made a hasty dart across a couple lanes of traffic to take the exit. I arrived shortly after they did. She just wanted to tell us that

Todd had introduced her to us, how much she appreciates our updates, and that she carries us in her heart, praying without ceasing. Oh my gosh, that encounter could not be coincidental.

A short time later, our dear friend Marianne texted saying something to the effect that she's showing up in a couple of hours with her extra Crock-Pot filled with vegetable soup for us to cook in case the Meal Train gets interrupted in the snow this week. And Terrell across the street, a state trooper, who had to be at work today, offering to stop anywhere on his way home to pick up anything for us. Kareem and Daad, just down the street, called ready to do anything day or night to help us. Calls, texts, Facebook comments, mail, and emails from far and wide. Oh my soul, what do people do without dear Christian friends?

Someone needs to write a hymn about a herd! Until such time, here's almost one:

> *Blest be the tie that binds our [herd] in Christian love;*
> *the fellowship of kindred minds is like to that above.*

> *We share our mutual woes, our mutual burdens bear;*
> *and often for each other flows the sympathizing tear.*
> *"BLEST BE THE TIE" – JOHN FAWCETT, 1782*

All we can say is "thank you" and "thank God"
from the depth of our beings. —Mark

FEBRUARY 18, 2015

Lexie, the hospice admitting nurse, came shortly after lunch to begin sharing information and answering questions, completing forms, obtaining base-level vitals, assessing care needs, determining if equipment is needed, etc. The attending nurse will come tomorrow or Friday depending on her other appointments. This weather has created a bit of backlog for all their home-care nurses. We will be glad to see her, but we are managing okay on our own. Honey is a good patient, low maintenance, and acts thankful for all I do for her.

Charles and Andrea navigated the Meal Train yesterday on roads of snow and ice, delivering a wonderful dinner for last night and a second stanza for today's lunch. Have we said thanks to all the Meal Trainers? What a difference you have made all these months. Food preparation must be a spiritual gift that apparently I mostly missed out on, although I'm doing better in that department of late.

Another of our former youth choir accompanists weighed in a couple nights ago. Virginia played for the first youth choir I ever directed—at First Baptist Church, Kerrville, Texas; she was also Honey's best high school friend, college roommate, and maid of honor. They also both sang in the girl's sextet directed by the church organist, who doubled as the pastor's wife. Those gals sang very well; in fact, that whole youth choir was already quite good when I arrived, even better than the adult choir at that church. I remember only one song those girls sang—"I Never Walk Alone"—and some of you out there may be able to help me with the words; it would be a marvelous song for today. It certainly is a good reminder at our house right now.

> I never walk alone in stormy weather,
> when_____
> I know I'm safe because we are together,
> and_____

I never walk alone, Christ walks beside me.

He_____

With such a friend to comfort and to guide me,

I never, no I never walk alone.

Thanks for continuing to look in on us and lift Honey and me to the Father. Though not the happiest season of our lives. we're doing okay and attempting to walk more by faith than by sight. God is faithful. as is the herd. so we are blessed and ever grateful. —Mark

The Lord is my shepherd; I shall not want.

He maketh me to lie down in green pastures:
he leadeth me beside the still waters.

He restoreth my soul: he leadeth me in
the paths of righteousness for his name's sake.

Yea, though I walk through the valley
of the shadow of death, I will fear no evil;
for thou art with me; thy rod and thy staff they comfort me.

Thou preparest a table before me
in the presence of mine enemies;
thou anointest my head with oil; my cup runneth over.

Surely goodness and mercy shall follow me
all the days of my life:
and I will dwell in the house of the Lord for ever.

PSALM 23 (KJV)

MARK & SUSIE EDWARDS

For many years, we've heard good things about hospice, and early on, we, too, are impressed. Even though they have been severely challenged this week because of the icy roads, they have done what they said and done so promptly. Early on in this cancer journey, our friend Dora Ann heard (or perhaps just assumed) that our house needed to be cleaned, so she sent Joyce, her house-cleaner, to our place and picked up the tab. Joyce and her crew do such a good job, we added them to our "staff" immediately. Today was cleaning day, and when I told Joyce our hospice nurse was making her first visit today, she said, "I wish you could get Lisa; she helped my mother and we just love her. We're still friends." Guess who our nurse is. We are delighted.

Honey remains a great patient, appreciates your prayer support, enjoys your cards and comments, and in my opinion, is handling this hard road with unusual grace. She told me tonight that she wants me to be her scribe one of these days so that she can say some things to you in this space. We will do that soon.

I love this seventeenth-century hymn. The tune is in a minor key, but it is not a dirge. It is a powerful statement sung majestically at a pretty good clip.

> *If you will only let God guide you,*
> * and hope in Him through all your ways,*
> * whatever comes, He'll stand beside you,*
> * to bear you through the evil days;*
> * who trusts in God's unchanging love*
> * builds on a rock that cannot move.*

[Here's the hard stanza]

Only be still, and wait His leisure
 in cheerful hope, with heart content
 to take whate'er the Father's pleasure
 and all discerning love have sent;
 nor doubt our inmost wants are known
 to Him who chose us for His own.

Sing, pray, and swerve not from His ways,
 but do your part in conscience true;
 trust His rich promises of grace,
 so shall they be fulfilled in you;
 God hears the call of those in need,
 the souls that trust in Him indeed.

"IF YOU WILL ONLY LET GOD GUIDE YOU"– GEORG NEUMARK, 1657 (PSALM 55:22);
TRANS. CATHERINE WINKWORTH, 1863, ALT.

Honey has always lived a life of joy and deep gratitude,
traits over which not even cancer has power. —Mark

Honey spends most of the time in bed and sleeps an awful lot. Of course, she perks right up when the hospice people come and wants to know all about them. Interestingly, in the course of conversation, we mentioned that we were members at First Baptist Church Nashville, and immediately Laura said, "Oh, I love that church." It turns out that when they moved here from New Jersey in the early 90s, she had two preschoolers and somehow got involved with our church's MOPs (Mothers of Preschools) program. She went on and on about how nice everyone was, how helpful they were, etc., etc. She could not say enough good about what that had meant to her.

If you didn't see the "Notes from Susie" installment on which someone posted a video clip of a selection from the YouthCUE Concert at Baylor Sunday night, I encourage you to look at it. The piece is called "Susie's Gratitude," composed and conducted by Randy, my brother in whom I am well pleased. Many of you know that Randy is also a vocational minister of music. Additionally, more than twenty-five years ago, Randy founded a nonprofit organization—YouthCUE Inc. (www.youthcue.org)—that exists to assist, train, support, and inspire youth choir directors across the country. He does an annual YouthCUE Festival at Baylor each February, and the clip is from this year's festival. The piece was inspired by Honey, who Randy and my sisters love like a sister. The clip is very touching, and I hope you'll check it out if you haven't seen it.

One section of the *Celebrating Grace Hymnal* in which I find myself often these days is "Perseverance." Therein is some good "soul food":

Be Strong in the Lord—and be of good courage.

O Love That Will Not Let Me Go—I rest my weary soul in Thee.

All the Way My Savior Leads—I know whate'er befalleth, Jesus doeth all things well …

We Walk by Faith—and not by sight

I Want Jesus to Walk with Me—all along this pilgrim journey

Guide My Feet—while I run this race

Leaning on the Everlasting Arms

Here's a stanza of yet another:

There is never a day so dreary, there is never a night so long,
but the soul that is trusting Jesus will somewhere find a song.

REFRAIN

Wonderful, wonderful Jesus, in the heart He implanteth a song;
a song of deliverance, of courage, of strength;
in the heart He implanteth a song.

"Wonderful, Wonderful Jesus" – Words by Anna B. Russell

Honey and I are finding those words to be true although the song is not always bright, light, and happy. But nevertheless, it's a song of deliverance, of courage, of strength. —Mark

Susie Mark

Tonight's update is a joint venture between Honey and me. For several days, she has said she wanted me to be her scribe so that she could say some things to a whole herd of very special people. Now she's telling me that she expects me to chime in, so I guess we'll see how it goes. She's over here dozing in and out but still ruling our roost. (Don't tell her I said that.)

"I understand that several thousand years ago there were scribes for the prophets who told them what to write, and supposedly they wrote it. However, I decided that likely those scribes wrote some of their own words, so this will be edited closely. I'm going to think about this as we go, so it may be a little slow. Like Mark says, I doze in and out, so I hope it makes sense."

Zzzzzzzzzzzzzzzzzzzzzzzz!

"Please forgive my slowness in writing thank-you notes for flowers, meals, and other acts of kindness, but just know that we continue to be grateful and thankful for your generosity and kindness. I've noticed that sometimes lately I'll be writing a note and my pen will have slid down the page (like some of this chocolate ice cream has just now slid down my arm … on the sheets Mark washed TODAY). Many comments—Facebook and otherwise—mention the inspiration that our posts are to you, but you need to know that your comments are an inspiration to us, giving us strength and encouragement. We continue to feel your love and blessings each day, and it means so much to us. I thank God several times a day for the best caregiver a patient could ever have … and also a scribe.

"It's bedtime now, so this prophet is signing off. I don't know if those guys had Blue Bell™ ice cream centuries ago, but I sure enjoyed mine tonight. Thanks, Susan and Wilburn."

FEBRUARY 26, 2015

Mark

Tonight's update consists of a guest editorial. My cell phone signaled me this morning about 8:30, and the message read something like, "I landed in BNA (Nashville) about an hour ago, having some breakfast, I'm here for a couple of days to spend time with you. I'll see you in a little while." It was from Randy, my brother. He has a way with words, accompanied us to Dr. Penley's office, and got a glimpse of a day in the recent life of Mark and Honey, so I thought it might be nice to have a variation on the theme of "Notes from Susie." Please welcome Randy Edwards to the editor's desk.

Randy

Wow, it's good to finally make it to Nashville! My plan was to get here at the beginning of last week, about the time Susie went into hospice, but the weather made travel impossible. I had Southwest Airline tickets from SAT to BNA for February 16, and subsequently I must have changed those tickets online half a dozen times, moving them forward to when I hoped the weather would be better. It's good to finally be here in chilly Tennessee.

When I arrived this morning, Janis was just pulling into the driveway. She brought food, along with the natural effervescence that is apparently characteristic of her. It's my hunch that Janis would brighten any room, but then, so would Susie. Mark and I let the two of them visit a while, and from time to time, we heard duo laughter wafting from the distant bedroom. When Janis left, we loaded up and I was able to navigate Susie and Mark to their meeting with Dr. Penley, the oncologist. In typical fashion as earlier reported by Mark, Susie greeted everyone in the office by name and wanted to know how they

were doing. We were then able to settle into the examining room where Dr. Penley met us several minutes later. Susie, very weak by this point, lay down on the examining table and closed her eyes until Dr. Penley arrived.

What I witnessed in the examining room over the next twenty-five minutes will likely be forever etched into my memory. A few hours later, I now view the scene as a virtual Norman Rockwell masterpiece, complete with still poses, highly expressive facial features, bold colors, and a spotlight shining from above on a compassionate doctor ministering to an ailing patient. The interchange of nonverbal language between doctor, patient, and caregiver was subtle but full of power, gratitude, gentleness, quietness, and peace. The mutual exchange of friendship, respect, goodwill, and love was palpable. And observing silently from the corner, I thought to myself,

> *In this very room, there's quite enough love for all of us.*
> *And in this very room, there's quite enough joy for all of us;*
> * and there's quite enough hope, and quite enough power*
> * to chase away any gloom,*
> * for Jesus, Lord Jesus, is in this very room.*
>
> *"IN THIS VERY ROOM"* – WORDS AND MUSIC BY RON AND CAROL HARRIS © 1979
> RON HARRIS MUSIC. ALL RIGHTS RESERVED. USED BY PERMISSION.

Yes, Dr. Penley was encouraging a patient and a husband he obviously cares about deeply. He assured them that he is on call 24/7 when there is a need. He commended the work of hospice, confirming they will do a wonderful job of keeping Susie comfortable for the rest of her life. Susie left the office as she arrived—in her wheelchair. She departed with all smiles and not the faintest hint of a tear. Good-bye, Dr. Penley! Thank you Tennessee Oncology Group!

And as I peck at this keyboard seeking something significant to say, I am hearing the sounds of gratitude continue on into this cold Nashville night. As world-class Mark puts extraordinary Susie to bed, I hear the kind, gentle voices and muffled giggling of a faithful husband and an eternally beautiful wife facing life head-on, with gratitude.

And just now, as I was about to sign off, Mark came in and said Susie wants to see me before she goes to sleep.

Moving carefully into the pitch-black bedroom, I sat down on the side of the bed, and for the next five minutes Susie held my hand and told me how grateful she is for the banner the Baylor Festival students signed for her, and the photo of the Festival Choir standing around that banner. I had them in hand when I arrived this morning. "These are real treasures to me," Susie said in her mezzo piano alto voice.

"You are a treasure to us, and we love you, my sweet sister, Susie."

With that, I gently kissed her hand, and we exchanged good-nights and see-you-in-the-mornings.

Walking out of Susie's dark room, I began to hear music: Mark at the grand piano in the living room playing gently "Refuge," the anthem written in honor of Susie by our friend Keith Christopher. Mark is putting Susie to bed with the gentlest piano sounds.

How sweet is that? How romantic is that? How beautiful is that?

This is Randy Edwards, reporting live from Fredericksburg Way in Brentwood.

And all is well.

Honey and I are doing okay considering what we are facing at the moment. Not much of it is fun, but Honey's spirit and demeanor make things so much better than they could be. I have never seen the minimum requirements for a Perfect Patient, but I feel like Honey would meet most of them and exceed the whole.

Much of the activity around here has been in the form of people dropping by for brief visits, sometimes bringing something, and always offering to "do anything for you" and meaning it. Shortly after Randy left Saturday afternoon, I was standing at the kitchen sink trimming stems of some few-days-old cut flowers that needed fresh water (my repertoire of semi-skills has expanded) when the doorbell rang. Longtime friend David had called earlier, was in town, and wanted to come by, so I went to the door still holding the slightly fatigued bouquet of flowers.

But at the door was Nan, who had called the day before saying she wanted to drop some things off Saturday afternoon, and boy did she ever—good stuff! I gladly ushered Nan into the kitchen where we exchanged flowers—her fresh-vased tulips brought for Honey, and I gave her my handful that needed resurrecting. Nan has served as one of the First Baptist Sunday sanctuary flower girls, and I put her right to work—the Lord provides at just the right time! I turned her loose on every living plant and cut flower in the house, and she performed miracles.

In a few minutes David arrived; he and I visited while Nan and Weslee presided over goings-on in the kitchen when the doorbell rang again. Weslee answered the door, howdied briefly with the ringer who sort of rang and ran. Still visiting with David, I casually asked Wes who was at the door. "Richard." What? I hastened to the front door and was able to hail down him and Mary Lea, who was waving vigorously out the passenger side window. They stopped, and we all went out and visited in the sunny street for about fifteen minutes.

Sometime during that sequence, Nan gave me a hug and left. I recall the hug and her kind words, but when escapes me.

Yesterday afternoon the doorbell rang, and it was our neighbor down the street needing some help with his Cub Scout son's toy race car. We went down to the shop and spent about an hour working on that, which was fun and offered a nice break. Then it was time to make the frozen fruit salad I had promised Honey. In the midst of this, another repertoire-expanding opportunity, it occurred to me that it was taking longer than it should and that dang, this is Suzan's recipe; she's always wanting to do something for us, I'll bet she would have done this had I asked. It was at that point that my wood-working mission statement came to mind—"I may not be very good at this, but I AM slow!"

For a change of pace and scenery today, Honey spent most of the daylight hours on the bed in the front room, which is brighter and lighter because it faces the outdoors. We had our noon picnic in there and remarked how these days, we are eating all over the house. Marrier, Honey's personal care tech, came to help with her shower. Marrier is great, and we're always glad to see her. She works hard, is very gentle, and is as sweet as she is good. Pat sent Jim over with a bag of food treats, and then neighbor Martha sent Wayne over with a carton of Blue Bell™…especially good news to Honey. Then Martha #2 brought Honey a colorful butterfly pillow. We are not hurting for food or the support and love of friends.

Reflecting on a busy but good weekend amid difficult life circumstances, another new hymn in the *Celebrating Grace Hymnal* (# 378) comes to mind:

> *We gather here in grateful praise,*
> *in prayer and song our voices raise,*
> *for all our blessings, large and small,*
> *we thank You, God, who gives us all.*

For loved ones, family, treasured friends,
 eternal life that never ends,
 for daily bread, sins washed away,
 we thank You, God, afresh each day.

We thank You for the sacred word,
 and for the call Your church has heard
 to live as You would lead each day,
 we thank You, God, Your will obey.

Praise God, the source of everything,
 praise God, the Son, our Lord and King,
 praise God, the Holy Spirit near,
 we thank You, God, for You are here.

Words are inadequate to express the depth of our thanks to you, our family and treasured friends traveling with us and looking in on us. We certainly love each one. —Mark

Today has been a good day, much better than yesterday. I was in no mood to write an update or anything else last night. But this morning we woke up to about 3 inches of new snow and it was beautiful although it creates all manner of problems for some, including us at times. Early on we got Honey's clothes changed and I wheeled her into her day room – the guest room with the three big windows looking out on the street and facing west. When the sun finally came out early afternoon, the neighborhood glistened, the streets began to melt, and we could see a snowman being built by some stir-crazy kids down the cul-de-sac. To get some exercise, I cleared our driveway – mostly.

Honey has been better today; it must be the steroid she started this morning. She ate more, seemed to have a little more energy, and took at least one less pain pill than usual. She was even able to have a nice visit with former Chapel Choir singer Rachel, who navigated the Meal Train, bringing too much food—all homemade except the watermelon and nectarines. That gal can cook, too! Rachel and her husband, Aaron, lived in Guatemala early on in their married life, but they and now their son, Noah, are back here. How great it is to see teenagers grow up before your very eyes and become wonderful adults/parents. Thank you, God, for giving Honey and me a place of service that extended almost a whole career.

I finally started reading the book that Kelly, one of our herd, sent us. It is entitled *Choosing Gratitude*[7], and it looks good. The premise is that gratitude is more than polite "thank yous" in the daily course of life. Gratitude is a way of living, a belief system, and extends through the negatives of life. The author says that gratitude doesn't come naturally; we have to learn it. That is true of me, although I'm not so sure but that it came naturally to Honey. She's always been a person of gratitude and perhaps even more so in recent years. Go figure! If I'm learning gratitude, it must be from her. I'm looking forward to getting deeper into the book. Thanks, Kelly-gal!

Here's a little worship song that seems right for tonight:

Give thanks with a grateful heart;
 give thanks to the Holy One.
Give thanks because He's given Jesus Christ, His Son.
And now let the weak say, "I am strong";
 let the poor say, "I am rich,"
 because of what the Lord has done for us.
Give thanks!

We are more than thankful for you; we are bloomin' grateful! —Mark

Darling Daniel,

I love my card you made and the flower pens. You draw so well and I love having things you make. Thank you, sweet one. I missed giving you a hug but we will give lots of hug next time I see you.

I love you,
Honey

NOTES FROM Susie

Mark

When I awoke this morning, the bright, almost-spring sun, was already leaking through the slats of the large window blinds in our bathroom facing east. My day began with a favorite hymn, so tonight's update begins, rather than ends, in song:

> *When morning gilds the skies my heart awaking cries,*
>> *may Jesus Christ be praised!*
> *Alike at work and prayer to Jesus I repair;*
>> *may Jesus Christ be praised!*

[My favorite stanza]

> *The night becomes as day when from the heart we say,*
>> *may Jesus Christ be praised!*
> *The powers of darkness fear when this sweet song they hear,*
>> *may Jesus Christ be praised!*

> *Ye realms of humankind in this your concord find:*
>> *may Jesus Christ be praised!*
> *Let all the earth around ring joyous with the sound:*
>> *may Jesus Christ be praised!*

> *In heaven's eternal bliss the loveliest strain is this,*
>> *may Jesus Christ be praised!*
> *Let earth, and sea, and sky from depth to height reply,*
>> *may Jesus Christ be praised!*

> *"WHEN MORNING GILDS THE SKIES"*– WORDS KATHOLISCHES GESANGBUCH, 1828

Now that's the way to start a morning!

Then the whirlwind began. Let's see—I think we got up a little later than usual, and Honey didn't seem to feel very good. Her first words were, "I don't think I like the steroids." Apparently, they affected her sleep and she was a

little draggy. On our schedule today was Marrier to help her with a shower, and possibly lunch to be brought in by Lonnie, Honey's longtime boss and full-time friend.

Martha was coming at 1 p.m., and the happy Hiller man (plumber) was coming between 2 and 4 to install a comfort toilet in our bathroom. Sometime in the middle of all of that, Honey needed to catch an extended nap or two. With some roads still icy, Marrier wouldn't be able to get here until late in the morning, about the time Lonnie would be arriving, so we waived her off and decided we could manage the shower ourselves. One less stop for Marrier would ease the day for her, and we were glad to do that.

One of the delights we have experienced during our now two-year journey has been the range and uniqueness of gifts you have given. Things like note cards and stamps for Honey to use, sending one's housecleaner to our house, music composed/performed/published in our honor, in addition to all the food brought, flowers sent, and the hundreds of cards delivered. Two more unique, thoughtful gifts came just today—Martha came to "scribe" notes to people from Honey, whose handwriting now looks more like mine; and Julie offered their play room, backyard, creek, recreational equipment, and child supervision for our grandkids when they are visiting us and Honey needs to rest. Julie says their place can absorb a lot of messy and loud. What gifts! How can we keep from singing?

Thanks to so many for helping us navigate our bumpy road. You are the hands and feet, yea, the whole body of Christ. All we are needing, God's hand is providing ... bountifully! —Mark

I started an update last night but was interrupted and never got back to it. It seems as though that has happened all week. It has been very busy around here. In addition to seeing to Honey, we acquired a hospital bed and relocated our favorite patient to the guest room. The guys delivered the bed a day early, which pretty much began the whirlwind that's been blowing at our house since too early Tuesday morning. John installed the flat-screen (and hid all the wires), Alyssa dispatched Steve to find and deliver extra-length sheets, Brandon helped me find places for displaced furniture, and today Jane, our decorator friend, put her finishing touches on the "new" room. It is fresh, bright, spacious enough, functional, and as joyful as a home hospital room can be. Honey loves it all, and that's the main thing.

Standing in the doorway, I see Honey reading a few cards that came in today's mail. On the wall are two photos of Honey's parents—Mimi and Boompa—and the photo on the flower table is Pawpaw, my paternal grandfather. He's wearing his pajamas and his greasy hat. (He, too, was a church musician – volunteer at his very small-town Baptist church.) On the wall to Honey's left is also a photo of her maternal grandmother—Mama—who lived with Honey's family and was very special to her and likely the single reason Honey has always taken a special interest in senior adults. On the wall directly in front of Honey are the engagement photos of both her parents and mine. So our patient has an impressive cloud of witnesses keeping watch.

Honey struggles to eat much since nothing tastes like it should, and food seems to get stuck going down. Meal Trainers, your provisions are SO helpful, SO very good, and SO much appreciated, but because Honey doesn't eat much, less for us is better … really. Wow, you have fed us bountifully now more than two years. I hope you have some idea of how this ministers to us.

Tomorrow Marrier comes to help Honey with a shower and hair-doing, the hospice nurse looks in on us, and someone is coming to draw blood for some

genetics study that may be particularly beneficial to Weslee, Nathan, and their kiddos. We were supposed to have that latter work down at Vanderbilt yesterday, but Honey wasn't up to the trip.

We're hanging in as best we can, trying to be as positive as possible, but realizing the climb is more arduous along this stretch. We remain grateful, joyful in our faith, family, and friends; we are at peace with the road in front of us.

Here's another new hymn in the *Celebrating Grace Hymnal* (#630), not written about a sick room, but it could have been:

> *Look, you saints, the cloud of witness gathered 'round this sacred place;*
> *rise as one to cheer us onward, all who choose to run the race.*
> *Sound the trumpets! We will journey swift of foot and brave of soul.*
> *Let us run the race before us with our God, as those of old.*
>
> *Though the journey seems unending, full of mystery, joy, and pain,*
> *Jesus' open arms receive us evermore with Him to reign.*
> *Praise to God, the crown of honor waits for all. The Victor cries,*
> *"Join those saints, the cloud of witness;*
> *God's redeemed shall claim the prize!"*

Your photo may not be on one of Honey's new walls, but we are sure you are among the cloud of witnesses cheering us onward. —Mark

We join with the Psalmist in declaring, "This the day the Lord has made. We will rejoice and be glad in it." The situation at our house is much the same, but at least some of our rejoicing was that the sun came out this morning, and it was beautiful all day. We enjoyed some things that we would otherwise take for granted. Honey wanted me to go to church nearby, so I got up earlier than usual to do our now-normal morning routine to get down the street by 8:15. We also were able to "attend" worship at our church via live streaming. Gathering with the saints at the steeple is always a good thing. While Honey slept this afternoon, I was able to take a good walk.

Honey ate a good breakfast, lunch, and dinner. We have discovered that she eats more if I feed her, so we just set up shop in her room and eat off the same plate. Otherwise, she just messes around, dozes off, and it all gets cold. Another thing that helped Honey today was getting a shower during which I changed her bed linens (which reminds me—I need to go rescue those things from the washing machine now eight hours later). Then she put on a new gown that Marianne purchased and brought to her, and some bright lipstick that Ann brought her a couple weeks ago. By the time I did her hair (?), she looked like a million dollars—but we both forgot the earrings. What's with that? All of this felt good to her, but it certainly does sap every ounce of what little energy she has.

I'm investigating home health-care options in addition to hospice. So many friends have graciously offered to come spell me for a few hours, which is so thoughtful and so much appreciated. We will gladly do that some, but with Honey needing to be lifted and such, I hesitate to leave her with anyone who is not accustomed to giving that kind of assistance.

Honey is a steel magnolia, but she is tired and this stage of illness is very hard. Thankfully, meds control pain and nausea, but the flip side is that they also

make her sleep most of the time and disable her from being able to stand on her own or even leave the bed much. She's not able to visit with friends very long at a time; those of us who know her best realize what a loss that is to her. But when she smiles, any room still lights up. She always wants me to read these posts to her, but I'll skip this paragraph. It's not that we haven't talked about all of this and more; last night through her tears she said she wanted this be over, and through mine, I said, "Me, too." Whew, that's hard to say!

I love this old gospel song that our good friend Jimmy used to sing so well and from the depth of his soul and played for him through the depth of mine:

> *In shady green pastures so rich and so sweet,*
> *God leads His dear children along;*
> *where the water's cool flow bathes the weary one's feet,*
> *God leads His dear children along.*
>
> *Sometimes on the mount where the sun shines so bright,*
> *God leads His dear children along;*
> *sometimes in the valley, in darkest of night,*
> *God leads His dear children along.*

REFRAIN
> *Some through the waters, some through the flood,*
> *some through the fire, but all through the blood.*
> *Some through great sorrow, but God gives a song,*
> *in the night season and all the day long.*
> "GOD LEADS US ALONG"– G. A. YOUNG

It's a night season around here and for many of you, but God still gives a song. So let's sing it! —Mark

So much for bravery, grit, and inspiration! Tonight's notes are hard. But from the beginning we determined that we would be truthful here so that you could believe us. Life is not always pretty and positive. Honey is getting weaker by the day. Yesterday she didn't feel like getting up and making the wheelchair trek to the bathroom to get her shower, so Marrier did the sponge bath routine which, surprisingly, Honey rated as right refreshing. She slept nearly all of yesterday, received her meds, drank enough water, but all she had to "eat" was a protein milkshake that she requested about bedtime.

This morning I was able to transition her to the "bedside facility," but it seems as though that may not happen again. Her leg strength is simply not sufficient to help me enough; it is a danger to both of us for me to take on that much limp weight. Today she has slept virtually all day with the exception of the half hour or so that the hospice nurse was here. The nurse—a substitute—took vital signs, rubbed/patted around on her some, and although we had never seen her before, Heidi treated Honey with the tenderness of a longtime friend. Those hospice folks are good.

Hospice provides a booklet subtitled *The Dying Experience*, written by an award-winning hospice nurse (RN) and prominent speaker on the dynamics of dying. She validates what I've read elsewhere—though not heeded—that, "When a body is preparing to die, it is perfectly natural that eating should stop." She goes on to say that this fact is one of the hardest concepts for a family to accept. I certainly can validate that it is hard for THIS family to accept.

I come from a long line of feeders, among whom my mother was chief. (Our line also includes eaters, too, of whom I was chief.) No one went hungry at HER house unless that one chose such. Just a couple of nights ago, I wrote that Honey ate more when I was feeding her. Well, of course she did! I'm still feeding her, whatever and whenever she wants, but only when she asks for it.

Her body knows itself better than I; that's hard, too, because I'm a fixer—also in my lineage. But we have talked about wanting this to be over, to complete this journey, so I don't want to extend the climb, the battle, by "force feeding" her. That's a lofty principle of the head that, in reality, breaks my heart.

She does sleep a lot, but when I go in and smooch her on the neck with our usual, "I love you, buddy!" she manages to wrap her boney arms around my neck and respond in kind. I still do and she still does, so that's good. I'm telling you, it's hard to see your forty-five-year bride of choice waste away before your very eyes.

Then the phone rang and it was Diana, a new deacon, whom I met only a couple months ago at a deacons meeting. Completing my four-year term, I was rotating off and she had been elected onto the active body, so we had a delightful visit over dinner. Diana is an articulate woman from Mississippi—a news writer for Baptist Press. She was asking if she could schedule a time to come out and offer homebound communion for Honey and me during Holy Week.

I explained to her that Honey's condition wouldn't really be conducive to that—it appears God is choosing to heal Honey on the other side of the river, but that healing is a miracle on either side. Diana chimed in, in her natural and most refreshing African-American spirit, "Yeah, she's got the victory either way. Satan may try to get in the way, but he's lost out!" Sister, there's no need to come out here—you and I have just HAD communion! I'm thanking God tonight especially for Diana who called in the nick of time.

In the *Celebrating Grace Hymnal*, there is a short section of hymns under the heading of "Seasons of Life." The section begins with a responsive reading that seems appropriate tonight. I'll read the light print and you take the **bold**:

In all of the seasons of life,
God, the Creator, gives us a song!

There is a song for the beginning of life's journey
and a song for going home.
God, the Creator, gives us a song!

There is a song for one voice
and a song for many voices.
God, the Creator, gives us a song!

There is a song for victory
and a song for defeat.
God, the Creator, gives us a song!

There is a song for times of plenty
and a song for times of want.
God, the Creator, gives us a song!

There is a song for mourning
and a song for celebration.

In all of the seasons of life,
God, the Creator, gives us a song!

As the hymn writer wrote.
"In the heart He implanteth a song."
Thanks. herd. for singing along with us. —Mark

This is Randy Edwards. I have been asked to write tonight's update, so I am glad to contribute this report to all who read Facebook's "Notes from Susie."

Although Susie's condition continues to decline as anticipated, it is clear that she has a very strong heart that does not want to quit. Jennifer, the hospice nurse, came by this afternoon and, among other things, checked Susie's vitals: pulse rate, blood pressure, and respiration are all within perfectly normal range. Susie is now in a near-constant state of sleep, but she will sometimes stir just a bit, open her eyes momentarily, and occasionally try to speak a word or two. She is obviously very, very weak, but she shows not the slightest indication of pain. Thanks be to God for that as well as so many other blessings.

When I arrived back here yesterday morning, I went straight to Susie's bedside to greet, hug, and kiss her on the forehead and cheeks. Mark announced to her that I was there, and although she never opened her eyes, she was able to put her arms around my neck and hold on tightly. She said very softly and repeating several times, "O, my word, it is so good to see you. It's wonderful … to …" After a bit, I softly asked, "Susie, sweetie, how is your pain?"

"No pain. No pain at all."

And again I say, thanks be to God.

Mark is doing a superb (no, actually, a SUPERB) job in his role as primary caregiver. He is both meticulous and tender, highly efficient (anyone surprised by that?) and extremely gentle. In a word, pretty much perfect. I am both proud of him and in awe of him, something I have always been able to say, but especially now. When Susie does depart for the Father's House, Mark is going to need to apply some of the same caregiving principles to himself. He

must be weary to the bone, but he moves around like a teenager and rivals the energy level of his two children in their thirties.

And speaking of children in their thirties, Weslee and Nathan are here tonight and are doing exceedingly well. What wonderful "children" these two are … what a wonderful family of four! And their families back home complete with Susie's and Mark's five grands, all under eleven, are pretty special, too!

It's almost time for me to catch a flight back to San Antonio, so I'll begin to sign off. However, I cannot end this update without thanking all of you for your support, love, prayers, and friendship for Susie, Mark, Weslee, and Nathan! We are their "herd" of support, and I can't imagine any family in the world being surrounded by more wonderful people than you. The constant food provisions (wonderful fixings), the drive-by visits, the phone calls, the emails, text messages, and responses to Facebook postings. You are indeed extraordinary. Thank you.

I leave you with one other Norman Rockwell–type image tonight: Mark and I sitting at Puffy Muffin Tea Room yesterday for a late lunch. He ran into approximately a dozen friends with whom he spoke and to whom he introduced me. Sitting at lunch consuming our chicken salads, Mark began to quote hymn texts as only he can. Short snippets of hymns one after another … and then, two in particular.

He would quote then cry, quote then cry, quote then cry. I sat in astonishment and had a sincere urge to reach down and remove my shoes. I was sitting at lunch, with a saint, on holy ground.

My life flows on in endless song; above earth's lamentation,
I hear the sweet, though far-off hymn that hails the new creation.
Through all the tumult and the strife, I hear the music ringing;
it finds an echo in my soul—how can I keep from singing?

"HOW CAN I KEEP FROM SINGING" – ROBERT LOWRY, 1869

Sometimes a light surprises the child of God who sings;
 it is the Lord who rises with healing in His wings.
When comforts are declining, He grants the soul again
 a season of clear shining to cheer it after rain.

In holy contemplation we sweetly then pursue
 the theme of God's salvation and find it ever new;
 set free from present sorrow, we cheerfully can say,
 "Let the unknown tomorrow bring with it what it may."

It can bring with it nothing but He will bear us through;
 who gives the lilies clothing will clothe His people, too;
 beneath the spreading heavens no creature but is fed;
 and He who feeds the ravens will give His children bread.

Though vine nor fig tree neither expected fruit should bear,
 though all the field should wither, nor flocks nor herds be there;
 yet God the same abiding, His praise shall tune my voice,
 for while in Him confiding, I cannot but rejoice.

"SOMETIMES A LIGHT SURPRISES" – WILLIAM COWPER, 1779 (HABAKKUK 3:17–18)

NOTES FROM *Susie*

Mark

An eventful week it was. This time last week we knew Honey would not live much longer. The hospice nurse who came last Sunday predicted that Honey would die later that day or Monday, but warned us that she had seen people live in that nonresponsive state for two or three weeks. Hearing that, our hearts sank. The nurse's initial prediction was less than twelve hours short.

Last Tuesday morning (March 24) Honey's signature smile had turned to a fully relaxed jaw and opened mouth through which she breathed erratically and belabored—all typical of a dying body. Her once sparkling eyes were now fully open and glazed over, seeing nothing. Her skin decidedly yellowed. That was not the bright face and fresh countenance we knew. Kathy – the home healthcare nurse – now here, Nathan and I headed out to run a few errands while Weslee went about going through some of Honey's things. Very shortly Weslee returned to Honey's room, gazed at Honey, and asked Kathy if Honey was still breathing. "Yeah, she just turned her head toward the windows."

On closer look, they discovered that no, Honey's breathing had ceased, that she had died. Nathan and I were little more than a mile down the road when Weslee called saying Honey was gone, that "she had done well!" All the way back home and through tears of joy, Nathan and I repeatedly thanked God aloud and celebrated Honey's glorious healing. Returning to her bedside, I couldn't help but notice that Honey's eyes had closed some, her lips now almost met, and there was a slight and peaceful lift in the corners of her mouth. I believe Honey had turned and looked straight into the Light. What a sight! She was safely home and all was well! Oh my gosh, what a blessed gift to her and me! I needed that final picture of her.

Our family could not be more grateful for the outpouring of love and support for more than two years now and for your responses to us since Honey's death. Nor could we be more pleased with the memorial service Friday afternoon. Some personal thank-you notes will be forthcoming, but to the First Baptist

Church family, staff, musicians, and food fixers/servers we say a very special word of thanks. At church today, I was told that more than 150 people watched the service online and literally some of the uttermost parts of the earth. That's amazing, and we are delighted that our far-away herd was able to be with us to celebrate Honey's life well-lived.

I guess we will continue to post updates here for a while; writing them is both cathartic and therapeutic for me, and in the coming days, I need some of both. So you are welcome to look in if you like.

In the meantime, here is another new hymn in the *Celebrating Grace Hymnal* I've been sort of saving for this day. The hymn is by Susan Palo Cherwein, and the music was written by my good friend David, whose church in Richmond, Virginia, has prayed for Honey these two years.

> *In deepest night, in darkest days,*
> > *when harps are hung, no songs we raise,*
> > *when silence must suffice as praise,*
> > *yet sounding in us quietly*
> > *there is the song of God.*

> *When friend was lost, when love deceived,*
> > *dear Jesus wept, God was bereaved:*
> > *so with us in our grief God grieves,*
> > *and round about us mournfully*
> > *there are the tears of God.*

> *When through the waters winds our path,*
> > *around us pain, around us death:*
> > *deep calls to deep, a saving breath,*
> > *and found beside us faithfully*
> > *there is the love of God.*

Thanks be to God. Onward! —Mark

CELEBRATING ALONE

The kids and grands left mid-Sunday afternoon after we had been to church and out to lunch. Both families have busy lives. Weslee and Nathan had been with us ten hard and wonderful days during which their spouses had carried extra loads, so I was anxious for them to return to their respective routines. But I knew what would happen when they left; I had felt it coming on and building up most of the day. I held it together until they left, mostly for the grandkids' sake. Our four grandsons are ages five to eleven and our only granddaughter is just twenty months, too young to understand the situation. Those little boys had navigated this first serious blow in their lives extremely well—thanks to careful and thoughtful parenting—and I didn't want them to be upset upon leaving.

Sure enough, when they all drove away and I walked into the empty house, the floodgate opened and I was able to turn … it … loose. The release was such a relief, although it didn't last more than a few minutes. That must be because I have been practicing grieving these many months, letting out a little along the way. I am grateful God gave me just over two years to get used to the idea that Honey would die much too soon, and I would be alone. Now a week beyond Honey's death and two full days into living alone, I still have weepy moments, and fully expect them on occasion going forward. Talking about her doesn't seem to set me off, but it's the random routines and realizations that sneak up on me. But that's okay and a healthy part of this process.

None of the grandkids attended the graveside service Friday morning, but Sunday afternoon Chris and Weslee were able to slightly alter their usual route home to take their boys by the cemetery. The boys selected a few flowers from some of the beautiful arrangements at the house to place on Honey's grave. I would love to have observed that experience, but Weslee reported they handled that well, too, and everyone was okay. Whew! Both sets of parents, amid their own grief and loss, did a masterful job helping their kids.

Although losing Honey was/is hard, I'm thankful for the time of year it happened. She would have been miserable not being able to get out to enjoy the freshness and smile of springtime—and Honey was definitely a springtime

gal. But had she died in the dark and cold of winter, I would have been miserable and depressed. Thank you, God, for the timing. I'm also thankful that both our kids were able to be with us during her last days; it was a special time for all four of us, and the three of us were able to help Honey graduate to greater life. And, of course, all the people around and alongside us doing whatever they could to make our hard road easier remains a rich blessing.

The music at Honey's memorial service was wonderful. The choir of mostly current, along with a good many former, choir members was excellent and the congregational singing spirited. I was reminded yet again a big part of what kept us there as minister of music three full decades. What a gift to our family!

Tonight we offer the text of the second anthem the choir sang Friday afternoon at the memorial service. It seemed just right for celebrating Honey's life and ministry. These words were penned by our longtime friend Terry York, and the music by our friend David Schwoebel:

> *Music sung, music played,*
> > *Gospel lived, rehearsed and prayed,*
> > *humble, meek, yet unafraid,*
> > *we are called to live His song.*
>
> *Angel songs sung on earth,*
> > *earthborn songs of second birth,*
> > *choirs of sinners find their worth,*
> > *we are called to live His song.*
>
> *To live His song, to be His music,*
> > *to know a harmony with Christ that sings and soars;*
> > *to live His song, even when sorrowing;*
> > *to live His peace, His joy, His love,*
> > *to live His song.*
>
> *Distant songs yet unknown*
> > *claim our hearts as His alone,*
> > *draw us ever t'ward His throne,*
> > *we are called to sing His song.*

To live His song, to be His music,

 to know a harmony with Christ that sings and soars;

 to live His song, even when sorrowing;

 to live His peace, His joy, His love,

 to live His song.

Tomorrow I'm going to take a day trip with Nathan, for whom it will be a business trip. I've threatened to do this many times in the past and now I can. We'll have a good time.

Love and blessings unto all.

Barbara Sue "Susie" Edwards, aka "Honey" passed away on March 24, 2015 after a two-year battle with cancer. She was born August 14, 1951 in San Antonio, Texas and in a few days became the adopted daughter of Grady Abner and Barbara Thompson West of Premont, TX.

She is survived by her husband Mark; daughter, Weslee Edwards Hill (Chris) of Martin, TN; son, Nathan Daniel Edwards (Corri) of Hoover, AL; grandchildren, Jonathan Allen Hill, Andrew Christopher Hill, Thomas Wesley Hill, Daniel Tucker Edwards, and Ella Anne Edwards; brothers, Grady Abner West, Jr. of Fort Worth, TX and Randolph Thompson West of San Juan Capistrano, CA; sister, Brownie Lynn Curry of Brownwood, TX and numerous nieces and nephews. Susie's greatest delight on earth was her family, but she was also a 28-year employee of Tennessee Baptist Convention. She was active in the music program at Nashville's First Baptist Church and worked with preschoolers for thirty years. However her favorite role at the church was being the wife of the music minister; she also loved being a Sunday morning greeter.

Holy Week and Easter took on a different meaning for me this year. Some of it had to do with the fact that I was able to attend Maundy Thursday and Good Friday services last week and then, of course, Easter this morning. I had never attended all three during the same season, but it made a difference. Each service was well done and stood on its own, but taking in all three between Thursday night and Sunday morning, the story was more dramatic and the significance more real.

I've been a Baptist all my life, but I fear most of our denomination has lost out by largely neglecting the Christian Year, which is based on the life of Jesus. (As an aside, a large portion of the *Celebrating Grace Hymnal* is arranged according to the Christian Year, from Advent to the coming of the Holy Spirit—#78–244.)

Not only the Holy Week services, but also Honey's recent death most assuredly played a part. Frequent use of words like *pain, death, grave, resurrection, victory*, and so on were constant reminders of recent days gone by. But, by the grace of God, I seem to connect more with resurrection than death, with victory more than the grave. I keep waiting for Honey's death to push me to the point of profound sadness, even despondency. Oh, I miss her like crazy and sometimes it sneaks up on me. Things occur that I want to be sure to tell her but … oh, yeah! Sometimes I just have to say aloud, "Honey is gone," or "Susie is dead!" This house is fairly large and pretty empty, but I guess her two-year illness prepared me for this season even more than I realized. I have sad moments, for sure, but they haven't lasted as long as perhaps I thought they would. I am grateful to be able to function, but life is certainly taking on some different meaning.

This afternoon I drove out to the cemetery, my first time since we buried her ten days ago. There was some sadness, of course, but then I remembered Honey's comment last summer when we bought those plots. She and I were standing near our spots almost to the top of the hill, looking across the valley below toward the road—quite a nice view—when Honey stood straight up and declared, "I think I can live with this!"

Christ the Lord is risen today,
 earth and heaven join to say,
 raise your joys and triumphs high,
 sing, ye heavens, and earth, reply,
 Alleluia!

Love's redeeming work is done,
 fought the fight, the battle won,
 death in vain forbids Him rise,
 Christ hath opened Paradise,
 Alleluia!

I love the first two stanzas of that hymn, but the latter two jumped out at me today:

Lives again our glorious King,
 where, O Death, is now thy sting?
Dying once He all doth save,
 where thy victory, O grave?
Alleluia!

Soar we now where Christ has led,
 following our exalted Head,
 made like Him, like Him we rise,
 ours the cross, the grave, the skies,
 ALLELUIA!

"CHRIST THE LORD IS RISEN TODAY" – CHARLES WESLEY, 1739

APRIL 14, 2015

A good many herdspersons have gently and graciously inquired as to goings on with me of late, and I sure do appreciate every gesture of concern. A bit of silence should not be read as curling up into a ball and shutting down or

shutting out. Admittedly, there has seemed to be less to say, reminding me of the opening lines of a hymn I shared a few posts ago:

> In deepest night, in darkest days,
>> when harps are hung, no songs we raise,
>> when silence must suffice as praise,
>> yet sounding in us quietly
>> there is the song of God.

And as I think over the past few days, that seems to be the case—the song of God has been sounding in me quietly—in my "going out and coming in." Much time, of course, has been spent caring for the legal/business matters in the wake of Honey's death. That, and pondering anew how singleness will play out now in everyday life. Fortunately, I have good help with the former, and we're crossing things off the list one at a time.

Over the weekend, my longtime friend John invited me to go help him with a couple of projects at his Center Hill Lake house. (John and Martha hosted Honey and me overnight over there a year and a half ago, and we had a great time.) Martha was in Atlanta this weekend, so John and I enjoyed a delightful couple of days working, boating, and visiting. The Middle Tennessee weather Saturday and Sunday was about as picture perfect as one can imagine.

Late yesterday afternoon Kareem, my down-the-street neighbor, called and came by to visit. He was in New York tending to his dying brother-in-law when Honey died, so we had some catching up to do. Kareem and his wife, Daad, loved Honey (of course), and we have become good friends over several years since they moved in.

It was nearing dinnertime when he left, so I embarked on my maiden voyage fixing dinner from scratch. I'm not sure from whence cometh dinners or what all I've eaten the last three weeks, but rest assured knowing that I have eaten well. Being a south Texan raised on homegrown garden vegetables, I have

been extra hungry lately for pinto beans (or black-eyed peas) and cornbread. In recent summers, Honey and I have stockpiled in the freezer shelled peas from the farmer's market, and last summer four okra plants in our garden-ette produced enough okra for such a time as this. Saturday morning before heading to the lake I cooked a freezer bag of lady peas, bought an onion, put a pack of okra in the fridge to thaw, and made sure we had an egg, milk, and cornbread mix.

The major task for producing dinner was making the Texas gumbo—onions, canned tomatoes, and sliced okra cooked together in a cast iron skillet. I had made gumbo once before, but with Honey coaching me from her manger in the den. I didn't need the whole onion, but rather than put half of it in the crisper drawer only to ruin before I called on it again, I just threw it all in the skillet. While it cooked I warmed the peas and made corn sticks. Gen-tle-men, that was good eatin'! I'm pretty sure Honey in heaven was proud! And there are even leftovers for later.

Waiting for Robert to join me at lunch today, I walked down to CVS to see Linda, our favorite pharmacist. The staff there had all signed a card to the kids and me, but I hadn't been to see them since Honey died. She saw me approaching the counter and immediately came around her workstation for a hug and a weep. She said she loved Honey so much and did everything she could to help. I assured her the feeling was mutual and that we appreciated all the individual attention she gave us, especially the past two years.

Lunch with Robert was like a pastoral visit. We talked about Honey and our past two years; we laughed, I wept intermittently, and he held his at bay—mostly—for nearly two hours. A fine and insightful professional musician himself and maybe Honey's favorite Sunday school teacher, he reminded me of Leonard Bernstein's contention that "music is what happens between the rests." Robert's observation is that I have had a song in my soul all my life, even during Honey's extended illness and death, and that perhaps I am now in one of those "rests." That's good, Robert! *When harps are hung no song we raise.* I'll bet you are right.

Dinner with Kim and Jimmy tonight was wonderful. Jimmy is vice chair of the First Baptist Church Nashville Bicentennial Committee (2020) that I chair; Kim and I go way back. I first met them after church the first Sunday they visited First Baptist Church in 1985, and Kim was working with me as a summer replacement in the music office two days later. She became church pianist in 1993 and then joined me working on the *Celebrating Grace Hymnal* in 2007. There's no telling how many miles we logged together all over the eastern part of the United States the next six years. Honey jokingly referred to Kim as my "hymnal wife."

Wonderful words of life early this morning—an old gospel song, #643 in the hymnal Kim and I helped build:

> *There is never a day so dreary, there is never a night so long,*
>> *but the soul that is trusting Jesus will somewhere find a song.*

[If you know it, sing the refrain with me …]

> *Wonderful, wonderful Jesus, in the heart He implanteth a song;*
>> *a song of deliverance, of courage, of strength;*
>> *in the heart He implanteth a song.*

"Wonderful, Wonderful Jesus" – Words by Anna B. Russell

Celebrating the song sounding quietly.

APRIL 20, 2015

A look at last week's calendar revealed that I was pretty busy. Breakfast with Sam, back-to-back lunches with two friends, dinner with Jimmy and Kim, dinner with our favorite teenager at the church we served while in seminary church, an appointment here and there, some Celebrating Grace tasks, plus an overnight trip to Atlanta for a minister of music friend's father's funeral sort of filled up the week. This week's forecast appears much the same.

My brother Randy also attended the funeral, so we shared a room and enjoyed some high-level visitation. Going on at the hotel next door to ours was a Mercer University event, so we also got to visit with some of their attendees—our friends John and Babs from San Antonio, and Tom, Julie, and Carolyn McAfee, who trusted me to help them produce the *Celebrating Grace Hymnal*. It was a good trip on many levels.

Today, I enjoyed an extended lunch with my friend Frank, with whom I worked longer than with any other pastor—ten years—and who helped us recently with Honey's memorial and graveside services. Frank excels at presiding over the "tender times" in people's lives—baby dedications, weddings, and funerals. I have never worked with a pastor who was more supportive and encouraging to me than Frank. I will always be appreciative of that and the friendship we share.

Our dear friend Marte left a bag of goodies—very goodies—at the church for me to pick up today for tonight's dinner. She said it was potato soup, which it definitely was; but then there was also the cornbread, salad, homemade dressing, and sweets. How does husband, Gary, stay so trim?

I still miss Honey terribly, and as reported earlier, sometimes it is overwhelming and those times often show up unexpectedly. Last night the sanctuary choirs of our church and First Baptist Church, Huntsville, Alabama, joined forces and voices to present Mendelssohn's oratorio *Elijah*. I was able to attend and enjoyed it very much. Near the end of the oratorio is my favorite aria in the whole work. It occurs after the prophet Elijah has been swept up to heaven in the chariot.

The song is not part of the story, but functions more as the moral of the story; the tenor sings that aria based on Matthew 13:43:

> *Then, then shall the righteous shine forth as the sun*
> *in their heavenly Father's realm,*
> *Shine forth as the sun in their heavenly Father's realm,*
> *Then shall the righteous shine forth in their heavenly Father's realm,*

As the sun, as the sun in their heavenly Father's realm.
Joy on their head shall be everlasting, joy on their head shall be everlasting,
And all sorrow, all sorrow and mourning shall flee away for ever.
Then, then shall the righteous shine in their heavenly Father's realm,
Shine forth, shine in their heavenly Father's realm,
Shine forth as the sun in their heavenly Father's realm,
Then shall the righteous shine in their heavenly father's realm.

It wiped me out. First of all, it is a beautiful aria and the lines peak in exactly the right spots. Second, when I conducted *Elijah* thirty-one years ago in the same room, Archie stood straight up and sang the fire out of that song long after most singers his age should even attempt such. I celebrated his wonderful gift of singing that night, and I'll never forget the experience. But then Honey came to mind and I'm tellin' ya, more than a little bitty tear let me down. Honey, Archie, nor even Elijah were righteous, but they have been *declared* righteous by the word and work of God; now they "shine forth as the sun in their heavenly Father's realm." Oh, my soul, what a blessed thought! "And all their sorrow and mourning flee away for ever." Oh, thank you, God! In the meantime:

> *While we walk the pilgrim pathway, clouds will over-spread the sky;*
> *but when traveling days are over, not a shadow, not a sigh.*

[Sing with me]

> *When we all get to heaven, what a day of rejoicing that will be!*
> *When we all see Jesus, we'll sing and shout the victory.*
> "WHEN WE ALL GET TO HEAVEN" – ELIZA E. HEWITT, 1898

Grace and peace to our friends and herd near and far.

Warning: Travelogue Ahead! A couple of months before Honey died, I decided that after it was all over I would get in the car and drive—retracing some of our steps plus taking some new ones. That's what I'm doing as we speak.

I left home last Wednesday and drove to Texarkana where I spent the night with Diane, my favorite Presbyterian pastor cousin, and her carpenter husband, Greg, who have a wonderful place in the country for bird-watching, journey-sharing, and bread-breaking. We crammed all three into twelve hours of pure joy. Family blood is a good thing. I know and love that gal.

Next stop was nearby Shreveport to reconnect with Lance, my best friend during Natchitoches days (nearing forty years ago). He and I don't stay in constant contact by any means, though he stuck as closely as anyone's brother during Honey's illness and was able to attend her memorial service. But on those rare occasions we are able to visit, we pick up seamlessly where we left off last. He and bride, Glad, feel a lot like family, and as he said when we parted, "We are brothers with different mothers." Spot on! The first of two intermediate back-road stops en route to Shreveport was the historic little town of Jefferson, Texas, where I enjoyed a "kornbread" sandwich near the town square. Honey would have loved that little town, although I didn't see a Christmas shop where she could always leave at least a little money.

The second was across the state line in Plain Dealing, Louisiana, childhood homes of friends and Santa Fe condo-sharers, Fred and Jo Ann. Sitting in the car under the shade tree at Plain Dealing Baptist Church while texting Todd, their middle son, I was aware that someone had pulled up beside me. The driver asked if I needed to get in the church, reporting that she was the church secretary and thus held the key. I introduced myself and wondered aloud how long she had been a member of the church, that perhaps she knew Fred and Jo Ann, and maybe even Bill and Muriel, my former colleague at First Baptist Church Nashville who once pastored Plain Dealing Baptist.

"Oh yeah, Freddy and Jo this and that … and Muriel was the smartest woman I ever knew." Sure enough, on the church's wall of fame as you walk into the sanctuary were several pre-1970 photos of Bill on the business end of a groundbreaking shovel along with "Freddy's" mom and dad. Todd texted right back, among other things, dispatching me just down the street to Giles Snack Shop to meet and greet eighty-four-year-old Annie Lou who runs the place. Annie Lou was right there behind the counter waiting on customers who ventured in for a mid-afternoon snack in her quaint little shop in midtown Mayberry.

"Annie Lou, how long has this place been here?"

"When Freddy and Jo were young, we had a drive-in out there on the highway. We'd stay open at night as late as the teenagers were there. Parents appreciated that because it gave the kids a place to go, and they knew we'd make them toe the line."

What an extraordinarily sweet stop along the way! She seemed blessed, and I certainly was.

The weekend destination was Natchitoches, Louisiana (from whence Honey and I moved to Nashville nearly thirty-eight years ago), but not before surprising Karen, a now mid-fifty-something former Chapel Choir singer graduating from nursing school—her third degree. Turning around from the other direction, she exploded upon discovering it was I offering to help with her hat. Her parents and I pulled off the surprise; it was great!

Natchitoches is the oldest permanent settlement of the entire Louisiana Purchase and the setting and filming location of the movie *Steel Magnolias*. Honey and I loved that stop along our music ministry journey and have been back several times since. We served three churches in our time, and all were special and good—each just right for us at just the right time. As usual, I stayed with Pat and Mike (Karen's parents), and they treated me royally. And as usual, they invited people to their house Saturday night for dinner and

catching up. Former chapel choir singers/accompanists/parents showed up, some of whom I have not seen since we left.

Sitting in worship Sunday morning next to Sue Beth, one of our two teen-age accompanists, I couldn't help but relive some of the highlights of those most formative four years in that wonderful church—the ideal first steeple experience for a minister of music just coming out of seminary. Oh my gosh, I missed Honey, but I am almost sure she was there. Hugging farewell and driving away, tears flowed—tears of certain sadness, but very soon joy and deep gratitude trumped it all.

> *Through all the tumult and the strife*
> *I hear the music ringing;*
> *it finds an echo in my soul—*
> *how can I keep from singing?*
> "How Can I Keep from Singing" – Robert Lowry, 1869

MAY 11, 2015

Tonight's update evokes the immortal country hymn written by Earl Green and Carl Montgomery: "Twelve days on the road and I finally made it home last night."

It was a great trip, but I was ready to get back home. That trip would have been a real "Honey-pleaser," because of all the people we got to see. Honey and I served three churches during our married life, and I saw friends from all three. Plus, I even had lunch with Virginia, one of the "teenagers" from the church I served my senior year in college—Honey's home church in Kerrville, Texas. Virginia and Honey were also college roommates their freshman year at Baylor and both married exactly one week apart at the same altar by the same preacher.

Of special delight on this trip was discovering how young people who were in choirs I directed all these years have grown up and are actively living

their faith, committed to God's call and claim on their lives. They are raising wonderful children of their own, are active in their churches, and some are leading worship. Amy talked about bearing appropriate witness as principal in a large elementary school in a Dallas suburb, and each is making a difference in the world around them. Working with teenagers in whatever capacity is hard work in many ways, but for those still at it, be not weary in well doing, it is worth it.

I spent a night with Honey's brother in Fort Worth. He and I are in the same boat of losing our spouses, although he is a couple years ahead of me. Ab cared for Karen much longer than I took care of Honey, so I'm hanging on to some of his testimony and insight.

While I was away, our son, Nathan, was called to be the bi-vocational minister of music at Second Baptist Church in Memphis. (Anyone out there very surprised?) He and Corri have wrestled with this calling in his life for several years, and now things seem to have fallen in place. He has the eye, ear, and heart for this ministry, and I could not be more happy or proud. Corri—also raised in a minister of music's home—will complement him just as her mom complemented Ronnie and Honey did me. Nathan's "day job" is one of those that allows him to work from nearly anywhere, so they will be moving to the Memphis area (Collierville) in the next few weeks.

I attended church Sunday at Immanuel Baptist in Little Rock, where former FBC Nashville choir member Eric is minister of music. He and Missy are doing a great job there. He doesn't lead worship exactly like I do, and that's as it should be. For one thing, he is more comfortable with and gifted for a broader range of music than I—good for him and good for that church. The last stop for this trip, I drove away, and this old song that I hadn't even thought of in many months came to mind:

> *Singing I go along life's road,*
> *praising the Lord, praising the Lord.*
> *Singing I go along life's road,*
> *for Jesus has lifted my load.*
> "*Singing I Go*"– Eliza E. Hewitt

Jesus seems to be lifting my load of loss, although He and I still have a bit of work to do. I returned to a pretty quiet house, a whole box of mail—much of which needs immediate attention—but also a batch of wonderful notes from many of you. And then sweet Rachel and son Noah brought wonderful dinner for tonight and tomorrow and... .

I'll see you down the road a piece.

MAY 25, 2015

Two months ago yesterday Honey died. As that hymn says,

> *Days of darkness still come o'er me,*
> *sorrow's paths I often tread,*
> *but the Savior still is with me;*
> *by His hand I'm safely led.*
>
> *"I WILL SING THE WONDROUS STORY"*– FRANCIS H. ROWLEY, 1886

The spiritual reality of that bit of lyric is spot on although, thankfully, some of the specifics overstate my experience. For me, "days of darkness" are more like moments of sadness and "often tread" is more like occasionally. I miss that gal so much and there's a big hole in my heart, but we had a great run for a lot of years, chocked full of blessings, which trumps some of the sadness. Sometimes I catch myself wondering what Honey's doing today in heaven, and then her "hall ministry" at Tennessee Baptist Convention comes to mind quickly.

The time I miss Honey most is at dinner. During most of our married lives, breakfast took on all manner of forms and times. She worked at the TBC and sometimes came home for lunch, but working downtown, I never did. But we nearly always had dinner together, and more times than not, Honey fixed it and I usually cleaned up. The food was nearly always wonderful, and that's when we caught up and kept current. Nathan liked to call on his way home from the office during our dinner and often accused us of "practicing for the Home" because we ate so early ... at least by his standard. So for me these days, fixing dinner and then eating it alone is a new routine that isn't much fun, but it does seem to be getting easier—both the fixing and solo eating.

Another time I miss Honey is traveling, of which I've done a good bit since she died. It's not so much the driving as it is when the day is done and I'm getting ready to turn in. While working on the *Celebrating Grace Hymnal* for three years and continuing for another three, I traveled a lot, nearly wearing out a new car. But I always called her before going to bed—always! There's a moment of sadness that is yet real.

I thought about Honey a good bit today and actually had planned to go to the cemetery, but the rain sabotaged those plans. I got up this morning and took a walk as the sun rose, during which I caught myself thanking God again that Honey didn't have to be confined to a sick bed during the pretty weather. That would been hard for her because she was a bright springtime/summer gal, and worse, she would have felt bad for me being pretty much tethered inside the house. She was always more concerned about me—and you—than about herself, and she didn't have to work at that. That's just the way she was.

After a pretty crowded last week, it was a quiet weekend around here. Several projects put on hold for days and weeks have been accomplished or at least begun, so it has been fine. Jim, my neighbor out our front door, invited me to go with him to the symphony Friday night since his wife is out of the country for a few days. Friday night's weather was near perfect, and we enjoyed the visit and concert. I have also picked up a few woodworking projects, so the sawdust is once again flying in the shop, which is a very good thing. I have a great shop for which I am most grateful. Greg and Etta down the street are moving to another house in the neighborhood and want me to build shelves in their new garage. That may be my favorite woodworking project; I love to build shelves/storage for people's garage gear, a.k.a. junk. Those projects involve the parts of woodworking I enjoy most—figuring out a plan, cutting, and assembling. Plus, it's not usually a long, drawn-out ordeal, and in a day or two or three you walk away with a new status of hero.

Another project completed this weekend was a vocal solo arrangement for Gordon to sing at our church in a couple weeks. It's a century-old gospel song that has become more meaningful to me of late:

There is never a day so dreary, there is never a night so long,
but the soul that is trusting Jesus will somewhere find a song.

There is never a cross so heavy, there is never a weight of woe,
but that Jesus will help to carry because He loveth so.

There is never a care or burden, there is never a grief or loss,
but that Jesus in love will lighten, when carried to the cross.

[Okay, all sing ...]

Wonderful, wonderful Jesus, in the heart He implanteth a song;
a song of deliverance, of courage, of strength;
in the heart He implanteth a song.

"Wonderful, Wonderful Jesus" – Words by Anna B. Russell

Thanks for looking in, keeping up, and pulling for. Love and enjoy those around you—they are gifts and treasures.

JUNE 8, 2015

I like to walk early in the morning, preferably before the sun comes up, earbuds in place listening to NPR's *Morning Edition*. Today was perfect. Sometimes the news is all bad, but today there was a piece about Karim Wasfi, the conductor of the Iraqi National Symphony Orchestra, who, after acts of terror in his hometown of Baghdad, grabs his cello, goes to the site of the violence, sits down, and plays. The combination of music and place has become his form of resistance to terror and respect for fallen ones. Whereas some choose battle and destruction, Wasfi chooses civility and beauty.

Toward the end of the interview he said something that, for many of us, needs to become a memory verse: "Unlike what people think, we have a choice of fighting back. We can't just surrender to the impending doom of uncertainty by not functioning. But I think it's an awakening for everybody to make a choice and to choose how they want to live, not how they want to die."

NOTES FROM Susie

Looking back, I think Honey made that initial choice about living a long time ago and then she made it again a couple of years ago when "violence" invaded her life and the "battle" forced her hand. Her form of resistance was peace, gratitude, and joy. Not many choose how they want to die—Honey certainly didn't choose cancer, but in light of her simple but deep faith, she did choose how she would live with cancer.

But not even cancer destroyed her peace, gratitude, or joy. She died just like she lived, and in the process showed us a good way to do both. The real beauty of that truth is that Honey taught us unintentionally and would blush at the suggestion otherwise; that's just the way she was.

> 'Tis so sweet to trust in Jesus, just to take Him at His word;
>> just to rest upon His promise, just to know, "Thus saith the Lord!"
>
> Yes, 'tis sweet to trust in Jesus, just from sin and self to cease;
>> just from Jesus simply taking life and rest, and joy and peace.
>
> I'm so glad I learned to trust Him, precious Jesus, Savior, Friend;
>> and I know that He is with me, will be with me to the end.

[All sing now …]

> Jesus, Jesus, how I trust Him! How I've proved Him o'er and o'er!
> Jesus, Jesus, precious Jesus! O for grace to trust Him more!
> "'TIS SO SWEET TO TRUST IN JESUS"– LOUISA M. R. STEAD, 1882

I hope you will choose to live life well whatever your circumstances. I hope I will, too. In doing so, the journey will be more joyful.

EPILOGUE

It has been a few months since Honey died, and I continue to work through the grief process that, looking back, actually began soon after we received her diagnosis. Still, though, I catch myself trying to solve the unsolvable and unravel that which we will only "understand better by and by." This closing chapter articulates some of those musings, discoveries, and lingering questions. What follows should be considered reporting rather than recommending—save one comment.

First of all, our two-year ordeal was very hard, but not horrible. Most of that had to do with Honey's genuinely sweet, positive attitude, which made the difficult journey so much easier for both of us. I was able to retire—again—from the workforce and be a stay-at-home caregiver. I was better at caregiving than I and probably many others anticipated; I was more than glad to help her and wouldn't take anything for that rather extended experience. We had each other, leaned on one another, and actually had some fun times even when the going was tough. We made light of even heavy things and were able to find some humor in things that clearly weren't ultimately funny at all.

This attitude and approach could have come as a result of a statement a caregiver friend made to me one Sunday morning after church. His partner of several years had recently died of cancer, Honey had just been diagnosed, and I asked him how they walked their long road together. He said that they consciously chose to live in total denial as long as they possibly could. What? Then he explained not *denial* in the sense of "this is not happening, we don't have cancer, no need of medical care, everything is going to be okay," but rather "denying that awful disease the power to take away our joy, to keep us from living every day to the fullest, or to redirect our focus toward the dark side of life." I can tell you that is far easier to say and write than to actually do, but it is possible by the grace of God.

My favorite uncle, a poetic and prophetic preacher, used to say, "The older we get, the more like ourselves we become." Honey was Exhibit A of that. So many people marveled at how she handled her illness, how bright her smile, how warm and welcoming her spirit, how calmly she spoke of her condition. But that's the way she always was. For nearly forty-five years I saw her take an

occasional hit of some kind, cry through it, "lick her wounds," and then stand straight up and move forward with new resolve—and yes, gratitude, and joy. As the plot thickened, she became more and more like herself.

The last two years of her life were but a small slice of her otherwise beautiful and almost storybook sixty-three years, as well as our nearly forty-five years together. We were determined that this brief stretch would not define or detract us. We enjoyed recalling, reciting, and celebrating anew how God's goodness and mercy had, indeed, followed us all the days of both of our lives. We were both raised in good Christian homes; both navigated safely through high school; we found each earlier on; we served three wonderful churches; Weslee and Nathan—our children—were/are wonderful; we have had good jobs, a stable home, enough money, good, good friends through the years, caring neighbors. The list is endless. Life has its ups and downs, its joys and sorrows, its curves and straightaways. But until March 2013 we had been pretty much spared serious challenges and difficulties that other couples and families face. By the grace of God, we were able to focus on and live in the light of all the joy and brightness that had characterized the vast majority of our days.

Another reason we could do that was because we were leaning hard into the faith we'd professed and the hymns we'd sung all these years. We found that both took on deeper meaning. Spiritual attitudes and principles to which we were exposed from infancy now had life-urgent application, to the point that words literally became flesh. Music at church, specifically hymnody, was an integral part of our growing-up years separately, but together it constituted a whole career. Now, though, we heard familiar hymns anew and sang them with greater gladness. The Psalmist said, "Let the words of my mouth and the meditation of my heart be acceptable in thy sight, O Lord, my strength and my redeemer."

It is generally accepted that the things we say spring from that which is within us—that words of our mouth begin as what the Psalmist calls meditations of the heart. True enough. But I have come to realize that heart-mouth flow also travels the other direction—that words of the mouth not so much **begin** as meditation of the heart, as that they **become** the meditation of the

heart. Honey and I spent nearly a lifetime putting and practicing good words (hymns) in our mouths that took root, becoming meditations in our hearts from which we were able to draw incredible strength, peace, and even joy amid the raging storm. What a gift to us!

When we began to suspect that efforts to arrest Honey's cancer were likely doing as much harm as good, she made the difficult decision to focus on quality of life rather than quantity. That was a pivotal point; I say pivotal, because from that point on and in everyday conversation, she began to surface matters of "final" nature in a matter-of-fact way, and most of the time out of nowhere. For example, one night when Nathan was here, the three of us were sitting in the den visiting—they were talking and I mostly listening in—when she blurted out, "Well, I don't want to die at home." Or one night after we had turned out the lights, she said, "Do you think you'll keep this house?" One night she was paying bills, working the checkbook or some such at the desk in our home office. I walked in to retrieve something when she said, "You're going to have to start doing this before long" and proceeded to begin coaching me.

These announcements were made with no hint of gloom or sadness; it was just her facing the hard facts and making necessary arrangements. One thing that got to me most was when she would go down to her craft room in the basement and work toward finishing scrapbooks of some of our trips or more likely of grandkids, while listening to CDs of hymns. She went about that task as calmly, resolutely as always, enjoying doing something for her and us to remember later. To share that story even now wipes me out. When she worked on those and I was working at my basement desk fifteen feet away, I would just have to leave and do something else ... which usually began with some private sobbing.

Private sobbing happened more frequently as Honey got weaker. Tending to her in the sick room, I was able to go about necessary tasks with calmness and often a degree of lightness, but when I left the room all bets were off. It

tore me up to see my bride bravely deal with pain and hear her express honest gratitude while wasting away to near nothing,

When she would bring up a topic that needed discussion—like, "Do you think you'll keep this house?"—I would always talk with her about it. I don't think she ever surfaced anything like that that I had not already processed in my own mind, but I waited until she brought it up—not hoping to avoid the issue, but it seemed better to wait until *she* was ready to talk about those things. I didn't want her to think that I was fretting, unduly burdened, or rushing matters.

Our five grandchildren were her absolute delight. No one loved or was loved by their grandchildren more than Honey. No one. But there came a time when she quit talking about them. It must have been too painful for her to realize how much of their lives she was going to miss. There are photos of those five all over our house, and I have frequently talked to those photos when walking by one of them. When I realized she wasn't talking about them, I ceased talking to their images. That was not easy, though probably polite.

And speaking of grandchildren, the young are resilient. Honey's illness and especially her death were hard on those four little boys—ages five to eleven (Ella, our granddaughter, is too young). Ever since those guys were big enough to walk, "Target runs" with Honey happened every time they came to see us. They each had a gift card for the purchase of an Icee™ on their way to the toy aisle, where they could get anything they wanted for fifteen dollars. Early on in her illness, Honey was understandably concerned that her bald head would be a shock and downer to the boys. But within ten minutes of their arrival, they were having a big time trying on Honey's new wigs and telling her how cool she looked with a head that resembled their summer cuts.

But those boys' resiliency had a lot to do with how their parents and Honey herself handled the situation and prepared them. Honey would answer any question, calmly talk to them about anything, and always bless them before

finishing the conversation. Through their own pain and then grief, the boys' parents filtered what they told them and chose carefully their times with Honey moving toward the end.

Honey died near the end of March. Christmas three months earlier was perfect. We were all together; Honey felt pretty good, and she was able to enjoy it all. But on December 28, the downward spiral began with a visit to the ER. The boys didn't see Honey after that; their parents decided that Honey at Christmas was the lasting image they wanted for their guys. After Honey died, the boys didn't attend the family visitation the night before the memorial service or the interment the next morning, but later they did come to the church for lunch and to attend the memorial service. As Weslee's bunch left town, they took their three by the cemetery to place some flowers on Honey's fresh grave. Nathan took his crew by there later. I think they made the right decisions from start to finish.

Beginning to ponder Honey's death months before the fact, my main concern was the grandsons. I thought we adults would be okay, but my heart broke for those boys who adored Honey. Four months later, they do miss her, and when I'm with them, one of them will say so. But the young are, indeed, resilient, and we seem to have safely navigated that tricky spot. To quote Honey, "Thank you, Father."

I find myself enjoying talking about Honey. When friends came around for the first time after Honey died, often times some didn't seem to know what to say or not say. We've all been in those situations, and it can be awkward. But I have tried to ease the anxiety by saying up front something like, "It doesn't bother me to talk about Honey; sometimes it slips up on me and I get a little emotional, but that's okay and it doesn't last long." Talking about her and saying her name aloud seem to be therapeutic. Besides, we had such a good life together, we had so much fun, and she was so respected and loved, there was plenty of good material to talk about. Most of those conversations take on the same bright mood exactly as they would have had Honey been presiding. That seems to be the best way to remember and celebrate her.

My good friend Carolyn and I both lost our spouses way too soon. She has ten years of perspective more than I and wrote this poignant personal message inside her card on the occasion of my first birthday A.D.:

"These 'firsts' are very difficult but hope you have a very special birthday and do something fun! [*I did, indeed!*] I enjoyed so much the pictures Weslee posted on your anniversary [*ten days before my birthday*]—Precious memories! Jim and I had just celebrated our 42nd on September 1 before he died November 3. Each time we recall the past and are thankful that it happened at all, we revolutionize its meaning. And we celebrate life!"

Did you get that last part? "Each time we recall the past and are thankful that it happened at all, we revolutionize its meaning. And we celebrate life!" Well put, Carolyn—yes, "thankful that it happened at all ... and we celebrate life!" Neither Carolyn nor I deserved stellar spouses more than anyone else—they were grace gifts to us, and when we look back and realize that, the least and best we can do is be thankful and celebrate the life we were each able to share for forty-plus years. Gratitude trumps sadness and yields joy. Thanks be to God!

Recently, two very familiar passages of scripture have stopped me in my tracks anew and are helping me celebrate God's goodness yet again. Lifted from their contexts, they could easily have been in the same chapter, but they are three hundred pages apart in my Bible and separated by twice that many years of origin.

> *"'For I know the plans I have for you,' declares the Lord,*
> *'plans to prosper you and not harm you,*
> *plans to give you hope and a future.'"*
> JEREMIAH 29:11

> *"And we know that in all things God works*
> *for the good of those who love him,*
> *who have been called according to his purpose."*
> ROMANS 8:28

Then down the page, it says:

> *"What, then, shall we say in response to this?*
> *If God be for us, who can be against us?"*
> Romans 8:31

Honey died way too soon to suit me. Her early death certainly was not in the plans either of us made. But just as the prophet Jeremiah was speaking God's word to God's children in exile in Babylon, and just as the Apostle Paul was addressing first-generation Christians in Rome who were trying to figure out how to live victoriously in light of God's grace, so their unison message of old is clear to us this day: God is in charge, God loves us, He knows what He's doing and what we're doing. He sees further down the road than we, we are in His care, and the path ahead is for our eternal good rather than harm.

Our choice, then, is to believe that or not, live in its light or not. My hunch is that Honey's ability to face death with such peace and joy is full evidence that she had set down her full weight squarely on that truth. Death just may be one's final act of faith. If so, Exhibit A—Honey!

I am not ready to say that two years of painful cancer and ultimately Honey's death were God's plan, but I firmly believe that God is working good things in the lives of those of us left in the wake of her death. The opportunity to compile/write this book seems to be early evidence of God's "work for the good" for me. Reliving and scripting some of the story is emotional and even somewhat painful, but the greater portion is joyful and gratifying. We know not what lies ahead, so we are trying to trust the One who clearly does; frankly, there's some excitement in living expectantly even through the shadows.

A few years before Honey's diagnosis, a friend of ours who had been widowed for several years was remarrying. One night at dinner, Honey and I were talking about her, celebrating her newfound joy, which appeared to be part of God's good work in her life. We both readily agreed that when one us was left alone, that it would be okay for the other to remarry; but laughingly, we both preferred that the survivor not bring a date to the departed's funeral.

I am pretty sure that I will be better at living alone than would have Honey. While solo living so soon was not my Plan A, it has not been as difficult or devastating as I might have thought, had it so much as crossed my mind five years ago. But her two-year illness surely provided generous time to prepare for this day; one of our family's wise and rather recent dear friends called it "anticipatory grief"—another of God's working for good in all things.

In the opening paragraph of this Epilogue, I mentioned that these pages would consist primarily of reporting rather than recommending. But please allow one recommendation.

I loved and appreciated Honey, and she knew it, because I told her so ... often. I was committed to her, and she knew that because I showed her my love from beginning to the very end. I affirmed her all along the way in so many ways, but admittedly sometimes she struggled to believe she was as good as I said. Even with all of that expressed and demonstrated love, appreciation, commitment, and affirmation, it wasn't enough; but, in a case like ours, it probably never could be. Please don't read this as some kind of guilt trip for Honey or me, but rather a healthy realization of basic human frailty and finiteness.

If I had our lives together to do all over again, I wouldn't want to change much because, as it was, we both had a great time and she died just as she lived—with a grateful heart and joy-filled spirit. But I'd like to think I would make more of some of the good things, take greater advantage of some opportunities, and try to create more times to celebrate. My single recommendation:

When it comes to expressing love in word and deed to the one(s) closest to you, err on the side of extravagance rather than of want. That doesn't mean breaking the bank to lavish the loved with "stuff." It does mean taking every opportunity to bless and build up the other for their sake.

We conclude this telling of Honey's story borrowing a couple of paragraphs written by her friend who doubled as her boss at the Tennessee *Baptist and Reflector*, where she worked and "hall ministered" for nearly three decades. Lonnie Wilkey writes,

"Susie was the chief proofer for the paper for most of her time on the staff. We would give her 'hard copy' of the stories she was proofing. We usually would type or write '30' at the bottom of the page so she would know that was the end of the story.

There is no '30' on Susie's story. Those who knew her best will have precious memories of her and the times that were shared, and one day we will see her again in heaven. That's the hope and promise we find in Scripture.

Thank you, Susie, for your friendship and for the memories. So long, for now."

Be still, my soul: the Lord is on your side.
Bear patiently the cross of grief or pain;
> *leave to your God to order and provide;*
> *in every change God faithful will remain.*
Be still, my soul: your best, your heavenly friend
> *through thorny ways leads to a joyful end.*

"BE STILL, MY SOUL" – KATHARINA VON SCHLEGEL, 1752; TRANS. JANE BORTHWICK, 1855

My life flows on in endless song; above earth's lamentation,
> *I hear the sweet, though far-off hymn that hails the new creation.*
Through all the tumult and the strife, I hear the music ringing;
> *it finds an echo in my soul—how can I keep from singing?*

"HOW CAN I KEEP FROM SINGING" – ROBERT LOWRY, 1869

In the bulb there is a flower;
* in the seed, an apple tree;*
* in cocoons, a hidden promise:*
* butterflies will soon be free!*
In the cold and snow of winter
* there's a spring that waits to be,*
* unrevealed until its season,*
* something God alone can see.*

There's a song in every silence,
* seeking word and melody;*
* there's a dawn in every darkness*
* bringing hope to you and me.*
From the past will come the future;
* what it holds, a mystery,*
* unrevealed until its season,*
* something God alone can see.*

In our end is our beginning;
* in our time, infinity;*
* in our doubt there is believing;*
* in our life, eternity.*
In our death, a resurrection;
* at the last, a victory,*
* unrevealed until its season,*
* something God alone can see.*

NATHAN'S REFLECTIONS

We were at a gas station in Chattanooga on Sunday night, December 28. We had just eaten dinner with some dear friends and were headed to Gadsden, Alabama, to close out our Christmas holidays. It had been a wonderful visit in Nashville for all. Mom felt good and was able to enjoy the days with her whole family around. But, by Sunday morning, Mom was tired and experiencing severe back pain. I was not surprised as the text messages came throughout the evening that an ER visit was looming. I was reflecting on our visit and the developments since our departure as I pumped gas. Corri and Ella were next door getting ice cream (it's *never* too cold), and Daniel was with me. "Daddy," he said, "the next time we go to Nashville, will we see Honey?"

I smiled, trying to conceal the moisture in my eyes, looked at my son, and simply said, "I don't know." I had wondered many times through the journey how I should prepare him for the likely outcome of Mom's illnesses. How do you prepare your kids for something that you yourself have not yet processed and accepted? Daniel has always been keenly aware of his surroundings, both physical and emotional. He has always wanted all of the facts, no matter what they were, and is not a fan of surprises. (Some might say he's a bit like his father in those respects.) He knew that she was sick, and he knew that she wasn't getting better. I'm not sure what he saw before we left that made him think this might be his last time to see her. Whatever it was, his amazing spirit was right. For a number of reasons, we chose not to take our whole family back to Nashville until after Mom died.

A very wise person helped me to understand that there isn't necessarily a *right* way to handle this type of situation. We simply handle this in the best way we know how. I believed her (mostly) and applied that same philosophy to how we helped Daniel prepare for Honey's passing. As he is one who needs facts and details, we answered all of his questions directly and truthfully. We prayed specifically for Mom—for less pain, for informative and definitive tests, for positive test results; and for strength and comfort when results were not what we had hoped. We assured him that Honey would be healed in heaven with God. We told him that we would be sad because she wasn't here with us, but we should be glad that we knew her, and thankful that she would no longer have to live in pain.

Perhaps the best part of how we helped our kids prepare for Honey's death was that we didn't have to do it by ourselves. In many ways, Honey herself prepared both Daniel and Ella. While she was sick, she did everything she could to have the strength to honor the sacred Target run with them. She continued to tell them that she loved them dearly … just because they live and breathe, and she continued to tell them how much joy they brought her.

Even before she was sick, though, she was helping him prepare to remember her after she was gone. There were times in his younger years when Daniel would spend extended periods of time with Honey and Papa. They would stay in Birmingham while Corri and I took trips, or we would send him to Nashville to visit. Each time, Mom would have special things for them to do. She would research museums, farms, parks, and everything in between to be sure that there was plenty for them to do. She took pictures, and she made scrapbooks of their adventures together. I underestimated the value of these treasures. While Honey was still alive, we would wake up to find Daniel flipping through the pages of those books. That has not changed now that she's gone. We still find him reading those stories and seeing the pictures of those special times. It is a way that Mom helped prepare our son to remember her after she was gone.

One of the great tragedies in this is that Ella, who was twenty months old when Mom died, will not remember her very much. She probably won't remember all of the tender hugs and kisses on her neck that Mom gave her in the short time they knew each other on this earth. But Mom gave her one of those build-a-bear bunnies. She recorded herself saying, "Hi, sweet Ella-girl. It's Honey. I love you." It is a special gift, and it stays in our playroom for Ella to listen to from time to time. I believe the message is still true—Honey still loves Ella-girl. As she gets older, and her attention span longer, Daniel will also be able to share his books with her, and tell her about all of the adventures that he had with Honey. It won't be the same, but it will special to hear Daniel recall Honey from his perspective and pass on what he knew of her to his little sister.

There are many things from Honey's life that we could try to instill in our kids. But, one trait is clearly a "must": Honey lived a life of absolute gratitude. She was thankful in all things, for all things, and especially, for all people. When our kids begin complaining about something they didn't get or doing something they'd rather not, Corri and I try to remind them about Honey. We tell them that the best way we can remember Honey, and to thank God for getting to know her, is to show gratitude in all things, for all things, and for all people. We have to remind them of that from time to time. We all need reminding of that ourselves from time to time.

Honey was a special lady and is dearly missed. I don't know if we prepared our kids for her death in the *right* way or not. We simply did the best we knew, and we do the best we know. And we pray to God that He will impress upon their hearts and minds Honey's love and gratitude in all things, for all things, and for all people.

WESLEE'S
REFLECTIONS

As a counselor, there have been many times I have sat across from a client and walked with them down their personal road of grief offering advice, hope, encouragement, and hopefully comfort along that often difficult road. Taking classes, reading books, and having a piece of paper on your wall that says you have learned enough to help others doesn't always mean you are adequately prepared to help your own loved ones as they travel down the same road of grief.

Chris and I have three precious boys, and I knew from the beginning that each one would approach Honey's illness and death differently. The challenge was knowing what each needed and when they needed it. As a whole, we were up front with them when we knew specifics to tell them. It was a hard balance to find between too much and not enough information for children under age ten. We prayed for Mom at mealtimes, and any time the boys had questions we answered them to the best of our abilities. I probably shielded them from most of the day-to-day stuff to keep them from being overwhelmed with it all.

There were tests run, and to keep them from worrying about them, I usually waited until after the results were in and a plan was in place before I shared with them. We didn't hide things from them, but we also didn't want to burden children with adult situations. It was a balancing act, I'm telling you, and I am sure I "chose poorly" on more than one occasion. I remember Mom being worried about how the boys would be when she lost her hair. I told her that we weren't going to hide it and we would take our cues from them with that one. I didn't want them to be scared of cancer or of Mom, so we decided that if they were curious then we would let them see, and if not, then she would leave on her wig. We had a great time trying on her wigs and rubbing the stubble on her bald head. Once we decided that we were going to take some cues from them, things were a little easier for Mom, too, I think.

Individually, though, it was a little more challenging. Jonathan is ten and the first grandson on both sides of the family. Honey was his most favorite person that ever had (and ever will) walk the face of the earth. A perfect example was one Memorial Day weekend. Mom and I had flown to Washington, D.C., for a friend's wedding. As we were taxiing into the gate in Nashville, I looked at

NOTES FROM Susie

Mom and told her that I believed Jonathan would be more excited to see her than me and that I would be okay with that, but she assured me he would be more thrilled to see me than her. As we walked up the concourse, she took all the carry-ons and purposely walked several paces behind me so that Jonathan would run to me first. As soon as we saw him, I got down on one knee and had arms outstretched to grab my little two-year-old, who was running full tilt. I watched as he ran right past me and grabbed onto Honey's leg. I burst into laughter. I was so very thankful that he loved Honey as much as he did, and that two-year-old little boy knew his Honey loved him more than anything else! There was a bond there that words fail to describe.

I have always said those who love deeply hurt deeply, and I was well aware that this child who loved Honey so deeply was hurting as deeply as he loved. He happens to be our child who internalizes what he is feeling and thinking. Getting this kid to talk is like getting water from a stone. We would tell him things going on with Mom, and he would get quiet and pensive. We have learned that he needs some time to process before he talks. We would give him some space to think, and then a little later we would ask if he wanted to talk or what he was thinking. Sometimes he would talk and other times he wouldn't. We didn't want to be pushy and hovering, but we wanted to be near for whenever he needed us.

Andrew is now seven and our middle red-headed boy. He is *my* child, and for those who have known me since I was little, they know that he is the one I deserve and am "paying for" because of the way I was. He is the biggest of the boys, but don't let the big exterior fool you; he is the most tenderhearted kid I have ever known. He is perceptive, emotional, and a talker. He is the one who would ask most often how Honey was doing. He is the one who would ask for prayer for Honey at church. Andrew is the one who would randomly stop what he was doing just to go find Honey and give her a hug and kiss. He's also the one who would ask her about how she was feeling, what her meds were for, and what her hair looked like if she had any.

He is more of a Papa's (my dad's) boy, but he was tender to Mom and wanted to help her feel better. He would cry because he didn't want Honey to hurt

and he didn't want Papa to be all alone. Andrew was the one who wanted to talk about Mom and would plop himself down on my bed so that I could explain things he didn't understand; that's what we would do. I tried to explain the best I could without giving too many details that would overwhelm a then five- and six-year old, but enough that he understood. I held him when he cried and let him talk about her as much or as little as he wanted. He is still the one who will randomly blurt out, "I miss Honey," or will tear up just thinking about her or about Papa being alone without her in the house.

Thomas is our five-year-old and youngest. Mom was diagnosed with ovarian cancer two weeks after he turned three. He has some memories of Mom (usually involving Target), but so much of what he knows are stories we tell and pictures we have. Don't get me wrong; he has memories but very few of them are before she was fighting cancer. He didn't ask many questions, but I think he listened and watched pretty closely. He was watching all of us to figure out what he was supposed to do and how he was supposed to react. I was told a story of a conversation he had with my mother-in-law during the week in March I was in Nashville. She had asked him what he thought about all that was going on and he said he was "embarrassed." She went on to tell him there wasn't anything to be embarrassed about and tried to help him understand a little more of what was going on.

Later, after the funeral, when he and I were talking, he mentioned something about being "embarrassing," and I asked what he thought that meant because it was an odd way to describe what we were talking about at that moment. He described feelings of sadness and fear and confusion, but a different kind that he hadn't really experienced before. He didn't have words for what he was feeling, so we were able to use that to help him name them and help us understand him better. There were a few times he would bring up Mom and we would talk about it, but if he was done talking he would switch subjects, and frankly we followed his lead.

One week sticks out most vividly in my mind as we were all processing what the inevitable outcome was going to be for Mom. I had come back from a weekend trip to Nashville, and our family was sitting down to Sunday night

dinner. It was a gut-check moment for me as I told the boys that Mom wasn't going to be getting better. I tried to balance each of the kids' needs as I carefully chose the words I said. I watched Jonathan clam up and try to change the subject. I watched Andrew's eyes fill up with tears and then try to comfort me. I watched Thomas as he looked around the table. We left the table that night, but the conversation stayed with everyone. It wasn't until Wednesday night after church as I was tucking the boys into bed that it came up again. Andrew crawled up on the top bunk, laid his head down on his pillow, and told me that he had asked for prayer for Honey since she was going to die from her illness.

I said, "Yes sweetheart, she is."

At that moment Jonathan, who was in the bed behind me, said, "WHAT?!?!?!? Honey is going to die from cancer????" I turned around to see the fire and tears in his sweet, big blue eyes. I said, "Yes, sweetheart, she isn't going to get better and she is going to die from cancer." His face got red, the tears started flowing, and out came everything he had been storing up. He hit his bed over and over with balled-up fists and screamed, "I. HATE. CANCER!!!!!!" When he got all the rage out and collapsed in a ball of tears, we all just cried and hugged and held each other tight because there was nothing else that could be said or done. He had said it for all of us. He said and did what we all wanted to be able to do.

One weekend when I was in Nashville for a 5K race, I stayed the night at Mom and Dad's; it was after a particularly rough round of chemo that really knocked Mom down. I went home from that weekend with the distinct feeling that Mom wouldn't be alive a year later. That wasn't a pessimistic thought, just a realistic one that I had to learn to come to grips with, no matter how much I hated the thought. I told Nathan my feeling, and the two of us made a trip a week or two later to be with Mom and Dad for Mother's Day. We also were there for birthdays and made it a point to celebrate the special days, because as much as we had hoped for many more years together, I think we knew deep down, the road was going to be short.

I pretty much told all of my family that I was going to be in Nashville for Christmas Eve and Christmas Day. I told them they could be wherever they wanted, but if anyone needed me, I would be in Nashville. Mom and Dad tried to tell me they would rather me be at our home like we have been every Christmas morning for years, but this stubborn daughter won that battle. I told them that was part of my gift to Mom since she had told me so many times that Christmas Eve was "Christmas" to her. I also told Dad that it might be my last one, and this daughter needed to have that memory. It turned out to be the best one and the best present I could have been given!

Mom felt great or at least better than she had in some time. Dad sat at the piano and played carols while we all gathered round and sang. We took pictures and videos. We made the most of the time we had and soaked up every moment that we could. Mom had chemo on Friday the twenty-sixth, and on Saturday the twenty-seventh she was starting to hurt. Sunday morning she was really in pain, and church was out of the question for her.

When Mom was well, she was a fixture at the Welcome Center at First Baptist Church Nashville every Sunday morning. When we were in town, Jonathan would accompany Mom to her greeting station and they would have some time together, which they both loved. He was so hoping that he would be going with her on the twenty-eighth, and when I told him that she wasn't well enough to go, he got sad and I think it sunk in that he wouldn't be doing that with her anymore. I asked him if he wanted some "special time" with Honey, and his eyes lit up. We usually kept the kids out of her room so that she could rest, but I went in and told Mom what was going on with Jonathan. In typical Mom fashion, she put on the "I'm great" face and yet again was able to help someone feel like the only person in the entire world. Jonathan was thrilled when she welcomed him in, and as soon as I felt like he was comfortable (he didn't want to bother her), I left and they had their time together. At one point, he ran out of the room and down the stairs to get something to show Honey, and the smile on his face as he ran past was priceless.

We chose not to have the kids back in Nashville after Christmas for several reasons, but honestly, seeing Mom not being the Mom/Honey we all knew

was hard enough for a thirty-nine-year-old, and I didn't want to subject the boys to something I was struggling with myself. I so wanted the memories of Christmas to be the way they remembered her—part of the reason we opted for them not to see Honey's body in her casket. I wanted them to remember the singing and the presents and the matching pajamas and the Target run. I wanted Jonathan to hang onto the special time he had with her that Sunday morning on her bed. I wanted them to remember her smile and her laugh and her tears during the prayer that we would all sing at mealtime. I wanted them to remember Honey the way they saw her so many times before. If that was the wrong choice, I will gladly pay for therapy later.

One other thing we did to help our boys was that we made sure their teachers knew what was going on in our family. I kept them updated and would communicate when each one seemed to be having a particularly rough time. I also made sure each kiddo knew that his teacher(s) knew and if any one of them found himself upset, then there was a support system in place—teachers, friends (who are like family) in the school, the school counselor—and if any one of them needed me, they had the freedom to call and I would get there as soon as I could to either help calm them and send them back or to take them home. Jonathan did much better just knowing he had several places to go to if he needed someone. Not sure he ever used his resources, but just knowing they were there if he needed them brought him comfort.

There are books to be read, there are classes that can be taken, there are degrees to be granted, but when it comes to helping your own little ones navigate this road, you do the best you can do, and hope and pray that God takes what you've attempted to do and that He makes it something helpful, beautiful, and part of His plan in their lives.

We had an amazing herd throughout Mom's journey. I was appreciative of the hope they carried for us and the encouragement they gave us. For so many months after an April 2014 weekend in Nashville, when I realized that the road we were on was going to end with Mom's death, I had a hard time knowing how to respond to phrases like, "Well, Weslee, God is still in the miracle business." I wanted to be thankful for that hope and encouragement,

and I wanted the people offering it to feel like they had helped me, because let's face it, knowing what to say and when to say something during these times is tricky and uncomfortable.

I responded with a smile and a "He sure is" on many occasions, but that never seemed authentic on my part. I know God is bigger than cancer. I know God is bigger than any emotion I feel. I know God is with me every step of this journey even when I don't feel it. I know that God is still in the miracle business, and I also knew that Mom would die from cancer and I would be forced to accept that even though I didn't want to. I remember one round of tests in October 2014. We were waiting to see if the last round of chemo had helped at all, and I was talking to a friend who had walked down a similar path. I said, "I don't know if it is worse to get bad news or good news today. That's awful to say, I know, but if we get bad news then I don't have to get my hopes up again just to jump back on this road of terminal cancer again in a few short weeks or months. I accepted that this is where we are and I don't want to hope it will get better just to have to accept that it won't get better again later. I just can't do it."

Sometime after that pivotal moment for me, I "found" (really God gave me this) a new response to those "miracle" conversations. Whenever someone would tell me God was still in the miracle business, I would agree and respond that I wasn't so sure that the miracle He was going to do, and was already doing, was going to be in Mom's healing on this side of the Jordan. The bigger miracle was that each and every time Mom and Dad posted something on Facebook, there were over six hundred people it reached plus a good many others who received the posts directly via email; nor did that six hundred include the small groups, the choirs, Sunday school classes, prayer groups, and churches that were praying for all of us. Six-hundred-plus people! That's no small church!

And nearly every post included a hymn and what it meant to Mom and Dad, or a scripture or both. ALMOST. EVERY. ONE. So I started thinking that the miracle God was doing was reaching six-hundred-plus people with His

message of how faith is lived out in the struggles of life. I was reminded of the boy with two fish and a few pieces of bread.

It also reminds me of how Moses (and Aaron) led the Israelite herd through the desert. In our case, and how these two connect, Mom and Dad started out on their cancer journey and along the way we gathered a herd. Mom and Dad led it through the wilderness of cancer and all the while tried to follow the cloud by day and the fire by night, looking for the manna for the day in the morning (because it was new every morning—Great is Thy faithfulness!) and out of the measly "fish and bread" they had in sharing their journey, six-hundred-plus people were fed every time a Facebook post went out. That may be a stretch for some to see, but I see God's miraculous hand all over it! And isn't that what God does? He takes the humble and the meager and the poor in spirit and the broken, and He works it together for good.

December 28 was the last day the boys saw Honey in person. We would FaceTime on some days when she felt up to it, but that was the last time they saw her in person. Nathan and I began an every-other-weekend schedule of sorts where I would go one weekend and he the next, then we would graciously give them a weekend without the hovering children. We did that because Mom and Dad didn't want to "mess up our busy schedules," but both of us kids wanted to be a help to them and as I said many times, "I only have one mom, so I'm going to be there." Nathan felt the same. He and I took turns taking care of each other, too. We talked often and kept the communication flowing in both directions.

Around mid-February, Nate told me that being there was getting hard, so I told him I was good and happy to take over those weekends. It wasn't long before we were juggling when it was time for hospice to come in and when he or I could be there to help Dad. On Thursday, March 19, I left for Nashville and Nate made the trek on Friday (his birthday). When we left our families we didn't know how long we were going to be in Nashville, but we were assuming it would be for the duration. During those few days we toyed with when the spouses and our kids should get there. We all decided that seeing

Mom was hard for a thirty-nine- and a thirty-six-year-old, so we all decided not to ask our kids to be there either. We wanted them to remember Honey the way Honey was—full of life and joy, the way she was at Christmas.

When it came to funeral events, we asked Chris and Corri to bring the kids the day of visitation, but we chose to let a family friend keep them during the visitation. Part of that decision was, again, because I didn't want those to be the last memories of Honey, but it was also because sitting or standing and behaving in one room surrounded by people they didn't know for several hours was a bit much to ask of three boys. I jokingly said I didn't want Andrew trying to ride the casket or climb inside to hug Honey. I suppose it was also a selfish thing, too—I wanted to be able to address things with the boys as they had questions; I knew I wouldn't be able to be a mom to the boys, and a daughter, all while welcoming guests and hearing and telling stories of Mom.

We also didn't have them come to the graveside for her burial, which preceded the memorial service at the church. Part of this decision, on my part, was that watching someone be lowered into the ground is the hardest part for me. The other deciding factor was that it was going to be an all-day thing for them if they went; I wanted them to be present more for the celebration and memorial service for her. Harpeth Hills Memory Gardens is on our way home, so leaving town, we stopped by to let the boys put some memorial service flowers on their Honey's new grave. It was not easy to drive away. Each time we go to Nashville we make it a point to stop by and "see" her on our way home.

Do I miss Mom?!?! Of course! Do I wish as anything she was here to talk to? Every single day. In the midst of my sorrow and sadness do I see where God has been at work? I sure do! Can those things coexist? They sure can, and they do.

✪CODA

Today is All Saints' Day. The branch of Baptists in my history has not, for whatever reason, observed All Saints' Day. But since retiring from vocational music ministry after serving three of those Baptist churches, I frequently attend 8:15 worship at Brentwood United Methodist Church a mere mile and a half from my house. Looking in on this Methodist steeple for eight years now, today is not the first All Saints' Day for me, but today's installment was more meaningful, more emotional, and more joyful.

We began with—

> *For all the saints, who from their labors rest,*
> *who Thee by faith before the world confessed,*
> *Thy name, O Jesus, be forever blest.*
> *Al—le-lu-ia! Al—lelu-ia!*
>
> *Thou wast their Rock, their Fortress, and their Might;*
> *Thou, Lord, their Captain in the well-fought fight;*
> *Thou, in the darkness drear their one true Light.*
> *Al—le-lu-ia! Al—lelu-ia!*
>
> *O may Thy soldiers, faithful, true, and bold,*
> *fight as the saints who nobly fought of old,*
> *and win with them the victor's crown of gold.*
> *Al—le-lu-ia! Al—lelu-ia!*
>
> *From earth's wide bounds, from ocean's farthest coast,*
> *through gates of pearl streams in the countless host,*
> *singing to Father, Son, and Holy Ghost.*
> *Al—le-lu-ia! Al—lelu-ia!*
>
> "FOR ALL THE SAINTS"– WILLIAM WALSHAM HOW, 1864 (HEBREWS 12:1)

It was wonderful—a great hymn tune and powerful text—and sing it, we did!

Later we sang a new one to me:

Rejoice in God's saints, today and all days;
* a world without saints forgets how to praise.*
Their faith in acquiring the habit of prayer,
* their depth of adoring, Lord, help us to share.*

The line "a world without saints forgets how to praise" stopped me in my tracks; I couldn't sing anymore. Studying the rest of the worship guide during the offertory I noticed that that arresting line was also the title of the sermon to follow. Apparently I was not the only one halted by it.

Sermon takeaways for me, thanks to Senior Pastor Dr. Davis Chappell:

- In the Greek, saint means "set apart." Some faith traditions "set apart" their saints formally; canonization in the Catholic Church is an example.

- Saints are not limited to those who are dead, but also includes the faithful living among us; it's called ALL Saints' Day. It is a "great [large] cloud of witnesses," many of whom have gone before, but some of whom are still at hand.

- Saints are not those who never sinned/sin, but those who never stop doing good.

- The native tongue of the saints is praise.

- A world without saints forgets how to praise; but …

- A world *with* saints *recalls* how to praise.

- "Precious in the sight of the Lord is the death of his saints." (Psalm 116:15)

After the sermon, the names of that congregation's members who have died since the previous All Saints' Day were read as the assembled stood in remembrance. Then seated, we were invited to call the names of other saints from the privacy of our hearts. Following that moment of silence, my dear, regular

pew mates on either side—Anne (eighty-something) and Kent (younger than I)—gently patted me on the knees. They loved Honey, too.

It is interesting (and delightful) that now going on eight months since Honey died, things continue to line up, to make sense, things I hadn't fretted or even wondered about. Honey was and is a saint. Oh, I've known that a long time, but now it makes even more sense. She certainly was not sinless—we shan't pursue that line of thought—but she never stopped doing good, not those two years she was sick, nor even in her death. Honey's "native tongue" was praise. You read her updates, and many of you observed her as she sang in the choir. Her face was bright, her joy and gratitude were obvious. People have commented about that for years.

So, should we use Saint Susie or Saint Honey? Either would embarrass her.

> Rejoice in God's saints, today and all days;
> a world without saints forgets how to praise.
> In loving, in living, they prove it is true;
> the way of self-giving, Lord, leads us to you.

Good job, Honey! And thanks for blazing the trail for us. We'll see you down the road.

Mark

> We lift our voices in a song of praise to you, Lord,
> knowing that the very gift of song comes from you,
> knowing that without song, life would lose its luster,
> knowing that one day our song will have no end.
> Alleluia! Amen!

NOTES FROM *Susie*

NOTES

1 Lucado, Max. *Grace: More Than We Deserve, Greater Than We Imagine.* Nashville, TN: Thomas Nelson, 2012.

2 Morgan, Robert J. *The Red Sea Rules: 10 God-Given Strategies for Difficult Times.* Nashville, TN: W. Publishing Group, 2014.

3 Adams, Carol Hamblet. *My Beautiful Broken Shell: Words of Hope to Refresh the Soul.* Eugene, OR: Harvest House Publishers, 2002.

4 Taylor, Barbara Brown. *Bread of Angels.* Cambridge, MA: Cowley Publications, 1997.

5 Lucado, Max. *Grace Happens Here: You Are Standing Where Grace Is Happening.* Nashville, TN: Thomas Nelson, 2012.

6 Lucado, Max. *God Will Carry You Through.* Nashville, TN: Thomas Nelson, 2013.

7 Autry, James A. *Choosing Gratitude: Learning to Love the Life You Have.* Macon, GA: Smyth & Helwys Pub. 2012.

INDEX OF HYMN COPYRIGHTS

All copyrighted material is included with the permission of the owners. No further use of these copyrights may be made without obtaining permission directly from the appropriate owners. Material in the public domain is not listed in this index. Every effort has been made to determine and locate the owners of all materials that appear in this book. The publisher regrets any errors or omissions.

"All Glory Be to God on High" – Nicolaus Decius; trans. Gilbert E. Doan © 1978 Augsburg Fortress Press. All rights reserved. Used by permission.

"All Things Are Yours" – Words Bryan Jeffery Leech © 1989 Hope Publishing Company, Carol Stream, IL 60188. All rights reserved. Used by permission.

"Ancient Words" – Lynn DeShazo © 2001 Integrity's Hosanna! Music (ASCAP) (adm. at CapitolCMGPublishing.com) All rights reserved. Used by permission.

"At the Break of Day" – Words and music by Aristeu Pires, Jr. © 1990 JUERP. International copyright secured. All rights reserved. Trans. © 1992 Ralph Manuel.

"Be Not Afraid" – Words Isaiah 43:1–4; music by Craig Courtney © 1992 Beckenhorst Press Inc. All rights reserved. Used by permission.

"Be Strong in the Lord" – Words by Linda Lee Johnson © 1979 Hope Publishing Company, Carol Stream, IL 60188. All rights reserved. Used by permission.

"Children Are a Gift from Heaven" – Words John E. Simons © 2010 Celebrating Grace Music, a division of Celebrating Grace, Inc. All rights reserved.

"Creator God, Creating Still" – Words by Jane Parker Huber © 1980 Presbyterian Publishing, Westminster John Knox Press. All rights reserved. Used by permission.

"**Creator God, We Give You Thanks**" – Words by Betty Anne J. Arner © 1973 The Hymn Society (Admin. Hope Publishing Company, Carol Stream, IL 60188). All rights reserved. Used by permission.

"**Give Thanks**" – Words and music by Henry Smith © 1978 Integrity's Hosanna! Music (ASCAP) (adm. at CapitolCMGPublishing.com) All rights reserved. Used by permission.

"**Give Thanks to God**" – Words J. Paul Williams © 2010 Celebrating Grace Music, a division of Celebrating Grace, Inc. All rights reserved.

"**God Is Our Refuge**" – Words by Jay Johnson (Psalm 46); music by Allen Pote © 1986 Hope Publishing Company, Carol Stream, IL 60188. All rights reserved. Used by permission.

"**Grace Alone**" – Words, Jeff Nelson and Scott Wesley Brown © 1998 Universal Music – Brentwood Benson Publ. (ASCAP) (adm. at CapitolCMGPublishing.com). All rights reserved. Used by permission.

"**Great Is Thy Faithfulness**" – Words Thomas O. Chisholm © 1923, Ren. 1951 Hope Publishing Company, Carol Stream, IL 60188. All rights reserved. Used by permission.

"**His Name Is Called Emmanuel**" – Words Ken Bible and Tom Fettke © 1998, 1999 LNWhymns.com / Pilot Point Music (both admin. by Music Services). All rights reserved. ASCAP

"**Hope, Peace, Joy and Love**" – Words and Music by Randy Edwards and Sherry Upshaw from Within the Seasons of Our Lives © 1999 Birnamwood Publications (ASCAP), a division of MorningStar Music Publishers Inc. St. Louis, MO. All rights reserved. Used by permission.

"**How Deep the Father's Love for Us**" – Words Stuart Townend © 1995 Thankyou Music (PRS) (adm. worldwide at CapitalCMGPublishing. com excluding Europe which is adm. by Integritymusic.com) All rights reserved. Used by permission.

"**How Lovely, Lord, How Lovely**" – Words by Arlo D. Duba © 1986 Hope Publishing Company, Carol Stream, IL 60188. All rights reserved. Used by permission.

"Hymn of Promise" – Words and music Natalie Sleeth © 1986 Hope
Publishing Company, Carol Stream, IL 60188. All rights reserved. Used
by permission.

"I Love You, Lord" – Laurie B. Klein © 1978 House Of Mercy Music
(ASCAP) (adm. at CapitalCMGPublishing.com). All rights reserved.
Used by permission.

"I Never Walk Alone" – Words and music by A. H. Ackley © 1952 Word
Music, LLC. All rights reserved. Used by permission.

"I Shall Know Him When He Comes" – Words Charlotte Lee; music Douglas
E. Wagner © 1991 Hope Publishing Company, Carol Stream, IL 60188.
All rights reserved. Used by permission.

"I Want to Walk as a Child of the Light" – Kathleen Thomerson © 1970
Celebration

"If I Fly as Birds at Dawning" – Words Edith Sinclair Downing © 2009
Wayne Leupold Editions, Inc. Used by permission.

"In Christ Alone" – Words and music by Keith Getty and Stuart
Townend © 2002 Thankyou Music (PRS) (adm. worldwide at
CapitolCMGPublishing.com excluding Europe which is adm. by
Integritymusic.com). All rights reserved. Used by permission.

"In Christ We Live" – Jane Martin and Donn Wisdom © 2010 Celebrating
Music, a division of Celebrating Grace, Inc. All rights reserved.

"In Deepest Night" – Words Susan Palo Cherwein © 1995 Augsburg Fortress.
All rights reserved. Used by permission.

"In This Very Room" – Words and music by Ron and Carol Harris © 1979
Ron Harris Music. All rights reserved. Used by permission.

"Jesus Is Lord" – Words and music Keith Getty and Stuart Townend
© 2004 Thankyou Music (PRS) (adm. worldwide at
CapitolCMGPublishing.com excluding Europe which is adm.
by Integritymusic.com). All rights reserved. Used by permission.

"**Jesus Is the Song**" – Words and Music David Danner © 1979 Broadman Press (SESAC) (Admin. LifeWay Worship c/o Music Services). All rights reserved. Used by permission.

"**Jesus, Walk Beside Me**" – Words Mary R. Bittner © 2004 Wayne Leupold Editions, Inc. Used by permission.

"**Like a Mother with Her Children**" – Words Jann Aldredge-Clanton © 2010 Billingsly Square Music, a division of Celebrating Grace, Inc. All rights reserved.

"**Look, You Saints, the Cloud of Witness**" – Words by John H. Dickson and music by Jonathan Crutchfield © 2010 Billingsly Square Music, a division of Celebrating Grace, Inc. All rights reserved.

"**Lord, I Lay My Life Before You**" – Words Jan McGuire © 2010 Celebrating Grace Music, a division of Celebrating Grace, Inc. All rights reserved.

"**Morning Has Broken**" – Words by Eleanor Farjeon © by Eleanor Farjeon in The Children's Bells, Oxford University Press. Reprinted by permission of Harold Ober Associates, Inc., New York, and David Higham Associates Limited, London.

"**My Lord Is Near Me All the Time**" – Words Barbara Fowler Gaultney © 1960. Renewed 1988 Broadman Press (SESAC) (Admin. by Music Services). All rights reserved.

"**My Lord Knows the Way**" – Words and Music Sidney Lawrence Cox © 1951 NewSpring Publishing, Inc. (ASCAP) (adm. at CapitolCMGPublishing.com) All rights reserved. Used by permission.

"**My Soul Proclaims with Wonder**" – Words Carl P. Daw, Jr. © 1989 Hope Publishing Company, Carol Stream, IL 60188. All rights reserved. Used by permission.

"**O For a Faith, a Living Faith**" – Words William R. Hornbuckle © 2010 Celebrating Grace Music, a division of Celebrating Grace, Inc. All rights reserved.

WHAT OTHERS SAY

Any good music minister knows that singing forms our faith. Mark Edwards has spent his life helping others engage in that practice, but as his wife, Susie (Honey) and Mark journeyed through their most challenging days they allowed others a window into their own faith journey to find scripture, song, and loving relationship on full display as they faced the predictable highs and lows of a battle with cancer. I was privileged to be one of those peering through the window via Facebook updates and the "Notes from Susie" reflections in this tome. I have treasured friendship with Mark for a long time and worked in the same building with Susie for fifteen years. When I first heard the news of the onset of Susie's illness I found it hard to find words to express to my friend the depth of my care. Words of hymns, however, came to mind and heart often and I would send a phrase off in a text message to Mark. Of little surprise, most every time I texted him, Mark would fire another hymn phrase right back. When we talked by phone Mark would remind me that Susie and he had determined to "choose joy" through this journey, and choose joy they did. You will see it reflected in these pages, and sense the warmth of Christian fellowship exemplary of what "church" is supposed to be. You will get a glimpse of the love and devotion that defines the Edwards family. Perhaps, like me, you will find renewed resolve to express in word and deed your own love for others, especially your spouse. I hope you will also find the song of deliverance, of courage, of strength, implanted in the heart of Jesus followers.

Paul Clark Jr
Director of Church Music
Tennessee Baptist Convention

Attentive physicians learn much by caring for their patients. Susie Edwards taught me much about living with grace. She faced an illness that could have made her angry or bitter, for it robbed her of time with those that she loved. Nonetheless, she possessed an air of quiet dignity and peace that allowed those around her to see that she would not allow cancer to dominate her spirit. Even in the toughest of times, she wore a gentle smile that put others at ease. She taught me that we have the ability to live fully, even when confronting the most difficult of life's circumstances. I am grateful to have known her, and miss her very much.

In the book, Mark's brother Randy writes about the last time that we were all together in my office. We had said just about all the words that needed to be said, and sat quietly for several moments. As I recall, I held her hand--I had a tear in my eye, and a lump in my throat. He remarked that he felt the presence of Jesus in that small exam room. I know that God's peace was abundantly present, and it helped us all at that very difficult moment.

DR. CHARLES PENLEY M.D.
Tennessee Oncology

When you work closely with a person for more than 25 years you really get to know the individual. Susie Edwards could light up a room with her smile. She was a friend to all, including those she never actually met. In her role with the *Baptist and Reflector,* Susie formed amazing telephone "friendships" that were meaningful to her and the other person. I am not surprised that Susie handled her battle with cancer with dignity and class. After all, that was how Susie lived her life every day.

LONNIE WILKEY, EDITOR
Baptist and Reflector

Some of us grieve from afar. Reading "Notes from Susie" made the hours and miles disappear. What I learned from watching Susie's struggle with cancer can be described this way: gratitude in action. Even reports of her worse days didn't end without a list of people and experiences she appreciated.

"Notes from Susie" became a personal primer of cancer treatments; the blatant honesty burned my eyes with tears of compassion but brought me closer to her in prayers and concerns.

So if "God inhabits the praise of his people," Susie was never alone.

CAROLYN JENKINS, MINISTER
Arlington, VA

Susie Edwards greeted members and guests at First Baptist Nashville with a smile that conveyed warmth and love. You'd find her in our Infant Care Sunday School Class loving on babies and assuring young parents that their baby would be well cared for while they connected with others for Bible Study and Worship. Until Mark retired as Minister of Music, Susie sang in the choir. She was the consummate supporter, encourager, cheerleader and defender of her church staff. She was a prolific writer of notes to people who were going through difficult times. This may have been her most prominent spiritual gift. She knew how to love God and love people. Together she and Mark loved First Baptist Nashville well for over thirty years. We miss her terribly.

DR. FRANK R. LEWIS, SENIOR PASTOR
First Baptist Church, Nashville, TN

I was a young teenager in Premont, TX, when Barbara and Grady West added a beautiful baby daughter to their family. We know her today as Honey - Barbara Sue West Edwards. Susie's mother, Barbara, was one of the most important influencers in my life. (Susie had the determination of her mother, the gentleness of her father and the compassion of her grandmother and aunt.) I was thrilled when Mark and Susie moved to Tennessee and only a few blocks from my home. I was blessed to walk with them through Honey's cancer battle. Honey battled cancer with a steadfastness that exceeded her body's capacity to beat the dreaded disease. I am humbled as I add my word of endorsement to this book that reminds us of Honey's and her family's unwavering dependence on God during these perilous days. Praise God from whom all blessings flow....

MYRTE VEACH
Long-time family friend

As I read this book, I was amazed over and over again. I have known Mark and Susie for quite some time now, but what I could not have known is the depth and intensity of their faith through this wilderness journey. Surrounded by friends and family and walking on the sure foundation of their faith in God, they moved through this frightening darkness with breath-taking strength and grace. I have never seen such a strong proof that the hymn can be a means of conveying God's presence and Grace.

I suppose there were more hymns quoted in this book than in any other I have read and every one is a source of strength, an expression of praise, a comment on what is going on at the moment. Thank you Mark, Susie, your family and friends for taking all of us on this trip a step by step, week by week journey from life to death to life, all of it expressed in those wonderful hymn texts whose power we can hardly overstate.

Because people are not the same they will not deal in the same way with these life and death events and journeys but let there be faith in God's on-going presence and care and the road we walk will lead us beside still waters, through green pastures and into the house of God forever. Let there always be great hymns to help us speak both God's presence and our response.

KEN MEDEMA
Composer and Concert Artist

CPSIA information can be obtained at www.ICGtesting.com
Printed in the USA
LVOW10s0010120516

487822LV00001BA/1/P